Praise for Wh

"Crawford writes ecstatically of driv and agency of flooring it out of tl reels out ahead in rhythmic curves.

driving like *Moby-Dick* is about whaling. . . . Crawford has something important to say." —*San Francisco Chronicle*

"[An] absorbing book. . . . [Why We Drive] is about a freedom that is being lost to the cynics of surveillance. . . . This book is a defense of felt life against the intrusions of the technocrats. . . . Crawford spreads his wings way beyond cars. . . . Plain funny."

-New Statesman

"A pleasure to read. . . . [Crawford's] thesis demands that he convey the pleasure of driving, and he's up to the task. . . . And he addresses some huge, fascinating issues: how people retain self-respect when computers are deskilling them, and sovereignty over their lives when computers are spying on them. Much of modern life raises these questions, but people's relationship with their cars perhaps best exemplifies them. . . . An enjoyable, scenic cruise round a fascinating landscape." —Sunday Times (London)

"One of the most original and mind-opening studies of practical philosophy to have appeared for many years." —John Gray, UnHerd

"A biographical, philosophical inquiry that explores a fascinating paradox: the whole allure of driving is freedom, but it's also dangerous, so it has to be regulated. . . . This is a lovely book that applies history, philosophy, and literature to one obsessive subject. . . . A culture war over cars that pits town against country, walkers against drivers, and freedom against order." —*Telegraph* (UK)

"Fascinating.... Crawford skillfully takes us through the gears as he intelligently, and in a very American way, flies the flag for individualism over dour corporative determinism." —*Mail on Sunday* (UK)

"A passionate appeal to the importance of the autonomous individual in the face of the dehumanizing pressure of automation. . . . This book will have you pining for the freedom the open road has always represented. . . . His delight in his subject makes for an enjoyable reading experience even for the non-enthusiast. . . . Employing memoir, journalism, cultural criticism, and political philosophy and never shying away from the contentious—the author makes being human seem worthwhile." —*Kirkus Reviews*

also by Matthew B. Crawford

SHOP CLASS AS SOULCRAFT THE WORLD BEYOND YOUR HEAD

WHY WE DRIVE

Toward a Philosophy of the Open Road

Matthew B. Crawford

WHY WE DRIVE. Copyright © 2020 by Matthew B. Crawford. All rights reserved. Printed in the United States of America. No part of this book may be used or reproduced in any manner whatsoever without written permission except in the case of brief quotations embodied in critical articles and reviews. For information, address HarperCollins Publishers, 195 Broadway, New York, NY 10007.

HarperCollins books may be purchased for educational, business, or sales promotional use. For information, please email the Special Markets Department at SPsales@harpercollins.com.

A hardcover edition of this book was published in 2020 by William Morrow, an imprint of HarperCollins Publishers.

FIRST CUSTOM HOUSE PAPERBACK EDITION PUBLISHED 2021.

Designed by Elina Cohen

Illustrations by the author

Title page art © Shutterstock / Dudarev Mikhail

Library of Congress Cataloging-in-Publication Data has been applied for.

ISBN 978-0-06-274197-4

22 23 24 25 26 LBC 65432

After attending the Portland Adult Soap Box Derby, I went for a hike in the foothills of Mount Hood. I stepped off the trail for a bit, and a moment later heard voices approaching. But they weren't talking, and they weren't really singing. After a few more seconds of listening, I realized they were trying to mimic the sound of a two-stroke motorcycle. Peering around the edge of a boulder, I saw a man and a woman running down the trail with their hands in front of them, as though grasping handlebars. When their voices raised in pitch, they would twist their right wrists. Hopping off little jumps, they would stick their butts out to the side, as though kicking the rear wheel of a bike out to add a flourish. motocross style. (This was a moment to rev the throttle too.) Here was a middle-aged couple in their own secret world, abandoning themselves to the motor equivalent of air-guitar. Clearly, they were enjoying themselves more than anyone over the age of twelve has a right to. This book is dedicated to them.

Contents

Prelude: Without a Road 1 Introduction: Driving as a Humanism 4 Cars and the Common Good 35

Rolling Your Own

Breaking Down: 1972 Jeepster Commando 49

Project Rat Rod 59

Old Cars: A Thorn in the Side of the Future 66

The Diminishing Returns of Idiot-Proofing as a Design Principle **84**

Feeling the Road 107

Automation as Moral Reeducation 116

Folk Engineering 128

Motor Sport and the Spirit of Play

The Motor Equivalent of War 163 The Rise of the Bicycle Moralists (A Digression) 179 Two Derbies and a Scramble 184 Act I: Demolition Derby 184 Act II: Adult Soap Box Derby 187 Act III: Hare Scramble 191

Democracy in the Desert: The Caliente 250 199

Self-Government, or Not

Prelude: The DMV Experience 213

"Reckless Driving:" Rules, Reasonableness, and the Flavor of Authority 215

Managing Traffic: Three Rival Versions of Rationality 241

Road Rage, Other Minds, and the Traffic Community 249

Meet the New Boss

Street View: Seeing Like Google 265 A Glorious, Collisionless Manner of Living 277 If Google Built Cars 293 Concluding Remarks: Sovereignty on the Road 311 Postscript: The Road to La Honda 315 Acknowledgments 317 Notes 321 Index 349

Prelude WITHOUT A ROAD

It is forty-eight degrees Fahrenheit and sweat is dripping down my back. My goggles are steamed up and it is hard to see. I am on a tract of land owned by the railroad, a wooded area in Richmond, Virginia, with discarded beer cans and the occasional homeless encampment commonly referred to as "behind the Martin's." Riding a dirt bike on a narrow, meandering trail that is rocky and muddy, with protruding roots and fallen limbs, creek crossings, steep descents, and tight switchbacks, at a mere fifteen miles per hour, I might be taxed to the very limit of my mental ability. Picking lines, making imperceptible decisions of throttle, clutch, steering, braking, and body English, revising them on the fly as surprises arrive at my front wheel—all this demands total concentration. When I push the pace beyond my current level of confidence in response to some challenge of the terrain, it is a leap of faith. Or perhaps it is a query. I can't say to what entity this question is addressed—myself? the obscurities of the trail? a loving providence? It is a position of utter exposure to contingency: let's see how things go. If it goes well over the following seconds (meaning without mishap, maybe even with a glimmer of some new finesse), this faith redeemed is the sweetest vindication I know of. For a moment, I feel existentially *justified*. In pursuit of that feeling, I once took four trips to the ER over the course of twelve months: two broken ribs, a broken heel, what I feared was a separated tendon (it was a muscle strain), and a case of heat exhaustion.

To ride a motorcycle off-road is in no way typical of the driving that we do most of the time, and therefore perhaps an odd choice of anecdote to open a book that ranges widely over the driving experience. But the heightened feeling of exposure one has on a dirt bike recalls one to a basic truth: we are fragile, embodied beings. There is a certain risk that is inherent in *moving around*, by whatever means. A responsible person does everything he can to minimize this risk. Yet is risk somehow bound up with humanizing possibilities?

In his exquisite essay about walking the hostile streets of Kingston, Jamaica, as a boy, and then New Orleans as a young man, Garnette Cadogan writes, "When we first learn to walk, the world around us threatens to crash into us. Every step is risky. We train ourselves to walk without crashing by being attentive to our movements, and extra-attentive to the world around us." As adults, we sometimes walk simply because the street beckons with serendipity; you never know who or what you are going to find when you step out onto an urban sidewalk. "Serendipity, a mentor once told me, is a secular way of speaking of grace; it's unearned favor. Seen theologically, then, walking is an act of faith. Walking is, after all, interrupted falling."

The heightened contingency of driving off-road resembles

ω

walking in the faith it enacts—that of throwing oneself into the world with hope. The ancient Greeks had a single word to express the condition of being "without a road," when the way forward is not clear: *aporia*. It represents a moment pregnant with the arrival of something unlooked for.

These experiences of serendipity and faith feel a bit scarce in contemporary culture, and the language for articulating them seems to be fading from common use. We have a vision of the future in which there would be little scope for such moments; the most authoritative voices in commerce and technology express a determination to eliminate contingency from life as much as possible, and replace it with machine-generated certainty. That's what automation does, whatever else it may accomplish. Suddenly it is in the realm of mobility that this vision is being expressed. Suddenly driving is a topic that cries out for critical, humanistic inquiry.

Introduction DRIVING AS A HUMANISM

On September 19, 2016, the National Economic Council and the U.S. Department of Transportation held a joint press conference. "We envision in the future, you can take your hands off the wheel, and your commute becomes restful or productive instead of frustrating and exhausting," said Jeffrey Zients, director of the National Economic Council. President Barack Obama himself wrote an op-ed on behalf of driverless cars in the *Pittsburgh Post-Gazette* the same day. President Donald Trump affirmed these priorities early in his administration.¹

Driverless cars will finally solve the problem of moving people around with maximum efficiency, by ceding human control to impersonal algorithms. They promise to bring a messy, dangerous domain of life under control at last. Traffic jams will likely become a thing of the past, and accidents will be greatly reduced. So we are told, at any rate.

сл

In this we can detect a familiar pattern. Driverless cars are one instance of a wider shift in our relationship to the physical world, in which the demands of competence give way to a promise of safety and convenience. The skilled practitioner becomes a passive beneficiary of something more systemic, rendering his skill obsolete. *Human beings are terrible drivers*—that is the refrain.

It's hard to disagree. We are so distracted behind the wheel, we are already driving as if our cars were self-driving. But they are not, and the result can be deadly for anyone not encased in the ever-growing mass and air-bagged bloat of contemporary cars. Motorcycle deaths have shot up, and highway deaths overall rose at their fastest rate in fifty years from 2013 to 2015, despite a proliferation of new safety features.² The causal sequence that led us to this point is not hard to identify. Arguably, the first and fatal development was that cars became boring to drive, starting in the 1990s. I mean really boring.³ The problem is that they got very heavy, and pursued a goal of maximum insulation from the road by damping out all mechanical "transients"-a design ideal that previously informed only luxury cars but trickled down to car makers' entire model lines.⁴ With no shifter and no clutch, you don't really feel that you are doing anything. This lack of involvement is exacerbated by features that partially automate the driving task, such as cruise control.⁵ Nor, with GPS navigation, are you much required to notice your surroundings, and to actively convert what you see into an evolving mental picture of your route. Between the quiet smoothness, the passivity, and the sense of being cared for by some surrounding entity you can't quite identify, driving a modern car is a bit like returning to the womb.

The smartphone arrived in 2007. Now we had something to keep boredom at bay while getting around in the new manner, and it proved irresistible. This irresistibility became the basis of a new business model in Silicon Valley: harvesting and selling our attention. This is not hard to do when the road is a distant and dimly felt thing, as it is when one is serenely cocooned in four thousand pounds of plushness. The windshield begins to seem like one more screen, and it cannot compete with the dopamine candy offered on the other screens. So now Silicon Valley is going to solve the problem of distracted driving that it helped to create, by removing us from the driver's seat. Perhaps that is a good thing, on balance, given the realities.

But it also represents a quiet coup of some consequence, and we do well to pause and consider the direction we are headed. We catch a glimpse of one possible future in the animated film *WALL-E*, in which we see grotesquely fat people ferried about a hovering grid in their car-like pods. Finally relieved of the burden of paying attention to their surroundings, they slurp from enormous cup holders and gaze raptly at their screens, untroubled by the overdetermination of their world. Their faces beam, in a slackened sort of way, with the opiate pleasure of novelties piped into their cockpits from afar. These beings are completely safe and content, and somehow less than human.

The scene is powerful because it presents an image in which we already recognize ourselves, with a shock of aesthetic revulsion. Is this revulsion *merely* aesthetic? Or does it offer us an affective cue that there may be something important at stake, a threat of human degradation that we should try to clarify? And if that is the case, what is the positive possibility that is absent or diminished in this dystopian automotive picture? What is so great about *driving*?

One way to approach the question is to compare driving to air travel. There was a car commercial airing on television recently that showed a guy being jostled about and casually abused in the course of a long plane ride home. The ad was able to convey the intended mood with just a few deft strokes, as we are all familiar with the helpless feeling of being at the mercy of U.S air travel, that opaque hybrid of corporate and government entities that soothingly repeats its paramount concern for our safety

INTRODUCTION

7

and convenience. Dazed and subtly brutalized, the man finally emerges from the stale air of the terminal to the sunshine of the parking deck. He lays eyes on his car and a glimmer of humanity returns to his face. He takes the wheel, stick shift in hand, and now we see him banking through an undulating series of turns as a canyon road spools out in front of him.

To be sure, an advertisement for a car is going to play up the positive aspects of driving, while downplaying the hassles of traffic, the environmental costs of automobility, and greater risk of accidents (per mile traveled) compared to air travel. But as a swipe against the airlines, the ad is brilliant. And it portrays something real (however partial the portrayal).

What, then, is so special about driving? That is the animating question of this book. In trying to answer it, I will be attempting something like "philosophical anthropology." For driving is a rich and varied practice. As with any such practice, a full consideration of it can focus light of a particular hue on what it means to be human. It can also shed light on the challenge of *remaining* human against technologies that tend to enervate, and claim cultural authority in doing so. The boosters of driverless cars are unimpressed with pleasure as an ideal and suspicious of individual judgment.

The proposed book is political in spirit, if we may take that term in its broadest sense. As we become ever more administered and pacified in so many domains of life, I want to explore this one domain of skill, freedom, and individual responsibility *driving*—before it is too late, and make a case for defending it. For self-driving cars to realize their full potential to reduce traffic and accidents, we can't have rogue dissidents bypassing the system of coordination that they make possible.⁶ Their inherent logic presses toward their becoming mandatory—if not by fiat of the state, then by the prohibitive calculations of insurance companies, who will have to distribute risk among fewer human drivers. Or by the portioning out of scarce road surface, with preference given to driverless cars. At bottom, the all-colonizing character of driverless cars derives from the fact that robots are a very awkward fit with human drivers, and are likely to remain so. The prospects for these two kinds of intelligence to share the road gracefully are quite dim, as we will learn from the literature on "human factors" in automation.

If our fate is to be that of passengers, let us first understand what we are being asked to give up. You've filled the tank and checked your tires. Did you let your boss know you're leaving work early? He'll figure it out. You inch out of the city with the other refugees and get through a couple of toll booths. If you're lucky, you might hit the lights just right through the suburbs. Eventually the strip malls give way to farmland, and now a shady country road reels out ahead in rhythmic curves. You stick your hand out the open window and let it undulate on a cushion of pressure. You can breathe.

Nobody is tracking you, directing you, or managing you. You are *roaming*: an excellent tonic for the confinement of work and family. The gas pedal and the steering wheel are wired directly to your will, via the seat of your pants, and there is no committee involved.

A child's life is highly scheduled and supervised, a consumer's preferences captured in an algorithm, an employee's performance plotted against the average. Life often feels overspecified, fully modeled and determinate, but the road has a dicey quality to it. We usually have a destination in mind, but when we get behind the wheel we expose ourselves to unexpected hazards, as well as unlooked-for moments of discovery. On a road trip, you encounter landscapes and human types beyond the ken of your usual routines, and there is something rejuvenating about this. It reminds you that there are possibilities you hadn't reckoned with, lives you could have lived—or might yet.

6

Of course, most of the driving we do is nothing like this. It is routine, and may itself be experienced as a source of confinement. Still, the absence of *remote control* when we get behind the wheel is significant. On your daily commute, maybe you spot a familiar car or two outside the pub, and stop for a drink (just one!) between work and the second shift that we call home. My bartender Troy relates that a certain regular abruptly left his freshly drawn pint on the bar and could be seen driving slowly around the block several times. He then came back in and resumed a leisurely conversation. His wife had Facetimed him, and he thought it best to conduct the exchange from behind a steering wheel. In this everyday bit of domestic evasion, he could count on his own car not interjecting with error messages. (In the soothing voice of HAL 9000: "Hello Dave. Are you looking for a grocery store? I notice you're getting low on milk at home.")

We don't give much thought to the moments of release that open up when there is some slack in the plan, but I think we would miss them if our movements were more thoroughly coordinated. Sometimes, what you are doing when you drive your car isn't very well captured by the term "transportation," which suggests a simple point-to-point goal to be achieved with maximum efficiency. Such simplifications have always been the price paid for bringing new domains under technocratic control.

Ian Bogost offers a convincing thought experiment about the terms on which the public will have access to roads as public infrastructure comes to be financed and planned by partnerships between municipalities and tech companies. "It's easy to imagine that cross-town transit might soon require acceptance of nonnegotiable terms of service that would allow your robocar provider to aggregate and sell where you go, when, with whom, and for what purpose." One can imagine the removal of street signs, those eyesores that aren't needed by autonomous vehicles, tipping us further into dependence on the cartel. Bogost writes that "other, stranger realities are possible. Imagine if walking across the street required a microtransaction to insure safe passage. Violations might be subject to tickets or fines—although more likely, your local transit vendor would already know where you are thanks to your smartphone, and just debit your metered service plan accordingly."⁷

Something about this picture sits ill with our liberal political traditions, but its wrongness goes deeper still. As creatures who are self-moving, freedom of movement would seem to be the most fundamental freedom there is, a minimal condition for that basic animal pleasure that makes life sweet.

The good news is that the conceptual frame we need for critiquing this trajectory is available in the liberal tradition, though it is found in strands of liberal thought that have fallen into disuse. I mean pluralism: the Tocquevillian awareness that when people come together around some particular interest that they share, such associations become a rival to the central power. They provide a check on its tendency to gather ever more power to itself. That central power needn't be the state; it may be an apparatus of technocapitalism devoted to our comfort and convenience, and to keeping us entertained. The rival sites of association I want to consider in this Tocquevillian light are the cells of car enthusiasts that we will encounter in this book.

The book proceeds in part by an examination of various automotive subcultures—a demolition derby in the American South, a desert race in southern Nevada, the professional drifting circuit, a hare scramble in Virginia, an adult soap box derby in Portland, Oregon. Though they may appear a bit exotic, the heightened enthusiasms of these groups are not simply alien. They will bring into relief different aspects of the appeal that driving has for all of us. And because they are *sub*cultures, they help to clarify what is precarious in the freedom to drive against the backdrop of a certain vision of progress. What is at stake is not simply a legal right, but a *disposition* to find one's way through the world by the exercise of one's own powers.

These are powers of a particular sort. They are not simply those of a pedestrian, as they involve us intimately with machines. Accordingly, this book is not a cry for "the human" *versus* technology, if we take the former as a term reserved for man at his most naked and innocent. My motive is not such a distant and hypothetical ideal, but a lifelong affection for something utterly familiar—the experience of using a car or a motorcycle as a kind of prosthetic that amplifies our embodied capacities.

номо мото

When we have learned to walk, we have only just begun our journey toward full mobility in the world of artifacts, as there remain to be mastered all those modes of movement that extend and transform our native powers, from bicycles to skateboards. With each of these comes some new competence—and the peculiar pleasures of that hybrid creature *homo moto*.

When a person is depressed, he lets himself be carried along by life, indifferently. Like a passenger. And conversely there seems to be an inherent connection between movement and joy. My young dog goes tearing around the yard gratuitously, making sharp cuts and great looping circles for no apparent reason. She is blisteringly fast, she knows it, and these eruptions seem both to express her joy and to cause it. Lucy has a definite need for speed.

Elsewhere in the front yard, my daughter J spends hours on a thirty-foot rope swing, having hit upon a technique that requires no adult to push her. She pushes off from the massive oak tree with her feet and does an arcing circle that brings her back to the tree at a tangent. In the course of her arcs she spins, languidly or furiously according to the extension of her legs. She has learned the conservation of angular momentum and always meets the tree feet-first, ready to push off once again. Children have a knack for finding affordances in their environment that give them new avenues of movement and joy. When we get a little older, we begin to notice how a new avenue might be opened up if we alter the environment—for example, by stringing a rope up on a tree. (That's what dads are for.)

Or by adding wheels. Now we're talking. I's first wheeled convevance was a scooter. Because my own skateboard is so much faster (it is designed for carving long arcs down hills), I used a bicycle to accompany her on her first excursions beyond the driveway so I could use the brakes to stay near her. With the graveness that only children are capable of, she pushed off onto the gentle slope that runs away from my house while muttering warnings to herself about various hazards in the broken pavement, and occasional yelps of fright. By the third or fourth such excursion, she had it wired. Wind in her hair, she must have sensed my own joy alongside her and reckoned it worth breaking her concentration on the pavement, just long enough to shoot me a glance of grinning pride. A pogo stick followed, and soon enough came mastery of that ultimate childhood conveyance, a bicycle. Her need for speed has developed apace with each breakthrough of her expanding mobility. As Nietzsche said, joy is the feeling of one's powers increasing.

Combine that thought with another: Aristotle said that what distinguishes animals from the rest of nature is that we are "selfmoving" (unlike a rock); we get up and go. Often for no good reason. Aristotle might have been on to something, as we are now learning that self-locomotion, as distinct from being carried passively, is tied to the development of our higher capacities. Navigating space and exploring our environment influence how the hippocampus develops, and this structure at the center of the brain is where we develop our cognitive maps of the world. We have specialized cells dedicated to place, others that specialize in head direction, and "grid cells" that are activated by movement as we roam through an environment, allowing us to build a coordinate system for navigating.

But it gets more interesting still. Self-mobility appears to be deeply implicated in the development of "episodic memory." As M. R. O'Connor writes, "Our cognitive maps of space ... are the locus of ... our memories of the past." This makes sense; events always happen in some place. Time and space are connected in experience, and therefore also in memory. And it is only after the brain becomes capable of place learning, through the slow development of the hippocampus (via roaming self-locomotion), that we begin to retain episodic memories. The psychologists A. M. Glenberg and J. Haves hypothesize that this mutual dependence of self-movement and memory may explain why we don't remember our earliest childhood. They note that "infantile amnesia starts to dissipate when children begin crawling and walking. Once babies begin moving through space rather than being carried passively ... the brain's place cells and grid cells start firing and aligning themselves to the environment, encoding the spaces being explored and ultimately building the scaffolding of episodic memory."8

Let us draw the implications of this out just a bit further. Our memories of particular events provide the dots that we connect to tell stories about ourselves. With such storytelling, we are getting into the territory of the distinctly human. We don't simply exist, like an animal that lives entirely in the present. We *interpret* our existence. We do so by composing a narrative that makes sense of our past episodes, and this narrative template provides a basis for imagining ourselves into the future. There is a striking implication here. The subjective coherence of a life—our persistent identity through time—seems to be built up from some basic *motor* capacities.

It is therefore not surprising that some of our best stories retell episodes from the road, and often convey the contingency and adventure of exploration. I will offer one of my own shortly, a story of breaking down on the highway in a 1972 Jeepster Commando.

To the extent we are disburdening ourselves, via technology, of being mentally involved in our own navigation and locomotion, we would seem to be embarking on quite a significant social experiment. The merits of such an experiment can be debated, but in any case it should be undertaken in full awareness that our mobility as self-directed, embodied beings is fundamental to our nature as it has evolved over millions of years, and to the distinctly human experience of identity.

MOTOR SPORTS

Driving is a practice that can be developed to an astonishing level of skill, in the exercise of which some of the most impressive (and troubling) human qualities shine forth: daring, finesse, and aggression. Accordingly, motor sports occupy a prominent role in the anthropology I wish to develop. Sport is a realm of play, free of all utility. It shows us the peaks of human performance, and such peaks are good to have in view as we sketch the broader plane of experience. Further, motor sports can serve as a tonic for the creeping enervation that comes with peace and prosperity. In their warlike energies, motor sports offer a window into a part of our nature that is subject to atrophy, for better or worse. To bring out this parallel, we will take a historical detour into the practice of aerial combat by fighter pilots in the First World War, a literal case of motor sport to the death.

It has been said, "Every man dies. Not every man lives." I suppose the idea is that merely breathing doesn't count as living. Such a motto is at odds with the mentality of health and safety. But if we take a wider view of "health," we can't overlook the simmering discontent, even self-loathing, that men (especially) often suffer in bourgeois society, where the threat of physical harm is almost entirely absent. The *question* goes unasked and unanswered.

Put simply, there is a certain tonic effect in being scared shitless and trusting in your skills to see you through. It focuses the mind. It clears away the nonessential. And when it is over, you feel elated to be alive. For a brief spell, you feel justified in taking up space on the earth.

A few years ago, I was loaned a brand-new Ducati by the good people at *Popular Mechanics* (they had hired me to write a story). I took it on the canyon road that leads up to the Mount Wilson Observatory outside Los Angeles. At one point, my front tire hit a patch of sand just as I was apexing a blind curve, with my head about three feet from the rock face on my inside. The front tire slid maybe a foot, my inside boot dragged. Then the bike gripped, sorted itself, and kept going, finishing the turn upright. It was one of those episodes—a little glimpse of mayhem where, if you come through it, you feel like you stand a little taller afterward. "To dare, to take risks, to bear uncertainty, to endure tension—these are the essence of the play spirit," Johan Huizinga writes. We will learn much more from Huizinga in the chapter titled "The Motor Equivalent of War."

FOLK ENGINEERING: ROLLING YOUR OWN

A fundamental fact about human beings is that we are *homo faber*, as Hannah Arendt said. We make stuff. Doing so seems to express a deep necessity we have to point to something visible in the world and say, "I did that." When you combine this aspect of the human with the *homo moto* aspect, what you get is the passionate involvement of the gearhead.

We are living through a period that I expect will come to be viewed as the second golden age of hot-rodding. The first began after World War Two and continued until the advent of electronic engine management in the 1980s. At that point things became a little opaque under the hood, and all but the most intrepid were deterred from monkeying with recent-model cars. They sought out older models, and that was a thriving scene for a while, but eventually investors decided that old cars are objets d'art and their prices went through the roof, out of reach of the typical shade-tree mechanic.

But then a couple of things happened. Computer geeks discovered cars, or gearheads learned how to code; in any case people figured out how to hack the software that makes contemporary cars run, and turn it to illicit purposes. Even more important, the internet happened. Technical forums have sprouted up devoted to the minutiae of many makes of car. Especially well represented are makes favored by various cells of enthusiasts, not least for being affordable and therefore providing suitable platforms for experimentation. What I find most appealing about these communities is that they cultivate a deep cognitive ownership over one's car that stands in stark contrast to the passivity and dependence of consumer culture. Further, the sustained, searchable conversations among people grappling with the same set of technical challenges have greatly accelerated the progress of knowledge.

Nobody in the year 2000 would have believed that after a century of development the two-valve-per-cylinder, pushrod internal combustion engine still held so much untapped potential, or that hobbyists would soon be building air-cooled Volkswagens for daily driving with up to ten times the horsepower that Ferdinand Porsche had in mind when he designed the engine in the 1930s.

I am one such hobbyist; I am currently restoring and radically modifying a 1975 VW Bug. The building of the car is itself an argument to explore what driving can be. In engineering the car, I am seeking to realize at the highest level I can the qualities that make driving *fun*. In this I am not adopting the purist mentality of the "period correct" restoration; wherever current technology can make a tangible contribution to the driving experience, I am using it. I will give an account of building the car in the chapter "Folk Engineering."

The idea of rolling your own is a bit extreme; few of us will ever dive so deep into our cars. But those who do venture down into the nuts and bolts bring back from the experience a useful perspective. Rolling your own is about the pleasure of truly making a car your own by mixing your own thought and labor into it. Doing so alters the driving experience; the car becomes more thoroughly an extension of oneself. This brings heightened anxiety as well as satisfaction-it becomes impossible to drive without vicariously suffering all the little metallurgical traumas endured by the car in the normal course of operation. Cold starts produce a shudder of physical discomfort as one visualizes crankshaft bearings devoid of oil pressure, in minute detail. On hot days one squirms a bit, wondering just how appalling the intake air temperatures are getting as the engine becomes heat soaked. Should I listen for that elusive, flitting rattle of detonation (barely audible but possibly catastrophic), or turn up the radio and try to enjoy life while I can? Better check the data log when I get home. And so on. If ignorance is bliss, this level of involvement would be something close to the opposite of bliss. Especially if you have four months' salary and more than a hundred hours of careful assembly invested in your motor. (Meanwhile the car's body may be a motley palette of gray primer, Bondo, and rust.)

The bliss that does come is fleeting. It arrives when you hit the apex of a broad left-hand turn at speed, at an rpm that you know your motor likes because you spent weeks poring over dyno charts, compressor maps, and camshaft profiles to make it so. You feel the responsive tautness of the chassis that you stiffened and tuned with just such maneuvers in mind, and it spurs you to indulge in a little throttle-induced oversteer. The rear end breaks loose, tightening your line through the corner and depositing a few mils of rubber into the atmosphere as a wisp of white smoke. This is not mayhem, Officer, this is control.

As you sit on the shoulder of the road, blue lights flashing, you notice somebody in a new BMW looking on, appalled. (Or at least, you like to imagine he is appalled. More likely he is amused, or looking at something else entirely.) Class war is one of the minor pleasures of rolling your own, a reverse snobbery that adds to the relish of those who are initiated. In the perverse logic of the gearhead, to be persecuted by an uncomprehending state acting on behalf of an uncomprehending bourgeoisie is . . . to *win.* Such are the pleasures of the dissident.

Gearheads typically rely on parts cars stashed on or around their property—slowly cannibalized stores of oxidizing treasure, the presence of which may offend local sensibilities. We will consider the politics of this in a chapter titled "Old Cars: A Thorn in the Side of the Future." "Cash for clunkers" programs claim the mantle of environmental responsibility, yet such initiatives enforce the obsolescence of perfectly serviceable cars, with unrecognized environmental costs. In a related vein, antijunk ordinances directed against old cars are sometimes little more than municipal piracy undertaken on behalf of real estate interests. A suburban aesthetic of tidiness is dressed up as "green" moralism and used not only against enthusiasts, but against frugal and resourceful people who may rely on a parts car or two parked out back.

TRUST AND SOLIDARITY ON THE ROAD

Researchers have found that many traffic jams result from episodes of slight braking that propagate backward and become full stoppages, initiated by somebody's failure to drive *smoothly*.⁹ "Smoothness" could be defined as a driver keeping constant the time gap that separates her from the car in front of her, which she does by attending to the cars yet farther ahead. It is small lapses of anticipation that cause most traffic jams, not crashes. The more we treat the road—the whole situation—as an object of joint attention, the better the experience.

Long haul truckers are fairly solitary creatures, but in his autobiographical book *The Long Haul*, Finn Murphy describes a community of attention that sometimes coalesces when a group of trucks fall into formation.

It was wonderful sitting in the cradle of the convoy. If the front door [lead truck] saw a gator in the road (gators are big pieces of tire tread on the roadway) he'd drawl "Gator" on his radio and pull into the hammer lane. I'd pull out after the Armellinis. We all fell into a groove. Everybody was driving well, everybody was professional, everybody was going fast but not crazy fast, and there was a plane of consciousness that we had together. It's the closest thing to a Zen experience I know, except when I'm in my loading trance. Both of those things are what keeps me out there. The rest is just hassle.

I was once riding in a car through the rolling horse farms outside Charlottesville with my friends Joe Davis and Elizabeth Lasch-Quinn. Joe was driving; I was in the backseat. Betsy related a time when she was driving from New Jersey to Virginia and found herself behind the same truck for many miles. Sometimes she would need to pass the truck to maneuver around another vehicle, and then she would drop in behind it again. It said "SHOE" on the back. She and SHOE went on like this for some time. SHOE would discreetly flash his taillights at her, she believed, to signal an imminent move. She imagined SHOE noticing her tact on the road, and she certainly appreciated his crisp lane changes. It was a whole relationship. Finally, SHOE pulled off at a rest stop, and Betsy felt a little bit betrayed. She considered pulling over as well. But she didn't want to seem like a stalker.

What sort of place is the road? We are both together and very separate in our cars, so it has an interesting hybrid quality to it, unlike any other shared space I can think of. It used to have a more straightforwardly public character. Before the arrival of automobiles in significant numbers in the 1920s, the urban street was a place dominated by pedestrians, horses, and streetcars that ran on tracks. It was the place where children played-and why not? When automobiles first came on the scene, they were generally viewed as intruders. "They obstructed and endangered street uses of long-standing legitimacy," as Peter D. Norton writes in Fighting Traffic. "Before the city could be physically reconstructed for the sake of motorists, its streets had to be socially reconstructed as places where motorists unquestionably belonged." To view the street as a motor thoroughfare seems selfevident to us now, but it had to be redefined as such. This was a hard sell, given the carnage automobiles had lately caused. Norton writes of a "violent revolution in street use circa 1915-1930" that has been all but forgotten; "the full scale of the wave of blood, grief, and anger in American city streets in the 1920s has eluded notice."

The street had been a public good, a shared amenity for uses that themselves had a public character to them. To ride in a streetcar is to share a conveyance with others, obviously. What about walking? In a sense, it is a solitary activity, but in another it is public: one is *exposed* while walking, and the presence of others has a different quality than when one is driving. In a car, one is encased in one's private property, and significantly shielded from others by it. We feel free to yell curses at others while driving that we never would on a sidewalk. And of course, there is more reason for cursing on a motorway, as others in *their* private cars are very much in one's way. Where previously the street had the character of a commons, it is now a place of *competition* for something scarce: street capacity. But on the street as thus transformed, there remains a kind of social grace (on a good day). We will explore the competitiveyet-cooperative space of the urban intersection in the chapter "Managing Traffic: Three Rival Versions of Rationality." The first version of rationality that can be invoked for managing traffic is, simply, rule following. Taken too far, this becomes a highly inefficient way to manage traffic, as you have no doubt noticed while sitting for minutes at an empty intersection, waiting to turn left. Rule following also becomes a pretext for the transformation of law enforcement into a for-profit enterprise. And in fact, we have permitted ourselves to slide into an illiberal traffic regime of photo radar speed traps and red-light cameras. This regime claims for itself the unassailable high ground of safety. But as I will show, this claim is highly dubious.

We are told that this mess is soon to be replaced with a system of algorithmic control that has no room for human agency whatever: the "autonomous intersection." The claim made on behalf of this second version of traffic rationality needs to be taken more seriously: at its most supple and sophisticated, machine learning would permit a fuzzier logic of right-of-way to be enacted. Rather than strict turn taking or rule following, the trajectories of cars would mutually adapt to maximize flow. This would happen without human involvement; the cars would communicate with one another and work things out on the fly. Ironically, from an overhead view, this might look remarkably like the highly improvisational flow of an unregulated third world intersection, where traffic often flows beautifully. If all goes according to plan, such a computer-controlled intersection might achieve a third world level of efficiency! But this achievement would require massive expenditures, both private and public.

The third form of traffic rationality is one that comes into view as soon as one recognizes the oddly gratuitous nature of such a project and permits oneself a curious glance backward, as it were, to "less developed" parts of world. Rather than try to duplicate the efficiency of their driving practices with computers, we might instead look to such practices to remind ourselves what human beings are capable of, when left to their own devices. This becomes a meditation on the meaning of self-government.

I believe it is in this vicinity that we should look if we want to understand why self-driving cars play prominent roles in several dystopian films, including Blade Runner, Total Recall, Minority Report, and WALL-E. In these films, drivers have become passengers and appear as a new class of administrative subjects to be managed. I use the word "subject" to mean both an object of political rule and the type of person-the form of subjectivitythat is assumed or required by such rule, and thereby brought into existence. A passenger is detached, isolated from others, whereas the give-and-take of urban driving is a realm of interaction that demands the skills of cooperation and improvisation. As such, driving is a form of organic civic life, and the disappearance of civic feeling is key to the dystopian mood of these films. Driving is a way of interacting with others while having shared, concrete interests at stake. Alexis de Tocqueville suggested that the habits of collective self-government are cultivated in practical activities like this that demand cooperation, and such habits are indispensable to democratic political culture. But from the perspective of a central power (whether governmental or techno-utopian), what is wanted is an idealized subject of a different sort, an asocial one who permits an atomized account of human beings to be operationalized. This subject resembles the narrator of the Iggy Pop song "The Passenger": "I am a passenger / I stay under glass." A society of such isolated subjects will be more efficiently and pliably governable.

At the Caliente 250, a desert race that has been taking place annually for generations, we will meet a tight-knit body of motorsport families who gather in the small town of Caliente, Nevada, each spring and proceed to enact what looks to this writer like an exemplary case of deliberative democracy and environmental stewardship. Here the competitive passion of motor sport is tempered by a very concrete sense of shared inheritance. The desert is fragile, and so too is the accommodation between the local ranchers and the racers. Together these fragile things make possible an activity that they love, and which binds them together through time. Preserving the social and natural conditions that make the race viable requires a shared sense of stewardship that stands in stark contrast to the popular image of heedless, high-rpm vandals.

DRIVERS AS MORAL TYPES

Something about driving brings out passionate moral judgments of our fellow citizens' habits. We see a pair of conjoined drivers going down the interstate in the left lane, the one in front clearly intent on preventing others from breaking the law, the one in back furiously tailgating to make a point. One is not *supposed* to pass on the right. They continue like this for miles in a drama of righteousness, each deserving the other's company. The most dangerous and obstructive drivers are those who are inflamed with a sense of justice.

By way of contrast, consider the social grace of pulling over on a twisty road for someone to pass. In the car-conscious culture of southern California this usually occurs quite promptly; it is just understood that a canyon road is a public playground, and people get out of one another's way. The courtesy pull-over does not often occur where I live, in Virginia, because we believe it is an *illegitimate pleasure* that the faster person behind us is seeking.

Americans noisily claim the idea of liberty as their own, but the more you see of the world, the more comical this becomes. A Harley rider wearing the costume of rebellion swelters in a traffic jam in Virginia while an inviting yard and a half of space goes unused between lanes. The word FREEDOM is spelled out across the wings of the eagle on his vest. Meanwhile, on the other side of the world, a family of four on a 50 cc motorcycle deftly weaves through the congested streets of Mumbai, a garlanded image of Ganesh (Remover of Obstacles) attached to the handlebars.

Lane splitting by motorcycles—called "filtering" in the UK makes road use more efficient for everybody. It is an accepted norm all over the world; as far as I know the United States is the only nation where it is illegal. Except in California, where it is permitted. The lore among motorcyclists is that the California Highway Patrol lobbied to make it legal, and did so for reasons that show their awareness of the road as a shared attentional space. The CHP motorcycle officers wanted to be able to split lanes themselves when necessary, and they realized that if all motorcyclists were granted the privilege, the effect would be to train drivers in cars to be alert for motorcycles, especially when traffic slows to a crawl. And this is indeed what has happened. In my experience, the drivers of L.A. and the Bay Area more closely resemble European drivers in having some acquaintance with their mirrors, and a modicum of peripheral awareness.

More so than my motorcycling friends and acquaintances, I split lanes when traffic comes to a crawl, regardless of what part of the country I am in. I break the law. Let me preface this by saying that I ride bikes that are quiet, and try to do so courteously; I am not one of *those* people. I concede that splitting lanes is especially dangerous when done outside California, but given the hyperalert state I enter when doing it, the danger comes mostly from the reactions of drivers who feel I am taking something away from them, as though I were jumping in line. What I am doing, in fact, is reducing my own consumption of street capacity to zero.¹⁰

I have had drivers deliberately swerve into me, and plenty of honking and yelling. And I have to admit, all this hostility adds to the relish. There is a scene in *Easy Rider* where the main characters are sitting around a campfire, complaining that the "straight" people look on them with fear and loathing. Their new acquaintance, played by Jack Nicholson, breaks it down for them: They don't hate you because you are dirty, or because you have long hair. They hate you because you are free. When you split lanes, you can feel this hatred. At the risk of vanity, I choose to interpret it as the *ressentiment* of those who are trapped in their cages because they are too risk averse to be free. In Plato's dialogue *Gorgias*, a character named Callicles says, "I believe that the people who institute our laws are the weak and the many. So they institute laws and assign praise and blame with themselves and their own advantage in mind."

In splitting lanes, a motorcyclist is not taking advantage of other drivers; they cannot make use of that space. But he is *expressing a view* of the prevailing traffic morality, and the police powers that enforce it. He does this not with a verbal taunt but by exposing his body to harm, trusting in his own reflexes. One suspects he *loves* traffic jams.

In the Monty Python movie *Life of Brian*, John Cleese plays a typical Roman gentleman of the pagan era. Out for a stroll, he stumbles upon a crowd. Some crazed hippie-like character is giving a speech, and Cleese begins to take interest. Eventually we realize it is the Sermon on the Mount. Standing in the back row in his toga, he leans over to the guy next to him and says, "What Jesus blatantly fails to appreciate is that it's the meek who are the problem."

This could be taken as the motto of a counterrevolutionary driver's utopia, along roughly pagan lines.

A UTOPIAN THOUGHT EXPERIMENT

If we are to remain free to drive our own cars, we will have to give some thought to how to manage this privilege in a culture of distraction. A useful point of comparison is existing law in Germany, where on certain roads you are free to drive as fast as you please. But if you cause a serious accident, you are never allowed to drive again, essentially. The law grants wide discretion and assigns total responsibility. That is, it treats citizens like adults. This is a bracing concept, maybe a little too radical for the United States.

But what if we took the spirit of the German law and allowed it to inform one pole of a continuum that would have room for all of us? Including those who, quite reasonably, want to be ferried about with minimum involvement? Consider, as a thought experiment, a regime of graduated driver's licenses, pegged to both the competence and the involvement of the driver. The first thing we do, we put all the old people in self-driving Ubers. They'll love it. Next we take all those who would rather play *Gran Turismo* than learn how to drive an actual car, and put them in the trunk. With a game console, of course. And juice boxes.

With these matters settled, we can start making finer distinctions. The restrictions and permissions you enjoy as a driver would be based on certain competencies (perhaps your time through an autocross course; the alacrity with which you can slot your car into a tight parking spot; the prettiness of your bootleg turn), and tied as well to certain characteristics of your car. First among these would be weight. A car that weighs a thousand pounds less than the cars surrounding it accomplishes three things: it is more maneuverable, it poses less threat to the occupants of its more massive neighbors should they collide and, most important, the driver of the lighter vehicle has *more skin in the game*, for the same Newtonian reasons. He or she is due a certain presumption of attentiveness.

The next consideration, on the vehicle side of my utopian licensing regime, would be the "ecology of attention" the car supports.¹¹ The fewer the distractions, the more permissive the license granted to the driver-car combination. At the upper limit,

if you are willing to drive a fully shielded car from which no communication is possible, with no stereo or navigation system, and you are able to put said car into a controlled four-wheel drift at will, and that car is three standard deviations lighter than the median car, then you would enjoy the highest grade of license, and the greatest latitude in doing whatever seems best to you in getting from point A to point B.

Further, let's make the licensure of any driver-vehicle combination visible to other drivers at a glance, perhaps on license plates of different colors. This would enlist vanity and social comparison, those powerful aids to virtue. It would make visible a rank order of drivers.

Would such hierarchy be compatible with democratic culture? In principle, yes. Anyone with sufficient interest can become a skilled driver; he or she only needs to care about driving. Further, the lighter and simpler cars that would support higher-level licenses would cost less, not more, than their bloated alternatives. The existing competition in automotive luxe, which leads many people of scarce means to take on extra debt in the hope of raising their social position, mainly to the benefit of car dealers, would find a rival domain of competition. It would be one in which one distinguishes oneself not by conspicuous consumption but by skill—and a demonstrated regard for the shared environment that is the road.

SOVEREIGNTY

I once spent a month in Tibet. It is a motley automotive scene, with black Audi A6s (the standard ride of Chinese Party officials) stuck behind yak-drawn carts piloted by toothless matrons, often with a payload of hay that towers and teeters over the road. Motorcycles too are pressed into cargo duty, and weave among the herds of cows that sometimes block the road. I admired one little 125 cc bike that had a rack made out of rebar that had been crudely welded together-using a car battery for the welding arc, if I had to guess. I was intrigued by the fact that most of the bikes I saw had little Tibetan rugs on the seats. A significant portion of people on the Tibetan plateau are still nomads who shepherd their yaks from a winter camp to a summer camp. I learned that traditionally they used rugs as saddles on the horses they used for herding. The small motorcycle has mostly replaced the horse for this purpose. Like motorcycles everywhere, they have upholstered seats. But in Tibet, one puts a rug on one's mount. Putting one on a motorcycle might have begun as some yak herder's joke, but they have come to serve a function that is real enough. Mostly ornamental, they express a certain cultural remembrance. This is a matter of concrete, daily concern in Tibet as the country is aggressively assimilated into China, with squads of Chinese troops goose-stepping menacingly through Lhasa and hordes of Chinese tourists overrunning the temples and monasteries as a matter of government policy, to combat the "regressive tendencies" of Tibetan culture. Where once they answered to an ergonomic need in the context of a certain way of life, the saddle rugs now answer to a need to say something about the value of that way of life, in the face of a threat to it. Having a rug on your bike says something, however unobtrusively.

In the Western context, I believe automotive subcultures have a similarly expressive dimension. They are addressed to softer erosions of sovereignty than the Tibetans face, but may be understood in roughly parallel terms. They enact, and implicitly assert the value of, ways of life that are at odds with . . . what? This is harder to answer. Whatever is self-evident, self-confident, well-funded, respectable. *Health and safety. Automation.* Car nuts tend to view as ideological what more well-adjusted people see as simple rationality.

Do their exaggerated enthusiasms distort their vision? Almost certainly. My premise is that their ornery passion for driving cars

INTRODUCTION | 29

that are fully their own also gives them a perspective that we ought to entertain. It equips them to see just how bizarre and tyrannical a vision of progress may become when it seeks to remove the human element from every human activity. Ideals such as benevolence and convenience are always invoked, and just as reliably the progress envisioned requires a reeducation effort, reforming people who put too much faith in their own powers. Don't fight the inevitable. With passivity and dependence comes the calm of enlightenment.

If such a picture of progress doesn't creep you out, this book is probably not for you.

The concept of individual agency is clearly key for critiquing this dream, but it is also inadequate to the political nature of the challenge. There is something new and voracious in the world that feeds on individual agency, and is basically imperial in its aspirations. What these aspirations are will become evident in two chapters, "Street View: Seeing Like Google" and "If Google Built Cars."

The term "sovereignty" comes to us from the history of fights for political self-determination, against imperialism. It is a term coeval with the rise of nationalism in the nineteenth century. On both sides of the Atlantic, the idea of sovereignty has suddenly reemerged as politically salient. If we take the political anger of populist movements at their word, it is a reaction to the imperiousness of political elites and corporate forces in pressing agendas of progress that seek to delegitimize the concerns of those deemed regressive.

Significantly, some of these populist movements began as automotive protests, or have significant automotive manifestations. The Yellow Vests, named for the safety vests all motorists are required to carry in France, brought paralysis to parts of Paris and other cities nearly every weekend from late 2017 through early 2019, precipitating a major crisis for Emmanuel Macron's government. It was prompted by a slight decrease in speed limits and a fuel tax, which hit the French equivalent of "flyover country" disproportionately. (Macron's political base is mostly metropolitan, relies on the Paris Metro, and takes its own environmental virtue as one of its titles to rule.) The most significant material damage done by the protesters has been to France's network of photo radar speed traps. (About 60 percent of them had been disabled as of January 2019.) There have been guerrilla actions against red light cameras and speed cameras in the United States as well, and they seem to express political discontent more than simple vandalism.

On the other side of the Channel, the mass protests of the London taxi drivers both expressed and contributed to the Brexit mood. This was a fight for economic sovereignty by highly trained professionals against the threat posed by foreign ridehailing firms that rely on map software, U.S. military satellites, and the subsistence drivers of the gig economy. Essentially, Uber created a system of labor arbitrage to sidestep and nullify local control. The protests of the Germans against a proposed speed limit on the autobahn explicitly referenced the Yellow Vests, in a rare expression of French-German solidarity, and gave rise to a slogan adopted not just by the car lobby, but by dissident political parties: "Freie Fahrt für freie Bürger!" which means "Freedom to drive for free citizens!"12 The common thread among these discontents is their sense that they have come to be governed by elites whose allegiance is to their own transnational class, rather than to the common good of the particular nation they happen to reside in. Somehow, changes in the driving experience are playing a role in developing these intuitions. Accordingly, the push to reclaim sovereignty is showing up prominently in people's stance toward driving, which has become a bit prickly. As though we regard the authorities that regulate traffic as lacking political legitimacy.13

The protests of the last few years have generally been regarded as the expression of economic grievances, or else as the eruption of a spirit of pure negation, a "revolt of the public" that is more nihilistic than principled. There is surely truth in these interpretations, but in the pages to follow I will suggest a further possibility: that these movements are partly a response, at once spirited and rational, to a creeping colonization of the space for skilled human activity. This may take the form of automated traffic enforcement, which elides the role of individual judgment (both that of a cop and that of a driver) in determining the appropriate speed, or it may take the form of elected officials holding a press conference to inform us that driving is drudgery, and we're no good at it anyway. (Jane Jacobs referred to "Utopian minders of other people's leisure.") These are examples of a much larger trend. The technocrats and optimizers seek to make everything idiotproof, and pursue this by treating us like idiots. It is a presumption that tends to be self-fulfilling; we really do feel ourselves becoming dumber. Against such a backdrop, to drive is to exercise one's skill at being free, and I suspect that is why we love to drive.

THIS BOOK WILL appeal to driving enthusiasts. But readers who are indifferent to the pleasures of driving may nonetheless find here a case study that can illuminate broader questions—about the fate of human agency and the prospects for democratic governance, not least. For one theme that has emerged with force in this inquiry is that of self-government broadly understood, both as an individual capacity for self-command and as a political dispensation. Thus, self-government may mean the ability to skillfully control one's car, the ability to temper one's impatience with other drivers, and the ability to keep one's attention directed to the road in the face of multiplying distractions, on one hand. On the other hand, the issue of self-government is present in questions such as, who gets to decide what sort of regime of mobility we will inhabit? These different scales on which we pose the question of self-government are surely interlocked, or imply one another. For example, if we are so distracted behind the wheel that we are already driving *as if* our cars were self-driving, this suggests we need some benevolent entity to step in and save us from ourselves, by automating a task we are no longer capable of doing for ourselves.

In drawing a straight line from self-command to selfgovernment in the political sense, I mean to claim the problem of driving for the liberal-republican tradition of political reflection. This tradition holds that a people worthy of democracy must be made up of individuals capable of governing their own behavior in the first place, and have therefore earned their fellow citizens' trust. When you are leaned into a blind curve on a two-lane country road on a motorcycle, it becomes very clear that the road is a place of mutual trust. This is one of the most interesting things about it. Driving is thus ripe for the attention of political theorists who are interested in what a republican social order looks like at the fine grain. Let's understand this fragile order while it still persists, in such unobtrusive pockets of daily life as driving. Such pockets may hold clues that can guide our hopes for the renewal of social trust more broadly.

HOW TO READ THIS BOOK

"Consistency of tone" is one of those precepts pressed upon writers by writing teachers. Any reader who expects consistency is likely to be bewildered in what follows, as I have found it necessary to offer arguments, stories, interpretations, and observations that are wildly different in kind, according to their place in the whole. Some of these are highly personal. To the extent my method is sociological, it does not rise to the level of proper ethnography, or even serious journalism. I simply relay various scenes of automotive enthusiasts I have come across in the course of my own movements, interpreted through the lens of my own preoccupations. I have tried to understand these scenes sympathetically, but it will be clear that I have succeeded in this with some cases better than with others.

Throughout, the reader will find a persistent complaint about traffic rules and enforcement, and a skeptical view of certain safety mandates. My beef with officialdom comes from a variety of perspectives, and the reader may begin to wonder about the coherence of the argument. An unsympathetic reader may conclude prematurely that it proceeds from libertarian chafing against restraint of any kind, which is easily ridiculed as juvenile. What are these various perspectives?

At some points, my argument puts safety foremost but points to the perverse effects of the existing traffic regime, especially when it becomes a source of traffic-ticket revenue that various jurisdictions depend on. In such cases, safety and revenue are sometimes in direct competition, and I come down on the side of safety. At other points, I criticize "safetyism" itself, and here the argument cuts in quite a different direction, as it includes a more or less "vitalist" critique of our never-satisfied quest for greater safety (think Teddy Roosevelt and William James). Safety is obviously very important. But it is also a principle that, absent countervailing considerations, admits no limit to its expanding dominion. It tends to swallow everything before it. Once you indulge the vitalist perspective with some sympathy, your gaze is shifted and it becomes easier to see the ideological work that "safety" does in our society.

Those who invoke safety enjoy a nearly nonrebuttable presumption of public-spiritedness, so a stated concern for safety becomes a curtain behind which various entities can collect rents from perfectly reasonable behavior. The trick is to formulate rules that are at odds with our natural reasonableness (for example, setting the speed limit below the speed dictated by the features of the road). That way you can guarantee a certain rate of infraction, and therefore revenue. If one cares about safety (and who doesn't?), one does well to take a skeptical look at the safetyindustrial complex, and its reliance on moral intimidation to pursue ends other than safety.

To do this thoroughly, one must venture beyond the mental universe of risk reduction altogether. That universe takes its bearings from the least competent among us. This is an egalitarian principle that is entirely fitting in many settings, a touchstone of humane society that we rightly take pride in. (One of the people closest to me is significantly disabled, and I am often moved with gratitude for the accommodations our society makes for her.) But if left unchallenged, the pursuit of risk reduction tends to create a society based on an unrealistically low view of human capacities. Infantilization slips in, under cover of democratic ideals. I will insist, on the contrary, that democracy remains viable only if we are willing to extend to one another a presumption of individual competence. This is what social trust is built on. Together, they are the minimal endowments for a free, responsible, fully awake people.

CARS AND THE COMMON GOOD

In her 1961 masterwork *The Death and Life of Great American Cities*, Jane Jacobs noted that "everyone who values cities is disturbed by automobiles." They seem to stretch and rend the fabric of social interaction, which requires a certain intimacy of scale and fluidity of movement. To make way for cars and all that comes with them, such as parking lots, gas stations, and major arteries, "city streets are broken down into loose sprawls, incoherent and vacuous for anyone afoot." Neighborhoods that were once "mar_T vels of close-grained intricacy and compact mutual support" are "casually disemboweled."

The rise of the automobile is closely connected to the transformation of American cities in ways that Jacobs and many others (including myself) regret; this complaint is prominent in the "new urbanism." But on Jacobs's account, this connection isn't entirely a causal one; "we blame automobiles for too much." She finds a prior cause of the degradation of American cities in urban planning, the kind that seeks to optimize the city according to a plan hatched from on high, without a street-level understanding of what makes a place thrive. She offers a thought experiment in which the automobile had never been invented, but the modernist project is left otherwise undisturbed (think windswept plazas and high-rises, or model suburbs of socially detached, nuclear families). In that case, the automobile would have to be invented. "For people to live and work in such inconvenient cities, automobiles would be necessary to spare them from vacuity, danger and utter institutionalization."

On Jacobs's account, the connection between the automobile and the deadening of cities is not a straightforward one, rather it is "one of those jokes that history sometimes plays on progress." She notes that the rise of the automobile in everyday transportation happened to correspond with a period during which the ideal of the "anti-city" was being worked up in architecture, as a sociological development, legislatively, and in the way cities are financed. She insists that "automobiles are hardly inherent destroyers of cities" and remarks that "the internal combustion engine, as it came on the scene, was potentially an excellent instrument for abetting city intensity, and at the same time for liberating cities from one of their noxious liabilities."

She means the horse.

Recalling his boyhood in London in 1890, an English architect wrote in 1958 of the three- and four-story stables that dotted the city, like today's parking garages. The chandeliers of upperclass homes were "encrusted with dead flies and, in late summer, veiled with jiving clouds of them." Despite the "numerous corps" of boys darting around among wheels and hooves to clean up after the horses, the manure "flooded the streets with churnings of 'pea soup' that at times collected in pools over-brimming the kerbs." Cart wheels would "fling sheets of such soup—where not intercepted by trousers or skirts—completely across the pavement, so that the frontages of the Strand throughout its length had an eighteen-inch plinth of mud-parge thus imposed upon it." The clean-up crews who manned the "mud-carts," ladling up the soupy mess, were "clothed as for Icelandic seas in thigh boots, oilskins collared to the chin, and sou'westers sealing in the back of the neck," routinely splashing pedestrians in the course of their work.

And then there was the noise, "a thing beyond all imaginings" as iron-shoed horse hooves collided with cobble stones and "the deafening, side-drum tattoo" of wheels on these same cobbles, "jarring from the apex of one set to the next like sticks dragging along a fence," plus "the creaking and groaning and chirping and rattling of vehicles, light and heavy, thus maltreated," as well as the clanking of harnesses and all such horsey stuff. On top of all this, one had to endure the sound of other human beings trying to communicate over the din, "the shrieking and bellowings called for from those of God's creatures who desired to impart information or proffer a request vocally."¹

For a given amount of horsepower, an automotive engine is cleaner and quieter, Jacobs points out. Further, "The power of mechanized vehicles, and their greater speed than horses, can make it easier to reconcile great concentrations of people with efficient movement of people and goods." The problem, of course, is that there are simply *too many* cars, so they "work slothfully and idle much," often progressing no faster than a horse.

And there is the rub. The explosion of automobile use in the twentieth century, and resulting congestion, is a complex story that can be told in a number of ways, but clearly it was *not* a simple consequence of consumer demand for automobiles in a free market. Rather, it was in significant measure a consequence of policy choices by public authorities. The construction of roads for automobiles was massively subsidized, at the expense of public transportation. According to James J. Flink, the public investment in street improvements to accommodate automobile traffic that American cities embarked on in the 1920s "antedated by a generation or more the motorization of the urban working class." Flink interprets these investment priorities as a transfer of wealth, with working-class streetcar riders in effect being "taxed by city planners and politicians to make possible middle-class automobile use."2 In the 1930s, Franklin Delano Roosevelt embraced road building as a jobs program, with an eye also on the utility of highways for national defense (this at a time when Adolf Hitler was constructing his autobahn).³ Progressives embraced automobility as a government project well suited to the exercise of their enthusiasm for state-directed investment, rational planning, and national vigor in the tradition of Herbert Croly's "New Nationalism," which greatly influenced FDR. The Works Progress Administration, a key element of the New Deal, provided ten times as much funding for streets and highways as for public transportation.⁴ But it wasn't until after the war, during the Eisenhower administration, that construction of the Interstate Highway System began. It was a project of Napoleonic ambition, undertaken in an era when the state enjoyed a level of prestige, credibility, and legitimacy that is hard for us to imagine in 2020. Such legitimacy, surely enhanced by success in war, permitted the use of Napoleonic methods as well. As Dan Albert relates, "Government experts laid out the system's 41,000 miles of highways.... Government planners decided where to put the 1.6 billion metric tons of rock, sand, cement, and asphalt in the system. In the process, they scripted and supervised people's movements, choosing where they could alight and escape. To do all of this they razed entire districts of homes and shops using eminent domain to condemn and take privately held land."5

This history offers challenges to both automotive libertarians and anticar progressives. The motorization of America, and all the economic progress and social dynamism that came with it, was not simply an eruption of individual freedom, as expressed through consumer choice. It was to a significant extent an undertaking of the government. But by the same token, the congestion and sprawl that came with our overdependence on the automobile cannot be blamed on a mistaken libertarian faith that "the hidden hand" of the market will bend individual choices toward the collective good. On the contrary, our overdependence on cars was engineered by the state, energized by the same faith in central planning and sincere (if shortsighted) devotion to public felicity that has always been the pride of progressive governance.

These are lessons we do well to keep before us. To make this history pertinent to today's situation, we need to recognize that initiatives of central planning now often come, not from the state, but from tech companies that aspire to quasi-governmental "platform" status. This fact scrambles certain of our intellectual habits and political reflexes, or ought to. Given how much our daily lives are nudged and steered into channels engineered by tech firms, one can no longer sensibly adopt a conceptual demarcation between "the private sector" and "government." In this moment of ambiguity about the driverless future, various interests have recognized a brief window of vast opportunity—if they can advance a profitable interpretation of cars, roads, cities, and mobility itself that will come to seem the only reasonable one.

The Volvo Concept 26, a concept car, is named for the number of minutes of the average American commute (in each direction). Its cabin takes on different configurations, rearranging the furniture for a "drive" mode, "create" mode, and "relax" mode. The centrally mounted tablet moves with you as your seat recedes progressively farther from the car's controls in each mode. The idea is that because you are not burdened with the drudgery of driving, you are freed up to be creative. In case there were any doubt, in the publicity photo we see a man who is obviously a creative: he has flowing, Lord Byron–like hair and holds what appears to be a small leather-bound volume of poetry in his lap, savoring these precious minutes to restore his creative spirit.

More likely, he will spend these minutes irritably sifting through offers of various products and services tailored to his creative lifestyle and to his intended destination, conveyed through the same tablet interface, each of which must be declined before the car will proceed on the route he had in mind initially. Has anyone bothered to ask why the world's largest advertising firmfor that is what Google is-is making a massive investment in automobiles? By colonizing your commute-currently something you do, an actual activity in the tangible world that demands your attention-with yet another tether to the all-consuming logic of surveillance and profit, those precious fifty-two minutes of your attention are now available to be auctioned off to the highest bidder. The patterns of your movements through the world will be made available to those who wish to know you more intimatelyfor the sake of developing a deep, proprietary science of steering your behavior. Self-driving cars must be understood as one more escalation in the war to claim and monetize every moment of life that might otherwise offer a bit of private head space.

GIVE ME SHELTER

According to the Pew Center, more than two-thirds of Americans sometimes sing in their cars while driving. Behind the wheel, we seem to feel released from social observation—as though we were in the shower! There is a subtler form of release as well, from a pressure that is harder to define. If your commute is going smoothly, it doesn't take up much of your awareness, leaving you free to daydream or engage in other forms of useless reverie. This type of driving is not very demanding, yet you are absolved of all obligation to be doing something else. How often is *that* the case? On the weekend, you *should* be taking care of all those little items of life maintenance, and you *could* take up one of the festering mandates of self-improvement that hangs over you like a fatwa. In the proliferation of demands you may do nothing at all, but the day is poisoned with antsy avoidance, the "blah" of Sunday afternoon. In a society in which any moment of repose has to be justified against the ruthless logic of "opportunity costs," commute driving is perhaps the only real Sabbath left to us. Traffic may be slow, but if it is flowing smoothly you are *moving forward*, and this seems to be enough to calm the time-guilt of modern life. Like the rosary, the near automaticity of this task requires just enough of your peripheral awareness, and bodily intervention, to give you the feeling that you are doing something necessary, and *therefore* you are left free.

In the voracious logic of today's capitalism, it is just such moments that must be ferreted out and brought into the system. Consider the boost to GDP if your Sabbath in the car could be turned to productive activity! You should be answering emails, shopping, or plugging yourself into entertainments that will keep your imagination well integrated with the hive.

My point is that we may experience our car as a humanizing space, a space of shelter, despite the many frustrations of driving. (We will consider these frustrations at length in the chapter "Road Rage, Other Minds, and the Traffic Community.") Pew conducted a survey of Americans' attitudes toward the automobile in 2006. Attitudes have likely shifted in the meantime. But with that caveat, a few of the findings are worth quoting here:

When asked whether they like to drive or consider it a chore, 69% of drivers in the survey said the former, while 28% said the latter...

Despite the growing hassles of traffic, many drivers have strong feelings of intimacy toward their cars—31%, for example, say they think of their car as having a personality. And despite the high price of gas, more than a quarter (27%) say they went driving "just for the fun of it" in the past week. . . .

Men and women are about equally likely to have done some driving just for the fun of it.⁶

THE FUTURISM BUSINESS

Driverless cars are going to happen in a big way, we are told, because it has been decided—by something called "the future." It has become clear that the effort to develop driverless cars is not a response to consumer demand, but a top-down project that has to be sold to the public.⁷ There is nothing especially new about that; for a hundred years, the science of marketing has been in the business of creating new needs. And in this case the propaganda program rests on some claims that are plausible enough—about enhanced safety and a reduction in congestion. But the crucial element in getting the public on board with driverless cars has been the assertion of inevitability. This assertion can be made self-fulfilling through sheer dint of repetition, if one has sufficient control over the Narrative.

But it is just here, in the realm of narrative tending, that the push for driverless cars has turned out to be ill timed, as it happens to coincide with a slow-motion collapse of the public's trust in Big Tech to serve as steward of our interests, and shepherd of the Future. Futurism is a genre of mythmaking that seeks to generate a feeling of inevitability around some desired outcome, a picture that is offered *as though it were a prediction*. This is a good way to attract investment. And reciprocally, the flow of investment dollars is a good way to attract public speechifiers (journalists, "thought leaders," etc.) who will lend their voices to the chorus of inevitability. One must *accept* the future rather than "cling to the past" (which often means simply accepting the present—what presently exists—as perfectly adequate). Do you prefer to wallow in the comforting self-delusions of "nostalgia"? We should notice that while driverless cars hold real potential to ease congestion, and thereby contribute to the common good, there has been no talk of treating as a public utility the infrastructure that will make driverless cars possible, nor of making their programming available for inspection. What is being proposed, as near as one can make it out through the fog of promotional language, is an "urban operating system" of mobility that would be owned by a cartel of IT companies, participation in which would not be optional in any meaningful sense.

The denizens of Silicon Valley are famously libertarian, according to their own self-understanding. But the "person" whose liberty they feel must be asserted against the state is that of the corporation. In December 2016, Uber defied administrative rulings by the California DMV, keeping its self-driving cars on the streets of San Francisco despite their registrations being revoked. The *New York Times* reports that "Uber has tended to barrel into new markets by flouting local laws, part of a combative approach to expand globally." It does so "not only in the United States, but in many of the more than 70 countries in which the company operates."⁸ In the mentality of corporate libertarianism, there is no concept of legitimate public authority as that which secures the interests of citizens against the power of monopoly capital.

The columnist John Harris asks, "If unprecedentedly cheap [driverless] taxi rides become the norm, what will be the fate of buses and trains? Won't all those fleets of cars cause unbelievable congestion?"⁹ It is a reasonable question to ask.

According to Bruce Scaller, former deputy traffic commissioner at New York City's Transportation Department, during the Uberization of the city between June 2013 and June 2017:

The number of taxi and for-hire vehicles increased by 59 percent, but the number of unoccupied vehicles increased by 81 percent, with each for-hire driver waiting 11 minutes between fares. During the afternoon rush, between 4 p.m. and 6 p.m., 10,000 for-hire vehicles are trawling Manhattan. Taxis and other for-hire cars now account for more than half of daytime traffic on major avenues.

The conclusion: The only way Uber and its competitors can make each trip so convenient for its passengers is to flood the streets with empty cars. You may not wait standing on the street for a cab, but now you wait on the street in a black car, behind all of those other black cars.¹⁰

Of course, these rides will remain cheap only until the buses and trains disappear. Then the laws of monopoly pricing will take effect. That would appear to be the plan.¹¹ And in fact municipal financing for public transportation has declined sharply; mass transit ridership is down, and its infrastructure is crumbling in many cities. Meanwhile, Uber continues to lose billions of dollars every year (\$14 billion between 2014 and 2018).

If one allows oneself to become curious about this last fact, the story of Uber becomes quite interesting. In 2019, the transportation industry consultant Hubert Horan published a study of Uber's economics and concluded that the firm has no hope of ever turning a profit. It "not only lacks powerful competitive advantages, but it is actually less efficient than the competitors it has been driving out of business."12 It turns out, on closer inspection, that Uber never intended to turn a profit from driving people around in a competitive market. By having earlier investors massively subsidize rides through low fares, the firm aimed for "growth at all costs," knowing that there are segments of the investment world that regard explosive growth as "the only important determinant of how start-up companies should be valued." Once the firm went public, its business model was essentially that of a Ponzi scheme, made possible by diverting attention from the massive fare subsidies (supplied by investors) responsible for its growth. Horan writes that Uber is indeed an innovative company. But its

innovation has little to do with "tech" or with finding efficiencies that had previously eluded the taxi industry. Rather, "Uber is the breakthrough case where the public perception of a large new company was entirely created using the types of manufactured narratives typically employed in partisan political campaigns. Narrative construction is perhaps Uber's greatest competitive strength." This narrative pitted heroic innovators versus corrupt regulators in the grip of outmoded ideas. (Let us take note of *why* taxis need to be regulated. As part of a city's transportation infrastructure, they provide a public good that is difficult to realize on a pure market basis, as some of the benefits are "external" to the pairwise transaction between rider and driver.)¹³

The business and tech press was well snowed by Uber's PR, according to which it was fighting on behalf of technological progress and economic freedom. The firm's actual economics went unexamined. Uber did everything it could to signal that "its eventual marketplace dominance was inevitable, that competitive or regulatory resistance was futile, and that journalistic probing was pointless." Meanwhile, its multi-billion-dollar fare subsidies "completely distorted marketplace price and service signals, leading to a massive misallocation of resources."

One effect of such misallocation is city streets clogged with empty ride-share vehicles, which of course is the very condition that makes it possible to "press a button, get a car" almost instantly. This seems like magic, and we can only marvel at what technology might deliver next. In light of Horan's analysis, one has to wonder: is Uber's conspicuous interest in driverless cars really driven by a hope to replace low-wage drivers with autonomous vehicles? Why transfer the capital costs of Uber cars from immigrants who are often financially unsavvy, and get locked into ruthless auto-lease agreements, to the firm itself? One suspects, rather, that noisily associating with driverless cars helps to preserve Uber's image as a "tech" company, rather than as an especially aggressive practitioner of labor and financial arbitrage.¹⁴ Beneath the cutting-edge hocus-pocus, Uber's "driver-partners" appear to have entered a sharecropper economy from which it is difficult to exit.

Our task in this chapter was to survey some of the lesspublicized business dynamics and public interests that we ought to keep in view at this moment, when our basic regime of mobility is up for grabs more than it has been since the dawn of the automobile a century ago. The next chapter takes a more intimate turn, and relates an experience of breaking down on the highway in the dead of night. It is a story of being ejected, unprepared, into the landscape and into the company of strangers, and having to rely on one's wits. No phone, no GPS.

No flashlight.

Rolling Your Own

BREAKING DOWN 1972 Jeepster Commando

I ordered another cup of coffee, though I had no intention of drinking it. It seemed the thing to do, since I was taking up real estate at the counter. I was in a diner off Highway 101 in San Miguel, not quite a town but a "census-designated place" in central California, bone tired and wondering what the hell I was going to do. It must have been around two in the morning. January 1987. The waitress likely wasn't used to seeing a twenty-one-year-old nursing a tab at such an hour; she lingered at my stool in a way that seemed to invite words. So I asked her if the local cops were likely to come and roust me, if I were to be found sleeping in my truck.

"Where you headed?"

"Nowhere, fast." I liked the sound of that; I'd been rehearsing it.

I explained my situation. She said there was a junkyard about a mile down the frontage road.

"Really?" A warm trickle of hope spread through my limbs, better than any amount of her sour coffee.

"And don't worry about cops. CHP is the only police through here." But that issue was now moot; I no longer felt the need for sleep. The junkyard would likely open in another six hours.

It had been five hours since my night took a bad turn. I was southbound on 101 in my 1972 Jeepster when a sickening sound from the engine bay—a rapid DAT DAT DAT DAT DAT announced that Plan A was out the window. As soon as I heard the sound I recalled a certain detail, one of a hundred on a mental to-do list that was a little too haphazard. This one concerned the mounting of the radiator: two bolts rather than four, as I now remembered, one of which didn't quite seem to match the threads of the nut that I had nonetheless jammed onto it, just to hold the radiator in place "for the time being" as I finished up an engine swap. That time was no longer being.

I had bought the Jeep the previous summer, after being charmed by a friend's 1964 International Harvester Scout. Four of us had taken it on a camping trip in the Sierras, a post-high school reunion the highlights of which included an ice-cold waterfall, sleeping under the stars on a massive slab of upturned granite, and the giddy pleasure of bouncing along a rutted trail in four-wheel drive, wondering if various streams were too deep to cross in a vehicle. Having four able-bodied youths to push and pull and dig, if need be, provided a little insurance. Together we might have been able to muster half a horsepower! But the little four-cylinder Scout with the manually locking front hubs handled it all with aplomb. It wasn't lifted, it had skinny little tires and a soft suspension: perfect. Brian had paid \$800 for it. It was painted desert tan.

The closest equivalent I was able to find, scouring Auto Trader for the Bay Area (a publication of classified ads you could buy at convenience stores) was a 1972 Jeepster Commando, one of the

BREAKING DOWN 5

early progenitors of what would soon become the SUV. It was baby blue, lifted, with a removable hard top and no roll bar. I took the top off immediately. Cruising around in the open air, perched atop an obviously unstable death trap, rowing through the gears frequently due to the low-revving engine (it had a manual four-speed mated to a straight-six), I felt like a devilish character in some adventure story. (The young male is given to motorized self-dramatization.) I felt charismatic through no merit of my own—other than having had the inspiration to seek this thing out.

But the story took a bad turn on the first page. The day after I bought it, I was doing a little nighttime four-wheeling (at a construction site, if you must know—I'm not proud of this) in San Francisco when the motor cut out. As I would discover after having it towed back to my place in Berkeley, a worn motor mount had allowed the engine to bounce around to the point that the oil filter got punctured by the motor mount, and there was no oil pressure warning light. The motor was fried.

I purchased an engine out of a different model of Jeep from a junkyard, and did the swap out on the street in front of my dad's house. It took weeks. Every couple of days I had to push the truck along the street to a different spot to satisfy a very zealous parking enforcer named Ortega who already had it in for me, based on my history of inoperable vehicles. A few days after I finished the engine swap, the truck got stolen in broad daylight, on Bancroft Way. Some months later the cops found the cursed thing, and this trip to Santa Barbara was my first real excursion in it.

Upon hearing the aforementioned *DAT DAT DAT*, I pulled to the shoulder of the road and popped the hood. I had no flashlight. But, feeling with my hands, it was clear that the radiator had indeed fallen from its mount. Into the fan. Coolant was everywhere, to judge from the sweet smell and slippery wetness. I rooted around in the back, which was full of stuff: I was on my way from Berkeley back to Santa Barbara for the winter term at UCSB. I found a coat hanger and some lineman's pliers, and I wire-tied the radiator up out of the way of the fan. The question, now, was how much coolant I had lost. And at what rate would it leak out when I started the motor up again? There was no washer fluid in the reservoir. I regretted having stopped to urinate an hour earlier: more precious fluid to use in a pinch.

I had no water in the truck, but I considered carefully which objects could be turned to use as containers. I had a couple of quarts of oil that might have to be sacrificed on the roadside—not the least of the environmental sins I had committed in the course of six years of dealing with fucked-up old cars. And I had a large stainless steel stockpot that I had been using for cliffside fires and as a makeshift barbeque on surf trips down the coast.

But where to find water? The road was pitch-dark. I hadn't passed an exit for maybe fifteen miles, and there was no sign of any exit ahead. I was somewhere near the border between Monterey County and San Luis Obispo County, the heart of rural central California: cattle, lettuce, strawberries, garlic. It was a moonless night; I could not see my own feet on the ground. But I could see a single light off in the distance to the east. Whatever lay between me and the light was invisible. It wasn't the sort of light that beckoned; the color of it was industrial looking, not commercial. It couldn't be a porch light.

I gathered my containers, crossed the highway, and scrambled blindly down an embankment. The sandy terrain was pocked with the fragrant chaparral of the inland coast. I crossed a flat and relatively even area; it seemed to be a dry riverbed. When the light was out of view, I could reckon my direction only by my general sense that the ups and downs of the terrain ran parallel to the highway. Several times I fell hard into what seemed like artificial trenches, very sudden and crisply edged, two or three feet deep. I came to a two-lane road, and now I could see the source of harsh white light that had been my pole star. It was above a door, the only entrance visible in a small compound of corrugated metal buildings, surrounded by a chain-link fence. It was a serious fence, maybe twelve feet high and angled outward at the top. I scanned the building, as much of it as I could see by the light, and didn't see any hose or spigot.

I doubted there was a soul in the vicinity. And in any case, I have a real aversion to making a nuisance of myself. I stood there for five minutes thinking, "Oh well." The voice of defeat. But then I thought of the overland odyssey of getting to this damn light; I was pretty well invested at this point. What the hell. I started yelling from the fenced perimeter. Nothing. I yelled some more. Still nothing. I was about to turn around and head back toward the highway when the door opened. Somebody was shining a flashlight at me.

"Hey. Hi. Sorry to get you up. I'm looking for some water," I said, loudly but not yelling. There was no response. But after another ten seconds a floodlight came on, and now I could see the backlit silhouette of a man walking toward me. Only when he got right up to the fence could I see his face. I told him my situation, and also asked how far it was to the next town south.

"How'd you get here?"

I pointed over my shoulder with my thumb. "Through there."

He paused and seemed to think. Yes, he would fill my containers. Emboldened, I asked if maybe he had some better containers he would be willing to part with. He didn't think so. He told me to walk twenty yards down the fence line; there was a gate there. He opened the gate, took my containers, and brought them back full after ten minutes. The next exit was Camp Roberts, a military base. After that, he wasn't sure. I asked him if he knew what the deal was with the trenches that I kept falling into.

"Those are tank tracks. This area is used for tank training and live-fire exercises."

"Oh."

Now I had a couple of armfuls of water, and I set off the way I had come. The first problem was that I had no light to guide me on the return. The second problem was sloshing. I was glad it was a warm night (for January) because I was getting pretty wet. I went slowly, taking smaller and more tentative steps than before, trying to visualize the terrain. I imagined how I might show up in a pair of night vision binoculars from the turret of a tank—I made for an odd thermal picture, I guessed, with my pot of cold water hugged to my warm torso, doing what must have looked like a crane dance of delicate marsh steps.

By the time I reached 101 and found my truck in the darkness, I had two quarts plus about two-thirds of a stockpot of water. I set the water down, opened the cab, and sat down, sweating. It was quiet. The moon was now rising, off to the southeast. I felt the momentary ease that comes with having accomplished something by force of will and physical exertion. I also felt pleased that I had prevailed over my inhibition to ask another human being to render aid, which was the most uncomfortable part. The arduous path by which I had arrived at that chain-link fence made it easier. I wasn't waving a handkerchief on the side of the road like some helpless incompetent. I had *earned* the right to ask that man for water, and he gave me water.

I took the cap off the radiator, which had long since cooled. I hoisted the stockpot up high (the Jeepster was lifted), feeling a burn in my shoulders. I rested it on the valve cover of the straightsix and positioned my body so as not to block the bit of moonlight that now made it possible to make out the features of the engine bay. I carefully tipped the stockpot over the mouth of the radiator and poured. For the first several seconds my aim was approximate, and the water splashed around, but now I had a good pour going, nice and slow. However, the sound of water hitting the ground didn't decrease. It seemed to increase. It was now a gush that sounded about equal to the rate at which I was pouring water in. I kept pouring, grimly, because there was nothing else to do with this goddamn water.

Only now did I recall that the entire excursion of the last two hours had been prompted by a mere hypothesis, a hope that the radiator was not completely destroyed. When a situation looks grim, but also you're not sure exactly how things stand, you form theories that are attractive not because they are the most plausible but because they give you something to *do*, and doing something is the only way not to be crushed by miasmic uncertainty and despair. Fetching water had given me a purpose. As so often happens for mortals like us, it turned out to be a pointless purpose. But string enough of these together and you've got yourself a life, of sorts. We are playthings of the gods, and to provide amusement is not nothing.

That is easy to say now, but at the moment I wasn't feeling so philosophical. When you work on cars, you come to identify with them. It's all about *their* needs. You put yourself in the service of these needs. Well, guess what, I got needs too. I need to get the hell out of here, Jeepster. Maybe you are *disposable*.

It was time to hit the road, heat exchange be damned. I got back in, started the motor, and drove. I'd like to say I drove her like a desperado, but no, I was looking at her temperature gauge the whole time. The needle was moving so fast I could see it sweep, like a second hand. After about two miles it was into the red. I pulled over and shut off the motor. Let's not talk.

I waited maybe twenty minutes and did another couple of miles. After a few of these short hops I had passed the Camp Roberts exit, which did not look the least bit hospitable, and made it to San Miguel, where I pulled into the parking lot of the diner. The motor dieseled on for a good fifteen seconds after I turned off the ignition as the red-hot combustion chambers continued to ignite stray bits of hydrocarbon sucked past the throttle plate in a rattling chain reaction that announced the arrival of a long-term counter sitter. Embarrassing.

Sometime around eight in the morning I picked my head up off my folded-up jacket at a booth in the diner, got in the truck, and drove the mile to the junkyard. I told the owner I had seventeen dollars. He took a long look at me, forming some kind of judgment. Then he let me root around in a pile of radiators. The trick was to find one that had an inlet on the top right and an outlet on the bottom left, with the same hose diameter as the original, and with dimensions that would fit in the available space. Mounting points would have to be improvised. The only viable candidate was from a compact car. I figured it would cool well enough to get me to Santa Barbara. In retrospect, this was a case of what the psychologists call "motivated reasoning." I wanted it to be true, and the physics major in me backed that wish up. Physicists, when they talk about actual things at all (as opposed to frictionless surfaces and perfect vacuums), register only "order of magnitude" differences. Anything less is too trivial to be of any theoretical interest. This radiator was smaller by about a factor of two Trivial.

I got the thing jerry-rigged into my truck. I was absolutely filthy, but happy, and I took off confidently down the frontage road toward the next entrance ramp. Before I even got onto 101, the temperature gauge was spiking. I saw it but decided it was an anomaly. Maybe there was an air bubble in the system and it would work its way out. Or something. I pulled onto 101 going maybe forty miles per hour in a state of willful, desperate theorizing, wishing the temperature away. After another mile reality was becoming too insistent to deny. I was refuted, utterly.

I nursed it along to the next exit and pulled into the parking lot of the first establishment, a motel. I got out, sat down on the curb with my arms propped up on my knees, and was still. I was done. I had nothing left of will, ideas, or cash. The Jeepster was

3

well and truly cursed, and I was ready to walk away from it: just start walking down Highway 101 like a hobo. I looked the part, certainly.

A funny thing happened as I sat there: my despair opened up, or it cleared the way for a different feeling. I felt free. Maybe I would take a job and live here in San Miguel for a spell. Maybe I would wander the hills and speak to crows. Maybe some voluptuous single mom would take me in and make me soup. I was healthy, I was capable, and I knew how to talk to strangers.

Looking back on that moment now, I can see that it was the freedom of faith—faith in my own powers, but also faith that the world was basically hospitable, if I threw myself into it with trust.

Just as this feeling of lightness and strength was spreading through my body, the owner of the motel came out and said, "Can I help you?"

Feeling magnanimous, I nodded behind me and said, "You want a Jeepster?"

He looked over at it. "Not especially. How much?"

"How much is a train ticket back to Oakland?"

"Probably fifty dollars."

"That's how much."

He drove me to Paso Robles. I took the next Amtrak north. There I retrieved a *different* piece of shit: a 1963 VW bus that was rotting in my father's driveway. I dropped the motor, put in a new clutch, and headed once again for Santa Barbara.

The steering wheel is nearly horizontal in those things, and huge. The effect is that you really do feel like you're driving a bus, steering hand over hand in a great looping motion around town as the expanse of unsupported sheet metal amplifies the mechanical noises like a drum. The steering wheel also makes a good perch on long trips; you can lean your forearms on it and relax. With your head inches from the flat windshield, you feel like a bow spirit. There is nothing in front of you but a piece of plate glass. Hunched over this way is a good position in which to give yourself over to reverie as the farms and hills of Central California go by at an unhurried, Volkswagen pace. Sometimes a car seems not simply to move you through the world, but to put you into the world more thoroughly.

PROJECT RAT ROD

Cognitive psychologist L. Elizabeth Crawford wondered if she could teach rats to drive. It was a question that arose out of a couple of ingredients. The first was her professional interest in the way our bodily locomotion through the environment affects such capacities as spatial memory. The second was more fortuitous: she had a sabbatical year during which she got into tinkering with electronics, combining sensors and actuators to do weird things just for the hell of it. (A keeper of chickens in a predator-rich neighborhood, she rigged up her chicken coop to detect when a hen had laid an egg, and to then send out a tweet consisting, appropriately enough, of the single word "tweet!") Around this time her husband was starting work on a book about driving, and the two of them had conversations that ranged from "embodied cognition" to animal intelligence; from human-machine interface and the peculiar pleasures of driving a car to the sometimes *mentally* enervating effects of automation. The connections between bodily skills and other forms of intelligence suggested fertile questions about culture and technology.

So. Could rats be taught to drive?

Crawford didn't know much about rats but Kelly Lambert, her colleague in the psychology department at the University of Richmond, did, so the two of them teamed up. According to Lambert, we have no idea what rats are capable of because rat research has always been conducted in a highly controlled lab environment, the point of which is to study the effect of one variable and eliminate confounding variables as much as possible. But it is precisely the richness of an animal's environment that calls forth its evolved capacities, many of which depend on a process of development (during the rat's own lifetime) in a natural setting no less than the selection pressures that have shaped the species over generations. She told me researchers have never investigated the question of skills with their furry subjects, as opposed to their ability to do simple, discrete tasks such as nosing a button to release a treat in response to some stimulus. Yet they are known to be very intelligent animals. Crawford wondered: could they be taught to find their way through the world by making use of a truly alien mode of locomotion? This would require learning a whole new set of "motor skills" and integrating these skills with their map of the world in a new way, successfully enough to get where they want to go. To get a Fruit Loop, as in previous experiments in Lambert's lab. But to do it in style, with a nice set of wheels.

Let us digress for just a moment to note a classic experiment that explored the role of movement in perception, and specifically the role of *self*-motion, as opposed to being transported around passively. Ten pairs of kittens were reared in the dark, except for three hours per day that each pair spent in a carousel apparatus that allowed one of them to move freely, while the other

PROJECT RAT ROD | 61

was carried passively by the movements of the first. The active kitten could move up, down, away from, or toward the center of the carousel, as well as rotate in epicycles at the periphery of the carousel's radius. The kittens could not see each other, and the surrounding environment was contrived so that both kittens received identical visual stimulation as they moved around; the only difference was that one moved itself, the other was passively carried. The active kittens developed normally; the passive kittens failed to develop visually guided paw placement, avoidance of a visual cliff, a blink response to quickly approaching objects, or visual pursuit of a moving object.

These finding were the tip of an iceberg that became "embodied cognition," now a prominent research program in psychology. As Alva Noë puts it, "When we perceive, we perceive in an idiom of possibilities for movement." Further, our perception of these possibilities depends on what kind of tools we use to get around, and a corresponding skill set.¹

Crawford's first order of business was to build a rat car, in what historians will surely regard as the pioneering attempt at "ratmachine interface" design (how this differs from getting a rat to simply press a button, we will get to shortly). She went to Radio Shack and got a cheap radio-controlled car, cannibalized the chassis and motors, then made an enclosure consisting of a transparent cashew container (the really giant ones you get from Costco) with some windows cut out of it to allow the rat olfactory connection to the environment. She made a control mechanism using the Arduino platform favored by tinkerers. I am proud to say I had the honor of welding up a rat-friendly joystick housing for an early prototype. It turns out rats don't like joysticks. (Or at least, Mario and Luigi didn't like my joystick.) They prefer separate left, right, and straight-ahead controls. In the current iteration of the rat rod (as I insist on calling it), Crawford is using conductive bars that the rats grab with their little mitts, closing a circuit.²

It took about a year of prototype development for Crawford and Lambert to get the basic rat ergonomics worked out, and to fine-tune some other elements of the experimental design. For example, because rats use smell to find their way as much as sight, and Fruit Loops don't have much aroma, various smelly substances were put adjacent to the Fruit Loop. As it turns out, a wet tea bag is just the ticket.

More significant, this research required a leap of faith to embark on a long-term program of rat driver's ed. Nothing remotely like this had been tried. There is a hundred years of research based on teaching rats to do various things by inducing a "conditioned response." Essentially, the rat is treated as a stimulusresponse machine that can be trained to display a certain range of behaviors.

Crawford, alive with an infectious geeky charisma, stood in her kitchen one morning in April 2019 and explained to me how this project differs. The initial task that the rats needed to learn was simply to press on a bar to make the car drive straight ahead to where a Fruit Loop awaited them. Their success at this, which came quickly, essentially replicated the kind of training that lab rats have long been subject to. This early training served to familiarize the rats with the car, get them comfortable with the setting, and acquaint them with particular people—generally undergrads in white lab coats.

The next task the rats needed to learn was to press on a bar located to their right to make the car simply *pivot* to the right, where a Fruit Loop was to be had. This task too was easily learned, and in line with the kind of tasks traditionally demanded of lab rats. (The rats were never taught to turn left, and the significance of this will become clear shortly.) These basic competencies became the scaffold on which the next stage of training would be built.

The car was placed at the far end of the driving arena from the Fruit Loop, and pointed in the wrong direction. After a protracted

period of trial and error lasting months, in the course of which the researchers permitted the rats to run into walls, get stuck and generally frustrated, something remarkable happened. Having taught themselves to turn left, the rats began to find their way, navigating to the Fruit Loop in a zigzagging trajectory, overshooting with their steering inputs and forward movements and then correcting course. Crawford explained to me how this task is different in kind from the previous ones. First, it is not simply more difficult, in the sense of requiring some new dexterity of an unaccustomed kind. What the final version of the driving task does is expand the problem space that the rat needs to solve. In fact, there is literally an infinite number of trajectories that could be taken to get from the starting point and initial orientation of the car to the location and orientation that allows the rat to get the Fruit Loop. After each zig, the rat needs to zag in response to the new situation. This is just what we do on a much finer temporal and spatial scale on foot (the subtle course correction that all animals engage in subconsciously). This open problem space resembles that of an animal's natural environment, as opposed to a laboratory setting contrived to elicit a particular behavior. But unlike the rat's usual reliance on its own bodily equipment for solving the problem, here its intention has to pass through a strange machine.

To watch the researchers' videos of rats unquestionably *driving*, with increasing fluidity, is astonishing.³ Crawford believes it is the first instance of genuine tool use by rats, if by that we mean the *flexible* use of an instrument in response to some evolving situation, in a feedback loop of perception and action that crafts the ongoing development of the situation toward some goal of the agent. That is, skill. The car becomes a kind of prosthetic, an extension of the rat's body, in the same way that the limbs of a tod-dler, initially alien and awkward, may be understood as prosthetics of the brain that gradually get integrated with the brain in the course of development. Thus does an embodied being become

competent, in ways specific to its environmental niche. Our limbs and hands and, later, various tools that we become skilled in using no longer feel like prosthetics. They fade into the background and become transparent, that is, unobtrusive conduits for both action and perception.

I believe some clues for the significance of the Crawford-Lambert rat driving project for human culture, including driving, may be found in earlier work by Lambert. In experiments on both rats and people, she explored what she calls "effort-driven rewards."4 Lambert found that "movement-and especially hand movements that lead to desired outcomes-plays a key role in both preventing the onset of and building resilience against depression and other emotional disorders. Furthermore, we are predisposed to preferring hand movements that our ancestors needed for survival-those necessary for nurturing, cleaning, cooking, grooming, building shelter and farming." Lambert theorizes that the enormous increase in rates of anxiety and depression over the last few decades may be due in part to our disengagement from the basic tasks of securing our own bodily needs, and "all the complexity of movement and thought processes" such tasks require of us.

"The decreased brain activation associated with increasingly effortless-driven rewards may, over time, diminish your perception of control over your environment and increase your vulnerability to mental illnesses such as depression. . . Anything that lets us see a clear connection between effort and consequence and that helps us feel in control of a challenging situation—is a kind of mental vitamin that helps build resilience and provides a buffer against depression." Closely connected to her work on effort-driven rewards, Lambert found that rats who enjoyed an "enriched environment" more closely resembling the natural world, with its problems to solve, were more persistent in solving problems and less prone to get stressed out, compared to rats kept in standard lab enclosures. In the rat driving study, Crawford and Lambert found that rats raised in an enriched environment learned to drive more readily, and that rats who drove themselves had a stress hormone response different from that of the rats who were passively driven. It is a difference that is associated with lower anxiety in humans.

As I see it, this work has a clear upshot for human beings. As we grapple with the challenges of automation, we may want to arrange our own environment like that of the happy rats, rather than the overdetermined world of their anxious counterparts. Of course, we do not simply live in the natural environment. But the built environment of technology and cultural practices can likewise be rich enough that it demands the use of our full repertoire of intelligence. Flourishing-that of rats and humans alike-seems to require an environment with "open problem spaces" that elicit the kinds of bodily and mental engagement bequeathed us by evolution and cultural development. These exquisitely honed human capacities include the glorious, centurylong development of the automobile, that astonishing tool, and the social intelligence that we have brought to bear on the problem of sharing the road together. If instead we put ourselves in a Plexiglas enclosure in which all our most basic needs are met, we will have nobody but ourselves to blame if we begin to feel like standard lab rats in a massive laboratory of social engineering. We would be safer that way, no doubt. But remember, all rats die. Not every rat lives.

OLD CARS

A Thorn in the Side of the Future

Once, in the grassy parking area of Virginia International Raceway, I spotted what appeared to be an AC Cobra from the mid-1960s. Usually these turn out, on closer inspection, to be kit-car reproductions. But this thing was ratty looking, like it had been living outdoors for fifty years and driven hard for just as long. It turned out to be the real McCoy. I talked to the owner, who'd had the car since the 1980s. He said he had driven it to VIR from Pennsylvania.

I felt cheered, for some reason. Such iconic cars are usually removed from circulation and overrestored. They spend their dotage as trailer queens, to be trotted out and parked as touring conversation pieces. When a formidable car is reduced to this, you can't help but feel an injustice has been done, as when you see a once-magnificent predator moping around in the zoo. But here was a Cobra in the wild, oblivious to decades of marketing

-

kitsch (images of the car are used to sell all kinds of stuff). Seeing it bruised, un-self-conscious, and happy in the muddy parking lot, the fog of cliché that hangs around this model lifted for me and revealed the thing-in-itself.

Old cars elicit a range of feelings. One of them is that elusive feeling that we sometimes try to name with the fraught word "authenticity." The car may bear visible scars of a life fully lived, traces of a past that lend depth to the present. The *Road and Track* columnist Peter Egan related his reluctance to restore his Lotus that had taken some beatings on the racetrack, and shared the wisdom of a Jaguar enthusiast who told him never to replace anything he could save. "You see these old factory inspector's chalk marks on the back of a dash panel and you realize the whole car is full of English ghosts. If you let them escape . . . they never come back."¹

Another enthusiast wrote, "Patina lends proof of life. . . . It tells a saturated story of age, of history absolutely unrevised. Its unique character of textures can't be bought for any price or fabricated with even a pretense of dignity."²

Most of us will never own a classic. It wasn't "patina" on the 1992 Camry I sold a few years ago, it was just oxidized paint. The interior's ratio of velour to dog hair had crossed some important threshold years earlier, but this was no spur to sentimentality. Still. We had been through many struggles together, beginning with the water pump and timing belt I had to replace a week after buying it in 2004, and this shared history gave rise to a certain loyalty. Distinguishing a classic from a car that is simply *done* is harder than you might think!

It would be easy to dismiss odes to old cars as the musings of nostalgic old farts. Or perhaps they express the connoisseurship of the aesthete who goes antiquing in the countryside, looking to appropriate other people's pasts as props to lend an ersatz depth to his life. But if we adopt a more charitable interpretation, we can note that for those who value them, old cars become the focal point for a way of orienting to the world and finding meaning in it. As such, they enact a moral sensibility of stewardship, an outlook that values continuity. And this is true not just of the comfortable middle-aged guy with his old Jaguar, but also of the Vietnamese immigrant with his early '90s Civic, equally precious. He too is likely to tell you "they don't make them like they used to."

For that is the curious thing about cars and our love for them: today's uninspiring models become tomorrow's classics. Some of them do, anyway. Which ones, one can't really know in advance. It seems to take about one generation, or a progression in one's own life from car-enthralled childhood to regret-burdened adulthood, for sentiment to attach to the material things of one's youth. Ironically, the design churn dictated by technological progress provides the raw material for retro fascination—quirks to be cherished by enthusiasts a generation later. Without progress, we would be denied the pleasures of nostalgia! Put the other way around, "retro" is a sensibility that has obvious appeal as a shelter from the relentless onslaught of the new.

YARD WEALTH

In 2016, I got a letter from my insurance company, stating that I needed to get rid of the "debris" around my house. My best guess is that they were referring to the highly sought-after, single-side-cover VW transaxle from the mid-1970s that was sitting under an overhang. Perhaps they meant also the front end, complete from spindle to spindle, that I removed from a donor car and that currently lay *in potentia* in my car port, awaiting a full rebuild before being transplanted into the Karmann Ghia. Could they mean the body pan rusting along the side of the house, with a perfectly serviceable torsion housing and trailing arms waiting

2

OLD CARS | 69

to be harvested? Or the heated leather seats under a tarp, which I spent three hours to remove from a late '90s Audi at Chesterfield Auto Parts (a salvage yard on the south side of town)? Surely they weren't referring to the roughly 2.6 dirt bikes, two of which needed only a fresh battery and carb rebuild. At the risk of boasting, I also have an impressive stock of new and scrap metal rod, flats, plate, square tubing, pipe, sheet metal, and a few solid billets, all nicely collated by shape, size, and type of alloy.

On my rides through rural Virginia, I see yards where old appliances, ATVs, furniture, and all kinds of crap are not strewn but obviously *arranged* in front of the house, and carefully mowed around. It looks like a yard sale, but it is not. What is it, then? It is something universal, apparently. Johan Huizinga reports that among the Trobriand Islanders, foodstuffs are not valued "solely on account of their usefulness, but also as a means for parading wealth. Yam-houses are so constructed that one can compute from outside how much they contain, and make a shrewd guess as to the quality of the fruit by looking through the wide interstices between the beams. The best fruits are the most conspicuous, and particularly fine specimens are framed, decorated with paint, and hung up outside the yam-stores."

My house is situated such that my yard wealth is not visible from the street, and I have placed it mostly out of sight of my immediate neighbors (because I am neither a Trobriand Islander nor an ostentatious redneck). I'm not sure what the zoning laws are (as distinct from the preferences of my insurance company), but for sure the general vibe here, on the West End of Richmond, is more uptight than it was where I lived previously, on the Southside. There, many people had project cars. While the toddlers and their mothers socialized on the sidewalk, the neighborhood social life of the males took place mostly in the unpaved alleys between streets, where the sheds and garages abutted. Everyone knew who had a sandblaster, who had welding equipment, who had a metal lathe, who was especially good at diagnosing electrical gremlins, and so on. There was a good informal economy of favors done and six-packs delivered. My next-door neighbor was a cop. We absolutely hated each other but regularly found ourselves in this kind of intercourse.

In my new neighborhood the lawns are meticulous, the houses are much farther apart, there are no alleys or sidewalks, and recycling is taken very seriously. An outdoor inventory of used auto parts is not part of that equation. Somehow, I gather, a \$40K hybrid SUV getting 31 mpg, and the intercontinental energy and material flows that brought it into being, are more "green" than a ratty-looking old Volkswagen assembled from cast-off parts, foraged locally, that gets 32 mpg.3 There is a certain aesthetic of cleanliness that must be adhered to. Better yet, invisibility. To count as green, those ugly chunks of rusting 1970s steel would need to be removed and recycled: melted down in a coal-fired blast furnace and sent across an ocean to become raw material for, say, an electric (i.e., coal-powered) car, to be returned to the U.S. on a diesel-powered container ship. Such details are best kept out of mind; the main thing is that this journey accomplishes a moral cleansing of the metal.

My insurance inspector might have been offended also by some items along the side of my garage: a bucket of waste oil, a handful of dead batteries, a cashew container full of used brake fluid, and red plastic cans of gasoline in various flavors (twostroke mix for the lawn and garden equipment, gas that is too far gone for internal combustion but still useful as a solvent, or for starting bonfires, and some fresh, premium stuff). Plus a can of kerosene that I use for cleaning parts. Depending on when he came snooping around, there may have been a yoghurt container of half-evaporated epoxy primer—because letting it evaporate and then taking the solid remains to the dump is the prescribed method for disposing of it. Would my insurer prefer that this volatile stuff, filthy and apparently haphazard but in fact carefully tended for use, reuse, alternative use, or disposal, be kept inside the shop, in closer proximity to the welding and grinding sparks?

Nobody wants to live next to a Superfund site; I get that. My point is that our judgments of "responsibility" get clouded with aesthetic considerations that are in turn wrapped up with classbased forms of self-regard and virtue signaling. Zoning laws, as well as the informal norms of bourgeois environmentalism, serve to maintain social demarcations (and with them, wildly divergent property values). They also enforce the planned obsolescence that our economy is based on.

People who work on old cars, whether as enthusiasts or out of necessity, are out of step with this regime. If we can unpack this conflict a bit, it may help illuminate some broader social tensions at the heart of our current politics and economy.

OLD CARS AND THE LOGIC OF DISPOSSESSION

In his outstanding book Junkyards, Gearheads and Rust, David N. Lucsko tells the following anecdote.

In the spring of 1999, Daniel Groff snapped. For more than twenty years the Elizabeth Township, Pennsylvania, man had been involved in a dispute with local officials over the condition of his property. Groff worked as a long-haul trucker, agricultural laborer, and mechanic, and over the years, old cars, trucks, heavy equipment, and parts of all sorts had accumulated on his land. For Groff, this was an essential repository of spares that enabled him to scratch out a living. But in the town's view, it was an "illegal junkyard," and Groff an irresponsible property owner. Toward the end of 1998, after countless hearings, injunctions, and appeals, the town gained the legal upper hand and notified him that it planned to hire a contractor to clear his land. But when the contractor arrived the following March, Groff refused to cooperate. Armed with a shotgun, he used a front-end loader to charge at the contractor's equipment, disabling it by pushing it from its trailer. He then retreated to a defensive position, loader idling and shotgun in lap. The ensuing standoff lasted until the fuel in his loader ran out, and as the police prepared to move in, Groff turned the gun on himself. Shortly thereafter his land was cleared, and, adding posthumous insult to injury, his grieving widow then received a bill from the township for the contractor's services.⁴

Lucsko remarks that "apart from its grisly ending, Groff's case was not unusual." He presents a history of ever more aggressive zoning and "eyesore" ordinances that reads as a chronicle of bureaucratic piracy, often conducted on behalf of real estate developers against long-established residents. The targets include businesses that deal in scrap materials (even in rural areas) as well as the gearhead next door. The legal devices used are various: unannounced changes to municipal bylaws, byzantine licensing requirements, or the peremptory reclassification of a residential property with project vehicles on it as an illegal junkyard subject to all the regulations of a profit-seeking business. Lucsko presents vivid details of official abuse in rural and suburban areas, while in cities the power of eminent domain has been used to "eviscerate entire industrial districts." One can never have enough lofts.⁵

As is so often the case, this story begins with good intentions: Lady Bird Johnson's initiative to clean up America, resulting in the federal Highway Beautification Act of 1965. Prior to this, the highway could be quite an ugly thing, with unrestricted billboards and lots of litter, as well as unscreened salvage yards and scrap metal businesses visible from the road. We owe Lady Bird thanks for making us more attuned to aesthetics as an important expression of national pride, and of regard for the common

OLD CARS | 73

good. But in Lucsko's telling, the Act's emphasis on beautification prompted a cultural shift that has turned out to be a mixed bag. It "gave rise to a far more radical wave of antijunkyard, antiscrap yard, and, for lack of a better phrase, anti-ratty-looking-car NIMBYism over the last five decades."⁶

Superficially, litter and the rusting carcasses of salvaged cars are both an affront to the eye. But while litter exemplifies that lack of stewardship that is the ethical core of a throwaway society, the visible presence of old cars represents quite the opposite. Yet these are easily conflated under the environmentalist aesthetic, and the result has been to impart a heightened moral status to Americans' prejudice against the old, now dignified as an expression of civic responsibility.

Prejudice against the old goes deep in the American psyche. Alexis de Tocqueville reported his conversation with an American sailor in 1831: "I ask him why the vessels of his country are constituted so as not to last for long, and he answers me without hesitation that the art of navigation makes such rapid progress each day, that the most beautiful ship would soon become nearly useless if it lasted beyond a few years." Here is a striking defense of shoddiness as a natural corollary of the faith in progress. Perhaps this sailor hit upon the hidden syllogism that can explain the otherwise baffling lousiness of so much our material culture.

The twentieth-century political philosopher Michael Oakeshott wrote that we are "ready to drop the bone we have for its reflection magnified in the mirror of the future. Nothing is made to outlast probable improvement in a world where everything is undergoing incessant improvement. . . . The pace of change warns against too deep attachments."⁷ The cultural maladjustment of the old car enthusiast lies in just this, a "too deep attachment."

The ironies of this attachment are inescapable, given that quick obsolescence has been a design criterion from early in the history of the automobile, part of the business model. This is generally credited to General Motors chairman Alfred Sloan. The idea was to offer not just one model of car (as did Ford with its Model T) but an array of models for different market niches: men, women, and people of varied income levels, with varying styles to mark these differences. The idea of the "model year" was introduced, and each of these would promise some improvement. At the heart of this marketing strategy was an idiom of technological progress that found easy resonance with Americans, however superficial or nonexistent the underlying technical innovations sometimes were. The push-button transmissions that were introduced from 1956 to 1958 by Chrysler, Packard, Ford, and Edsel on their high-end models weren't very good at shifting gears, but they had buttons.

Against such a cultural backdrop, in which old is bad and new is good, salvage yards "were guilty not only of being unsightly but also of undermining the logic of obsolescence by making it possible for older machines to stay on the road," Lucsko writes.⁸ Combined with the beautification efforts of the 1960s and a sometimes soft-headed environmental sensibility that emerged in the 1970s, this prejudice against the old imparted a forwardthinking glow to the throwaway mentality.

A telling expression of this prejudice, and its promotion by officialdom, is the various "accelerated vehicle retirement," or cash-for-clunkers programs, that have been pursued in recurring episodes since the early 1990s. Once again, we find a piece of well-intended legislation, in this case the Clean Air Act of 1990, giving rise to a murky set of incentives and opportunities. In this case, key elements of the legislation were conceived from the outset by corporate interests, for purposes that were not entirely public-spirited.

In 1990, the petroleum firm Unocal announced that it would give \$700 and a month-long bus pass to anyone in the

OLD CARS | 75

Los Angeles area with a car built before 1971, which it would then crush and sell for scrap. Calling it the South Coast Recycled Auto Program (SCRAP), Unocal planned to take seven thousand old cars and permanently remove them from service in this way. The firm was facing the necessity of substantial investment to bring its refining operations into compliance with the state's air-quality mandates, and this initiative to destroy old cars was a PR gambit. The key to the initiative was Unocal's characterization of old cars as "gross polluters," responsible for the lion's share of all automotive emissions.

Lucsko details how Unocal's SCRAP was "hailed by many corporate executives, journalists, environmentalists, and politicians as a creative and forward-thinking approach to the airpollution problem—a 'win-win' for everyone involved."⁹ This "everyone" mainly consisted of parties lying along the axis of commerce and officialdom, from Ford and its southern California dealer network eager to sell new cars, to banks offering reduced rates on new auto loans, to the South Coast Air Quality Management District. They not only praised the initiative but offered up more money to extend it. That summer, nearly eighty-four hundred SoCal (i.e., largely rust-free) pre-1971 cars—automotive gold—were irrevocably destroyed. Out with the old.

If Unocal's SCRAP program began as a speculative investment in public perception, it paid off spectacularly, and in retrospect it can be viewed as a sophisticated bit of legislative lobbying. The second Clean Air Act, then being drafted, would adopt the basic logic of SCRAP and for the first time treat mobile and stationary sources of pollution as fungible, creating a market for pollution abatement credits or offsets. Why retrofit a refinery to be cleaner when instead you can destroy old cars, thereby cleaning up not just the air, but those lingering emblems of backwardness?

It was an approach typical of the Reagan-Bush-Clinton years,

and could be taken as an early expression of what the political theorist Nancy Fraser has recently called "progressive neoliberalism," that pairing of progressive ideas with some of the more predatory forms of capitalism, in which the former element serves as the public relations wing for the latter. Under this dispensation, she said, "protecting the environment meant carbon trading. Promoting home ownership meant subprime loans bundled together and resold as mortgage-backed securities."¹⁰

How we assess the regime of carbon trading that underlies the clunker programs depends in part on an empirical question: just how dirty were the tailpipe emissions from those old cars compared to newer ones?

As it happens, I interviewed for a scientific job with the Santa Barbara Air Quality Management District in 1989, as the fresh recipient of a degree in physics from UCSB. I had also done combustion research for two summers at Technor, a start-up in Livermore, California, launched by a scientist at Sandia National Laboratories to commercialize a technique he had patented for reducing NOx (oxides of nitrogen) from the combustion product, using a process catalyzed by cyanuric acid. He hired me because I was a physics major, but also because I was a VW gearhead, and air-cooled VW engines had figured prominently in his early research (they offer a relatively simple platform for experimentation). We built a fully instrumented combustion reactor in our lab and used mass spectroscopy to analyze the gases. We also fitted a prototype system to a wood-fired power plant in the foothills of the Sierra.

I mention these biographical facts only to head off a reflex in some critics to assume that any skepticism of the claims made on behalf of "new technology" can only be due to a romantic, woolyheaded "anti-technology" prejudice. My sense is that critics who take this stance usually lack a technical background themselves. Such a reflex will not serve us well in this case, because on the

2

question of older cars being "gross polluters," there are facts of the matter, and they can be discovered. Lucsko has done just this, and his careful work is a model of history-of-technology that cuts through the official cant.

The narrative repeated by officialdom got established before the facts were in, and went on to play a causal role in the subsequent history. The statistics cited by policy experts on the question of old cars' emissions versus that of new cars varied wildly in the early days of this debate. When the factual picture is messy in this way, but on the other hand there is a public consensus that something must be *done*, there develops a great thirst for answers. Speaking simplistically offers a kind of cognitive relief. This is what politicians specialize in.

Speaking off the cuff in 1971, Ronald Reagan, then governor of California, told the Associated Press, "I have often wondered if we aren't going to come to a point where we are going to have to take a look at the possibility of funding and junking cars older than a certain age." A month later, Tom Carrell, the head of California's Senate Transportation Committee, echoed his chief executive with a similarly fateful bit of musing, but this time it was musing with numbers: "Getting old cars off the road is the only way to solve the problem. I'm sure that 50% of the auto smog problem is from the older car running on our highways." Heads nodded. The statistic that came to be repeated was that 50 percent of automotive emissions could be attributed to the oldest 10 percent of cars on the road. This would later be characterized as an "urban legend" by an official of the California Air Resources Board. But by then it was one of those factlike things, with a successful career and a constituency, that was too big to fail.11

It is true that by 1980, when the mobile-source provisions of the original 1970 Clean Air Act came into full effect, brand-new cars in the American market had greatly reduced emissions. But those same cars, tested at random roadside checks a few years later, were often found to be badly out of adjustment (or they had damaged catalytic converters), with correspondingly high emissions, while well-maintained older cars could be impressively clean-burning. Further, by 1985, only 6.7 percent of cars registered in the U.S. were built before 1970. That figure had fallen to just over 2 percent by the early 1990s, through natural attrition.¹²

It is also important to note that the persistence of the airquality problem in the United States was due in large measure to the fact that the number of miles driven per year in the U.S. nearly doubled between 1970 and 1990, despite the fact that the population had increased only 20 percent.¹³ The role of lengthening commutes in air pollution is significant here because, according to the insurance industry, older cars are driven far fewer miles annually than late model cars. This makes sense; if you have a hundred-mile daily commute, or you are a harried soccer mom, you are not likely to rely on an old beater, nor a treasured classic. In short, there is not now, nor has there ever been, any math by which old cars could account for half the air pollution, or anything close to it.

But the offhand suggestion that they do prepared the public mind for Unocal's "gross polluter" gambit. The real impetus for cash-for-clunkers programs came not from politicians, environmental scientists, or anyone else tasked with improving air quality, but from refineries looking to sidestep government mandates to clean up their own emissions.¹⁴

The perversities were such that there came to be *industrial demand for old cars*, viewed as raw material to be converted (through the alchemy of politics) into lucrative pollution offset credits. This led to "scrappage fever" in fifteen states in the early 1990s, after passage of the Act. Where there is demand, a supply of old cars must be found. This could have an unfortunate, predatory look to it if not given a gloss of expert consensus; one must bring government and NGO types on board. So, for example, Lucsko writes that in Chicago seven regional oil companies teamed up with General Motors, the Environmental Defense Fund, and the Illinois EPA to destroy old cars. In 1994, the California Air Resources Board got very zealous indeed, urging a statewide program to destroy *seventy-five thousand* vehicles per year. Many of these scrappage programs dictated that no parts be harvested from the cars before they were shredded; the goal was total destruction. Anything less would prolong the persistence of old cars on the road.¹⁵ OLD CARS

79

How are we to understand these clunker programs? Their net effect on air quality is something that can be argued over. In doing so, we would also want to consider their effect on the geographical *distribution* of air quality, including in our calculus emissions from the power plants that generated the electricity used to manufacture the new cars that replaced the old, the mining operations to extract their raw materials, the smelting of ore to make new steel, and transportation of these materials across various oceans. All of this would require further empirical and historical work to establish, and some of the data is irretrievably dispersed in the clouds; a full assessment would be a major undertaking. But my larger point does not rest on these particulars, for I want to consider the political plight of old cars as a window onto a broader nexus of forces.

The kind of material economy that has come to prevail over the last half century is one in which obsolescence is enforced as a corollary of the faith in progress. This has hidden costs, and these do not fall on all equally. To account for these, we need to consider not just things like air quality, but the *human* environment. Artifacts are sometimes central to those practices and those "too deep attachments" that give shape to a life, and that connect one generation to another.

GEARHEADS: A FURTHER THORN IN THE SIDE OF THE FUTURE

Young Vietnamese immigrants in Los Angeles in the 1990sthe children of the "boat people" refugees from America's war in Indochina-were buying '80s and '90s Hondas because that was what they could afford. Those cars then became the soil in which the "import tuner" scene took root in the United States. An ecosystem of folk engineering knowledge developed, just as it had decades earlier in the hot rod Volkswagen scene, or the small-block Chevy world. Or consider the communities that formed in the 1970s around the British Ford Escort and Datsun 510. That is, a mere utility or commodity car, with no special cachet whatsoever, became the focal point for an intellectually absorbing and timeconsuming activity, inherently social in nature, that gave a certain shape to the lives of those who were caught up in it. I suspect it is because of the role that a certain model of car (almost always an inexpensive one) plays in this world-making activity that it achieves folk-classic status. Viewed in retrospect, the car becomes an emblem of a life that has been lived. But unlike an old photograph, the car has itself been the recipient of attention and care over time; the visible traces of its physical history are the traces of some significant part of one's life, gathered into a thing one can touch.

Yet unlike a true classic car, the folk-classic plays this role only because the gearhead's relationship to it is *not* one of simple stewardship or loving antiquarianism. He wants to make it go faster, brake harder, corner flatter, and look more fly while doing so. (The *Onion* had a headline back in the '90s that referred to "inscrutable Asian car modifications.") The appeal of the car is that it invites *doing stuff* to it; it is not a static object of reverence. Ironically, it may later become such an object for the collector. He will pay a premium for a car with "period" modifications, if they are pure enough: a complete inversion of the spirit in which the modifications were first made.¹⁶ Hopping up your ride on a budget means sourcing used parts, and very often it means finding ways to adapt components from other makes and models to work with your car. The junkyard is the place where these discoveries are made, and Lucsko gives a nice account of this. Wandering through a junkyard with a tape measure and sketch pad, one can be overcome with a feeling of limitless possibility, alternating with a bitter sense of "what if": what if that Jeep transfer case were two inches shorter? Then I could easily shorten the drive shaft, use the whole 4WD Jeep drivetrain, build a subframe around it, and the whole package could be made to fit inside the wheel base of a VW Squareback body, and how cool would *that* be? OLD

CARS

00

At a salvage yard that is near a metropolitan area, you may find a photographer wandering around, savoring the old cars as "ruin porn." Junk cars present richly timeworn surfaces. To the contemporary artistic sensibility, there seems to be something inherently attractive about decay. Why this should be is hard to say. It could be a rejection, however conscious, of another attitude that the contemporary artist may feel is incumbent on him or her: hatred of the past.¹⁷ According to this view, art requires maximum liberation from the past, to clear the way for invention ex nihilo. But this is hard to live by. To spend time in a junkyard, surrounded by the inexorable process of decay, perhaps soothes the indeterminacy of a life in which little is inherited and simply settled. Old things carry history that is irreversible, beyond the reach of choice. They lend gravity, or at least a *mood* of gravity, to an existence that can seem unbearably light.

The gearhead too may enter a reverie in the salvage yard, but it has a different character to it. You may see him sitting in the dirt with a look of focused effort on his face, making odd gestures with his hands in that way people do when they are building something in their mind. It is not the aged surfaces that interest him, but the function of the thing, which is inherently ageless. Because he is entering into the same engineering challenges as those who first designed the component he is repurposing, he feels a kind of intellectual companionship with them across the gulf of time. And reciprocally, those anonymous engineers would be able to comprehend what he is trying to do. They may or may not approve, these ghosts, but there is plenty of basis for an imagined conversation—the kind of friendly quarrel that is possible only among people who speak the same language.

Speaking of the importance of salvage yards for "street rodders" in the 1950s, '60s, and '70s, Lucsko quotes one Joe Mayall, who wrote in 1981:

I've been a wrecking yard hound for as long as I can remember, and some of my best times were when I would just wander around in one, tape measure in hand, looking into and under every vehicle that was there. Sometimes I had a specific need, but often I used the opportunity to check out things that I didn't have a thought of using but might result in an idea for future use. You'd be surprised how much creative thinking can be generated by looking under a smashed-up car.¹⁸

This passage is from an obscure and long-defunct specialinterest magazine, *Street Scene*, which had the usual garish cover and tacky advertisements. Yet it exemplifies a point made by one of the most beautifully austere thinkers of the twentieth century, Michael Oakeshott, in his attempt to say what it means to have a conservative disposition. He identifies this, not with hankering after the past nor fear of the future, but rather *affection for the present*. One cherishes what actually exists, because one sees the value in it. This disposition

will appear more naturally in the old than in the young, not because the old are more sensitive to loss but because they are apt to be more fully aware of the resources of their world and therefore less likely to find them inadequate. In some people this disposition is weak merely because they are ignorant of what their world has to offer them: the present appears to them only as a residue of inopportunities.

This seems to capture the psychological truth of the wrecking yard as it is experienced by the automotive improv artist. For him it is a deposit of cultural ore to be mined and enjoyed today.

WE HAVE CONSIDERED the forced obsolescence of old cars that rests on a false environmentalism. We have considered a rich vein of creative possibilities that show up when one steps outside the obligatory logic of the New, with its accelerated estrangement from the present. On both fronts, the figure of the gearhead presents a countercultural point of reference who can facilitate our own self-criticism, and help us see the forced-march quality that "progress" sometimes has. The political economy of "salvage" has its corresponding moral economy, and on both fronts the gearhead finds himself at odds with what is most self-assured in modern society.

Recall the guy with the shotgun, holding off the authorities until he could do so no longer. Surely, he would count as a "deplorable" in today's political typology. The cultural resentments that build up under a regime devoted to progress can be seen as responses to a common pattern. People find themselves dispossessed of a way of life—a set of concerns by which they have oriented in the world, for the better part of a lifetime—by others who carry more authority, whether by virtue of money, political clout, or occupation of the moral high ground. (These tend to coincide.) What such citizens lose, when their old cars are declared a public nuisance, is a form of intergenerational wealth that is both material and sentimental.

THE DIMINISHING RETURNS OF IDIOT-PROOFING AS A DESIGN PRINCIPLE

One day in 2018 I ran out of gas in my 1970 Karmann Ghia (the gas gauge wasn't working—due to a bad ground connection, as it turned out). I had to hike a few blocks to a gas station. I didn't have a gas can, but the station had one for sale and I bought it. I filled it with gas and walked back to my car. But I couldn't get the gas out of the gas can. It had a spout like I had never seen before, and it was baffling. I suppose it was meant to be safer. It put me in the position of trying to guess what particular hazard it was solving, in the hope that with this clue, I might be able to reverse engineer the thought process of the committee who designed it, and thereby deduce the action they wanted me to perform upon the spout. Sometimes idiot-proofing is something you have to be really smart to defeat; you have to develop a whole psychological theory of your opponent. If you're an idiot like me, you don't pass the test and are not qualified to use this type of spout, apparently. In the end I took

it off, and proceeded to pour gas all over the car, my pants, and my shoes—in the hope of getting some of it into the gas tank. This didn't feel especially safe.

The perverse antagonism emanating from this plastic nuisance was driven home for me on this day by the contrast it presented with the Karmann Ghia, perhaps more than if I had been driving a modern car that day. The Ghia doesn't chime at me if I fail to put on my seat belt, leave the headlights on, or leave the key in the ignition. The gas gauge, when it is working, is accurate to within about one-third of a tank. If I drive off with the parking brake still engaged, there is no warning light on the dash to tell me. If the Ghia could talk, it would say, "Hey man, that's on you. I just work here." But in fact, it is an inanimate object, and it doesn't address me at all. It merely does what I tell it to do, without running it by a committee first. I like that about it.

When I take a passenger in the Ghia, I have noticed a certain consternation on his or her face as they fumble around to find the nonretracting seat belt that tends to fall down between the seat and the door, crank the window down, then slam the door shut with a tinny thwack. This is different. The dashboard consists of a speedometer, the aforementioned gas gauge, and a clock that is accurate twice per day. Mostly it is a bare expanse (not unlike the dashboard Mindful Mode available on the new Ford Explorer, but cheaper).¹ As I pull away from the curb, I have noticed a grin spreading across the face of my companion. You can hear the clatter of intake and exhaust valves opening and closing behind us, and the cockpit consists mostly of glass. My passenger looks enlivened, even giddy, at fifteen miles per hour. I suspect her delight comes not just from the mechanical sensuousness of the ride-the physicality of it-but from the fact that we seemed to get underway without permission. We're so accustomed to those buzzers and chimes on modern cars that we just tune them out, but somewhere beneath the threshold of awareness they remind

us that we are being supervised. It feels a bit illicit to just shove off without notice, like a canoe slipping away from the dock.

But this is mere poetry. Our concern in this chapter is with automobile safety, and this is a topic to treat in an unsentimental way, not in a romantic mood. Automobiles made today are a lot safer than those made in earlier decades. We will look at the various improvements that have made them so. We will also consider how improvements in the car itself can induce changes in driver behavior, and these are not always improvements. The net safety picture is thus messier than it appears if one confines one's gaze to the progress of technology.

Our focus here is not on "tech" that obviously compromises a driver's attention to the road, such as navigation screens and infotainment systems, but rather features and design elements whose very purpose is to increase safety. My intent is not to challenge the net positive effect of the safety improvements made to cars in recent decades—that is incontrovertible—but to chart the trajectory we have embarked on recently, and see where it leads.

The necessity of doing so becomes apparent once you start to look more closely at the safety claims made on behalf of autonomous cars, and on behalf of various steps in that direction, already available, that allow hands-free driving. In January 2017, the National Highway Traffic Safety Administration (NHTSA) published a remarkable claim that the crash rate, as measured by airbag deployments, "dropped by almost 40 percent in Tesla passenger vehicles equipped with the Autopilot Technology Package following installation of a new driver assistance system component, Autosteer."² This finding was widely reported in the press the same day it was announced—in "the nation's newspaper of record" (the *New York Times*), the highly influential Bloomberg organization, and elsewhere.³ Tesla's stock price was at \$216 at the end of December 2016, shortly before the announcement. In the following six months, it would climb to \$383. The technology and business website *Ars Technica* reports that when another Tesla customer died in an Autosteer-related crash in March 2018, Tesla cited NHTSA's positive report in a blog post defending the technology. A few weeks later, Tesla CEO Elon Musk "berated reporters for focusing on stories about crashes instead of touting the safety benefits of Autopilot." "They should be writing a story about how autonomous cars are really safe," Musk said in a May 2018 earnings call. "But that's not a story that people want to click on. They write inflammatory headlines that are fundamentally misleading to readers." Since Mr. Musk is concerned about misleading information, let us be sure we get this right.

The claim that Autosteer reduced crashes by 40 percent caught the interest of Randy Whitfield, who has a small research consultancy that specializes in "forensic statistical services" in the field of risk mitigation.4 Surprisingly, he would eventually write, NHTSA's announcement "was not accompanied by any of the data underlying this astonishing claim," making it impossible to try to replicate. Whitfield looked at insurance records involving Tesla crashes, and they didn't seem to match the government's figures. His tiny firm, with the imposing name Quality Control Systems Corporation, filed a Freedom of Information Act request for the data. NHTSA ignored the request. Eventually Whitfield sued the Department of Transportation. NHTSA's position was that compliance with the request was likely to cause Tesla "substantial competitive harm." It also never indicated the source of the data it had used in making the dramatic claim. In the course of the FOIA lawsuit, it emerged that NHTSA had relied on data supplied by Tesla.

With that massive caveat, the basic idea behind the safety improvement claim was to take the number of Tesla crashes before activation of Autosteer and divide it by the number of miles driven under that condition. Then do the same for miles driven after activation of Autosteer, and compare the two. When QCS finally got ahold of the data, two years after requesting it, it was a mess. For many vehicles in the dataset, the mileage was "unknown, unreported, or otherwise missing." If I have understood the analysis correctly, such missing mileage was assumed to be zero, when it appeared to be advantageous to Tesla to do so, thus inflating the accident rate per mile for those cases, thereby yielding a big improvement with the activation of Autosteer.⁵ Further, the authors of the study had simply aggregated various populations of cars, so that the numerator (number of crashes) and denominator (number of miles driven) were not taken from the same cars with the same drivers.⁶ But that was just the tip of an iceberg of methodological lapses, not all of which appeared to be innocent. Confining his calculations to the small subset of vehicles with complete information for pre- and post-Autosteer, Whitfield was left with only 5,714 vehicles out of the 43,781 included in the original study. For these more solid cases, what did he find? A "59 percent increase in the airbag deployment crash rate . . . following the installation of Autosteer."

How could this be? Shortly we will consider the special challenges that come with trying to take human beings out of the driver's seat on the assumption that computers can do it better. The government has quietly backed off its Tesla-friendly safety claims for Autosteer in response to QCS's report, calling its own findings "cursory." For its part, Tesla has stopped making the 40 percent crash reduction claim, and now puts a "quarterly safety report" on its website, which shows "Tesla cars with Autopilot engaged experience fewer accidents per mile than Tesla cars with Autopilot disengaged. These, in turn, experience fewer accidents per mile than the average car on the road."

Timothy B. Lee, author of the *Ars Technica* article cited earlier, contacted Whitfield and asked his view of Tesla's current safety claims. Whitfield pointed out that in making these more modest claims, Tesla is still not controlling for variables that are clearly important. The Autopilot package is supposed to be used only on

freeways, which have fewer accidents per mile than other streets. "So the fact that there are fewer crashes per mile when Autopilot is engaged doesn't necessarily prove that Autopilot is making the trips safer. It might simply reflect the fact that crashes are simply less common, on a per-mile basis, on freeways." Likewise, we would expect Teslas to have lower accident rates, based simply on the fact that the population of Teslas is relatively new, and newer cars crash at a lower rate than older cars. They are also expensive cars, which means that their drivers are likely to be richer and older than the average driver. Middle-aged drivers are safer than younger drivers. Wealthier drivers tend to keep up with vehicle maintenance better than poorer drivers. (You don't see a lot of Teslas rolling around on bald tires.) Lee writes that "Tesla's relatively low crash rate may reflect the demographics of its customer base more than the safety features of its cars." And he reports that "as far as we know, Tesla hasn't provided recent crash data to independent experts who might be able to control for these kinds of factors to evaluate Autopilot's safety in a rigorous way."7

Let us pause to absorb the lesson offered by this parable, in which a charismatic, forward-thinking tech firm found a reliable ally in the halls of government, and in a journalistic establishment eager to align itself with the forces of progress. (But let us also note the good work of *Ars Technica*.) I think it best to give the citizen-statistician Randy Whitfield the last word, as he states the lesson of this episode with admirable clarity:

The larger question is whether the field experience of autonomous vehicles and advanced driver-assistance systems will be fairly and transparently assessed by the public officials charged with insuring the public's safety while this technology is "betatested" on public roads. The litigation record in our case documents the resources which both NHTSA and Tesla were willing to commit to prevent public scrutiny of this taxpayer funded research, based on a fear of competitive harm to Tesla. The adversarial relationship which ought to obtain between regulators and industry, and between both of these and the profession of journalism, becomes a fiction under "crony capitalism." One gets the sense that these are no longer separate elites; that they have merged into a super-elite bent on controlling the narrative of progress, even if at the cost of the public interest.

WE HAVE A RISK BUDGET

At a conceptual level, the difficulties of disentangling the causal factors in traffic accidents, and the toll of such accidents when they occur, remain much as they were in 1975 when Sam Peltzman published his influential study Regulation of Automobile Safety. The car operates in a larger risk ecology that is affected by traffic density, speed limits, rates of traffic-rule enforcement, the design and condition of roads, the quality of driver education, the availability and quality of hospital trauma care, the percentage of drivers who are young and inexperienced, rates of drunk driving, and so on. But if we reduce the scope of considerations to physics-the domain of crash test dummies-there have been obvious and significant improvements in the safety of the car itself when it does crash. The biggest improvements came in the mid-1960s with the wide adoption of two new safety devices: seat belts and energy-absorbing steering columns (the latter prevent the driver from being impaled in a front collision; the steering column collapses instead).8 A further significant improvement came with the wide adoption of airbags in the 1990s, as a supplement to seat belts.9

Peltzman's contribution was to point out that we tend to change our driving behavior in response to the introduction of new safety devices, partially offsetting the gains in safety. The government, in mandating safety devices, "cannot require the purchase of more safety, but only of the devices that can reduce the costs

9 1

of an accident to life and limb. The distinction is important if the decision to run the risk of an accident is not an immutable outcome of pathological behavior." Rather, that decision is based on the costs and benefits of running the risk. "One result of (effective) safety [devices] is to reduce the costs of this risk, and this reduction should induce greater willingness on the part of drivers to run the risk. It is not the risk itself that a driver seeks, but its derivative benefits: getting from one place to another more quickly, permitting a young driver to use the family car, and so on."

Peltzman suggested we have a "risk budget" that is fairly constant, and we redistribute risk in response to a perceived gain in safety by altering our behavior. Not because we have a death wish, but because getting anything done in this world involves risk, and we accept this.

One has to distinguish between safety devices and design elements that reduce the risk of an accident occurring, and those that reduce the damage to life and limb of an accident (its "cost," in economist-speak) when one does occur. The latter include seat belts, collapsible steering columns, airbags, the location and design of fuel tanks, vacuum-activated fuel shutoff valves (which shut off the flow of fuel if the engine has stopped running), fuel pump relays controlled by an inertial switch (which shuts off the pump in the event of an impact), as well as crumple zones and other features of the crash structure designed to protect occupants. The other group of considerations-design features that reduce the risk of a crash occurring in the first place-include dual-circuit master cylinders (mandatory on all new cars sold in the U.S. since 1968) that separate the front and rear brake hydraulic systems so that if one fails the other remains effective; dash warning lights to indicate a loss of brake pressure or low fluid level; the wide adoption of disk brakes in the front (which are better at dissipating heat than drum brakes, and also more effective when wet because the brake pads squeegee the water off the rotor as it turns); bellows on brake reservoir caps that do not vent to the atmosphere (thus preventing the intrusion of moisture into the system, which can boil at operating temperatures, thus introducing a gas to the system, making the fluid compressible and thus less able to transmit pressure, as well as causing corrosion to brake components); improvements in synthetic rubber compounds and tire construction that have greatly increased the ability of tires to adhere to the pavement in both wet and dry conditions, through a wider range of temperatures; as well as electronically controlled aids such antilock brakes, traction control, and stability control.

These last two are easy to get confused. Traction control uses the wheel speed sensors that are part of the antilock braking system to detect a condition where one of the driven wheels is turning faster than the other, at a differential greater than that expected due to their traveling different paths (as when one turns), indicating a loss of traction at the faster wheel due to the application of too much throttle for the traction available at that wheel. The system intervenes by applying the brakes to the spinning wheel or by reducing torque to that wheel. Electronic stability control builds on traction control by adding further information, most crucially yaw (the difference between the car's attitude about a vertical axis and its direction of travel) and steering angle. If the car is not headed in the direction the front wheels are pointed, the stability control system "estimates the direction of the skid, and then applies the brakes to individual wheels asymmetrically in order to create torque about the vehicle's vertical axis, opposing the skid and bringing the vehicle back in line with the driver's commanded direction."10 Electronic stability control has been required on all passenger cars and light trucks sold in the United States since 2012, and has made a real contribution to automobile safety.11

Peltzman was a University of Chicago economist, and his

analysis shows the characteristic limitations imposed by assumptions about a "rational actor" whose behavior is guided by costbenefit calculations. One reason such an approach is unrealistic is that it doesn't consider the extent to which the pertinent considerations for such a calculation are "present to consciousness." A distinction must be made between safety features that are entirely unobtrusive (such as an energy-absorbing steering column, or an inertial fuel pump relay) and those that make their presence felt (such as a crash structure with high sills, an elevated hood, and wide pillars). As far as I can tell Peltzman himself never made such a distinction, yet it would seem to be crucial to his basic point. He presents data to support various *correlations* that suggest we have a "risk budget," but the causal picture is left mostly blank, to be filled in with the rational-actor assumption.

If the introduction of a new safety feature is going to change our driving behavior, that feature must be available to the mind, and not simply as a verbal proposition. If the driver happens to be a well-informed safety geek, something unobtrusive such as a collapsible steering column may be available to him in the form of a sentence: he knows that he has one. This is a little factoid-a bit of "propositional knowledge," as it's termed by philosophers of mind-that he can recall if you ask him about his steering column. But in our everyday activities we don't go through the world synthesizing every pertinent fact in our heads and adjusting our behavior according to a calculus. We are animals with bodies, not computers, and in activities like driving that become second nature, our actions are routinely guided not by propositions but by the world that reveals itself through our senses and bodily interactions. This is one upshot of the "embodied cognition" revolution of the last twenty years.¹²

Peltzman was surely right to emphasize that risk taking has both costs and benefits, but because the risks are of a statistical nature, rarely realized, while the benefits are concrete and always present, one needs to have a psychologically realistic account of how the cost side of the ledger actually impinges on a driver's behavior. Pace the assumptions of Chicago-style economics circa 1975, we are not omniscient maximizers of our own utility. Indeed, as folk statisticians we humans are horrible at estimating risk. In terms of their behavioral effects, more pertinent than the actual risk we run is the question of how exposed one feels while driving, subjectively. Unobtrusive safety devices are likely to have no effect on this, whereas the elevated, tanklike enclosure of a large SUV has a dramatic effect on one's feeling of bodily exposure. In the words of John Muir, author of How to Keep Your Volkswagen Alive, "If we all constantly drive as if we were strapped to the front of the car like Aztec sacrifices so we'd be the first thing hit, there would be a helluva lot less accidents." From my own unscientific observation, I have been struck by the inadequate following distances often maintained by a driver in a typical sixthousand-pound SUV. As though the possibility of bodily harm were a pure abstraction. One also suspects that many drivers of such vehicles have no idea how they would behave at the limit of traction.

Further, a more enclosing crash structure reduces one's peripheral awareness of nearby vehicles. You have to go looking for them, relying on convex mirrors to gain a field of view that covers bigger blind spots only at the cost of distortion ("Objects in mirror are closer than they appear"). You have to do a bit of cognitive work, transforming the weird image in the mirror into something you can use. This is something you are able to do quickly and accurately only if you are in the habit of relying on those mirrors, and have integrated their distortion into a mental model that maps the dimensions of your own vehicle onto the funhouse world depicted in the mirror.

If you have not driven a car from, say, the 1980s or earlier recently, you might be shocked at how much visibility we have given up, and with it, a corresponding situational awareness. Given this, it makes perfect sense that, as of model year 2018, all vehicles sold in the United States must have rearview cameras. This was an executive order by the Obama administration, the result of a campaign started by a driver who, heartbreakingly, reversed into his own daughter and killed her. Given how far we have gone down the road of pursuing safety through enclosure, elevation, and mass, such a mandate becomes necessary.

Bigger, heavier vehicles really are safer in a collision. For the occupants. We have been engaged in an arms race of vehicular mass, with every man for himself. But at what point do we begin to question this design trajectory, in which the pursuit of safety reaches a point of diminishing returns, with some design elements working at cross-purposes to others? The low-hanging fruit of safety gains was plucked with the mandating of seat belts and airbags, and the higher-hanging fruit was gotten with anti-lock brakes and electronic stability control. There remains fruit to be plucked, but the branches that must be climbed to reach it are getting rather spindly, by which I mean that the unintended effects on drivers (and hence, paradoxically, on safety) are likely to be more significant.

In March 2019, the European Commission, which is the executive arm of the European Union, announced that from the year 2022, all new vehicles sold for use on European roads must include lane-keeping and automated braking systems, as well as speed limiters and data recorders. (Who gets access to the data was not specified.)¹³

Before we parse the likely *safety* effects of these new safety features, let us admit another set of considerations: how much is all this going to cost? Writing in the *Times Literary Supplement*, Edward Luttwak derives a maximum affordable car price (about a third of one year's income) based on median incomes in metropolitan areas. That price ranges from \$32,855 in San Jose to \$6,174 in Detroit. The cheapest new car on sale in the United States in 2016 was the Nissan Versa sedan at \$12,825.

The near doubling of the average cost of a new car between 1977 and 2016 (adjusted for inflation) should be understood in tandem with falling or stagnant wages since the 1970s. Why do contemporary cars cost so much? A significant driver of their cost is a regulatory regime that requires ever more features and design elements dictated by safety, which in turn makes cars more complex and more expensive. Luttwak notes the effect of even a small marginal increase in the cost of automobiles. "The additional cost of those rear-view cameras—only a few hundred dollars—will deprive thousands more households of the chance to buy a new car."¹⁴

It is probably more realistic to assume that this additional cost will simply be added to the burden of consumer credit that American households bear.¹⁵ Either way, there is an argument from economic justice—as opposed to libertarian zealotry—for challenging the regime of infinite safety. Owning a car is a necessity for those on the periphery, more than it is for those in metropolitan centers serviced by public transportation. Luttwak points out "the intensely reassuring sense of freedom depicted in countless writings and films, which reflect the hard realities of labour-mobility imperatives even more than the romance of the open road."

But let us meet that safety argument on its own terms, and return to the question of safety gains sought by new technologies and regulation, beginning with another brief run through the developments of recent decades. It is a trajectory in which each new stage of safety equipment is more obtrusive than the previous one, and therefore has a greater unintended effect in retraining drivers.

Unobtrusive devices such as airbags, dual-circuit brakes, collapsible steering columns, and fuel cutoff devices are straightforward

improvements that are unlikely to have any effect on driver behavior. Seat belts are more obtrusive, and Peltzman does find that they alter our risk budget to make us drive less carefully. Antilock brakes and electronic stability control, which did not exist when Peltzman did his study, would seem to belong to a different category. Such minders can save you in a panic situation, but they also have a slight deskilling effect. They prevent a driver from learning the behavior of his car at the limits of traction, and how the car's chassis dynamics can be made to work for him or against him in the timing and modulation of steering and brake inputs. For example, it takes a certain amount of time for the weight of the car to transfer to the outside wheels in a turn, or to the front wheels under braking. Once the weight has shifted, more traction is available. So braking and steering inputs at the limit require a certain patience, on a time scale of about one second, and a calm sense of rhythm that corresponds to the car's weight distribution, spring rates, and damping rates. Such knowledge is located in a driver's entire body, and it is acquired not by reading but only by doing, by exploring the limits. Such knowledge, or rather skill, remains a very real safety advantage, even with the electronic aids in place.16

But because most motorists are indifferent to these finer points, ABS and stability control have made significant, net positive contributions to safety.¹⁷ However much they may erode our skills, they do so only at limits that most motorists successfully avoid most of the time and are not interested in exploring.

Automated lane keeping and automated braking are quite different on this score. They intervene more promiscuously and relieve the driver of the need to pay attention. Is this *necessarily* the case? Can't the threshold of intervention be set high enough to avoid this effect? Consider the feedback loop that such car tenders establish, and how it is likely both to disrupt the process by which we become skilled at driving initially, and to compromise the process by which we continuously tune up our vigilance. Such skill acquisition and maintenance happens through close calls. It happens through being scared shitless, and shocked into a recognition of one's own cluelessness.¹⁸ Spared such experiences, our vigilance atrophies, and the automated system must take up the slack. As this loop progresses, the automation's underlying assumption of our incompetence becomes progressively self-fulfilling. This is the problem we turn to next.

SEMIAUTONOMOUS CARS

The human factors literature on *partially* automated driving (such as the Tesla Autopilot package offers) sheds light on the more general problem of human-computer cooperation. Can these two forms of intelligence be made to work well together?

The National Highway Traffic Safety Administration has tried to bring order to the confusing space of automobile automation by designating five levels of progressively less human involvement in the tasks of driving, from Level 0 (a completely user-operated car) to Level 4, in which there is no human involvement whatever. It is in the middle levels that things get interesting.

Stephen M. Casner, Edwin L. Hutchins, and Don Norman have written a review article in which they synthesize the relevant human factors literature, much of it consisting of their own research.¹⁹ (Don Norman will be known to some readers as the author of a wonderful book for a general audience, *The Design of Everyday Things.*) In this article, they present a sobering account of the challenges that lie ahead for automobile design. The problem comes down to a basic ambiguity. They ask, "what is the role of a driver in a partially automated car in which some of the driver's responsibilities are replaced by computers, some of the time?" The transition to driverless cars will be difficult, "especially during the period when the automation is both incomplete and imperfect, requiring the human driver to maintain oversight and sometimes intervene and take closer control."

The systems they consider range from those that merely inform the driver, or provide advice (such as GPS and lane-departure warnings) to those that seize control of the vehicle when the computer judges the situation unsafe. The problems posed by navigation systems are familiar to most of us. First there is the fact that programming a destination into the system requires attention. Ideally one does this before embarking on a trip, but we don't always behave in the ideal way. The NHTSA recommends that interacting with an in-car information system should take no more than two seconds at a time. By that they mean time spent interacting with your eyes and fingers. But interacting with a navigation system using voice only has been found to be equally distracting.²⁰

There is a second kind of inattention problem posed by reliance on navigation systems. When they work well for extended periods, we disengage from our surroundings, or at least from the cognitive task of finding our way through them "when all is nominally going to plan."²¹ The word "nominally" is key. Complex automation systems that rely on artificial intelligence solve "most problems with ease, until they encounter a difficult, unusual case, and then do not." When they do not, they may not *know* that that they have failed. We have all heard the stories of drivers being instructed to drive off a cliff, or into a lake, when a navigation system mistook a footpath for a road, for example. Small errors in a database can have large consequences. This is the problem of *brittleness*, in which "blunders [are] made easy."

When a driver treats his car as a submersible, it is tempting to attribute this to his own idiocy. But the same phenomenon occurs with highly trained airplane pilots. The problem is that the automated system earns our *trust*, based on its usually impeccable performance. The automation knows best. Following the directions given by a flight-management system, the crew of a Boeing 757 flew the plane into a mountain in Columbia in 1995.²²

In cars, the brittleness of navigation systems can be mitigated if the designers give thought to the interface and provide more situational context, for example not just displaying the car in the center of the road but showing also where the road leads. Without such surrounding context, clues that something has gone amiss are less likely to be noticed. Interestingly, some researchers are taking insight from the finding that when we have a passenger in the car, we tend to collaborate with him or her in finding our way. Could such a collaborative approach be adopted by an automated system?²³

The upshot of the human factors research can be somewhat deflating. Casner et al. write that "navigation systems are an excellent example of technology introduced to automate a task for which *people already seemed reasonably competent*. Yes, drivers got lost before the introduction of navigational systems, but they seldom led to safety-critical incidents. GPS navigation has introduced many human factors complications we did not anticipate" (emphasis added).

Another class of driver aids consists of warning systems that alert a driver when he or she is doing something wrong. Lanekeeping alerts tell you if you start drifting into an adjacent lane, or you try to change lanes without checking your blind spot, and there is another car there. Casner et al. point out, "One unintended consequence of alerts and alarm systems is some drivers may substitute the secondary task of listening for alerts and alarms for the primary task of paying attention." This has been called "primary-secondary task inversion," and it is a familiar problem for pilots in highly automated airplanes. For example, they may subconsciously come to view their task as that of listening for an altitude alert, rather than that of maintaining the right altitude, and this is obviously a problem if the alert fails to sound. This is called the problem of *complacency* in the human factors literature. A related but distinct problem is that of nuisance alerts. Casner et al. write that "in aviation, alerts and alarms given in situations pilots do not find alarming cause them to ignore the alerts. It is easy to imagine our own reactions to a system that continuously reminds us we are driving five miles per hour over the speed limit." Yet it is just such a system that is being implemented by the European Commission, as a mandatory feature on new cars beginning in 2022 (see note 13 on page 329).

Lane departure warnings and speed alerts belong to a category of minders that merely inform and advise the driver. The next level of intervention consists of systems we have already considered: antilock brakes, traction control, and stability control, which intervene only at the limit and keep the driver in the control loop. A further escalation consists of systems that actively control the vehicle as a matter of course and remove the driver from the feedback loop. We already have some familiarity with this, in the form of cruise control. And we have learned that when a driver is out of the loop of controlling their vehicle, they tend to become sleepy and less vigilant, and it takes them longer to respond to sudden events.²⁴ This is a bigger problem in a car than in an airplane, since the road is a highly unpredictable space compared to the sky, and the time scale on which a driver must get him- or herself back in the loop, assess the situation, and respond appropriately may be a fraction of a second, rather than the minutes usually available to an airplane pilot. This is called the problem of "rapid onboarding."

One response to this problem is to add yet more automation, termed the "one more computer solution" by human factors researcher Earl Wiener. Adaptive cruise control is able to automatically adjust the vehicle's speed in response to that of a vehicle ahead. Combined with automatic lane keeping, such systems permit hands-free driving, and this is now available on many cars. The fine print that accompanies these features informs the customer that they need to constantly monitor the situation and be ready to resume manual control at any time. But this expectation is unrealistic. As the automation exerts more complete control, our attention isn't needed and tends to go elsewhere for longer stretches of time; we get interested in something else. How frequently will we glance up from our phones? And when we do, to reengage in the task of driving and assume active control, if it is needed, is not a simple matter.

Casner et al. write:

The driver must be able to determine, at any moment, what driving functions are being handled by the automation and what functions remain the responsibility of the driver. Eye-tracking studies of airline pilots reveal they persistently misremember the state of the automation, even when they themselves set up the state. They rely on their memory of having pushed a button and habitually ignore system-status displays that tell the real story. Incidents in which pilots pressed a button to engage a speedcontrol function only to later see their speed increase or decrease unexpectedly are commonplace. Pilots sometimes erroneously assume automation functions are available for use when they are not. Automation functions sometimes quietly turn themselves off for no apparent reason.

A case can be made that, given the unnatural cognitive demands of partial automation, automatic systems should be authorized to seize control from the human operator in a dangerous situation. In fact, seizing control is just what antilock brakes, electronic stability control, and traction control do, and these have made big improvements to the safety of modern cars.

But there are darker possibilities to worry about. Arguably, the event that kicked off the contemporary wave of human factors research into automation was the 1988 crash of an Airbus A320 at an airshow in Habsheim, France. The plane was full of journalists and raffle winners who felt lucky to be selected for this demonstration of the latest marvel. "The purpose of the flyover was to demonstrate that the aircraft's computer systems would ensure that lift would always be available regardless of how the pilots handled the controls."25 But as the pilots did a low-altitude flyby of the crowd, the plane put itself in landing mode. The pilots could see plainly enough that there was no runway ahead, only trees, and tried to climb. The pilots and the automation fought for control of the plane, and the automation won. The plane crashed into the forest and caught fire. Despite the heroism of the flight attendants in evacuating passengers, three people died: a little girl who wasn't able to release her seat belt (her brother tried to help but got pushed down the aisle by panicked passengers rushing for the exit), an adult who went back to help her as the cabin filled with smoke, and a disabled boy who wasn't able to move.

As our roads and bridges crumble for lack of investment, it seems a little dicey to hand off control to an internal conversation between your car's computers and previously compiled GPS maps—suppose there is a new and very large crater in the road? If there is a fight for control, we want whoever is right (the computer or the person behind the wheel) to win that battle, but both are fallible. The human being is more fallible than he was previously, due to the cognitive challenges of partial automation.

In *The Glass Cage*, Nicholas Carr writes, "We all know about the ill effects of information overload. It turns out that information underload can be equally debilitating." He cites work in human factors research that shows how making things too easy for people can backfire, because our "attentional capacity . . . shrinks to accommodate reductions in mental workload." This is especially worrying because it is hard to detect. The operator simply tunes out because he or she doesn't have enough to do. Further, when the driver (or pilot) is understimulated during routine operation, he is more likely to panic when overstimulated, as happens when dealing with a failure of the automation.²⁶

The automation is supposed to provide a comfortably long lead time for transition when it summons a driver to intervene. But the stubborn problem remains that when automation encounters an unanticipated problem, it often fails and the driver may have little time to respond. Studies of airline pilots responding to such unexpected events and "automation surprises" inspire little confidence.

With complexity comes opacity, and this is exacerbated by one of the central features of driverless cars as envisioned: the cars must be able to communicate with one another so they can orchestrate their movements together, both for the sake of avoiding collisions and for the sake of smoothing out the flow of traffic (thereby realizing gains in street capacity).²⁷ The driver won't be able to monitor these communications, as they will happen very fast, in the language of machines. Casner et al. point out that "almost anything a driver does in such situations is likely to degrade the automatically computed solution."

If there is an overall lesson to be learned from the human factors literature, perhaps it is this: automation has a kind of totalizing logic to it. At each stage, remaining pockets of human judgment and discretion appear as bugs that need to be solved. Put more neutrally, human intelligence and machine intelligence have a hard time sharing control. This becomes evident in the problems posed by partially autonomous cars, and is evident also in the problems posed when fully autonomous cars have to share the road with human drivers.

Driverless cars are programmed to follow traffic rules to the letter and err on the side of caution, making them an awkward fit with other cars piloted by humans. The *New York Times* reports that one Google car "couldn't get through a four-way stop because its sensors kept waiting for other (human) drivers to stop completely and let it go. The human drivers kept inching forward, looking for the advantage—paralyzing Google's robot." Of course, what human drivers do is make eye contact in such a situation, or read other cues of social interaction, allowing them to negotiate ambiguous cases of right-of-way and work things out on the fly. Some drivers are more assertive, others more defensive. It is not a stretch to say that there is a kind of body language of driving. This improvisation works just fine, for the most part.

But social intelligence is hard to reproduce with machineexecutable logic. Therefore, it is concluded, human beings must become more like machines, in order to make the road more hospitable to robots. According to the same *Times* article, "Dmitri Dolgov, head of software for Google's Self-Driving Car Project, said that one thing he had learned from the project was that human drivers needed to be 'less idiotic.'" Such an inference comes easily when you conceive reason as a computer scientist does; as asocial and fundamentally rule-like. From such a perspective, human beings do indeed look like inferior versions of computers.

The contest for control between humans and computers often looks like no contest at all, as a political reality. Viewed through the lens of press releases and credulous journalism, the logic of automation is joined, in the public mind, to the moral logic of safety, which similarly admits no limit to its expansion.²⁸ These two are symbiotic in the sense that safetyism provides legitimation to the business logic of ever more automation. Together they are unimpeachable in the minds of all right-thinking people, and to question Team Progress is to invite being labeled pro-death.

If we confine ourselves to factual questions about the likely safety gains to be had from self-driving cars, it seems to me the most prudent position would be to join the agnosticism of the human factors researchers.²⁹ As Casner et al. say, "In the coming decades, we will all participate in driving research as an enormous uncontrolled experiment takes place on our streets and highways." This they state as a matter of fact, as though we had no choice in the matter. Automaticity becomes a political mood, no less than an engineering project.

FEELING THE ROAD

My first car was a 1963 Beetle, which I bought in 1980 at the age of fifteen. At the time, I was working at an independent Porsche repair shop in Emeryville, California, doing mostly menial labor (cleaning parts, packing the occasional wheel bearing) while drooling over the 911s. A Bug was as close as I was going to get to one of those.

Soon after learning to drive in the Bug, I discovered the pleasure of driving sideways. With a 1200 cc motor that makes 40 horsepower on a good day, you're not going to get your jollies from straight-line acceleration. But with a "swing axle" rear suspension, the inside rear tire tends to tuck in as it gets unweighted while going around a corner, at which point it loses whatever meager traction it started with. (Mine was likely a dry-rotted, bias-ply tire dating from the early '70s.) And it is just here that the fun begins. You go fast into a corner (I use the term "fast" in a purely subjective way), lift off the throttle to get a little forward weight transfer while simultaneously jerking the steering wheel, and the rear steps out. Now you're steering into the slide and feeling like an action hero at twenty miles per hour. The quirky handling that results when you combine a rear-mounted engine with a swing axle is what led Ralph Nader to famously proclaim the Corvair "unsafe at any speed." What he didn't mention is that such a car is also "fun at every speed."

My sweetest teenage memories are of driving up to the posh Claremont Resort, whose white tower shines resplendent over Berkeley, and honing my skills in a sloppy slalom through the parking lot amidst the Jaguars and Mercedes. I say "sloppy," but in fact the pleasure came from a growing sense of artistry that I experienced when I executed a four-wheel drift with precision and control. Such a slide was especially easy to initiate if it was raining. Pushing the edge made it recede further. The proximity of expensive obstacles only heightened the thrill.

My morning drive to Berkeley High School likewise included a routine of getting a little sideways around certain intersections. A left-hand turn with good visibility is best, as you can pick a line with an early apex and leave room for some elegant lateral movement across two lanes on the exit.

As my skills developed, I made some improvements to the car. First came better tires. But this led to a bad scare. At the bottom of Powell Street, where it runs into the waterfront, I took the corner onto the frontage road at speed, intending to hang the tail out. Instead the tires held, and I found myself driving on two wheels for a long, breathless moment. This was a complete surprise, and no fun at all. Having nearly rolled the car, I added stiffer shock absorbers and a roll bar. The new shocks transformed the handling, dramatically reducing body roll. Then came a hopped-up, 1650 cc motor with a snappy throttle (due to a lightened flywheel) and about twice the horsepower of the original. It had just enough torque that now I could use the throttle to induce oversteer, and the fun was further enhanced.

Fast-forward to 2019. I am in the later stages of a decade-long project of building a hot rod Volkswagen (I will go into detail likely more than you want—in the chapter "Folk Engineering"). As the body shell neared the stage of being ready for paint, it was time to choose a color. I had a short list that included Nardo Grey, a muted, nonmetallic paint that has a ceramic look to it. It is offered by Audi and Porsche, but only on their most racy models. I called a local Audi dealership and asked if they had a car in Nardo Grey on their lot, as I wanted to see it in person, from different angles in the light. The woman on the phone pulled up their inventory on a computer and after a minute said, "Yes, we do. We have an RS3 in Nardo Grey. Would you like to schedule a test drive?" Such a possibility had not occurred to me, but it didn't require much deliberation before I coughed out a "Yes."

The Audi RS3 makes 400 horsepower from a turbocharged, five-cylinder engine mated to a seven-speed, dual-clutch automatic transmission with paddle shifters. On paper, its performance is every bit as impressive as this platform would lead you to expect: 0 to 62 mph in 3.7 seconds in real-world tests (faster than Audi claims). I was a little worried this test run might ruin the experience of driving an old Volkswagen, however radically modified.

I showed up at the dealership on a motorcycle, because any of the decrepit cars I own would have brought my "prospective buyer" grift to an immediate halt. The salesman took my driver's license because, he said, he needed to make a copy of it first. He was gone for a while, and it occurred to me that he was probably running a background check as well, and pulling up my DMV records. But apparently not, as he came back and we proceeded to get into the car. It's nice to be white!

I eased out of the parking lot; we navigated through some suburban streets and then onto an expressway. There were a few

on-ramps in the course of the drive, and traffic was light enough for some spirited maneuvers. But I could not connect with the car. I had it in the most aggressive of its driving modes (these determine the throttle map, shift responses, and suspension settings), but it still felt like there was a layer of decision-making happening somewhere else. The paddle shifters felt like what they in fact are: mere logic gates. I'm sure living with the car for an extended period would have allowed me to develop more feel for it, more connection, but my first impression was that it seemed to have its own priorities. It took my shift commands as a general statement of mood, a request to be given due consideration when the committee next convenes. The car never spoke rudely to me of being wrong, as when I nearly rolled my 1963 Beetle. It was more like "Your opinion is important to us." I must have been doing something wrong (maybe lifting off the throttle on upshifts, as one does with a manual transmission?), but was left to speculate what this might be. On downshifts, the computer auto-blipped the throttle to match rpms. I rather like doing that myself, with the heel of my foot. These auto-blips arrived at a moment that might have seemed good to management, but had no connection to my intended moment of turn-in on a corner. I was left with nothing to do, like a cubicle worker who grasps one day that his job has become outsourceable. And despite the Audi's prodigious torque, there was nothing raw or violent in its delivery. The car left me cold.

Is there something wrong with me? The RS3 is said to be one of the most exciting sport sedans you can buy these days. To me it demonstrated just how entrenched is the design ethic according to which mechanical realities must pass through electronic filters before they reach the driver. What lies behind this imperative? And how might it affect the acquisition of skill?

Consider the process of learning to play ice hockey, in which you use a stick both to act upon the puck and to perceive the current state of the puck (whether it is sliding or rolling, for example). For an expert player, the stick becomes like a prosthetic limb; it is integrated into his bodily awareness in the same way that an amputee comes to experience his artificial limb as an unobtrusive conduit of his actions and perceptions. There is a growing body of literature that support this idea of "cognitive extension." The new skills that we add to our repertoire when we learn to use tools and prosthetics become indistinguishable from those of the natural human body, in terms of how they are treated by the brain that organizes our actions and perceptions. The crucial fact that makes this integration possible is that there is a closed loop between action and perception: what you perceive is determined by what you do, just as it is when we make use of our own hands. Or a 1963 Volkswagen.

An expert hockey player's attention isn't directed to his stick, it is directed *through* his stick to the puck, just as a piano player's attention is directed not to his fingers, nor even to the instrument's keys, but to the notes he is playing. A real "driver's car" is one that accomplishes a similar disappearing act, becoming a transparent two-way conduit of information and intention. But there is a tension between this ideal and the trend to introduce ever more layers of electronic mediation between driver and road. This will not come as news to any driving enthusiast, but the reasons for it are worth parsing in detail if we want to clarify the challenges ahead in automotive design.

We now have throttle by wire, brake by wire, and electrical assist (versus hydraulic assist) steering, as well as traction control, stability control, and antilock brakes that modulate our driving inputs for us. Often what this amounts to is a genuine poverty of information reaching the driver, and a filter between intention and execution. What's more, an overzealous damping out of mechanical "transients" has made it necessary for the car to keep us informed by other means, rather than by the seat of the pants.

When I had my first child I also bought my first new car, a Scion xB. I used to wonder why sometimes it would beep at me when I went around a corner. It was completely mysterious. Was there a loose connection in my seat belt reminder? Only after several years did I realize it was the stability control, alerting me to its intervention. I figured this out finally because there was a tiny bit of text ("STABILITY") that would appear on the dashboard-not a place I normally look while cornering. Nor was I usually aware that I had broken traction. Direct transmission of information about the state of the car in relation to the road is diminished, and to compensate for this it is represented with symbols—a word and a chime. One problem with this approach is that such information is then sharing "cognitive channels" with information from other electronic devices.¹ Some of these may command greater interest-for example, a chime announcing the arrival of a text. In any case, the car beeps at me so gratuitously (if I open the door with the key in the ignition, or the headlights on; if I pull away from the curb before buckling my seat belt) that I simply tune out its nagging.

Car makers have attenuated the natural bonds between action and perception, interposing a layer of representations. The problem with a word or a chime is that of arbitrariness. There is no necessary, inherent connection between the symbol and what it means. The driver has to do some work of inference and interpretation to attach meaning to it. Inference is a slow, cognitively costly activity. It is the basis for our higher intellectual capacities, but if our basic motor functions of negotiating our way through the world are made to depend on it, the result is a lack of fluency. This is acceptable in an environment such as an airplane cockpit, where things happen slowly and smoothly. But driving a car in the uncontrolled environment of the street, with its sudden, unexpected contingencies, is done best if we are able to rely instead on the "fast, frugal" pathways of embodied cognition. Interestingly, the new wave of robotics research that began in the early 1990s has taken the learning process of toddlers as its inspiration, and seeks to exploit sources of order that are already available in the relation between the body (or robot) and its environment. The point is to learn by acting rather than trying to *model* the environment in advance with representations. As Rodney A. Brooks put it in a classic 1991 article, "the world is its own best model."²

This could be taken as the motto for a new direction in automotive design. To do so would be to accept the existence of two very separate classes of automobiles with different design criteria: driverless cars and driver's cars. The growing success of selfdriving cars is due to an exhaustive (and truly impressive) effort to model the complex, dynamic environment of an urban street. It is an achievement made possible by the staggering amount of processing power that has been brought to bear on the problem (and the creativity of engineers). But human drivers can also be very impressive—when they are equipped with straightforward tools that preserve the bonds between action and perception. What we have currently is a dysfunctional hybrid of human control that makes little use of the exquisite connections between mind and body, plus a crude interface of symbols.

Of course, the disconnection of today's driver is also exacerbated by the growing mass of automobiles.³ The wealth of unfiltered, fuzzy information presented by a harder-edged, lighter car elicits involvement; you have the palpable sense that it is your *body* that is going sixty miles an hour. Such existential involvement demands and energizes attention. This is why driving a light, primitive sports car is so exhilarating. Going forward, the design principle that could help us mitigate distracted driving, and recover the joy of driving, would be one that exploits the sensorimotor capacities we have developed through human evolution.

The fetish of automaticity and disconnection that has seeped

into cars over the last two decades cannot be called a tendency of "technology" if we insist that the standards of technology are simply those of function. Something else is going on. If we can understand what it is, we will be better able to critically assess recent automotive design and gain some independence from it. This is a task not for cognitive science but for cultural criticism.

In the affluent West, many of our energies of innovation seem to be channeled into *creating experiences* for the consumer that will make him feel good without making demands on him. This trend has been called "affective capitalism." Examples include computer gaming, pornography, psychoactive drugs, or a well-curated ecotourism adventure. Manufactured experiences are offered as a substitute for direct confrontation with the world, and this evidently has some appeal for us. We are relieved of the burden of grappling with real things—that is, things that resist our will, and thereby reveal our limited understanding and skill. Experiences that have been designed around us offer escape from the frustrations of dealing with other people and with material reality. They allow us to remain cocooned in a fantasy of competence and empowerment that is safe from the kind of refutation that routinely happens when you . . . ride a skateboard, for example.

In 2016, I was contacted by a public relations firm, acting as an intermediary for Porsche. The automaker wanted me to write an essay to include in their annual report. It struck me as an unusual request; apparently Porsche has taken to commissioning essays from independent writers to accompany the dry financials and corporate messaging. From me they wanted something philosophical, and emphasized the freedom I would be accorded. I took it as an interesting assignment.

I brushed up on the direction Porsche was currently taking, and I learned that they were making a big investment in autonomous car technology, which surprised me given their niche and their legacy. I came across a public statement from the CEO,

FEELING THE ROAD | 115

who asked us to imagine that in the Porsche of the near future. one could push a button and enjoy an exact reproduction of the throttle, steering and braking inputs of Michael Schumacher's best lap around the Nürburgring. (Schumacher was a dominant F1 driver.) I criticized this vision in my essay, making many of the same points I make in this chapter. In such a vision, the performance car becomes, essentially, an amusement park ride. But a very expensive one. A car that seeks to "create an experience" for us would compete for our fickle entertainment dollars with much cheaper diversions, including virtual ones. This struck me as a bad business strategy at a time when consumers, especially younger ones, are rediscovering the pleasures of "analog" and all things tactile, and I said as much.⁴ The PR firm told me that my essay was not acceptable. They also told me that it had set off a quarrel within the top ranks of Porsche, with one camp rallying to the essay and another rejecting it.5

The pleasure of driving is the pleasure of *doing* something; of being actively and skillfully engaged with a reality that pushes back against us. Only then do we feel the progress of our own mastery. In skilled activities, we sometimes recover the joy of childhood play, that period in life when we were discovering new powers in our own bodies. We may also regress to teenaged hooliganism and the unique pleasure that comes from enlarging those bodily powers through a mechanical extension of ourselves.

AUTOMATION AS MORAL REEDUCATION

What happens when an autonomous car cannot avoid colliding with another car, or with pedestrians, or a dog, and it must make a decision whom to hit? What sort of moral priorities shall the computers be programmed with? Anyone who took an undergraduate philosophy class in the last twenty years is likely to have encountered the "trolley problem," a classic thought experiment that goes like this. Suppose a trolley is headed on a collision course with a group of pedestrians. But you, as an alert bystander, can pull a lever to switch the track to a different course. The problem is, there is an innocent on this new track as well. But only one. Do you intervene to save the greater number, killing the lesser? Or perhaps the first trajectory would have the trolley mowing down a woman pushing a baby stroller, while the second would have it kill an elderly homeless person. (One can spin out endless permutations along such lines.) Does this alter your moral intuition? Such exercises belong to an intellectual style called "analytical moral philosophy." At its most systematic, it seeks to boil our moral intuitions down to nuggets that can be expressed with simplicity and precision. On one side, you have inputs consisting of empirical facts, on the other side you have outputs consisting of some new state of affairs in the world, and in the middle you have a person who applies *principles*. These principles need to be likewise precise, capable of clear articulation, and universally applicable.

One appeal of the trolley problem, then, is that it lends itself to a kind of moral calculus that resembles the input-output logic of a computer. The most widely adopted moral operating system, if you will, is utilitarianism, the motto of which is "the greatest good for the greatest number." Another appeal of the trolley problem is that one can ask people to imagine themselves in such a scenario, vary the specifications of the scenario, and see how they respond, thereby gathering social data. In this variant, the hope is that morality will finally become an empirical science. In both its idealist and empirical versions, this is a way of thinking about ethics that has a long pedigree, and has been subject to critique (perhaps most witheringly by Nietzsche, in his treatment of "the English moralists") for nearly as long, but has lately taken on a new life for reasons that should be obvious.¹ It offers a certain intellectual tractability that makes it seem a good fit with machine logic.²

And sure enough, when talk turns to the ethical dilemmas posed by driverless cars, the industry and its adjuncts in academia and journalism quickly settle into the trolley problem, that reassuringly self-contained conundrum of utilitarian ethics, and proceed to debate the "death algorithm." (Mercedes-Benz was the first automaker to come out and declare that its cars would be programmed to prioritize the lives of the car's occupants.) This way of thinking about ethics seems to permit the transfer of a moral burden to a machine. Or indeed, such transfer is *demanded* by the inevitable progress of automation. "We do not have the luxury of giving up on creating moral machines" say the authors of "The Moral Machine Experiment" in the journal *Nature*, citing works with titles such as "Standardizing Ethical Design for Artificial Intelligence and Autonomous Systems."³

This nicely jibes with the moral urgency of safetyism. To question either the inevitability or the wisdom of the trajectory that has been outlined is to mark oneself as a partisan of death: bad career move. But let us consider more closely the classic thought experiment that provides the analytical framework for "machine ethics."

One of the findings of those who query people with the trolley problem, as a way of probing their moral intuitions, is that if you are told that instead of just flipping a switch to kill the one person and save five others, you instead have to go and fight a fat guy, and maneuver him into position to throw him off a bridge (so his body will stop the train), people respond very differently: "Whoa, wait a minute!"The same calculus would seem to hold, for a consistent utilitarian, but the death-count-minimizing intuition summoned by the thought experiment is severely interrupted by the less sanitized scenario. We might conclude that what the thought experiment reveals is the artificiality of the sanitized version, in which choices appear like a menu of options made available to us without putting moral skin in the game.

But also, the more involving version of the experiment teaches us something substantive about the effect of abstraction (flipping a switch or pushing a button to make something happen). Such abstraction makes us stand apart from our deeds and inhabit the world a bit differently. Something like this is surely an issue for military drone operators who deal death from behind a video game–like console located far from the scene of assassination; there is now a literature on the "moral injury" they endure, with symptoms very like those of posttraumatic stress disorder. As one researcher put it, "Moral injury is more associated with an existential crisis, stemming from the violation of values pertaining to the sanctity of life, than with trauma."⁴

I think the case of drone operators is instructive, but note also that to be a passenger in a driverless car that accidentally kills someone is very different; it wouldn't make sense to view such an event as a "violation of values." In fact, it's hard to see how the conscience would be engaged at all. The passenger hasn't made a decision and then delegated its execution via a button; he hasn't *done* anything. And that is the interesting thing, this absenting of the human person from the frame.

One wonders about the societal effect of delegation at scale, or rather mass absenteeism, through widespread automation and its attendant outsourcing of human agency. What will it mean to stand at one remove from one's own doings, not episodically, but as a basic feature of living in a world that has been altered in this way? Can one even speak of "doing"? Such a change would seem to compromise our ability to form moral intuitions that are not based on evasive abstractions.

In one of his classic arguments, Bernard Williams highlighted the fact that what I am calling "absenteeism" was baked into the theory of utilitarianism from the beginning, two hundred years ago. A glance at this history will equip us to see our current move to create "moral machines" in a longer train of intellectual filiation.

The basic issue Williams picked out is that since utilitarianism is concerned only with outcomes or consequences, it doesn't really distinguish between my agency and someone else's. More than that, it insists that the agent himself view his own action from the perspective of the universal, and be indifferent to how it impinges on him uniquely. He is turned into a mere channel who stands between inputs from the world and outcomes, to be judged by the metric of "the greatest good for the greatest number." But how is that to be determined? It would seem to require some superintelligence with a God's-eye view of the universe who knows what is good for each person, and is able to somehow reconcile these competing goods according to an impartial arithmetic. The individual agent must simply defer to this. But how do we learn the result of the computation? Are there clerks who maintain a table of sums in real time, and serve as priestly intermediaries? To insist that the individual just step out of the way, as the evaluator of his own action, is absurd, Williams writes. "It is to alienate him in a real sense from his actions and the source of his action in his own convictions. . . . It is thus, in the most literal sense, an attack on his integrity." The most basic problem is that, as Sophie-Grace Chappell puts it in her essay on Williams, "There is no such thing as impartial agency, in the sense of impartiality that utilitarianism requires."5

This confusion about impartiality can result in real mischief when utilitarians are put in charge. Those who aspire to direct human affairs invariably believe themselves to have solved the Universal Calculation, and seek to make it effective in the world by morally disqualifying the various perspectives and projects of individuals that may be rival to the Impartial Point of View. Today, we are to understand that getting human beings to stop driving their own cars is not the project of those particular people who stand to make a lot of money from such a transformation, it is a project demanded by Morality Itself.

I don't mean to say that utilitarian ethics is a deliberate smokescreen for moneyed interests. That's not how ideology usually works. Rather, the easy plausibility that utilitarianism enjoys among us—especially in the Anglophone world, where rival moral traditions are largely moribund—creates a condition where the interested self-deceptions of messianic techies become the basis for our own collective confusion, and hence complacency. As we will explore in the chapters "Managing Traffic: Three RivalVersions of Rationality" and "Road Rage, Other Minds, and the Traffic Community," our ability to share the road together smoothly and safely is based on our capacity for mutual prediction. This is a form of intelligence that is socially realized, and depends on the existence of robust social norms that can anchor sound expectations of others' behavior. Automation may become attractive, then, as a response to declining social cohesion: it is an attempt to replace trust and cooperation with machine-generated certainty. As we learned in the previous chapter on idiot-proofing as a design principle, this is an approach that is likely to cause the further atrophy of our skills. Among these are the skills of collective self-government, rooted in shared habits of cooperation. A science of behavior management becomes necessary.

PROMETHEAN SHAME OR SPIRITEDNESS?

Departing from the trolley problem and its antecedents in utilitarian ethics, let us consider an entirely different way of thinking about human agency, and then see how it may illuminate automation from a different angle.

In ancient Greek, one doesn't speak of "morality" as an external demand laid upon us (and therefore always difficult to know, requiring guidance from priests), but of "virtues" in the plural, meaning particular excellences that are manifested in action. Here the ethical and practical are inseparable, and remain close to experience.

In the Aristotelian perspective as elaborated by William Hasselberger, virtue doesn't consist of a collection of true propositions that can be combined with circumstantial detail and entered into a moral calculus, to be solved by the application of universal principles, yielding an output consisting of the right action (as in the trolley problem).⁶ Virtue is more like a skill, acquired through long practice in the art of living. It consists of having the discernment to read situations well, and being habituated into a pattern of responding to them appropriately. There is no set of rules that could guide one adequately. Further, there isn't some separate faculty of moral reasoning that we call on, to be applied in discreet episodes of moral choice. Rather, we become *a certain kind of person*; our ethical dispositions develop continuously in concert with the way we perceive the world, and with tacit knowledge that we acquire but are unable to articulate. We know more than we can say, and "doing the right thing" (or not) becomes habitual, rather than something one has to deliberate about in each instance (or outsource to an expert). Often our response to a situation is already latent in the way we perceive the situation.

As embodied practical skills, the virtues have to be exercised or they atrophy. The point of this digression is not to complain that autonomous cars will lack Aristotelian virtue, but rather to consider their effect on *us*, in combination with all the other ways we are ceding responsibility to "intelligent" machines. As the space for intelligent human action gets colonized by machines, our intelligence erodes, leading to demands for further automation. By intelligence I mean bodily skills, cognitive skills, and ethical skills, for they are bound up together. Ultimately, it is *we* who are being automated, in the sense that we are vacated of that existential involvement that distinguishes human action from mere dumb events. An event is something nobody is responsible for.

Is there any useful upshot to this picture of ethical qualities being wrapped up with practical judgment and technical skills? I believe it can help us understand the peculiar challenges of partially automated driving. As we have seen, they are largely the same challenges as those revealed in recent plane crashes where "over-reliance on automation and lack of systems understanding by the pilots" were major contributing factors, according to the National Transportation Safety Board. Pilots sometimes have a "faulty mental model of the plane's automation logic."⁷ The point I want to investigate is how the opacity of the automation logic both encourages and requires a certain disposition of character in the operator, which we might call spiritlessness. Yet sometimes, *spiritedness* is the very quality you want in an emergency; a readiness to take charge.

Because highly automated cars are just beginning to appear on the road, we don't yet have a substantial or sophisticated body of crash analyses. But we do for airplanes. The most spectacular recent crashes involving highly automated airplanes have been suffered by airlines that, in their training of pilots, emphasize a more thorough deference to the plane's automated systems.⁸ In the developing world in particular, pilots typically have far fewer hours of manual flight time logged in their training, and they are encouraged to use the automation routinely.⁹ Pilots in such a regime don't develop as surely the reflexes and the mechanical intuitions that come from manually flying a particular model of aircraft and developing a feel for it, including a feel for when something is starting to go badly wrong.

Keeping these skills sharp is a problem for all pilots in the highly automated cockpit. As we saw in the chapter on idiotproofing, this is a major area of study in human factors research. But there is a subtler problem of ethical disposition, related to the atrophy of skills: it takes a certain amount of *assertiveness* to override automated systems, as the presumption is always in their favor. This is possible only if one has *confidence*—not only in one's skills, but in one's understanding of what is going on, and how to fix it. With such confidence, one does not develop a *habit of deference*, but the opposite. These character dispositions of pilots are formed through long bodily practice and cognitive formation.

Of course, confidence and assertiveness are desirable only if the pilot (or driver) really does have an adequate grasp of the situation-a better grasp than the automation does. In October 2018, a Boeing 737 MAX 8 crashed in Indonesia, and then another plane of the same model crashed in Ethiopia in March 2019. As it happens, the 737 is one of those legacy designs that has been kept viable through iteration, as new systems get retrofitted to an airframe that never anticipated their necessity. In particular, it has been fitted with newer engines that are more fuel efficient, to keep the plane competitive. But these engines hanging off the wings are much larger than those the plane was designed with originally. The plane in its current version, the MAX 8, is inherently unstable, aerodynamically. The problem was addressed by Boeing with a software fix: the rate at which the autopilot is authorized to push the nose of the plane down (to combat a stall situation) is four times greater than it was previously. Boeing did not inform its customers (the airlines) about important changes to the plane's automated systems. Internal documents revealed that they chose not to because, if informed, the airlines would have to retrain their pilots, including time spent on a simulator to get them used to the plane's behavior. This is a significant cost, which would make the plane less attractive to the airlines.¹⁰

Imagine the situation as the plane behaves in an unexpected manner, the pilot realizes he has an emergency on his hands, and fights the system for control. At this point, he is not feeling deference. He is engaged in an intense mental effort to diagnose the situation. Maybe he also suffers panic, which makes thinking difficult. He oscillates between a determination to seize control back from the automation, and second-guessing himself. Maybe the computer knows best? In the case of the 737 MAX, this second-guessing was in fact appropriate, because pilots were underinformed—and for reasons that in retrospect are not surprising, given the business logic of selling airplanes. (The deployment of driverless cars on public roads has in some cases revealed a similarly cavalier attitude about public safety, likely due to the imperative of being "first to market."¹¹) How much trust does the pilot place in things beyond his own comprehension? The greater the complexity of the plane's control systems, the more such trust is an element of his everyday flying. As a subjective matter of psychology, it is likely this trust gets converted into confidence (perhaps false confidence) when everything works smoothly almost all of the time. The pilot feels in command, but the limits of his command are not where he believes them to be, so when the crisis occurs it is disorienting.

A spirited readiness to take charge may well be maladaptive. To a committee designing an automated system, such a disposition in the operator—a confident human *individual*—may appear as a bug in the system. So there is a kind of character formation of the operator that needs to be accomplished, a reorientation that emphasizes the limits of his own capacities.

And in fact, such an orientation is already half accomplished for anyone who inhabits today's material culture. You never attribute infallibility to a machine you have made yourself, or a machine you are intimately involved with through maintenance and repair. But if the machine was designed and built in a vast collaborative effort, and is beyond the capacity of any individual to fully understand, and works flawlessly 99 percent of the time, we adopt a very different posture toward it. We are not just daunted by the obscure logic of such machines, but seem to feel ourselves responsible *to* them, afraid of being wrong in their presence, and therefore reluctant to challenge them even as the computer-plane flies itself into the ground or the GPS directs us to drive into a lake.

Systems designed to minimize the role of human intelligence tend to be brittle, as they are not able to anticipate every contingency. When they fail, their failures tend to be systemic, in proportion to the comprehensive reach of their control. Essentially, we are asked to place complete faith in a *committee*—at Boeing, at Airbus, and soon at Tesla and Waymo—that it was able to grasp every pertinent consideration in designing the system (and did so with engineering integrity uncorrupted by countervailing business considerations). On this design side of the equation there is certainly some hubris. But for the user of the system, the pilot or driver, a very different mentality is encouraged, nearly the opposite of hubris.

Günther Anders can help us understand our deference to machines, as a disposition. A refugee from Nazi Germany (and the first husband of Hannah Arendt), Anders settled in California during the war and worked a number of odd jobs as a laborer. He wrote an essay titled "On Promethean Shame." The phrase is arresting, since we are used to hearing about Promethean pride; the whole point of the Prometheus myth is to warn us about hubris. He begins his essay with a diary entry from California in 1942, in which he relates going to an exhibition of new technology with his friend "T." Anders became more interested in watching his friend than in the displays of new appliances. "As soon as one of the highly complicated pieces started to work, he lowered his eves and fell silent. Even more strikingly, he concealed his hands behind his back, as if he were ashamed to have brought these heavy, graceless and obsolete instruments into the company of machines working with such accuracy and refinement."12

Two days later, Anders makes another diary entry reflecting on what he saw. "Promethean defiance is the refusal to owe anything, including oneself, to anyone else. Promethean pride consists of seeing everything, including oneself, as one's own achievement. Some vestiges of this stance so typical of the self-made man of the nineteenth century are certainly still alive today. But I doubt they are still characteristic of us."¹³

In discussing these matters with his fellow émigré intellectuals in southern California before writing the essay (the company included Bertolt Brecht and Herbert Marcuse), Anders noted, "The artificiality of human beings increases in the course of history, because humans become the product of their own products. . . . A discrepancy, a widening gulf opens between the human and its products, because human beings can no longer live up to the demands that their own products place on them."¹⁴

These demands may be out of proportion to our natural powers, or different in kind. They often call on that narrow sliver of our competence that is based on language: for a pilot, perhaps reading a manual that describes various autothrottle modes. It doesn't stick in the body. The demands are at once circumscribed in this way, intensified, and somewhat cross-grained to our original, animal genius for learning about the world by acting directly on it. In response, we may become dispirited in the way an animal does when it is removed from its accustomed habitat, the one that calls forth its full repertoire of excellences.

In this dispirited state, we do in fact become incompetent. The end point of this trajectory is clear enough: the world becomes a techno-zoo for defeated people, like the glassy-eyed creatures in WALL-E, or like the lab rats who are raised in Plexiglas enclosures.

In the following chapter, we will consider a different way of living with machines.

FOLK ENGINEERING

The next few chapters deal with the ironmongery, and in these I have gone into rather more detail, for it is upon detail that the success or failure of the hardware depends.

-SIR HARRY RICARDO

Before we lose patience we would do well to recall the words of Marshal de Saxe: "Although those who concern themselves with details are regarded as folk of limited intelligence, it seems to me that this part is essential, because it is the foundation. . . . It is not enough to have a liking for architecture. One must also know stone-cutting."

-MICHEL FOUCAULT

When a red '75 Beetle started showing up in the parking lot of a building I frequent, and it emerged that Carl was looking to unload the car, my middle-aged life of automotive self-denial was put to the test, and immediately crumbled. He let me sit in the driver's seat, and it was like coming home. The cockpit of these cars is contained and intimate. Everything is within easy, natural reach. Merely resting my hands on the steering wheel and shifter, my feet on the pedals, summoned some dormant mechanical habits long forgotten by my conscious mind, but stored somehow in my body. With memories of downshifting into a slide, that body now said, "Oh. Yes." There is a distinctive smell to the interior made of cheap German vinyl. Or maybe what I smelled is the horsehair that is stuffed above the headliner, and in the ancient seats amidst the talkative springs. It is not a stretch to say that there is an organic, indeed horsey quality to old cars. A car from 1975 is a product of the industrial economy at its zenith, yet you can imagine (however accurately) the homely provenance of the car's materials, and the processes by which it was made. Because it is accessible to your imagination in this way, you may find that you want to *do stuff to it*. That is, you may be tempted to become a folk engineer.

If you're like me and get all worked up about the possibilities, prematurely, you might make a bad mistake. For example, you might neglect to pull the carpet up from your prospective purchase and look for rust.

As I write this, it is eight years since I bought the car, and all that remains of the original is the central spine, the rear torsion housing, and the upper portion of the body shell. The rest was iron oxide powder held in the shape of a Volkswagen merely by habit, aided by carpet mastic. In the time I have invested during this interval, a person of more cultivated tastes could have learned Chinese, or made good progress toward mastering the violin.

Why devote myself to such a project? I may be the wrong person to answer that question—obsession isn't very conducive to self-knowledge. But in the preceding chapters, I hope I have shown why one might look to an earlier stage of the automobile's development to try to reclaim the excitement of driving.

The fetish of automaticity and disconnection looks to me like a cultural spiral into Promethean shame: the very opposite of the mentality of mastery that we usually associate with technology. By way of contrast, and paradoxically, the Bug I am building will be an emphatically "modern" car, in that good old-fashioned sense of modern. In fact, I am giving it state-of-the-art digital engine management, using the do-it-yourself platform MegaSquirt. I think a fully free relationship to technology would be one that neither shuns it as alienating magic nor accepts uncritically the agenda that is sealed inside the black box. The design principles I am adopting in building the Bug are straightforward: lightness, rigidity, and directness of control. And, of course, horsepower—plenty of it. The result I am hoping for is a driving experience of suppleness and finesse, in which the car comes to feel like a well-fit prosthetic.

Such, at any rate, is my fantasy. For the first five years the project went entirely backward, and this for one reason: rust. Rust is the opposite of fantasy. As I disassembled the car, I kept finding more rust in the hidden hollows, leading me to cut out more sections of sheet metal to fully expose the rot to view. I quite literally cut the car into little pieces. While my fantasy life was taking place on the internet forums devoted to building something new and bitchin', my actual life in the shop spiraled into an ever more intimate involvement with corrosion.

From 2011 through 2017, I would lie awake at night visualizing the capillary creep of moisture into seams where two panels of sheet metal overlap, and it would give me an itchy feeling. The insidious genius of corrosion is that the more you know of its creeping ways, the more it colonizes your mind with schemes for defeating it. *Corruption must be rooted out*. I never wanted to become an amateur chemist, but it cannot be helped when you are trying to disentangle the various claims made for rust inhibitor, rust dissolver, rust encapsulator, rust converter, and all the wishful thinking that such terms convey.¹ Fatalism is the only truly rational response to the oxidative process; anyone who has spent years restoring an old car has failed to hear the words of the apostle who said, "Lay not up for yourselves treasures upon earth, where moth and rust doth corrupt."

Such wisdom is easier to state than to heed. In a burst of hope and inspiration I attached a skinny hose to a long stick for shooting epoxy coatings deep into heater channels that I had spent weeks rebuilding. I found copper-heavy primers that can withstand the heat of welding, to use in places that will be inaccessible to full corrosion treatment once I have welded a panel into place. I rigged up a siphon that allows me to use a pressure washer as a media blaster; imagine a jet of water at 3,000 psi *that is full of crushed glass*. I use it to remove the accumulated layers of road grime, undercoating, paint, primer, body filler, seam sealer, and—there it is!—rust. The irony is that most of this crap was deposited by previous owners in a vain effort to prevent rust, and now it stands in the way of *my* effort to seek and destroy the cancer. In Greek, "truth" is *aletheia*, that which is uncovered. A lust for *seeing* bare metal takes over; one wants to dispel all the sediments of confusion that have been laid down by others who didn't do their homework (obviously). Getting to the bottom of things, a tabula rasa that will lie fully exposed to my inspection and my will: restoring an old car becomes a metaphysical obsession that defies any honest cost-benefit analysis.

My wife is fond of reminding me of the concept of "sunk costs." It is meant to be a liberating idea: sometimes it makes sense to just walk away from something that you are invested in. You have sat through an hour of a bad movie, but there is no point in remaining till the end (though you feel like you *should*, because of your investment). In a purely theoretical mood, without reference to any particular eyesore in the driveway, she'll muse aloud that sometimes one has to step back and look at a project with the fresh eyes of someone who is noncommittal. Because she is so rational, she has no concept of being *loyal* to a heap of rusted metal.

INTERNAL COMBUSTION: THE ULTIMATE WIKI

The internal combustion engine is a miracle. The basic idea is simple enough: a piston moves down through a cylinder, increasing the unoccupied volume and thereby creating a vacuum. This vacuum draws a mixture of air and atomized fuel into the cylinder through an open hole. Then the hole is sealed up and the piston reverses course, moving up and compressing the air-fuel mixture into a much smaller volume (that is the combustion chamber. about one-tenth as large as the cylinder). Shortly before the moment of maximum compression, a spark is introduced. If all goes well, what ensues is a slow-motion explosion (gasoline has more energy per unit of mass than TNT), a pressure wave that is just shy of moving fast enough to count as "detonation." This forces the piston back down. Because the piston is connected to a crankshaft, its reciprocating motion in a straight line is converted into a rotary motion (imagine the wheel of an old locomotive being driven by a shaft attached near the wheel's circumference). The explosive energy that forced the piston down has been transformed into torque: the ability to exert force in a circular motion. Some of that energy is used to turn the wheels of the car and some is stored in a flywheel, attached to the end of the crankshaft, and that energy is going to be used now. The piston at this point is lifeless, having spent its energy. But the flywheel returns the favor, and the momentum of the rotating assembly carries the piston back up to the top. For this upward stroke, we're going to open a different hole at the top of the cylinder, to allow the burnt air-fuel mixture to escape. That's exhaust. Then that hole closes and the first hole opens again, and we're ready to repeat the whole process. These are the four cycles of a "four-stroke" engine: intake, compression, power, exhaust. In the course of the four cycles, the crankshaft has made two complete rotations and the piston has gone down, up, down, up.

The more you know of the details of its operation, and how many things must go exactly right for it to do what it does, the more preposterous it seems that such a thing should be possible, much less that an individual motor might do this unobtrusively for two hundred thousand miles with little maintenance or complaint. By my rough calculation, this adds up to something in the neighborhood of one billion revolutions over the lifetime of a motor.² For a six cylinder, four-stroke engine, that's three billion little explosions. For a person whose primary acquaintance is with things digital, this may be an abstraction—a mere string of nine zeroes, no more impressive than the zeroes that make up a gigabyte. But the reciprocating, rotating, flexing, abrading, burning, pounding components of an engine do this while inhaling dusty air, getting cooked out on the highway. What is more, all of these components are fully inspectable things that you can hold in your hand, draw a picture of, nick with a file, or chuck across the room in a fit. They have heft and shape. The whole ensemble operates without summoning inscrutable entities that are said to live in the Cloud. The homey, nonmagical *thingness* of a motor invites the basic human drive to understand; I can think of no more effective ally of enlightenment.

The development of the internal combustion engine offers a singular story of engineering progress. It has been an object of mathematical science since its inception, but it has likewise been the beneficiary of perhaps the most sustained and widely dispersed project of practical experimentation in human history, the ultimate wiki.³ Today's state of the art is the result of more than a century of back-and-forth between trained engineers and shade tree mechanics, illicit street racers and environmental regulators, high-dollar motor sports and cost-oriented automakers.

IN 1885, HARRY RICARDO was born in London to an architect father and a mother from an aristocratic family (his family name is of Portuguese origin, from the Sephardic Jews on his father's side). In 1898 his grandfather purchased an automobile, and we can suppose that young Harry was one of the first people in England to see one. He attended the elite Rugby School and began building engines at the age of ten. After his first year at Cambridge University he entered a competition put on by the University Automobile Club, which he won by designing and building the machine that could travel the farthest on one imperial quart of petrol. Ricardo built a single-cylinder motorcycle that went forty miles, which would give it a fuel economy of 133 miles per U.S. gallon. In 1904. One wonders what Ricardo's fellow toffs made of the ungentlemanly odors that must have emanated from the very pores of one so deeply immersed in engine work.

One of the most consequential engine developments of the twenty-first century is the use of "direct injection" to accomplish a stratified air-fuel charge, meaning that the ratio of air to atomized fuel is not homogeneous throughout the volume of intake charge admitted to the combustion chamber. A small area of richer mixture is ignited first by the spark, creating a fast-moving flame front that in turn ignites a much leaner mixture that fills the larger volume of the chamber. The result is better fuel economy, and greater thermal efficiency. While still a teenager, Ricardo built an engine that utilized this concept, a full century before its wide commercialization.

After university he set up shop, and during the First World War he took on the challenge of developing an engine for tanks that would emit less smoke. The smoke was a serious problem, because it would give away a tank's position. His first attempt, a six-cylinder engine, solved the smoke problem. He also increased power output from 105 horsepower to 150, climbing to 260 HP in later iterations over the course of the war. During the Second World War he turned to aircraft engines, with similarly spectacular results. Elected a Fellow of the Royal Society for his wartime accomplishments, he would enter the peerage as Knight Commander of the Most Excellent Order of the British Empire. I wonder if Sir Harry still smelled of carb cleaner as he kneeled before the queen, to be touched upon the shoulders with the ancient sword.

Ricardo's magisterial work, *The High-Speed Internal-Combustion* Engine, was first published in 1923 and rewritten in 1953. It opens with an interesting observation about the role of chance in the process by which certain designs beat out others.

When we review the progress of mechanical engineering in the past we find that each new line of development starts with a period of experiment and groping, during which a wide range of types is evolved. By a process of elimination this range is very soon whittled down to one or two survivors; in the final choice of these survivors, chance plays often quite as important a part as merit. We are too fond of crediting a few particular individuals with a monopoly of inventive genius. Ripe seeds of invention everywhere abound, and it awaits only a certain combination of need, of circumstance and, above all, perhaps, of chance, to decide which shall germinate.

On the one or two survivors, not necessarily the best, the attention of the whole engineering world is then concentrated, with the result that step by step they are improved out of all recognition and reign supreme, until they reach almost the very limit of their capacity, when new and fundamentally better types eventually replace them.⁴

What Ricardo didn't anticipate is that some people would never get the memo about the obsolescence of some earlier engine architecture, and keep pushing forward with it. When I was in high school in the early 1980s, Top Fuel dragsters were making 3,000 horsepower. Nobody could have imagined that early in the twenty-first century, the same 500 cubic-inch, two-valve-percylinder, push-rod V8, based on a 1950 Chrysler design, would be making 10,000 horsepower. That's greater by a *factor of fiftyfive* over the first iteration from the Chrysler Corporation which made 180 horsepower, considered a demonic figure at the time.

Human beings are often bullheaded in their attachment to something suboptimal. Call it loyalty, call it perversity, or call it a cultural inheritance, this conservatism has at times been responsible for amazing leaps forward, paradoxically enough. Ricardo's "ripe seeds of invention" that "everywhere abound" begin to germinate around some settled platform, "not necessarily the best," allowing a body of communal expertise to develop. The impatient optimizer may see such an inheritance as an obstacle, something to be swept away in the name of forward progress. But tradition can itself be an engine of progress. It organizes the transmission of knowledge. It also provides an idiom for some shared endeavor, and a set of historical benchmarks, such that one can imagine oneself outdoing particular human beings who came before, and who worked within the same basic limitations. Tradition thus provides a venue for rivalry in excellence, the kind that sometimes brings a whole community to new and unexpected places.

In this respect, I think it is fair to call hot-rodding an art form. I'm not referring to the candy-flake paint jobs, chopped roofs, and such officially "creative" stuff—I mean the engineering side of things. In art, the limitations imposed by one's materials are not *simply* limitations, they set the boundaries that give shape to an artist's imagination, structuring the possibilities she sees for invention. Further, the fixed qualities inherent in her medium connect her to the efforts of those who came before. If she is a sculptor, she cannot escape her awareness of what Michelangelo did with marble. She can pursue such escape—into the realm of ex nihilo freedom—but knows that in doing so she risks triviality.

I'll concede that I may be reaching a bit with this analogy to art. I am motivated by a felt need to justify, or at least understand, why I have spent a colossal amount of time and money building a high-performance, air-cooled Volkswagen engine when, for a fraction of the cost, I could have swapped a Subaru engine into my Bug and gotten comparable performance with greater reliability. There is a recipe for that swap; it has all been worked out. And I considered it. But I was afraid it would feel trivial, or that the project of building such a car wouldn't feel like *going further* on a storied trail of invention.

For the last thirty-five years (and especially the last ten) I have been working out in minute detail the mental construction of my ultimate VW motor. To say that I am invested in the form begs the question, why? Middle-aged nostalgia is surely playing a role. As I related in *Shop Class as Soulcraft*, a certain deeply countercultural VW mechanic had a formative influence on me as a teenager. But that's not the whole story, as I feel myself pulled into a history that reaches back before I was born, continues today as a vibrant and often heated quarrel on the VW forums, and inspires wonder at what might be possible in the future with these little magnesium-cased jewels. I am building this motor in two iterations. The first, normally aspirated, will make about 180 horsepower. The second, turbocharged and fuel injected, will make about 300.

THE PEOPLE'S CAR: A BIT OF HISTORY

In 1902, a young worker in the present-day Czech Republic, then part of the Austro-Hungarian empire, got drafted into the military. He had grown up working in the shop of his father, Anton Porsche, a master panel beater. (Panel beating is the art of putting compound curves in sheet metal by hand. It is how carriage and aircraft bodies were made in the early days and remains one of the crucial skills in making custom bodywork. Today we call it metal shaping.) Young Ferdinand Porsche landed a pretty good gig in the military, as chauffeur to Archduke Franz Ferdinand. You probably remember that name from a high school history lesson: he was the crown prince of Austria who got assassinated, a seemingly random spark that ignited the First World War.

By the time he got drafted, Ferdinand had left his father's

shop and been working in Vienna for a few years, first at an electrical manufacturer and then for the carriage maker Jakob Lohner & Company. After work, he would sometimes sneak into the local university and sit in on classes. Beyond this, and some night classes at his hometown technical school while still living at home, Ferdinand Porsche never received any higher education as an engineer. Yet at the close of the twentieth century he would be named Car Engineer of the Century by the Global Automotive Elections Foundation.

While at Lohner, Porsche worked on the first automobile the firm would make, unveiled in 1898. The twenty-two-year-old took the liberty of discreetly engraving "P1" on all the key components, standing for Porsche design number one. It was a bit of youthful audacity that looks justified in retrospect. His second design to be built by the firm was a hybrid, with electric hub motors and throttle by wire. The year was 1901.

Ferdinand Porsche would go on to put his talents in the service of the Third Reich and serve time in a French jail for his contribution to the German war effort. One reason the automotive history of this period is so fascinating is that its ugly political currents are inseparable from the genuinely *volksy* character of Volkswagen, the people's car.

The 1930s were a strange and terrible time in Germany, following the wholesale social breakdown of the Weimar years. The political passions then circulating are hard to disentangle from our present vantage, particularly the affinities that then appeared natural—on both sides of the Atlantic—between socialism and nationalism, two ideas that we now quarantine across a left-right divide. In the United States, Herbert Croly's "new nationalism" ideas were highly influential in conceiving the New Deal. In Germany, the party that came to dominate politics was called the National Socialist German Workers' Party—Nazis to you and me. The Nazis' relationship to socialism was basically fraudulent and opportunistic.⁵ But a worthwhile thought experiment in counterfactual history could begin by asking what the twentieth century might have looked like if the German labor movement of the 1920s hadn't gotten yoked to anti-Semitism, industrialized murder, and world conquest. What if the emerging amalgam of nationalism and socialism hadn't allowed itself to be co-opted, as it did, by a man so patently deranged? Such questions are not entirely idle for us today.

Imagine, if you will, a workers' leisure organization that brings libraries, affordable holidays, concerts, plays, and day trips to workers and their families. It would take families hiking, to the movies, to fitness clubs and sporting events. Imagine it has as one of its missions the mixing of different classes. For example, in sponsoring cruises it would allocate cabins based on a lottery, without reference to social status. This is not a utopian proposal of Bernie Sanders; it was actually accomplished by KdF, the leisure organization of the German Labor Front. KdF had more than seven thousand paid employees and 135,000 volunteers by 1939, and had sent about 25 million Germans on vacations. The initials stand for "Kraft durch Freude," which means "strength through joy."

At the Berlin Auto Show in 1933, the new chancellor (soon to be Führer) announced that Germany would build a car that is economical to purchase and to operate, and thereby "motorize the people." It would be called the KdF-Wagen: a reliable, nofrills family car. Jacko Werlin, a former Mercedes-Benz dealer, arranged for Hitler to meet with Ferdinand Porsche, who had recently hung out a shingle as an independent designer and automotive consultant, and had his own engineering firm in Stuttgart. By his own initiative, largely self-financed by borrowing against his life insurance, Porsche had already been working on prototypes that more or less fit the bill, with halting support from the firm Zündapp (soon to become famous for their motorcycles) and then NSU Motorenwerke. In this first meeting, "Hitler put forward demands that stunned Porsche: The car had to be able to cruise at 60 mph, fuel consumption was not to exceed 40 mpg, the engine was to be air-cooled, the body was to provide room for five people and the complete car was to be priced at less than 1,000 marks, retail."⁶ This seemed "utterly unrealistic" to Porsche. But that was not the response the Führer was looking for.

According to Edward Eves, writing in the VW Supplement to the May 1, 1969, issue of Autocar, "When Porsche showed his proposals for the power unit for the KdF-Wagen in 1936, established German manufacturers threw up their hands and said 'this aircraft engine' could never be made for the price. Any production engineer would say the same today."⁷ The air-cooled VW motor is commonly regarded as "simple," but outward appearances are a bit deceptive. It is a marvel of precision manufacturing compared to, say, the small-block Chevy V8, which has a similarly stubborn place in its own world of enthusiasts. In crucial respects, the splitcased, magnesium and aluminum VW motor of 1939 is closer to a modern Japanese motorcycle engine than it is to the cast-iron crudities of midcentury Detroit.

What accounts for the screwy economics of the Volkswagen engine? O. G. W. Fersen was an automotive journalist who visited the Berlin Auto Show of 1939, where the KdF-Wagen was unveiled, and took the car for a spin on the track. Recollecting thirty years later, in the same 1969 issue of *Autocar*, he reports that "the little car did look very 'cheap' with quite a lot of exposed sheetmetal in the interior and an engine that no one could call refined. But after all it was a full-sized car and it cost less than 1,000 marks, or as much as a medium-sized motorbike." Fersen explains the economics plainly enough: "The people's car was born by order of a dictator—disregarding cost and commercial reason—and it would be built by the [German Labor Front], a kind of stage-managed union." Because the German auto industry didn't think the car was feasible, the German Labor Front itself took command of the project, under the direction of Ferdinand Porsche. The result is the VW Beetle.

It was a socialist car, then. Its low cost and folksy back story was surely part of the appeal it would come to have for peaceloving American hippies of the 1960s counterculture. But it was also a fascist car, in the precise economic meaning of fascism: its low cost was due to dictatorial power, state-directed investment, and the outlawing of independent labor organizations not controlled by the Party. Nazi perversion of the ideal of free labor, or mockery of it, are well expressed in the fact that the phrase "Labor sets you free" was posted over the entrances to several of the death camps. The making of the "people's car" relied heavily on slave labor at Volkswagen during the war (mostly Czechs and other Slavic peoples who were marked out as racial defectives in Hitler's scheme). Once built, the plant at Wolfsburg mainly produced not the KdF-Wagen for consumers but the Jeep-like Kübelwagen and the amphibious, four-wheel drive Schwimmwagen for military use. (These were based on the same platform as the KdF-Wagen. During the war, the "people's car" was produced only in numbers adequate to serve the needs of Party dignitaries and diplomats.) In retrospect, Hitler's demands that the KdF-Wagen have such a fuel efficient, air-cooled engine were clearly motivated less by a concern for household economy than by his plan for far-flung conquests in regions sparse of fuel and water.

In a sense, the whole twisted ideological mess of 1930s German politics, with its mismatch between cultivated socialist image and underlying tendency to violence, is condensed into the air-cooled, flat-four VW motor. Twenty years after the war's conclusion, hot-rodders in southern California discovered for themselves that the people's engine, beloved by millions of peace-loving hippies, carried a vein of hidden Sturm und Drang that can be turned to warlike purposes.

It is a conflicted motor, then, and for that reason is ideally suited to the sleeper.

WHAT IS A SLEEPER?

Aristotle defined "irony" as a posture of concealing one's superiority. He called it a vice. He found this vice in Socrates, that notoriously ugly and penniless man who would go around Athens asking innocent-sounding questions of high-status men. If they took the bait, the ensuing exchange would reveal their confusion to all competent bystanders. This was not a very nice thing to do.

A rusty, decrepit-looking old Volkswagen with 300 horsepower could be taken as an instrument of Socratic inquiry, then. Let us pose a question at the stoplight, and see if the men of high repute deserve their standing in the city.

This is the basic dynamic explored in the Netflix show *Fastest Car*, in which high-dollar supercars are pitted against owner-built cars (some of them genuine sleepers) in the quarter mile. "Built not bought." This is the motto of the kind of man who looks at a Lamborghini and thinks "douchebag." How sweet it would be to give that car, and the man who drives it, a proper spanking.

SQUISHY, DRY-SUMPED 2276 BUILD

To understand the mental life of the gearhead, we are going to have to get into the ironmongery, as Ricardo would say. What follows may be too down in the technical weeds for all but the initiated. If metallurgy and measurement techniques are of no interest to you, just sit back, breathe in the aromatic hydrocarbons, and allow your eyes to glaze over as I reproduce a few entries from the build journal for this motor and try to explain what I am doing.

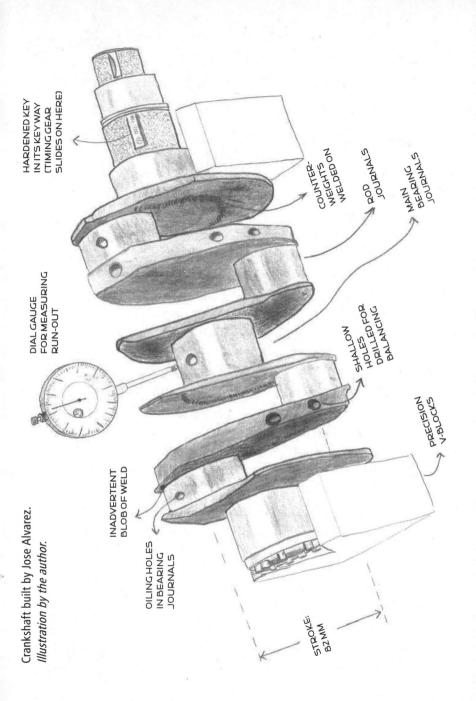

May 25, 2017

With crank on precision V-blocks at main bearing journals 1 and 3, run-out is barely observable (approx. 0.0003 inch at main 2 and 0.0004 at main 4), using dial indicator. Jose rocks!

The stroke of the stock 1600 cc VW motor—the distance traveled by the piston from the bottom of its travel in the cylinder to the top—is 69 mm. This distance is determined by the dimensions of the crankshaft. My crank was welded up from one of these stock units that had been chopped into bits by a fellow named Jose Alvarez, who has a business called DPR Machine in Santa Ana, California. This area is the Orange County epicenter of the air-cooled VW speed scene that began developing in southern California after the war, and remains one of those nowrare concentrations of engineering know-how that once dotted the American landscape.

Jose is the go-to guy for custom cranks. Speaking to him on the phone, I requested a longer stroke of 82 mm to increase the displacement of the engine, with counterweights added to smooth out the rotation (to allow the motor to rev higher), and rod journals made to the Chevy standard rather than the VW standard. Chevy rods are slightly smaller on the big end. Using them, I wouldn't have to remove as much metal from the crankcase to create clearance for this oversized rotating assembly.

Amazingly, this hand-built crank made to a "triple-o" standard (meaning tolerances within 0.000X inch of spec) cost no more than a mass-produced Chinese crank offered for the VW enthusiast: about four hundred dollars. The Chinese cranks you can get without waiting for months, and they are made of chrome-moly steel, which is supposed to be stronger. On paper. But the stock VW crank is made of *German* steel, and among those who push these little buggers to stratospheric torque and rpm numbers, it is often the preferred stuff. There has always been a bit of mysticism

FOLK ENGINEERING | 145

that swirls around metallurgy; it is truly an arcane science that goes back to the quasi-religious guild secrets surrounding Damascus steel and samurai swords. In medieval times, to a significant degree it was the state of metallurgy in a sovereign's realm that conferred military advantage, or not. But even in the industrial era, the knowledge and skill required for making good steel have not quite been reduced to following a recipe that can be fully spelled out. Like Walter White's meth, it's all about the cook.⁸

I also told Jose I wanted a larger than standard center main journal, to reduce flexing of the crank at high rpm. The inertial forces trying to flex the crank increase exponentially with rpm, and I intend to spin this motor to 7,000 rpm, whereas the stock motor risks grenading if pushed beyond about 4,500 rpm. As Sir Harry put it:

In the low-speed engine the dynamic forces set up by the inertia of the pistons and other moving parts are relatively small, hence these parts can be made very robust without imposing any undue stresses on the structure or the bearings, but dynamic forces increase as the square of the revolution speed and in a high-speed engine become the dominating factor. The essence then of highspeed engine design is the use of as rigid and compact a structure as possible containing the lightest possible moving parts.⁹

When Volkswagen introduced their "type 4" motor in 1968 for their heavier vehicles, later used also to power the Porsche 914, they increased the diameter of the crankshaft main bearing journals, with a crankcase machined to match. I was adopting this later standard in an earlier motor architecture. Back in the mists of time, some gearhead discovered that there is a particular bearing—made by BMW, not Volkswagen—that can be used to accomplish this adaptation.

Digging this information out of the community had not been

Connecting rod joins piston to crankshaft.

a trivial accomplishment. It required hours of reading through extraneous rants and years-old quarrels on the forums. But then again, I had been wasting large chunks of my life reading through this stuff anyway. Some of the threads are like detective stories, and you can't bear to stop until you've gotten to the end. Sometimes the technical mystery is resolved, but just as often the story peters out in a miasma of contradiction, seven pages in. Somebody changes the topic. There has been no book written on the subject since Bill Fisher's seminal How to Hot Rod Volkswagen Engines, published in 1970. The state of the art has progressed

quite a bit in the intervening half century, but the knowledge hasn't been organized.

One of the lesser-known improvements of the last twenty years is John Connolly's development of the "Super Squish" piston for the air-cooledVW motor. You have to sign a nondisclosure agreement to acquire a set of these from John, and agree never to post a picture showing the top of the piston. I am using these pistons and could describe them to you, but then I would have to kill you, dear reader. The main advantage is that they allow one to run higher compression without detonation. Allow Sir Harry to explain:

It has long been realized that it is the incidence of detonation, and of detonation alone, which, in the past, has set a limit to the power output and efficiency of the spark-ignition engine when running on volatile petroleum fuels. . . .

The mechanism of detonation is the setting-up within the cylinder of a pressure wave travelling at so high a velocity as, by its impact against the cylinder walls, to set them in vibration and thus give rise to a high-pitched 'ping'.¹⁰

The tendency to detonation is reduced by increasing turbulence in the combustion chamber. This can be accomplished through "squish." Ricardo explains that squish is "the rapid ejection of gas trapped between the piston and some flat or corresponding surface in the cylinder head."¹¹ Squish is achieved by manipulating the shape of the space left open between the top of the piston and the cylinder head.

I can say no more, for your own safety. Suffice to say that these arcane arts must be used for good and not evil.

May 27, 2017

Calibrated torque wrench.

Rod caps torqued to 24 ft-lbs with oil on threads.

#3 rod had zero side clearance, was binding, and the rod bolts gave me a queasy feeling upon torqueing. Something is amiss. Careful inspection found a little blob of weld protruding on the crank throw next to the rod journal. Fucking Jose!

I studied the situation with a magnifying glass and decided I should be able to remove the unwanted blob of metal with a file. I would be filing just a few millimeters from the polished surface of the rod journal, so first I protected it by wrapping a thin piece of soft aluminum around it, secured with a hose clamp.

With rod caps torqued, oil clearances of the rod bearings (measured with plastiguage) are all 0.002, side clearances (measured with feeler gauges) are as follows: #1 0.015, #2 0.016, #3 0.014, #4 0.009.

With the basic okay-ness of the crank and rod set now established. I used a bore gauge to determine the internal diameter of the timing gear, a micrometer to determine the external diameter of the snout of the crank, a small hole gauge to determine the width of the keyway, and a micrometer to determine the width of the key. Were all these items meant to work together? Yes, in theory. Then why bother measuring everything? In doing this kind of work, what you learn-the hard way, if necessary-is to trust nobody. The more you work with "high-performance," aftermarket and boutique parts, or even original factory parts, the more hardened you become in adopting this attitude. You can call it an ethic of suspicion, or you can call it empiricism. One develops a low regard for the testimony of others, for representations by interested parties, for reputations earned years ago. You trust your own instruments. Such a skeptical mentality comes hard to anyone in the grip of a fantasy budget for his fantasy motor, who merely adds up the prices of all the parts he sees in the magazines and thinks that is what the parts cost. Better to regard the thing vou buy as a first draft, an approximation of the final part. Your job, then, is to bring this hodgepodge of metal up to the highest standards. As the "mechanic in charge," you will be integrating parts made by dozens of different manufacturers according to some plan that was never their plan. There will be interference and incompatibility all over the place.

I digress on this because often if a hot-rodder tells a noninitiate that he is building a motor, his conversation partner will get a quizzical look and say, "You mean *re*building a motor?" Not really. "You mean you're building it *from scratch*?" Well, no again. What we do is called "blueprinting" an engine. This has an ambiguous origin. To have a blueprint is to have a master plan, in which the dimensions of everything are fully specified to within some acceptable tolerance. But the term probably comes more directly from the fact that machinists use blue dye to mark clean

Measuring the internal diameter of the timing gear. This one is straight-cut.

metal, such that any light scratching or scuffing leaves a witness mark that allows you to see where contact is occurring between two parts—how evenly a valve makes contact with its seat, for example, or how some flat surface deviates from a perfect plane (revealed by sanding the surface on a piece of glass and seeing where the dye remains), or the depth of engagement of the teeth of two gears that mesh. Such use of dye is an extremely sensitive technique for revealing irregularities that cannot be seen, nor measured with common machinist's instruments.

I put the crank in my freezer overnight. This caused some confusion in my household. The next day I took the timing gear that goes on the end of the crank, set it in a pot, covered it with vegetable oil, and put it on the stove in my kitchen until the oil began to smoke. Cooking up a motor often involves an excursion into the kitchen: baking, deep-frying, what have you. This dish was all about presentation. With a drizzle of motor oil on the snout of the chilled crank, I lifted the timing gear out of the hot vegetable oil with a screwdriver, grasped it with thick welding gloves, and immediately presented it to the crank. It slid on effortlessly. After a few seconds of heat transfer, the gear was immobile on the crank, with a room temperature clearance of about .0005 inch as measured beforehand. I would have preferred an interference fit of about .0005 (interference is the opposite of clearance), but this was acceptable. The hardened key would keep the two from rotating in relation to one another.

Here's the thing about timing gears. First, what are they? They mate the crankshaft to the camshaft. The one on the crank is small, the one on the cam is big, which makes the cam turn at half the speed of the crank. On a stock VW motor, they are helical-cut. This makes the gears less noisy (think of it as two objects-in this case gear teeth-colliding at a glancing angle rather than head-on. The teeth make contact gradually along their width rather than all at once). But because of the angle at which the teeth mesh, there is a thrust force introduced. That is, the gears are not only making the cam turn, they are also trying to push the cam along its length. This isn't something to worry about in a stock motor. But in a motor designed to turn higher rpms, you need to use stiffer valve springs (to keep the valves from floating due to their own inertia, i.e., losing contact with the springs that are meant to control them), and this increased spring pressure gets transmitted through the valve train to the gears, creating more thrust force, which wears out cam bearings. Dig? So, what one does is use gears that are straight-cut rather than helical-cut. This eliminates the thrust. Yes, they are noisier. The looser the mesh of the gears, the noisier they are. So, one would like to make the mesh nice and tight.

This is not simple. How tightly they mesh will be determined by how far the cam bore is from the crank bore in the case. This is not something you can adjust. That is why VW made cam gears in various over and under sizes, to compensate for minute variations in the spacing. But if you are using aftermarket, straight-cut

Helical-cut gears try to move along their axis of rotation. This is called thrust and it's bad.

gears, there is no variety of sizes. You get what you get. The ideal gear lash (empty space between adjacent teeth) is .000-.002. I measured mine at about .0045.

I know what you're thinking: Life is short, let it go. But once you break the spell of complacency and take responsibility for a motor, it is hard to accept parts that aren't perfect. Could I deposit some material on the cam gears to build up the surface, and thereby close up the gap between teeth? Nobody on the forums seemed to have tried this, as far as I could find. If the material were to flake off into the oil, the result could be catastrophic.

The mentality of being in charge spurs attempts at innovation and improvement. You feel emboldened. But you also feel the need for circumspection: if nobody else has tried this, there might be a good reason. Or maybe somebody did try it, and we never heard about it because they were too embarrassed by the result to report it. One must beware "the idiot tax," the risk

STRAIGHT-CUT CAM GEAR

Building up the surface of a gear set with plating, to reduce lash.

of failure that leads gearheads to adopt a kind of precautionary principle abbreviated as KISS: "keep it simple, stupid." Departing from convention, one is more likely to screw up than make a lasting contribution. But this is a lesson that usually becomes clear only in hindsight.

I considered electroplating the gears to build up the surface. Googling around, I learned that with electroplating it is difficult to control the thickness of the plating in small-radius surface features, such as the root of a gear tooth. But there is a process called "electroless nickel plating," the practitioners of which claim to have minute control over the thickness. I sent my cam gear off with a request for a nickel coating of .0018 inches, with a 6–10 percent phosphorous content to get the proper hardness. With that extra layer on each side of a gear tooth, I should reduce my lash by twice that number, or .0036, putting me at a hoped-for .001 lash, right in the middle of the spec. When I got the gear back, I baked it in a toaster oven at 550° F for two hours, per the instructions of the plater. He said this would raise the surface hardness to about 56 on the Rockwell C scale.

This was one episode in what became a prolonged education in various industrial processes, which became necessary once I no longer took for granted the adequacy of available parts. In the course of this education, which is ongoing (the car is not yet finished), I bought a metal lathe, gained access to a milling machine, and found it incredible that I had ever gotten by without these things. Measure everything, trust nobody, and make it from scratch if need be.

Such a mentality reminds me of that moment that is so often catechized in the story of modernity, when Galileo rejected received authority and believed his own eyes, aided by instruments he had built himself. To go deep into any technical field is to make progress in independence of mind, and feel a freedom to maneuver that grows in proportion with one's powers. It is to become modern again, as against the heavy blanket of magic that weighs us down with Promethean shame.

One can't quintuple the horsepower that a car was designed for and leave it at that, without rethinking every aspect of the car. Since finishing the rust repair, my time has gone into building a roll cage, seam-welding the body for greater rigidity (as opposed to the factory spot welds), bracing and triangulating in various places subject to new forces, building a hydraulic system for the brakes and clutch that uses four separate master cylinders (the car originally had just one), having custom axles made up, using heavier CV joints—the list goes on. I made custom rear hubs on my lathe, starting from an old pair of brake drums that had been lying around my shop for years. (Lesson learned: Cast iron is a disgusting metal to machine. It is dirty, dusty, and eats through tool bits like crazy.) I designed the hubs to mate to brake rotors from a Porsche 914, which I paired with brake calipers from a VW Golf (sourced from eBay) and caliper brackets from a VW Passat, in a process that John Lucsko aptly called "highperformance bricolage."

Such a cobbled-together system requires research, lots of it. For all the apparent infinity of the internet, there is one very basic kind of information that is rarely to be found anywhere on it: the dimensions of objects. And this reveals something interesting about contemporary material culture. Any object can be represented in various ways, according to the purpose served by the representation. On the web, what you will find is photographs of parts, prices of parts, and parts numbers. These are all you need, if you are simply replacing one part with an identical copy. Parts numbers are a system for managing inventory in an automobile manufacturer's vast catalogue. It is a way of bringing order to a universe of parts, many of which are made by subcontractors spread all over the planet, and these in turn are subject to changing ownership as they are merged and acquired in the churn of global capitalism. If he is of long tenure, the parts manager at a car dealership (who can be hailed from behind the parts counter if you are lucky) is a savant of this system, a philologist of parts numbers. He may be able to read a twelve-digit parts number and tell you not only what the part is, and for what model of car, but for what range of years. Of course, all of this should be in the computer that sits in front of each clerk at the parts counter. If the clerk is stumped (and this happens with some regularity, in my experience) and summons the manager, the manager may stare at the blown-up parts diagram for a moment and then stare off into space for a while, accessing some synaptic tether deep in his cortex and reeling it in. And then he will say something that makes sense only within his arcane world. "Wrong prefix. In 1993 they changed to a letter code, and the Camry had a mid-model-year production change." Or something like that.

This is the deepest level of institutional knowledge that one

WHY WE DRIVE | 154

can access, and it generally requires a trip to the parts counter: people who *know things* don't spend their time answering telephones.

But this sort of information counts as knowledge only if one stays within the prescribed world of the institution. Try asking the parts manager a question like the following: "what is the center-to-center spacing of the mounting holes on the bracket where it mates to the spindle?" What you will get is a long silence. It is like you just asked the most erudite mandarin in the court of the Chinese emperor which variety of saffron to use for an authentic Spanish paella, in tones suggesting he ought to know the answer. He has never been addressed in this manner. It's not the sort of question he has entertained before. If you follow up with "Well, do you have a set of calipers?" (for measuring) you reveal yourself as a troublemaker.

To engage in high-performance bricolage is to depart the world of parts numbers entirely and enter the world of dimensions, expressed in universal units. The thing about dimensions is, they are accessible to anyone with a few rudimentary measuring tools. Yet these dimensions are absent from inventory systems; they are not included in the systems of knowledge we have to pass through in dealing with material things. This is why you end up buying a metal lathe and a milling machine. It's just easier to make some parts than it is to hack a bureaucracy. Plus, you get to replace a frustrating activity with an enjoyable one.

This idea, "accessible to anyone," and the related idea of a universal standard (such as a unit of measurement), are at the very heart of the Enlightenment idea of knowledge. The whole point was to bypass the proprietary systems maintained by priests and scribes that kept the people in darkness, more easily controlled. This is *the* story we tell ourselves about what it means to be modern. What we have failed to notice is that we have constructed systems of knowledge, ostensibly hypermodern, that more closely resemble the medieval.¹²

Let me tell you about the transmission, if I may presume upon your patience. It needed to handle five times the horsepower of the original motor, and be able to transmit that power to the ground via sticky race tires without breaking in half. I also wanted a five-speed rather than the original four-speed, and a limited slip differential to put the power down in corners with a minimum of wheel spin. It also needed to fit, more or less. A transmission from a late-model Subaru seemed to be the ticket. It just needed to be shortened by a few inches. And it needed to be converted from all-wheel drive to two-wheel drive. Also, in an old VW, the engine is in the rear. In a Subaru, the engine is in the front. If you were to simply swap the Subaru transmission into a Beetle, you would have one forward gear and five reverse gears. That could make for some interesting parking lot shenanigans, but isn't very practical. The transmission output needed to be made to turn in the opposite direction (relative to its input) than its designers intended. Thankfully, all of these issues have been solved by a transmission guru in Australia named Todd Triebler. He manufactures a reversed ring and pinion gear set, and has a recipe for doing the swap more or less worked out.

More or less. The issue was the flywheel. The flywheel is where the engine, the transmission, the clutch, and the starter motor come together, and must be made to play nicely with each other. What was required was a flywheel that was fluent in both German and Japanese, and could serve as a go-between for these power trains with no natural basis for friendship.

This became an eighteen-month saga that unfolded over three continents. I made careful pencil drawings with dimensions labeled in tenths of millimeters rather than thousandths of inches, as preferred by my man in Australia, who used my drawings to make a computer model of the whole assembly. (In the U.S., machinists speak in inches, even when working on metric parts, because their tooling and instruments are calibrated in inches, and also because long use of these gives rise to embodied expertise: an experienced machinist knows what a step of two or three "thou" feels like as he drags a fingernail across it.) After much back and forth, he sent me a 3-D printed plastic prototype of the flywheel. The model needed some adjustment, and we went through another round of measuring and designing. Finally he sent me a flywheel machined from his computer model out of steel, somewhere in Asia, which I could tell by its surface finish, color, and the fact it arrived already badly rusted: due to the boat trip, but also due to the fact that this clearly wasn't "chrome vanadium" steel, like the original German flywheels.

After some further machining at my lathe and drill press, as well as some welding, grinding, the use of marking dye, and some unkind words for the whole nation of people Down Under, I had a working assembly. Almost. I still needed something so trivial it had escaped my attention until now: dowel pins to locate the clutch pressure plate on the flywheel. I measured the diameter of the holes in the flywheel where the dowels needed to go, using a small hole gauge and a micrometer: 0.315 inches, or eight millimeters. The corresponding holes on the pressure plate (an aftermarket unit to fit a 2014 Subaru WRX, whence my transmission came) were six millimeters. So the dowels I needed would have a step in them, measuring eight millimeters on one end and six millimeters on the other. Do such dowels exist? Did Todd make this flywheel with dowel holes the same size as those on a Subaru flywheel, so I could simply use the stock dowels? I looked online to see if I could learn that dimension, to check against my measured holes. Again, I found only pictures, prices, and parts numbers. So I went to the Subaru parts counter and asked to see some dowel pins.

"Model and year, please."

"Umm, for my imaginary car?"

"Eight millimeters on one end, six on the other" wasn't going

to get us anywhere. I spoke to the parts manager and to a service tech, the guy who actually *does* clutch work. Neither of them had ever noticed any stepped dowel pins of the sort I described. This led me to conclude that Todd had *not* made the holes according to a Subaru standard.

I was truly on my own now. I drove home, resolved to make some dowel pins. But as a last-ditch effort before departing society and going full Unabomber, I called the maker of my aftermarket clutch. I managed to get a technical person on the phone, and had an extraordinary conversation. What made it extraordinary was that this person *knew things*. And because he sits at the crossroads of many different makes of automobile, he knew things from a universal perspective, independent of the internal designations of the various manufacturers. Here is what he knew in particular, God bless him: Ford Mustangs from 2001 through 2014 that have the V8 option, but not one of the really crazy V8 options, have dowel pins that are eight millimeters on one end and six millimeters on the other. Wow!

I felt I was in the presence of greatness, and told him as much. We talked parts, we talked managerial capitalism. A nugget stored in his brain had solved my problem, and he had been duly recognized for this (by me), outside the incentives of his employer. Sometimes a real human connection happens in the most unexpected setting. He seemed reluctant to get off the phone. In me he had a conversation partner who understood the value that someone like him provides, and which so rarely shows up in an organizational flow chart: deep, specific, nonarbitrary knowledge. The kind that can be stated without the use of special nomenclature, or a system of signs internal to a bureaucracy.

It felt almost subversive, this conversation, like we belonged to a cell of saboteurs. We were the ones who would survive the collapse of the System—*parts numbers*—like the feral horsepower freaks depicted in *Road Warrior*. Those improvisational folk engineers of the Outback were a bit depraved, but they also preserved the seeds for civilization, and in watching them one could hope civilization might rise again.

In this they had to rely on one another. Here we get to a major complication in the story I have told thus far. *You can't measure things for yourself*, most of the time, because the objects you are wondering about (can they be made to fit?) aren't in front of you. I learned the recipe for my cobbled-together brake system from people on the forums. We stand on the shoulders of giants. Such shoulder standing is what civilization *is*; we learn from one another.

A monopoly of knowledge, guarded by a system of arbitrary symbols such as parts numbers, isolates us from one another and suffocates the human drive to innovate, those "rich seeds of invention that everywhere abound," as Ricardo named it. Such monopoly is what gearheads dissent from.

Motor Sport and the Spirit of Play

The possibility of violent death [is] the soul of all romance.

-William James

THE MOTOR EQUIVALENT OF WAR

DRIFTING

Buying a motorcycle with over 100 horsepower is kind of like buying a pound of coke. You're basically saying to yourself, *I'm just going to go ahead and be an asshole for the foreseeable future, and see what that's like*. What it is like is that the rest of the world is moving in slow motion, and it is excruciating. The lanes painted on the road appear acres wide. The enclosed, lumbering objects you share the road with are essentially standing still, and it makes no sense to abide by their rules.

Imagine you are Stephen Hawking and you wake up one day to discover that you have switched bodies with Stephen Curry. The life you have lived up to that point is no longer livable. However great the intellectual pleasures of black holes and equations, you suddenly have before you an unexpected cosmos that is deeply animal, an expanding universe that recedes from your present abilities and calls you forward: faster. Space-time dilates, and you are working in a different frame.

After seven years of riding a bike with 35 horsepower every day, I bought a modern Yamaha with about 120. It was roughly like going from an Irish donkey cart to something nuclear powered, with the precision of a Swiss watch. The acceleration was nearly hallucinogenic, the cornering scalpel-like.

A few months later I rode it down to Virginia International Raceway to watch races in various motor-sport disciplines that were crammed into a single weekend. I was creeping along North Paddock Road, shortly past the entrance to VIR, when I spotted a plume of smoke billowing into the heavy summer sky. It wasn't a little smoke, it was a dense, rolling cumulus. That looks bad. I pictured a driver trapped upside down in a roll cage, frantically trying to activate a fire suppression system. But then it occurred to me that this smoke wasn't black, as you would expect from a gasoline and plastics inferno; it was white. As I got closer to the action I could see that this was tire smoke, and that it is not the sign of a mishap but rather *the main point* of drifting.

Drifting is a motor sport in which one goes around corners sideways, tires spinning furiously. How sideways? The most acclaimed drivers sometimes take it to the point of entering a corner nearly *backward*, which has the visually elegant effect of prerotating the car, pointing it in the direction it will be headed as it exits a 180-degree turn. Picture a really excellent movie car chase and you'll begin to get the idea. To watch two or three cars drifting in tandem, a few feet apart as they slide through a series of turns, is to learn that human beings have come up with a new form of dance. It might be the most beautiful thing that happens on four wheels.

But for the moment, I had some more pressing concerns of a personal nature. I was going to ride in one of these 1,000-horsepower beasts, and I didn't want to soil myself. Some of the drivers appeared to be at the ragged edge; I really thought a red Nissan was going to lose it a number of times and go careening into the concrete barrier, but somehow the driver brought it back each time. The speed, the ground-shaking exhaust noise, the thick contrails of tire smoke, and above all the intensity of purpose that was evident in the driving made me wonder if I might have gotten in over my head.

Surely my driver would take it down a notch or two, having a civilian in the car? As I stood there sweating in jeans and boots and a bad case of helmet hair after the three-hour ride from Richmond, I signed a waiver that was too long to read—though my eyes did pick out the phrase "extremely dangerous."

My driver, Forrest Wang, looked about twenty-five years old. He wasn't wearing a fire suit, a Hans device (the standard neck restraint), or any such markers of prudence. He was wearing a T-shirt that mimicked the eponymous *Run-DMC* album cover, but instead read RUN 2JZ. (2JZ is an engine code.) This wasn't Formula One. There were no "Fly Emirates" or Rolex banners draped across the track, and no medevac helicopter idling nearby. I asked: Forrest built his own roll cage. "That's awesome!" I said, with less than perfect sincerity.

This would be a practice run, at an event that was not part of the Formula D points series, but with the same cohort of series competitors on track together. So while there were no standings (or sponsorship dollars) at stake, it was a collection of egos who were well-known to one another. All the established beefs were in play. The usual, secretive hardware adjustments were being tweaked in the various camps around the staging area, each with a couple of nylon tents to shield them from the Virginia sun. Forrest's mom sat at one of these tents, selling T-shirts.

When the time came, Forrest helped me assemble, latch, and tighten the cams on the six-point harness that held me rigid

against the deeply bolstered race seat. It was only at this moment that I remembered a little factoid about helmets. I was wearing my full-face motorcycle helmet. Motorcycle helmets are not allowed by automobile racing sanctioning bodies because they are not fire resistant. I entertained a vision of myself as a full-face burn victim and briefly entertained calling for a different helmet, but we were in the staging lane with three other cars. Their engines were running. A schedule of engine heat-soak and cooldown was being mentally monitored; laps remaining on the tires at current track temperatures being estimated. It was too late to raise helmet worries.

When I say, "Their engines were running," that may suggest something like an idle, as at a stoplight. This was more like the barking, snorting, and stamping of rodeo bulls in the interval between the moment when the strap is mercilessly tightened against their scrotums and the moment when the gate is opened and they are allowed to take their best shot at dislodging their tormenters. A couple of seconds after the flagman dropped his flag and the first car launched onto the track, a very loud clunk emanated from under our car and resounded through the bare metal shell of the cabin, which was completely devoid of soft materials. Forrest had just dropped the transmission into first gear. He remarked that the sound was due to the "dogbox" sequential transmission, which allows very fast, hard shifts but dispenses with such niceties as the meshing of gears. It was mated to the chassis with solid metal mounts for maximum rigidity, without noise-absorbing rubber insulators. We lurched and inched our way up to where the flagman stood.

Our turn to enter the track came, and this was the moment I was most curious about. What would it feel like to accelerate in a two-thousand-pound car with 600 horsepower and big, sticky race tires?¹ It feels . . . *violent*. The predominant sound came not from the open exhaust or the spooling turbo; it was the gear noise of the

transmission, which sounds oddly like the high-pitched whine of a radio-controlled car.

I braced my feet against the footholds as we approached the first corner. It was a fairly sharp left. Forrest turned the wheel slightly to the right, then hard to the left while hard on the gas. The effect was to toss the rear out. Now he was countersteering toward the right as the car drifted through the left-hand turn, hands moving in a blur from the rapidly spinning steering wheel to the shifter and back. Drifting is a very different game than road racing. Road race instructors sometimes tell their students to slow their hands down. It is a mental/physical device to help them relax: don't "chase speed," let the track come to you, and let the car's chassis dynamics determine the rhythm of your inputs. To exceed the limits of traction is to fail to go as fast as possible. In drifting, on the other hand, the driver uses the car's dynamics to deliberately put it out of composure. Yet there is another level of composure that emerges from the mayhem. There was one sequence of corners that Forrest executed with a kind of liquidity that had me moaning in my helmet; it was a moment of pure aesthetic rapture.

In this regard, drifting is a curious form of motor sport. It is more like figure skating than speed skating. The contestants don't wear glitter and sequins, but they do strive toward ideals that are basically aesthetic, and for that reason they are harder to judge by simple criteria such as elapsed time (though speed is one of the criteria). To appreciate the performance requires initiation into an art form.

We had gained on the cars that started earlier, and now the show would begin in earnest. Two cars veered off onto an alternate path that ran to the side of the main track. I turned to see them chasing each other, sideways, perhaps twenty yards off to the right and on a trajectory that looked to intersect with ours. Thick plumes of white smoke billowed from under each car. Forrest looked off to the right as well, and slowed. Just before our paths met, the other cars shifted from starboard to port tack, weight shifted now to the left and yawing clockwise. Forrest accelerated, threw his car into a similar angle of attack, and fell in behind them seamlessly. Scratch that; "seamless" makes it sound like the outcome was assured, but in fact it was a moment of acute tension. It was like watching Bode Miller on the ragged edge of control in a downhill ski race—not on TV but while riding piggyback.

Now all three cars were sliding in rough, unstable unison, five to ten feet apart, through what I believed was a broad right-hand sweeper, though after the first moment of turn-in I couldn't say for sure because the cabin had completely filled with tire smoke, and beyond the windshield was a solid, featureless white. Yet Forrest did not let off the gas. I had the sensation of yaw, but no visual cues whatsoever for perhaps four or five seconds. When the smoke cleared, we were going very fast. Forrest had been driving blind through the entire turn. There is a lot of trust among these rivals.

Our tandem drift reminded me of moments that would occur when I played pickup games of ice hockey in the 1990s, outdoors on Chicago's Midway. Sometimes when the puck would ricochet off in a new direction I found myself leaning hard into a turn, banking in unison with two or three players (from whichever team—it didn't matter at that moment) like fighter planes in formation. Each of us wanted that puck like a greyhound wants the bunny—and would have taken one another's head off to get it. But on another level, what I felt was an intense love for the moving bodies who chased it with me. Together we did something beautiful to behold, and we knew it.

In *Homo Ludens*, his classic study of "the play element in culture," Johan Huizinga wrote that play is marked by "a spirit of hostility and friendship combined." He found this in sport; in ritualized combat; in the competitive dances, stylized insult trading and boasting matches of every culture that remains vital. I think this captures pretty well the social element of motor sport. Huizinga writes that "the human need to fight" is intimately connected to "the imperishable need of man to live in beauty. There is no satisfying this need save in play."²

Play is common to all the higher animals. Huizinga writes, "We have only to watch young dogs to see that all the essentials of human play are present in their merry gambols. They invite one another to play by a certain ceremoniousness of attitude and gesture. They keep to the rule that you shall not bite, or not bite hard, your brother's ear. They pretend to get terribly angry."

If the sporting of dogs resembles human play, we may as well say the converse, that play expresses the "animal spirits" of man. As such it stands against the ideal of rational control that has become so pervasive in contemporary culture. "To dare, to take risks, to bear uncertainty, to endure tension—these are the essence of the play-spirit," Huizinga writes. Thus understood, play answers to a very basic need. It may be the most serious thing we do. But it expresses a part of the soul that sits uncomfortably with the contemporary taste for order, and is therefore subject to censure as irresponsible (on safety grounds) or, because it is competitive, as a threat to the ethic of equal esteem.

When Teddy Roosevelt made a case for "the strenuous life" a century ago, and criticized the "mollycoddle" type that he saw proliferating, he spoke for an emerging "vitalist" tradition that meant to give the animal spirits their due. This line of thought responded to a creeping utilitarianism that seemed to be loosening the tension in the soul, unstringing the bow of action. In France, Henri Bergson spoke of "élan vital" as the decisive human quality. In Germany, Friedrich Nietzsche wrote with contempt of "the last man," that calculating creature who seeks only comfort, safety, and the "small pleasures" of the bourgeois. In the States, William James sought a "moral equivalent of war" that would preserve the quality of hardness in times of peace, because he judged it a cultural necessity. More recently, the movie *Fight Club* revived this strand of critique. It draws on intuitions that could be called neopagan, since the virtues it emphasizes are not the Christian ones of meekness and humility.

The rationalist looks with suspicion on those wellsprings of culture—play—that have no utilitarian justification. Play is superfluous. Because it serves no end beyond itself, it stands outside the calculus of means-ends reasoning. An episode of play interrupts the *seeking* that an acquisitive society is based on. Bounded within definite limits of time, often taking place in a playing field (or racetrack) set off from "the real world," play presents an interlude, a pause in the endless deferment of joy that is daily life.

So far so good; one can well imagine the Montessori crowd nodding along with this endorsement of play. It is, after all, a cultural staple of ours to bemoan an overly structured and protected childhood. Yet it is the aspect of contest, the thirst for *distinction*, that Huizinga identifies as the crucial, civilizing element of play. This we are not so comfortable with; self-esteem is something to which all are equally entitled. Before returning to motor sport, I would like to offer a few thoughts on the psychology of rivalry in general, as I believe our determination to quarantine and suppress it in contemporary culture lies just beneath the surface of some of our difficulties.

PLAY AND THE ORIGINS OF SOCIAL ORDER

Our aspiring nature connects us to other people through emulation. Emulation (I want to be like *that* person, not *those* selfsatisfied people) gets you off the couch, but ultimately it is your better self that you feel you must answer to. What that better self might be capable of is something you have to discover, and the whole process is set in motion by watching other people and feeling the sting of rank. Huizinga writes that "the competitive 'instinct' is not in the first place a desire for power or a will to dominate. The primary thing is the desire to excel others, to be the first and to be honoured for that."³ This distinction between wanting to excel others and wanting to dominate others gets elided in egalitarian culture, and the thirst for distinction is thereby subject to all the suspicion that should be reserved for a would-be tyrant. The irony is that this clamp-down on the spirit of contest *itself* expresses a tyrannical need to control others.⁴ You see it in the playground minders of affluent progressive schools, for example, who monitor play for signs of incipient trauma to the fragile selves they are busy cultivating.

Since one purpose of this book is to consider the evolving means and ends of social control, we do well to remind ourselves that there is a long pedigree, going back to *The Leviathan* of Thomas Hobbes, for the idea that democracy requires equal esteem, not merely equal rights or equal opportunity. A people whose energies of rivalry have been safely corralled into socially useful channels (economic productivity) will also be a people who are isolated from one another, and therefore easier to control.

Huizinga gives us reason to worry that this aspiration to control and flatten the lust for distinction ends up cannibalizing the real source of social order. The contest for honor gives rise to deference and trust among players, and on Huizinga's account it is precisely here that we should look for the origins of institutions.⁵ Contests and games require rules, after all. Unlike the simple lust for power, they require that participants recognize the legitimacy of standards that aren't simply emanations of their own will.

The sense of a world that is indifferent to you, and a capacity to accommodate yourself to it, is precisely what an infant lacks. The world revolves around him, and he experiences his mother as an omnipotent extension of his own will. Anything that thwarts his will is enraging. This is called infantile narcissism, in the Freudian schema.⁶ Let's combine this nugget from Freud with what we have learned from Huizinga. The world does not love you simply for being you. But if you rise to its challenge, it may confer on you distinction of a public nature. One puts oneself up against others in a publicly visible fight for distinction, while submitting to the common rules of some established game. The ego and the superego need one another: there can be no well-founded pride without a corresponding capacity for self-disgust, and it is other people (and their rules of play) who provide the marks on this vertical scale.

To efface the scale or deny that it exists, in the name of egalitarian scruples, is to guarantee arrested development on a mass scale. This can take a number of forms, and I think we would do well to entertain a hybrid Freud-Huizinga perspective in trying to make sense of some contemporary manifestations of infantilism. Consider the sad ritual of mass shootings by young men who seem unable to conceive a way of making a mark on the world—of making themselves known to others—but through an eruption of solipsistic rage. He acts out a fantasy of omnipotence that has never come up against the civilizing resistance offered by other people. Such an action is the opposite of fighting and playing.

GENTLEMEN AT PLAY: MOTOR SPORT TO THE DEATH

In his canvas of archaic cultures, Huizinga finds that a fight to the death between two groups is often portrayed as an instance of playing. In one such fight (in the Hebrew Book of Samuel), the word used to describe the deadly contest is "taken from the sphere of laughter." Greek vases depict armed contests accompanied by flute players, and at the Olympic games there were duels fought to the death.

A modern-day equivalent might be found at the Isle of Man TT motorcycle race, still taking place annually, in which it is routine for a few people to die each year. (It is full-bore road racing with speeds reaching 200 mph, but conducted on narrow public roads, many of them bounded by stone walls.) Such spectacles are sometimes lumped together with activities like bungee jumping or riding roller coasters. But mere thrill seeking is sterile, as are mere games of chance such as Russian roulette; they may induce a rush of adrenaline in the participant but are not productive of culture. As Huizinga writes, "The picture changes as soon as play demands application, knowledge, skill, courage and strength. The more 'difficult' the game the greater the tension in the beholders. . . . The more apt it is to raise the tone, the intensity of life in the individual or the group the more readily will it become part of civilization itself."⁷

There is a gorgeous film about the most recent decade of MotoGP motorcycle racing, *Hitting the Apex*. It is narrated by Brad Pitt (one of the stars of *Fight Club*, as it happens). In it there is an interview with the team manager of Jorge Lorenzo, who has been one of the premier riders—a player, you might say—in this era. The manager says, "I have been fortunate. This is the message." He indicates that his good fortune consists of being able to put himself in the service of something beautiful. "In the motor-cycle world, anyone who falls, like Lorenzo or [Marc] Márquez, who races with broken bones, demonstrates that one can come back from injury to continue to breathe the intoxication of a dream. . . . We must share the scent of victory and make those around us happy by our example." Players make those around them happy by their example: motor sport echoes the civilizing spectacle of archaic contest.

World War One saw the emergence of a new form of combat, the aerial dogfight, that might be regarded as a case of motor sport to the death. Its resemblance to archaic contest is singular when viewed against the backdrop of industrialized slaughter, which made its first appearance in that same conflict. To grasp the singularity of the dogfight, we also need to grasp the nature of the surrounding catastrophe.

The rapid mechanization of war toward the end of the nineteenth century and early in the twentieth was repellant to those, of an aristocratic temper, for whom the aesthetics of war were crucial to the elevating social function they (still) believed war played. Further, the type of human being who is competent with machines, such a chauffeur, was seen to be of a lower order than the type who embodies the military ideal. Winston Churchill expressed these lingering prejudices in My Early Life, published in the early 1930s. He had been commissioned as a cavalry officer in 1895, serving in the Fourth Hussars, and in this passage he conveys a young gentleman's view of war.

There is a thrill and charm of its own in the glittering jingle of a cavalry squadron manoeuvring at the trot; and this deepens into joyous excitement when the same evolutions are performed at a gallop. The stir of the horses, the clank of their equipment, the thrill of motion, the tossing plumes, the sense of incorporation in a living machine, the suave dignity of the uniform all combine to make cavalry drill a fine thing in itself. . . .

It is a shame that War should have flung all this aside in its greedy, base, opportunist march, and should turn instead to chemists in spectacles, and chauffeurs pulling the levers of aeroplanes or machine guns.⁸

Manfred von Richthofen was good with horses too. He was commissioned as a cavalry officer in 1911 and had a lovely life in his regiment, consisting of horse racing and jumping competitions as well as drills. Then the First World War broke out, in August 1914, and the gentleman was unceremoniously deposited at Verdun. This was not nearly so sporting. As the stalemate of a new sort of ground war set in, the cavalry had become obsolete overnight, and the horseman found himself in the trenches. We can imagine young Manfred looking up from the mud, the misery, the sheer *impasse*, and seeing a solo figure aloft, maneuvering with freedom.

He knew nothing about these newfangled aeroplanes and, like most officers, had held in contempt the men who operated them. But just look! The banking dives, the swooping lines of pursuit in three dimensions, sometimes descending to treetop level: two pilots playing out their deadly drama for all to see. The old prejudice crumbled, and Manfred von Richthofen put in for a transfer to the air service.

He got his first taste of aerial combat in the late summer of 1915. On September 17, his squadron encountered a formation of Allied planes, and Richthofen picked a Farman FE.2b fighterbomber as his target. This was a "pusher" biplane, with the propeller in the back, allowing the forward observer to fire a swiveling .303 machine gun as the pilot, seated behind and above, maneuvered the plane. Richthofen's squadron dove out of the sun. It is reported of Richthofen that

his inexperience allowed the Allied observer to get off some dangerous bursts at him, but he finally managed to close in and riddle the belly of the Allied plane. He followed the crippled plane down to the ground and landed near it. He watched German soldiers lift the two mortally wounded British aviators from their cockpits. The observer, seeing Richthofen and recognizing him as the victor, acknowledged him with a smile before dying.⁹

As Richthofen's first confirmed kill, this British flier could not have known that the victor he acknowledged would come to be known as the Red Baron, with eighty confirmed air victories. (The benchmark for being designated an "ace," on both sides of the war, was five victories.) What interests us is the smile. Perhaps that detail is an embellishment; it has a whiff of mythology about it. But myths are significant, as they point toward shared ideals. The dying aviator's smile may be understood as a sublime instance of sportsmanship; he was not a sore loser. For the aerial dogfight has the quality of a deadly game, of precisely the sort Huizinga finds in archaic societies. Airmen would sometimes "drop challenges" behind enemy lines: an invitation to play.

Manfred von Richthofen finally met his match in Canadian Royal Air Force pilot Arthur Roy Brown, who pursued Richtofen as he in turn pursued another Canadian flier. The chase crossed over into Allied territory in France and the machine-gun nests of the Fifty-Third Battery, Australian Field Artillery. It is disputed who fired the shots that brought down the Red Baron. As one historian tells it, "Whether hit from the air or the ground, Richthofen was mortally wounded. He tore off his goggles, opened the throttle briefly, then cut off the engine and dipped down for a crash landing. His plane bounced once, breaking the propeller, and settled in a beet field . . . near Sailley-le-Sac. He died moments later. It was 10:50 a.m."

What I find especially significant are the events of the following day:

Manfred von Richthofen was laid to rest late in the afternoon of April 22 in a small, unkempt cemetery in Bertangles. He was buried with full military honors after a short service by an Anglican chaplain. Twelve men from No. 3 Squadron, Australian Flying Corps, each fired three rounds into the air. Other officers placed wreaths on the grave. The body was set with feet facing the marker, a four-bladed propeller trimmed to form a cross.¹⁰

In the regard it expressed for a deadly enemy, this funeral is in the same spirit as the dying Englishman's smile. In all play there is a play-community, and it stands apart from "the others" (for example, the French villagers who were incensed that a German was buried in their town and tried to dig up the body). When war is approached as a game, the humanity of one's opponent is an indispensable premise. Indeed, more than being merely human, he must be a *worthy* adversary or the game is not worth playing. Play is inherently exclusive, and it follows that war understood in this way is necessarily limited. The principle of contest is violated in mass extermination, no less than it is in the ambush or the punitive expedition.¹¹

If one were to force these little details—the smile, the funeral to fit into the standard Marxist historiography of the First World War, it would go something like this: the elites of the combatant countries felt more allegiance to one another than to their own countrymen, therefore such gestures of politesse may be taken to express a class solidarity that trumped national loyalty. There is surely something to this; there were instances of officers from opposing armies meeting to play poker, by way of alleviating the crushing tedium of trench warfare (and perhaps, the crushing tedium of the company of their countrymen of lower rank).

But entry to the game of aerial combat was not tied to class distinctions, and indeed the undeniably *noble* character of this game posed a direct challenge to the prejudices of class. The youthful snobbery in Churchill's dismissal of "chauffeurs pulling the levers of aeroplanes" would be nowhere evident in 1940 when Churchill, now prime minister, visited the RAF bunker at Uxbridge during the Battle of Britain on August 16: Upon leaving, "Churchill told General Hastings Ismay, 'Don't speak to me, I have never been so moved.' After several minutes of silence he said, 'Never in the history of mankind has so much been owed by so many to so few.'"¹²

In referring to "the few and the many," Churchill invoked a timeless theme of politics. But these few, the RAF fighter pilots,

were not drawn primarily from the higher ranks of British society.¹³ Yet they seemed to embody the aristocratic ideal of archaic warfare: contempt of death, expressed in single combat on behalf of a larger collective. The spirit of chivalry aspired to by the horse-born soldiers of Churchill's youth had found unexpected expression amidst industrialized slaughter, from an unexpected class of people. Thus does civilization renew itself.

THE RISE OF THE BICYCLE MORALISTS (A DIGRESSION)

Sometimes the "human need to fight" that Huizinga describes takes the form of culture war, and this may get expressed through vehicular politics. Consider the rise of the bicycle moralists.

A friend writes from Oakland about a "nerdy academic lawyerdad" who yelled "Mindfulness!" by way of admonishing his roughhousing kid on the play structure at the elementary school. The same dad bicycles his kid to school. "Instead of just going onto the sidewalk and into the schoolyard like other bicycling parents, he pulled up his customized parent-child bike in the backed-up line of cars at the curb and had his kid climb off the back as if climbing down from a backseat. I felt like I was watching that trendy pro-bike urbanism made personally rigorous enough to become mental illness, literally a delusion: 'My bicycle *is* a car!' It was a scene from Monty Python."

Assuming the guy wasn't actually suffering a delusion; I suppose

biking his kid to school carried more polemical thrust if he waited in the car line. "This is my car. It gets infinity miles per gallon." If he merely biked to the school unobtrusively, it wouldn't have any consciousness-raising effect.

Another friend writes from London, "I've noticed that the motorists are generally calm and accepting these days, whereas the Lycra-clad commuter-cyclists are more likely to be in a rage of frustrated entitlement. I notice that some of these guys—the ones with ALL of the kit—like to police other people's behaviour on the road, including (perhaps especially) other cyclists who don't have as much kit as them. Meanwhile those cyclists with very little kit speed around like anarchists, looking for red lights to break and pedestrian crossings to speed through. I think things are quite different since they put in these cycle lanes that segregate bicycles from the motorised traffic a lot more—a lot more antagonism takes place within the tribe now that the obvious enemy has been kind of neutralised. A new hierarchy is emerging, tribes within tribes, and far less camaraderie."

I can imagine urban bicyclists might feel a big ontological divide between themselves and the motorists, much as when motorcyclists refer to cars (and the people in them) as "cages." They probably feel superior for being more agile, more viscerally engaged in battle, more in the world. It feels *unjust* to have to share the road with these big, lumbering invalids, these sorry existential cases, on terms of equality! But while motorcyclists tend to be regarded as footdraggers in the march of History—reckless, noisy, and somehow not at all green (despite getting fifty miles per gallon) bicycles, on the other hand, are forward thinking, European, at the heart of every new-urbanist plea for making cities more human. It must be a powerful mix. With their visible performance of doing the right thing, bicyclists also get to wear very smart-looking outfits that show what kind of body comes with being virtuous.

Maybe because of the era I grew up in (I was born in 1965), I

don't immediately associate bicycles with virtue. Back then they were just, you know, fun.

In my town there was a notorious gangster named Troy. Word on the street was that he had done hard time, some said for killing a man. He must have been about thirteen, I was eight. One day I saw a crowd outside my house, which was at the bottom of a steep hill. I went outside and learned that Troy was at the top of the hill on his bike. His minions and groupies had set up a ramp, followed by about ten full-sized trash cans. This was going to be some real Evel Knievel stuff, right in front of my house! What I remember vividly is that as Troy came screaming down the hill, *he was peddling furiously*. He launched, cleared the garbage cans for the most part, and landed in a great shower of sparks, visible even in the daylight. There was blood. It was really bad. It was also the most awesome thing I had ever seen. It put me on notice that there are human beings who belong to a whole different order of badass.

Around this same time (it must have been about 1973), I had come into the unprecedented sum of twenty dollars, a birthday present of cold cash from a mother with a bad conscience. Of this I had nine dollars and eighty cents left, which I kept in a Donald Duck coin purse. I needed to go across town, to my dad's apartment on Carleton Street, and I distinctly remember fretting about the money, about the wisdom of transporting such a sum on my person. I decided to risk it. And sure enough, I had gone about three blocks when Troy and his thugs rolled up on their BMX bikes and proceeded to box me in. I was very afraid. Troy was still in bandages, which only made him look more hardcore.

"Nice gooseneck," he said, eyeing my bike. Indeed it was. It was "heat treated" (for extra strength), which you could tell from the flat black finish. Apart from the motocross handlebars, this gooseneck was the one item of trickness on my junkyard-salvaged Stingray, and Troy's eye had gone straight to it. "Can I have it?" I honestly don't remember how that part of the conversation progressed. But by the time I was on my way, I had been relieved of my \$9.80.

A fatalistic child, with no habit of seeking adult succor, it was only by some slip of my tongue that my father learned of the theft. He was outraged. He demanded to know where the thief lived. I tried to tell him, Dad, you don't understand. This is Troy. This is not somebody you go looking for. But he persisted. We drove to the house of a kid who might possibly know where Troy lived. We were standing on his porch at night, and he wouldn't give up the information. He seemed to be physically sick at the demand, but my father kept grilling him. This seemed madness to me. Adults can be so clueless about the real hazards of the world.

The house described was more like a shack behind a proper house, in somebody's backyard. My dad pounded on the door and after a long pause a woman opened it. The air wafting out of the house had the smell of cigarettes. He told her the situation angrily. At this time my dad was about the same age I am now, and in 1973 he looked like a Hell's Angel. He was nothing of the sort, but he was kinda scary looking, with long, straggly hair, unwashed clothes, and a big mustache. Troy's mom was apologetic. Clearly, she was ready to believe any accusation against her son. There was no father. She summoned Troy from elsewhere in the shack (he had probably heard the whole exchange) and out he came. The person who presented himself bore little resemblance to the fearsome gangster. He seemed to have shrunk into himself, with downcast eyes and a barely audible mumble in response to the interrogation. The mom produced some money, saying "How about I just give you ten dollars." I clearly remember my dad's response: "I don't want to rip you off." It was the sound of righteous justice. At this point I was feeling a little bolder and found my voice. I offered that, well, there was also the cost of the Donald Duck coin purse, which according to Troy was long gone. This seemed to resolve the issue of the twenty-cent differential. My dad took the ten dollars and we were on our way. On the way back to his car, he handed me the money.

I was stunned. The episode remains for me a lesson in what it takes to be a father, and why a kid might want to have one.

I have one other memory of my dad rising to the occasion in this way, and oddly enough it too involved a bicycle. He had gotten me a new one after the one I had was ripped off. I'd had the new one only a few days when it too got nabbed, despite being locked. With shame and trepidation, I told him what happened, and during that very conversation I happened to be looking out toward the street through the narrow driveway hemmed in with bushes when, for a second or two, I believed I saw my new bike rolling down the street, accompanied by another. I told my dad. We sprang into action and ran to his car, a red 1963 Ford Fairlane convertible with a top that didn't go up. Rather than open the door, he vaulted into the driver's seat while I ran up the trunk of the car and hurdled into the passenger seat, like Batman and Robin. We were off, and took a lucky guess: toward San Pablo Avenue. We hadn't gone maybe three blocks when we spotted the two kids rolling down the center of the street. My dad pulled up right next to the kid on my bike and grabbed him by his backpack, then slowed to a stop. His partner kept going, peddling furiously and looking back in terror. Now, I don't condone this, running down a kid on a bike in a car. But this was a different era. and people did things like this, I guess. In any case, I had my bike back, and how sweet it was.

TWO DERBIES AND A SCRAMBLE

ACT I: DEMOLITION DERBY

"Hit that car! Hit that car!"

The woman stood on the perimeter, pointing. She was directing her toddler son to ram his toy electric car into another that was momentarily disabled, its plastic body hung up on a log. Carpe diem, little man. In the Scots-Irish school of child rearing, this early form of driver's education presents a teaching moment of wider import: initiation into the Appalachian ethic of animosity.

If you are an expat from, say, California, living in the South, the next time you are furiously tailgated by a pickup truck, or have a half-full can of beer thrown at you while executing what seems to you an entirely reasonable passing maneuver on a twolane road, just know that there is a *principle* at work. I came to the Warren County Fair for the demolition derby scheduled for Wednesday night, but arrived a day earlier for the "Power Wheels derby" on Tuesday night, not knowing what that might be. Maybe monster trucks? It had to be something awesome. As it turns out, Power Wheels are cars driven by toddlers. If you have spent time around family-oriented events in more polite precincts, you are used to hearing "don't hit," "take turns," "make sure everyone wins" and similar injunctions, all directed against what Johan Huizinga called "the human need to fight."

"Tech inspection" for the Power Wheels contestants consisted of checking to make sure each car had a balloon duct taped to both the front and the rear of the car. The point of the contest was to pop others' balloons while keeping your own intact. This more or less corresponds to the goal of demolition derby in its *mature* form, but with balloons standing in for sensitive components such as radiators.

In the adult derby on Wednesday night, most of the driving was done in reverse; the winning strategy is to use the back of your car to ram the front of others' cars. Fuel tanks (often consisting of a cheap plastic fuel can) are relocated to the interior of the car, to protect them. All glass is removed and bars of steel or heavy chains are welded where the windshield once was, to prevent the intrusion of another car into yours. Doors are welded shut. I saw the engine computer for one car glued onto the dashboard, to get it away from the radiator. The substance used for glue looked like great globs of roofing tar that had been shat out haphazardly by some passing megafauna. Some cars had exhausts exiting through the hoods, rather than hanging underneath where they would be vulnerable to getting caught on something, giving them a Mad Max vibe. With rattle-can paint jobs and materials that look like they came from Lowe's rather than Summit Racing, the cars are "use once and throw away." It's hard to make out any makes or models amidst the chaos of improvisation. One large blonde woman who

appeared to be about thirty years old had stenciled on her car, RAISE HELL EAT CORNBREAD.

The cars line up against a wall for the start, nose in. When the horn sounds, they back out and scatter, and the drivers start drawing beads on one another, heads turned back over their shoulders. Supposedly you are not allowed to ram the driver's side door of another car, but given the sloppy mud the cars maneuver in, the drivers only have so much control.

What I wasn't prepared for was the feeling of having gone back in time. Let me be careful here. It is tempting to romanticize rural people as the carriers of bygone virtues, or likewise to demonize them as dragging down the great leap forward. But the cultural moment I felt transported back to was not a Norman Rockwell scene of small-town tranquility. It was more like an Iron Maiden concert, circa 1983. But instead of stage effects, there were actual explosions (of batteries shorted out) and great plumes of radiator steam that looked enough like smoke to convey the proximity of fire and death. Such proximity seemed real enough amidst the loud crunching of sheet metal and the visible whiplashing of heads. One car rammed another with such force that the victim's car rode up over the aggressor's hood and onto his roof, and was perched there at a listing angle as the pirate continued plowing forward toward the concrete barrier. The helpless driver's car fell off onto its side and teetered for a moment before landing right side up, ready for vengeance.

"Hit him in the face!"

"Hit him again!"

The gentlemen to my right in the fenced-off beer pen had taken opposing sides in this emerging duel. They both appeared to be in their early fifties. The tall, lanky one had long hair that flowed out, clearly without benefit of cream rinse, from beneath a Confederate flag cap. The other was built like a fireplug and sported a little rat-tail braid, but was otherwise closely shorn. A lot of people talk about "senseless violence" like it's a *bad* thing. But to real connoisseurs, senseless violence is the best kind.

Well-adjusted people are sometimes drawn to this sort of spectacle, but may have a hard time saying why. Of course, there is an easy and respectable thing to say, namely that a contest like this serves as an "outlet" for energies that might otherwise find more destructive release. But to say this is to absorb the demolition derby into the cosmos of the *responsible*, and thereby invert the meaning it evidently has for its participants. What it seems to offer them is the sheer, Dionysian joy of destruction.

ACT II: ADULT SOAP BOX DERBY

A soapbox derby is a race, usually held by children, in which the cars are powered solely by gravity. Portland's Adult Soapbox Derby has been running annually since 1997 on Mt. Tabor, a steeply hilled park within the city limits. The event's website conveys the flavor of it—Burning Man on wheels would be an apt formula—and gives an account of its origins in an experience one of the founders had in San Francisco in 1994 when he witnessed a similar event. He describes the clothing first ("punk," "postindustrial," "ripped and stained pants") and then the action, with

some cars smashing into others. Throwing the daring riders into the blood-filled air and onto the merciless concrete. Another car lost control and sped into the spectators and off the cliff, while still some made it to the bottom and into victory and legend. The crowd was in a maelstrom, pouring beer over each other and raising their fists to the heavens.

I hadn't come across any such origin story for the Warren County demolition derby; as far as I could tell it was completely devoid of self-representations. The Portland affair sounded a bit frightening—this atmosphere of violence, criminality, and reckless abandon. Would I be able to handle it? Also, I was a little confused. A gravity-powered race with cars leaving one at a time should be a fairly calm and quiet affair, no?

I flew out from Richmond the day before the event, and on the morning of the race picked a place for breakfast that was mere steps from the park, which turned out to be in a lovely neighborhood of million-dollar homes. I had never been to Portland before and was curious to see how they lived. One thing I noticed was yard signs announcing the residents' affection for various classes of people. Some of these signs had lines written in Arabic that I wasn't able to understand. It's impressive that so many Portlanders have taken the trouble to learn this difficult language. As far as I could see, the only people fitting the categories enumerated on the yard signs who were actually present were some Hispanic groundskeepers who tended the botanical cornucopia outside a beautiful craftsman-style bungalow.

As I sat at an outdoor table at Coquine and watched the friendly ease with which the neighborhood people greeted one another on a Saturday morning—the good graces and atmosphere of complete trust—I caught a glimpse of a certain kind of utopia. The homogeneity of the place struck me as the very thing people were said to have wanted when they voted for Trump.

After breakfast I began walking up the hill and caught snippets of conversation as I passed by gathering knots of race spectators with picnic blankets. One well-tattooed woman said to her inky male consort, "Would you like a kimchi lemongrass Bloody Mary, or a regular Bloody Mary?" Farther up the hill, a man said to his blue-haired companion, ". . . and it's *real* free market, not this fascist shit we call capitalism." She looked bored and irritated.

There was a kiosk selling arty T-shirts that said FEAR THE FLAG, referring to the race officials with orange flags who were stationed at various points to keep spectators safely off the course. Ironizing authority even while exercising it, the motto is well tuned to that narrow frequency that allows an event like this to be carried off. There is a certain poignancy to the predicament of rebels become officials; one feels for the fragility of their selfunderstanding.

I found a spot near the starting line next to a man who had with him a young dog that was somehow both adorable and ferallooking. I said, "He looks like a jackal, or maybe a hyena." A voice behind me said, "You mean an African dog." I turned; it was a woman who appeared to be about seventy years old. She gripped one of those hiker's walking sticks, and had a stern look that suggested she might have some official capacity. I ignored her and said to the dog's owner, in a jocular tone, "You better keep an eye on him; he might come for your throat." "That's actually not funny," said the woman with the big stick. I decided to keep moving.

The derby is divided into two classes; the first consists of those intent on going fast. I wandered around the staging area before the race and saw impressive engineering in some of these cars, and nice fabrication work. The car that would go on to win this class was a fully enclosed aerodynamic job built and piloted by a team of U.S. Marines, who were there in their camouflage fatigues. They certainly stood out as different, and for that reason seemed oddly vulnerable, socially. They kept to themselves, a quiet countercultural presence on the hill that day.

The second class is made up of "art cars" and here the ingenuity on display was in the service of wit rather than speed. The wittiest team, to my taste, was dressed in saffron robes and piloted a cardboard Rolls-Royce bedecked with garlands of flowers—a reference to the notorious Bhagwan Rajneesh, whose followers took over a rural town in Oregon, and were eventually chased out with indictments for attempted murder. My other favorite was a reproduction of the lovable robot from the film *WALL-E*, complete with articulated neck and eyes that moved with uncanny expressiveness.

But I wasn't able to get much interpretive purchase on most

of the art cars, if indeed there was coherence to be found. I like art as much as the next person, but I have to confess I have never had much feel for "art" as an urban mood, identity, cultural stance . . . I'm not sure what it is, but clearly it serves some important function for those who adopt it. I gather it has something to do with pointed transgression against communal norms, or rather against norms that are said to have existed at some point. But also, paradoxically, it seems to be a way of belonging to something. And sure enough, the larger pool of entrants, and center of gravity of the event, clearly lay with this contingent. They seemed to have the prevailing spirit of Portland on their side.

I positioned myself at a curve and watched the cars come by in waves. The cars built for speed were sleek and generally moved down the road with a minimum of drama, the fastest reaching perhaps thirty miles per hour. Some of the art cars were doing around ten miles per hour, but of course in their case the whole point was drama, not speed. The drama came partly from whatever cultural reference the ensemble was meant to suggest, partly from the participants' efforts to deal with ungainly decorative appendages (some of these were huge), and partly from the effects of engineering decisions of the sort one might expect from humanities majors. I watched one car in the shape of a giant hobby horse struggle with a violent shimmy, its two front wheels mounted on separate, vertical steering axes with zero rake (or caster). (Think of the wheel on a shopping cart that shakes chaotically.) I couldn't help but feel sympathy for the people in the slowest cars. My guess is that when a participant visualizes race day ahead of time, he imagines himself in a speed-blur (as viewed by spectators), leaving a contrail of devil-may-care badassery to wash over spectators who could only wonder at what had just passed. But when the car is moving at a walking pace, it is hard to keep that on-the-edge-of-disaster vibe that the whole venture is predicated on. Those piloting the slowest art cars were left bare for a cold, sober inspection by the spectators. In silence, often. Some racers, rather than sit calmly in the car, gamely embellished with a pantomime of a struggle for control, but these seemed to fall flat at eight miles per hour.

I walked down to the finish line, passing a giant mousetrap along the way. At the bottom of the hill I saw a group of grown men dressed as Teletubbies standing next to a matching cartoonstyle mobile, and another group of grown men loitering near a giant baby carriage, dressed only in diapers. While the men seemed to favor themes of self-infantilization, the women contestants wore costumes of empowerment—black jeans, wife-beaters, and motocross helmets. I had the sense of having entered a game of signs with rules of play that were pretty clear to the initiated. In the game of Portland circa 2018, the rules seemed to require the men to signal "innocuous" and the women to signal "fierce."

In this one can sense a certainly gallantry. The men create space for the women to feel fierce by vacating that space themselves. I could view this costume drama only from the outside, like an American observer of the courtly play of French aristocrats in the salon of Louis XVI. As near as I could tell, to be a gallant requires the observance of certain obliging forms by the men—not a powdered wig and white man-makeup, perhaps, but the waving of a white flag in the battle of the sexes, with the expectation that such gestures will win approval from the women of this milieu. In the eighteenth century, very similar norms prevailed in the ruling class of a society that was about to collapse.

ACT III: HARE SCRAMBLE

On Memorial Day weekend, 2018, I rode east on Route 10 to Surry, Virginia, to watch my friend Barron compete in a hare scramble race. These are motorcycle races through the woods on dirt bikes. Today's course was about six miles long, tight and winding, and the adult riders would make five laps through it. The clothing, gear, and paint schemes are so uniformly garish and busy with brand names that it is difficult to make out where the boundary of rider and machine lies. Picture a hybrid human shape, like a centaur, standing on the pegs of a trail bike as it comes powersliding around a crook in the trail, launching off a bump and straight toward an oak tree, yet somehow banking in midair. The expert riders seem to steer with their asses, planting the airborne rear tire into the dirt to the left, to the right, and back, a rhythm of brief rooster tails and body English that merge into a high-speed, floating motion through the trees. The accompanying sound is the raspy, tinny high-revving of a two-stroke intermittently engaged, its instantaneous throttle response helping to steer the bike. The very best riders look like animals as they do this, as though this mode of movement had evolved over eons: strange and beautiful predators who bring the speed of the open savannah to the dark and intimate confines of the forest.

Because the course is so tight, there are very few opportunities to pass. So the start is crucial. The riders leave in successive waves a couple of minutes apart, from a line five to fifteen abreast depending on the number of entrants in a given class, starting in an open pasture. Each vies for the "hole shot" that will get them into the lead before the first turn. It's a chaotic free-for-all, with wheelies off the starting line, contact between bikes and riders sometimes going down in the first hundred yards. There is no impartial judge to declare a foul or false start, just a bunch of grown-ups doing it for themselves.

Except some of them are far from grown up. The Pee Wee classes (ages 4–6 and 7–8) start in the same way. Even more than the physical rigors of the sport, this absence of an authority figure to complain to makes an impression, if one is inclined to wonder what makes a kid tough.

The first races of the morning were of these children's classes; they were already in progress when I arrived. I noticed the occasional ponytail sticking out from under a helmet. The first race came to an end and the riders started pulling off their helmets, and sure enough, about a quarter of them were girls. They do not have a separate class; they just line up with the boys and go for it. Some of them go on to become "wicked fast," Barron told me, and race as Expert Women.

There is no supervisory entity making sure there is gender equity in the sport, nor does there appear to be a culture of special solicitude for women. They just show up and race. I talked to some of the Expert Women at the race. Most of them grew up in a family of riders, and getting on a motorcycle was as natural as getting on a bicycle.

There is something interesting going on here. If you are alert to it, you may be struck by a certain unforced ease of gender relations among elements of our society that do things like ride dirt bikes. Going back and forth between such precincts and the tidier scenes of upper-middle-class culture, one becomes aware of a contrast; a different flavor to relations between men and women. May we digress into this?

AN ODE TO REDNECK WOMEN

In those segments of society that are more geared into institutions, more dependent on them for the certifications and gold stars that keep people moving through the abattoir funnels of the meritocracy, there is a program of empowering young women that we have gotten used to. As a father of daughters, I gladly participate in it. Stepping outside that world, one sometimes catches a glimpse of a less administered scene, something closer to the self-governing "voluntary associations" described by Tocqueville. In contrast with girl power as an institutional mandate, in these informal scenes there is no bureaucratic authority making sure all girls feel properly, equally empowered.

I was surprised by the number of female riders at the hare

scramble. Heartened, too, as I would like to get my daughter J on a bike—simply because I think it would bring her joy. It got me thinking. What makes for strong women? The image of the female ass-kicker has become ubiquitous in advertising, in superhero movies, and in the violent female revenge fantasies that have become a staple of popular entertainment. The very qualities that are called "toxic" in a man often seem to count as "empowerment" in a woman. But the process by which our heroine became so formidable is an imaginative blank that rarely gets filled in.

Clearly, a lot of hope is placed in propaganda. I mean all that girl-power affirmation in schools, universities, the corporate workplace, organized youth sports, the parenting advice industry, corporate journalism, and so on. But the result too often has been a brittle fragility, to judge from the atmosphere of sexual paranoia and victimhood that prevails in upper-middle-class institutions around questions of gender. Administrative mandates and therapeutic regimens multiply—speech and behavior are ever more closely monitored—to protect the delicate sensibilities of our empowered young women. So maybe we should look further afield for an answer to the question of what makes women strong, beyond the social locations where this apparatus reliably turns its own failures into reasons to extend its reach yet deeper. In their relatively unmonitored social relations, the rednecks may have something to teach us.

As a way into this, consider Marilyn Simon's account of working at a twenty-four-hour restaurant as a fifteen-year-old girl, and being subject to relentless sexual harassment. Initially mortified and embarrassed, she soon found herself dishing out ribald comments to rival the line cooks.

I soon realized that, although one of them would proposition me a number of times during an eight-hour shift, I had the power to reject him—not just reject him but to do so with a playful insult that then made him the butt of jokes along the short order line for the rest of the shift. . . .

It was the very indecency of the back of house culture that made working at that 24-hour restaurant a tolerable job, and it was all the vulgar insults of the workplace that gave a kind of gritty dignity to our work there. Working there one became part of a family. Flouting the rules that govern social niceties, which had to be observed carefully in the restaurant dining room, was the initiation into the clan. What I've learned since that summer is that the culture of that greasy spoon kitchen has a rich anthropology; it's the type of community that populates the taverns of Shakespeare's plays, for instance, and it functions in direct opposition to officialdom. Its currency is an abundance of filthy lightheartedness, and its economy subverts the normative claims of merit and respectability, those two pillars of social authority and middle-class morality. In the kitchen, the more horrible you are, the better! The profane free culture of the kitchen was the antidote to the polite restraint of the dining room, as it is to the ethic of rigid inoffensiveness that governs our politically correct culture.1

Before one of the Novice races (for teenagers) I heard a woman who looked remarkably like Roseanne Barr bark at a lanky young man who was suited up in his riding gear, but had a hesitant look on his face: "Quit being a fucking vagina!" I had never heard this locution before, and was a bit taken aback. It was perhaps a saltier version of the sentiment that Plutarch records among the Spartan women, who would tell their sons going off to battle, "Return with your shield, or on it." The lower middle class is where patriarchy is said to remain the most unreconstructed. Yet such patriarchy, if that is what it is, appears quite compatible with cocksure women who seem to have no problem controlling their men—if necessary, by berating them to "man up."

Perhaps the class difference lies not in the matter of who wears the pants, but rather whether the ruling attitudes correspond to "male norms" or "female norms," to adopt terms used by the sociologist Patricia Sexton, writing in 1969. I know, this sounds terribly "binary" by today's standards. But Sexton's point is that either of these dispositions may be adopted by both sexes, or by neither. Their cultural dissemination and adoption is variable, yet the dispositions themselves are discernible as coherent clusters of values and behaviors. On Sexton's account, both the men and the women in upper-class society adopt more feminine norms, compared to the working class.² If we combine this proposition with Simon's insights about solidarity in back-of-thehouse restaurant culture, we can then entertain the following thought: perhaps the use of coarsely sexual language is, yes, a male norm, but one that sometimes serves not to terrorize women but to mark out a class boundary, on the other side of which lie the pearl clutchers.

On Sexton's account, working-class women prefer their men to be manly, and in that respect may be said to accept male norms as valid, even crucial. The standard feminist response is to say that in doing so, they suffer a false consciousness that guarantees their subordination. But that is hard to square with what one sees.

In fact, working class "patriarchy" can look an awful lot like matriarchy. A good depiction of this can be found in the television show *Sons of Anarchy*, about a motorcycle gang in northern California. Gemma (played by Katey Sagal), mother of the putative gang leader, Jax, and widow of the gang's founder, rules not as a mitigating or elevating feminine influence, but from within the male norms of the gang itself, which she entirely shares. She is both tough and womanly: super sexy.

Nietzsche gave a typology of three kinds of lovers. The highest kind longs not for a woman who will save him, a virgin reformer, but for a woman who will love him precisely for his wickedness. Gemma is that kind of woman, a literal partner in crime who spurs her son to a more clear-eyed ruthlessness. And there are indeed hints of an Oedipal dynamic at work between them. He wants to live up to the standards set by the father who won her. As Rousseau said, if you want men to be virtuous, teach women what virtue is. That seems to apply whether one is talking about pagan virtue or Christian virtue, male norms or female norms. Men will make themselves into whatever women prefer.

Plutarch relates that when the army of a certain city was routed, retreating to safety within the city walls, the mothers of the city blocked the gate against them, climbed up on the wall, lifted their skirts, and said, "What are you doing—trying to climb back in *here*?" The army went back out to fight, and prevailed.

But we have wandered to the topic of what makes *men* strong (answer: women who demand strength). We started with the question of what makes women strong, and let us return to it. I posed this question to a woman friend, Jess, after describing what I saw at the hare scramble. She said it is simply by "doing stuff, without focusing on the fact that you are a woman doing it." This sounds right, even obvious in retrospect, and suggests that at bottom men and women are not so different. It eloquently captures the attitude, or lack of attitude, among the women racers.

But Jess went on to name an obstacle to such straightforward "doing" that women are especially subject to in our society, which she called "an overcomer complex," ironically enough. I took her to mean the seductions of a certain moral valor that women are encouraged to claim for themselves in doing something *as* a woman, on the premise that this requires a special struggle against oppression, on top of whatever challenges may be intrinsic to the activity. This invites one to stand at one remove from the activity, self-consciously. Yet it is only through full immersion that one gets good at anything. The most impressive and successful women, like their male counterparts, seem not to feel burdened with responsibility to advance the arc of History; they just do what they do, and find their satisfaction in meeting the demands of their craft.

I wandered around the muddy pasture as the Expert Women were getting staged, making final adjustments to their bikes, wiping down their goggles, and getting lined up for their heat. I talked to one woman who appeared to be in her early thirties. She had less of a game face on than some of the others, so she was a bit more approachable. She had started racing just a few years earlier, after having kids, and absolutely loved it. I asked her about the culture of the sport, what it was like being a woman in this setting. Unfortunately, just then the horn blasted: thirty seconds to the start. The pasture exploded with the sound of engines starting, revving high and getting the cobwebs out. I didn't want to make a pest of myself at such a moment, but I also really wanted to know. I leaned in closer to her helmet and shouted, do you think this is EMPOWERING?

I can't say for sure if she heard me right. Maybe she only heard the more familiar syllables of "power." In any case, she shouted, "Try a two stroke! Thirteen-to-one compression!"

Just then the final horn blast sounded and she was off, sending a rooster tail of mud onto my notebook and bespeckling my glasses, her front wheel dancing in the air as she fought to get the hole shot ahead of the others.

DEMOCRACY IN THE DESERT The Caliente 250

I head out of Las Vegas in a rented Hyundai Accent on Interstate 15 for twenty miles, then onto Route 93. At the junction is a truck stop. As I contemplate the emptiness ahead of me, it seems prudent to stop and check the rental car's fluids, and stock up on water for myself as well. Soon I am back in the driver's seat, headed north on a two-lane ribbon through vast high desert, with a peak off to my right. As the sun sets haltingly behind the Sheep Range, three enormous, twin-rotor military helicopters slowly pass me, flying low off to my left in formation. They rise in unison to clear a ridge ahead and then disappear.

The Hyundai disappears from my awareness. The terrain is sparse chaparral at first, which over the next hundred miles gives way to cacti and freakish rock formations that make one wonder at the fecundity of mere geology. Piles of smooth, beach-ballsized rocks look like they have been carefully stacked into place by some ancient tribe of stone worshippers. After enjoying the vacant thrum of the wind and the tires for an hour or two, I turn on the radio expecting nothing at all. But this car has satellite radio, and I soon find a station that seems well matched to the landscape: classic Western or "cowboy" music from the 1930s. The songs are beautiful. I have never noticed such music before.

I stop to relieve myself, pulling onto the shoulder and shutting off the engine. The stillness of the desert is truly complete, the sky a fading blue-black twilight. The sound of my own footsteps on the gravelly soil is exaggerated, my presence bare to the sky. There aren't many creatures in the desert.

I am on my way to a town called Caliente, without a solid plan. I *had* a plan but it fell through, so my mood now as I pull into this sleepy settlement is alert and opportunistic. More sociable than usual, looking for an angle—just the sort of lone male you want rolling into your small town in a rental car. (We are subject to a different sort of scrutiny than the lone female traveler.)

My room at the Rainbow Canyon Motel is well situated on the ground level, where I have brought the folding metal chair out from the room and set it under the awning with a bag of pistachios and a tall boy. From here I can monitor the comings and goings at the town's lone gas station and convenience store, fifty yards away. The air at night is just the right temperature, and it does not cling to your skin like the summer air in Virginia. Around the lights of the gas station there is no cloud of mad insects.

My situation is this. I had arranged with Dave Hendrickson to be a codriver in his race car for the SNORE Knotty Pine 250, a 250-mile desert race put on by the Southern Nevada Off Road Enthusiasts. The acronym SNORE may be taken as a sardonic rebuke to SCORE, the body that puts on the high-dollar, mediasaturated Baja 1000. The problem was, Dave broke his foot at his last race, and now I was without a ride, hoping to make a new friend fast. While sitting at the breakfast counter of the all-purpose Knotty Pine establishment the following morning, I meet Carl Tygum, an eighty-five-year-old gentleman with gold teeth who moved to Caliente in 1982 and has worked as a "timber jack" and a miner. He recites some of his poems for me, and tells me how when he was a baby in South Dakota nearly his whole settlement died of cholera, but he was saved by two Native American women who knew the right remedies.

In the parking lot of the motel I meet Greg Meyer, a fiftysomething nomad living out of a small camper that appears to be of 1980s vintage, with a very friendly pit bull. Strapped to the back of the rig are a couple of shovels, a rake, a bucket, a rug, and some other implements for making campsites comfortable, a bumper made out of scrap aluminum extrusions, a bloody skull mounted to the dash, a message about Jesus stuck to the side, and the twelve-foot-long stalk of a century plant (a species of aloe) slung low along the side of the camper, for use as a teepee pole. He speaks energetically and with real conviction about the blessings of divorce.

I notice a small group milling about outside the Agape Baptist Church, just across the gravel road from my motel. I wander over to see what is going on, and am informed by Peg (not her real name) that their AA meeting was just letting out. She appears to be in her early sixties, and she tells me there are seven churches in Caliente, including Baptist, Methodist, and Catholic, as well as the Mormons who are a majority. One of her fellows said there are more churches than bars (which latter, by my fairly assiduous count, was two: the Knotty Pine and the Shamrock).

But none of these people are racing this weekend. So I start driving around, to see what there is to see. With the exception of the bright Sinclair gas station and a Family Dollar Store, Caliente looks like a place that time forgot, a ramshackle Western railroad town bleached by the sun and dotted with businesses that look like they have been deserted for decades. Many of the houses are double-wide trailers to which carports or other extensions have been added. Just past the Union Pacific rail yard lies the Caliente Youth Center. As I would learn shortly, it is one of three facilities in the state for housing juveniles who have been committed. According to Tina, a cashier at the Family Dollar Store, Caliente itself is a strong community in which children are taught to be helpful: they often bring in shopping carts that have been left in the parking lot, she says, or gather guppies from the stream to stock a neighbor's pond. She says there is very little drugs or other problems, despite Lincoln County being one of the most impoverished in the state.

The majority of residents are Mormon. Somehow the town is run-down without feeling seedy. It isn't stocked with mute, menacing Scots-Irish people, like the rural communities I usually pass through. Out West in the desert states, a visitor doesn't get that heavy vapor of suspicion that makes him want to keep to himself.

Or maybe the difference lies with me. I have found that when you are on the road by yourself without a plan or a host, you open yourself to others with less prejudice, and this can affect the way they receive you. It's good to get out of your own clotted-up life for a spell. Your tired internal monologues start to drop away, as do all those roles, stances, and resentments that attach you to your usual haunts and define you, too much.

I headed over to the meet and greet at the elementary school, a long-standing tradition in which the racers line up their cars outside the school, shoot the breeze with one another, and sign autographs for kids the day before the race. Tina, the cashier, tells me that the local kids grow up idolizing the racers, and some families have manned the same race checkpoints and pits for generations. The more prominent racers hand out cards or small posters with a photo of their car airborne through the desert. One team was handing out beads, Mardi Gras style. I talked to one grizzled old veteran who has been desert racing since 1970 and was here to support his daughter's car in the 1600 class. Others, such as Kenny Freeman, have been doing it since the early 1980s (Kenny would go on to take second place in 1600 at this race). Joe David, who took the Class 1 and overall victory in last year's race, is the son of Tom Koch, a former Mint 400 winner.

Dave Hendrickson, my erstwhile driver, told me to say hello to a few people in his absence, so I had at least that by way of introducing myself. One of these was Journee Richardson, who wears pink, has a pink trailer, and drives a pink 1600 car with #Team-Boob stenciled on the front. Dave is one of the elder statesmen of the sport, and told me he regards Journee like a daughter. He and his sons have helped with her car when she needed it. For her part, she says the race community is like a family to her, and that they take care of her. She also happens to be quite fast. On her calling card is a picture of herself leaning against the front end of her car, wearing a tank top that says, GIRLS GET DIRTY TOO! Later that day, after prerunning, I ask her how she likes the course. She says it's too smooth.

"I like it rough," she says.

"Oh," I say.

During a pause that may have lasted half a beat too long, I try to keep my eyebrow from arching. "Like Barstow," I say. "Exactly," she says, with an equally straight face.

The prerace drivers' meeting convened at seven thirty that evening in the school gym. There were speeches about state and federal land management issues, the hazards of wildlife, and the peculiarities of the course, in which there was limited room to pass in many areas, and curves where you really do need to go slow. "Be patient. It's not going to be easy. Use your head." There was a strict speed limit in the section of the course that passed through town, enforced only by the honor system. At stake was a long tradition of good relations between SNORE and the people of Caliente. This appeared to be a case of something described by Tocqueville: a voluntary association of people who come together around some interest and work things out for themselves. He regarded such forms of association as the nursery of democratic virtue, and of what was best in the American character.

"Children in their games are wont to submit to rules which they have themselves established, and to punish misdemeanors which they have themselves defined." Thus did Tocqueville marvel at Americans' habit of self-government, and the temperament it both required and encouraged from a young age. "The same spirit," he said, "pervades every act of social life." Writing in the *Atlantic*, Yoni Appelbaum notes the sheer bulk of voluntary associations that once took up the hours and days of Americans, from labor unions and trade associations to mutual insurers, fraternal organizations, and volunteer fire departments.¹ Toward the end of the twentieth century, however, this way of life more or less collapsed, as the Harvard political scientist Robert Putnam documented in *Bowling Alone*. We still have voluntary associations, but they are now typically run by salaried professionals, not the members themselves.

The phrase "use your head" was used a number of times at the meeting. This has become a somewhat foreign-sounding dictum in our highly managed and litigated society, in which people increasingly expect some certified-safe experience to be handed to them for money, as at an amusement park. And correspondingly, wherever large groups assemble there is an imperative to *control* every aspect of the environment, and prescribe every move—every allowed use. Usually it is some private entity that does this, not the government. Worse, it becomes an unthought posture we adopt for ourselves, having been trained to think of ourselves as consumers of manufactured experiences rather than as rational creatures capable of dealing with the world in an unfiltered way.

That doesn't wash out in the desert, under an open sky, amidst

the rattlesnakes. There really is something to the notion of "Western liberty," as against the crowded Eastern states where you can sense that the air you breathe has already been exhaled by a whole continent's worth of people on its easterly course, loaded up with moisture and expectations of compliance. Yet the mood among the racers is clearly *not* one of social defiance: given the responsibility they assume for themselves, their posture is inherently adult rather than adolescent.

I had failed to insinuate myself into a last-minute codriver seat the day before the race, which was no surprise. A mere scribbler from Virginia, I had nothing to offer by way of first-aid skills, a strong back for righting a rolled vehicle, or intimate knowledge of any particular vehicle's systems and construction. Wandering around the staging area as the various classes took off in successive waves, I was able to record the state of the art of folk engineering in the off-road world. In the pressure cooker of competition, what works and what fails is revealed more definitively. Refutation and refinement iterate more quickly. In the decades since I became enthralled with the Volkswagen-based Class 5 (Unlimited Baja Bugs) as a teenager, the amount of suspension travel in these cars has increased quite a bit, allowing softer spring rates and higher speeds through the rough stuff. The fastest classes, called trophy trucks, didn't exist when I was young. Nobody in the 1980s would have thought it possible that a six-thousand-pound vehicle could go over a hundred miles per hour through big bumps in the desert, but that's what forty inches of suspension travel and massive, externally cooled shock absorbers have accomplished. The trophy trucks were initially one-off, highly experimental creations, but the designs have converged.

As a spectator, I positioned myself at a few different spots over the course of the day-long race. Near the start, the cars had to traverse a cattle bridge so narrow that their tires partially hung over the edges on either side. Some drivers came to a stop before attempting the traverse, as though steeling their nerves for it, while others seem to think it better to keep a steady flow, their eyes on the horizon. Some even hit the gas a moment before hitting the steep ramp onto the bridge, to unweight the front of their car and make the transition smoother. I saw some near catastrophes, but nobody actually went plummeting off the bridge. (It would have been a fall of perhaps twenty feet, into a dry creek bed.)

Reaching the far side of the bridge marked the beginning of competition, as it was here that the in-town speed limit was dropped. The first miles were especially picturesque as the course meandered tight against the wall of red-dirt butte. From the paved road, I saw one Chevy Blazer of 1970s vintage get out of shape in this area, roll down an embankment, and come to a rest on its side in the creek bed. As the course receded farther into the desert, its path could be made out from a distance by the contrails of dust that rose high into the clear blue sky.

Next I positioned myself midcourse, which required driving the rented Hyundai down a dirt road that eventually intersected the path of the race. At this intersection there was a checkpoint where a few race teams had stashed fuel, spare tires, and other parts. Two of them had impressive chase-truck rigs, fitted out with mobile workshops for handling emergency repairs. The terrain here was more open, the course a silty wash through desert shrubs and cacti. The fastest cars I saw were going perhaps sixty miles per hour here, though it was hard to judge their net forward speed amidst all the extraneous motion, up and down and side to side. Occasionally one or two cars were bunched up behind a slower one, unable to pass and probably unable to see from the dust. The cars have bright red lights shining backward to help prevent collisions, but they are little match for the thickest clouds.

From here I made my way back to town and found a perch at the end of the course, where the cars descend a long, steep, and rocky hill that looms over Caliente, directly behind the Shamrock. The racers call it Oh My God Hill. I had walked up this hill earlier in the day. It is so steep in parts, and the surface so loose, that descending it on foot was a challenge. Standing now at the bottom of this section, I was amazed to see (or rather hear) that the most confident drivers were actually on the throttle down this hill. At this late point in the race, many of the cars didn't look or sound too good. I heard distressing sounds of unlubricated, metal-on-metal unhappiness, and fiberglass body panels flapping in the breeze after some mishap I could only imagine, now tethered to the car only by safety wire out of a gallant determination not to litter the desert. And this brings me to a bit of literary criticism: I have a strong suspicion that Hunter S. Thompson was quite off in his depiction of the Mint 400 in his 1971 book Fear and Loathing in Las Vegas. To be sure, that was a different era, and maybe desert racing in 1971 bore little resemblance to what it is today. But I doubt it. Rather, what is different is the surrounding culture, and the uses to which desert racing could be put by an ambitious writer.

It was an era during which a cohort of relatively affluent young people in certain metropolitan centers took itself to be in the vanguard of an anarchic, Dionysian revolt against the heavy hand of social responsibility. Thompson made himself one of the avatars of this cultural mood, in his highly performative way, and it was clearly with such a project in tow that he had his encounter with desert racing (on assignment for *Rolling Stone*). By his own admission (or boast), he seems barely to have noticed the race itself through the haze of drugs he brought with him from Los Angeles.

I didn't even know who'd won the race. Maybe nobody. For all I knew, the whole spectacle had been aborted by a terrible riot—an orgy of senseless violence, kicked off by drunken hoodlums who refused to abide by the rules. This is the Ken Kesey–meets–Hell's Angels cultural stew that Thompson served up consistently, with himself as the main ingredient, regardless of the milieu he was ostensibly reporting. But desert racing is a scene that rewards meticulous mechanical preparation and sustained focus, not inebriated abandon, so it wasn't the best venue for his shtick.²

IN THE HAZY afternoon hours after the race had finished I found a perch at the Shamrock. The bartender Mike seemed somehow unacquainted with bourbon, though I spied a bottle of Makers and directed him to it. There I met Victoria Hazlewood, a twentysomething new to desert racing, and a codriver in one of the heavier buggy classes. Her car had some kind of mechanical issue, came to a stop, and got rear-ended by another going about eighty-five miles an hour (visibility is sometimes close to zero). She said she must have blacked out for a few seconds, because she doesn't remember it. I said, "Jeez, you better get yourself checked out." She said, "Eh. I'm used to it. I ride rodeo." An hour later, I saw her onstage at the awards barbeque at the fire station, handing out plaques to winners in the various classes.

What is a community? It's the kind of thing a person might be called upon to make a speech in front of. First- and second-place finishers came up one at a time and were handed a microphone. It was time to say something worthwhile, and make a good showing.

One man took the occasion to mention a fellow competitor and his wife, whose truck and trailer had rolled over on the way to the race and had to be airlifted to the hospital. He dedicated his first-place finish to them, and encouraged others to visit them in the hospital. Speaking in front of a large group isn't something most people have many occasions for. It is a moment of showing yourself in speech. It is your whole body that is exposed; you feel the adrenaline in your blood, the clammy sweat on your palms,

DEMOCRACY IN THE DESERT | 209

tightness in your throat, the possibility of disaster. Between the awards ceremony and the drivers' meeting, I was struck that this is a community that generates and renews itself through speech as well as action. The actions are all directed toward winning individual and team distinction, while the speeches are occasions to demonstrate regard for the common good. I had watched one little boy sit in the front row of the drivers' meeting at the gym. He listened intently to the serious business of the adults, and I wondered at the education he was receiving. For here was something like the New England town hall meeting described by Tocqueville, a school of citizenship that shows each June in the Nevada scrub like an annual desert bloom.

Self-Government, or Not

We look with profound contempt upon the way in which savages cling to their lawless freedom.

-Immanuel Kant, Perpetual Peace

PRELUDE The DMV Experience

The DMV was packed. As the registered owner of five motorcycles (one of which actually runs), four cars (two running) and two trailers, I knew the drill. I stood in line to get a number, which put me in the sitting line. My number was S37. The monitors read

Now Serving: B34 P181 R211 R209 T88 B33

I took a seat and assumed the position—that posture you settle into when you know not what will befall you, nor when. I have developed my own practice for the DMV, inspired by the ancient wisdom of the East: surrender. When I set out for the DMV twenty minutes ago, my ego-self was still caught up in its own attachments, its plans and projects for the day. Foolish man.

The inscrutable numerology of the queue surely serves some purpose internal to the DMV. I suspect the HR department has quotas and schedules for tasks that fall into different categories: a straightforward registration renewal for someone who has his documents in order probably serves as a breather, a respite from the miasmic cases that require the higher-level wisdom of a senior court mandarin. According to the tenets of industrial psychology, the easy cases need to be metered out in a way that motivates and soothes. Soothes the employees, that is.

But for we who sit in the fixed plastic chairs, the unknowable quality of the queue seems designed to induce deep resignation to the apparent arbitrariness of a bureaucratic logic that above all tends its own internal conveniences. Going to the DMV is a civic education in submission to a type of authority that relies on unintelligibility to insulate itself, much as the airlines rely on concepts like "system error" to suggest that the consequences of management's decisions lie beyond human knowing.

In this we see the revival of what is really a premodern form of authority. We take ourselves to be ultramodern, but the peculiar quality of institutional life in the United States would seem to be taking us in the opposite direction, damaging citizens' faith in the power of logic to make sense of the world. What is at issue is our readiness to make an effort of understanding, and trust in our own powers of comprehension. These are features of the republican personality as articulated by various Enlightenment figures, but they are not what is wanted by the systems that administer us. In the following chapters, we're going to get into this.

"RECKLESS DRIVING"

Rules, Reasonableness, and the Flavor of Authority

In *Fear and Loathing in Las Vegas*, Hunter S. Thompson offers some wonderfully ill-advised advice for dealing with cops:

About five miles back I had a brush with the CHP. Not stopped or pulled over: nothing routine. I always drive properly. A bit fast, perhaps, but always with consummate skill and a natural feel for the road that even cops recognize. No cop was ever born who isn't a sucker for a finely-executed hi-speed Controlled Drift *all the way around* one of those clover-leaf freeway interchanges.

Few people understand the psychology of dealing with a highway traffic cop. Your normal speeder will panic and immediately pull over to the side when he sees the big red light behind him . . . and then he will start apologizing, begging for mercy.

This is wrong. It arouses contempt in the cop-heart. The thing to do—when you're running along about a hundred or so and you suddenly find a CHP-tracker on your trail—what you want to do then is *accelerate*. Never pull over with the first siren-howl. Mash it down and make the bastard chase you at speeds up to 120 all the way to the next exit. He will follow. But he won't know what to make of your blinker-signal that says you're about to turn right.

This is to let him know you're looking for a proper place to pull off and talk . . . keep signaling and hope for an off-ramp, one of those uphill side-loops with a sign saying "Max Speed 25" . . . and the trick, at this point, is to suddenly leave the freeway and take him into the chute at no less than a hundred miles an hour.

He will lock his brakes about the same time you lock yours, but it will take him a moment to realize that he's about to make a 180-degree turn at this speed . . . but you will be *ready* for it, braced for the Gs and the fast heel-toe work, and with any luck at all you will have come to a complete stop off the road at the top of the turn and be standing beside your automobile by the time he catches up.

He will not be reasonable at first . . . but no matter. Let him calm down. He will want the first word. Let him have it. His brain will be in a turmoil: he may begin jabbering, or even pull his gun. Let him unwind; keep smiling. The idea is to show him that you were always in total control of yourself and your vehicle—while *he* lost control of everything.

How often do our confrontations with the law have this concrete quality, where the Man is actually a man, and may be presumed to harbor human qualities behind the mirrored sunglasses? Including, quite possibly, the quality of being a bastard. It's the mustache that gives him away: here is someone who understands a good old-fashioned pissing contest, and though I will certainly lose the legal fight, the human fight isn't entirely effaced behind impersonal mechanisms, whether bureaucratic or technological. It's one thing to lose a fight, another to be imperceptibly suffocated under the insistence that there is no fight, only the operation of disinterested reason. Hannah Arendt called this "the rule of Nobody."

THE SAFETY-INDUSTRIAL COMPLEX: BEHIND THE CURTAIN OF PUBLIC AUTHORITY

Speed cameras are getting destroyed around the Western world, not in haphazard acts of vandalism, but in something that more closely resembles a political insurgency. Can this safely be written off as mere libertarian peevishness of the sort that comes naturally to adolescents and other malcontents? In some settings, it presents rather differently: as an especially concrete manifestation of a wider crisis of political legitimacy that has been brewing for some time in the Western democracies. The hunch I want to explore in this chapter is that the anger provoked by *automated* traffic enforcement, in particular, can shed light on our political moment.

In ever more areas of life, algorithms are coming to substitute for judgment exercised by identifiable human beings who can be held to account. The rationale offered is that automated decisionmaking will be more reliable. But a further attraction is that it serves to insulate various forms of power from popular anger.

Our readiness to acquiesce in this is surely due in part to our ideal of procedural fairness, which requires that individual discretion exercised by those in power should be replaced with rules whenever possible, because authority will inevitably be abused. This is the original core of liberalism, dating from the English Revolution.

Mechanized judgment *resembles* liberal proceduralism. It relies on our habit of deference to rules, and our suspicion of visible, personified authority. But its effect is to erode precisely those procedural liberties that are the great accomplishment of the liberal tradition, and to place authority beyond scrutiny.

Our larger purpose here is to understand why so many people feel angry, put-upon, and powerless. And why so many, in expressing their anger, refer to something called "the establishment," that shadowy and pervasive entity. What is at stake is the qualitative character of institutional authority—how we experience it.

IN FISCAL YEAR 2016, the District of Columbia took in \$107.2 million from its photo radar traffic enforcement cameras. Throw in red light cameras and parking tickets, and the figure comes to \$193 million, accounting for 97 percent of all fines and fees collected by the city.1 The rationale offered by the police is, of course, safety. Shortly after the program of automated traffic enforcement was launched, the chief of police took great offense at the suggestion that money might be driving it. Yet it seems the intersections where the cameras were installed were selected not because they were particularly prone to accidents, but rather because they had the greatest volume of flow and the shortest yellow lights. In their pitch to the city, the company that installed the cameras (a subdivision of the defense contractor Lockheed Martin) is reported to have emphasized that the vast majority of motorists cited would be commuters who live in Virginia and Maryland, hence not DC voters. Essentially it was free money being offered, a revenue stream completely insulated from political blowback. We cannot refrain from noting that the motto on DC license plates is "No Taxation Without Representation."

The growing automated traffic enforcement regime in the Unites States has been documented in some outstanding investigative journalism. The case of Washington, DC, was reported by Matt Labash in a five-part series published in the *Weekly Standard*. The case of Chicago has been presented in an ongoing series of deeply reported pieces by David Kidwell in the *Chicago Tribune*. Together with the scientific studies and government findings they cite, these provide a clear picture.

The duration of a yellow light, or "amber time," is one of the most reliable safety tools in the traffic engineer's bag of tricks. One might naïvely suppose that as long as the duration is consistent, drivers will adjust their behavior to match. But it is a fairly complex set of events that occur in the mind and body of a driver when the light turns yellow. Perception-reaction time is largely invariant for any given individual, a function of his or her neural wiring at a fairly "low level" (as the neurophysiologists say): how long does it take for the yellow light to get processed into an "action plan" and sent down the pipeline to generate the appropriate muscle responses? Individuals vary in this, and it is prudent to set amber times to accommodate the least catlike among us (the assumption in the formula used by the Institute of Transportation Engineers' Traffic Engineering Handbook to calculate amber time is a reaction time of one second). But there is another layer to our response that takes place at a higher, properly "cognitive" level and goes more slowly: you have to decide whether you are going to stop or continue through the intersection. Traffic engineers call this the dilemma zone. "Drivers have to make an instantaneous decision when the yellow light comes on," said one traffic expert quoted in the Chicago Tribune. "How far am I from the intersection? How fast am I going? How much time do I think I have? How long is the yellow light going to be?' And some drivers are going to make the wrong calculation, and maybe enter the intersection a fraction of a second after the light has turned red. It's not because they are doing it intentionally or aggressively," he said. "They just made a wrong calculation." Another expert quoted in the same story said that the problem with a yellow light that is too short is that "you are forcing the motorist to make a decision to either decelerate too quickly or to speed up to get

through the intersection. And that should not happen. If you are going to err, you don't want to set it too short."

The shorter the yellow light, the more compressed the dilemma zone is and the more variability there will be in how the driver in front of you responds to the appearance of the yellow. His behavior becomes less predictable. Increasing the duration of a yellow light even by a small amount, say from three seconds to three and a half, has a big effect in reducing collisions at an intersection, and it is free.²

But evidently free safety isn't nearly as appealing to the authorities as free money. As of 2016, Chicago's red-light camera system had brought in about \$600 million. The city's transportation website claims to follow the standard ITE formula, but investigative journalists from the Chicago Tribune discovered that the city tinkers with the equation's assumptions to generate shorter yellows, using a deceleration rate of 11.2 ft/second/second rather than the ITE's recommended 10 ft/sec/sec. They also assume cars are traveling at the posted speed limit, rather than surveying the actual speeds at an intersection or making more realistic assumptions, as traffic engineers urge municipalities to do. In 2014 the Tribune hired traffic researchers at Texas A&M University's Transportation Institute to conduct a study of Chicago's red-light camera system. They found that "the city routinely placed cameras at intersections that had few if any injury-related crash problems, leaving the cameras little room to improve safety. At the same time, experts found, the unnecessary cameras at more than 70 intersections prompted many drivers to slam on the brakes in efforts to avoid an automated ticket, causing a significant increase in injury-related rear-end crashes near cameras throughout the city." In 2016, the paper reported that "most of those cameras are still snapping photos-and raking in millions of dollars in traffic fines for City Hall-even though Mayor Rahm Emanuel and his transportation chief were given scientific evidence more than a year ago that showed many of the cameras are causing more injuries than they prevent."³

The firm that installed the cameras, Redflex Traffic Systems, is based in Australia. Now, a company from outside Cook County, to say nothing of another continent, doesn't just go waltzing into Chicago hoping to make big money without first establishing the right . . . relationships. The firm needed somebody to school them in the Chicago Way, and point out which of the aldermen and other relevant members of the City Hall ecosystem *take an interest* in the safety of the citizens. Think of the children!

Enter John Bills. He began his career with the city in 1979 as a street light repairman. But his real skills lay elsewhere. The *Tribune* reports that "for more than two decades, Bills was a top-earning precinct captain for Madigan's powerful 13th Ward political organization, rising through the patronage army as an early employee at the city's Bureau of Electricity, known by city workers as 'Madigan Electric' because of the number of 13th Ward loyalists employed there." Bills worked his way up to second in command at the city's Department of Transportation, where for about a decade he "accepted up to \$2,000 in cash bribes for every new camera that he ordered installed throughout the city."⁴

When you've got that kind of action, you're going to have challengers. The *Tribune* reports that "a competing camera company had aligned itself with Ald. [Edward] Burke, 14th, the powerful chairman of the City Council's Finance Committee." Burke "was working hard to torpedo the [Redflex] deal so it could go to his favored vendor, Automated Traffic Solutions—a company that had hired a longtime Burke ally as a subcontractor."

The net haul of Bills, the transportation manager, was about two million dollars before he found himself on that well-worn conveyor that runs from City Hall to the big house in Joliet thanks, as usual, to the good work of the *Tribune*. How much of that he got to keep is unclear; his attorney claims he was merely serving as a bagman for his patrons higher up the political food chain. We'll never know; Bills is the one who is now serving twenty years. The top executives of Redflex were fully informed about the kickback arrangement, as were all of the board members, in an internal memo. They have been accused of similar practices in thirteen U.S. states. It has also been a consistent pattern that when the cameras go in, amber times are reduced.

The case of Chicago, with its cast of colorful characters out of a David Mamet movie, risks diverting us from a more general truth of municipal finance: cities become hooked on any increase in revenue, and have a hard time revising automated traffic enforcement systems, even after their perverse effects have been demonstrated—or even allowing them to be debated in official circles.⁵ In 2017, the District of Columbia anticipated collecting more than \$837 million in traffic fines and fees over the next five years.⁶

There is a generalization to be drawn from these cases. Sometimes rules are deliberately formulated to be at odds with reasonableness, by parties who have an interest in the conflict this creates.

Manipulating amber times is an especially easy way to do this, but there are other tricks of the trade. The "geometric" elements of a road (lane width, shoulder width, curvature, grade) influence how we drive. Thus, if lane width is reduced from twelve feet to ten feet, the observed "free flow speed" (when traffic is light) of the average motorist on a high-speed roadway is reduced by 6.6 miles per hour.⁷ We naturally experience the increased challenge of staying close to the center of the lane and do the reasonable thing. Accordingly, there are lane-width standards that correspond to the posted speed limit; they are meant to align the law with our natural reasonableness. But to an enterprising local bureaucrat, these same facts present an opportunity. The George Washington Parkway in Washington, DC, is a notorious speed trap. The lanes are built to the 55 mph standard, but the posted speed limit is 45 mph. The reason this tactic is so effective for generating revenue is that motorists' speed is actually quite insensitive to the posted speed limit.

The Federal Highway Administration (FHWA) conducted an experiment and found that when the speed limit changed by 15 mph, the 85th percentile speed—this is the speed under which 85 percent of drivers travel—changed no more than 1 to 2 mph. In another study, the same team of engineers, headed by Dr. Samuel Tignor, formerly the FHWA's technical director for safety and research development, found that "current speed limits are set too low to be accepted as reasonable by the vast majority of drivers. Only about 1 in 10 speed zones has better than 50 percent compliance. The posted speeds make technical violators out of motorists driving at reasonable and safe speeds."⁸

One can find parallels in other policy areas where a proliferation of rules provides a sheen of rationality, but it is in the *gap* between the rules and reasonableness that officialdom feeds.⁹ Rigid sentencing laws and the "war on drugs" were indispensable to the rise of a massive prison industry. The TSA comes up with rules for a stage production of "security theater" that each of us must perform, while knowing full well the absurdity of most of it. Those machines you step into and receive a big dose of microwaves from? And the wipe-down with a towelette that is then inserted into a black box to detect explosive residue? Largely useless. The military refuses to use them; instead they use dogs if they are looking for explosives. But the machines are big business, and dog training is not. Meanwhile, independent audits that have attempted to sneak weapons onto planes have found that about 90 percent of them go undetected.¹⁰

When there is high-tech involved, as in automated traffic enforcement, we have a duty to scrutinize with special care the claims made by those who want to extract money from normal behavior, while expressing their solicitude for our well-being. Machines don't make judgments; they follow the laws of physics. They do, however, offer an image of neutrality and necessity, behind which the operation of human judgment becomes harder to make out, and harder to hold to account. The *Tribune* had to hire a team of forensic engineers from a different state to figure out what the city was up to with its automated enforcement. The real utility of a black box is that it serves to insulate power from popular anger.

This is highly germane to the way we experience public authority these days: it seems to be exercised by some entity that cannot be *addressed*, in the way that mustachioed CHP cop could be, and it may as well be located in Australia as at City Hall, for all one can tell. This surely contributes to the crisis of legitimacy that has been spreading through the liberal democracies. The "black box" quality of authority may be due to its being located in inscrutable machine logic, it may arise from the transfer of national sovereignty to opaque supranational bodies such as the European Union, or it may lay in the sociological gap between the majority and a ruling element that seems to have its own internal codes.

Toward the end of 2018, Emmanuel Macron faced mass political unrest on a scale France had not seen in the postwar era.¹¹ The Yellow Vest movement, named for the high-visibility vests all motorists are required to carry in case of emergency, marched through French cities by the hundreds of thousands. The revolt was precipitated by two measures: a fuel tax intended to reduce carbon emissions, and a reduction in speed limits. These disproportionately affected the French equivalent of "flyover country," or what the French geographer Christophe Guilluy calls "*la France périphérique*." Out in the hinterland, one must do a lot of driving, so these proposals touched on concrete interests. The interests of metropolitan professionals in finance, media, and academia—the heart of Macron's base—tilt differently. They rely on the Metro, and just as important, they inhabit a symbolic moral economy in which environmental virtue is crucial to the self-image of the class, and one of its titles to rule.

The famously well-educated French bureaucracy is drawn from this same milieu, coming up through the *Grandes Écoles*, and bleeds seamlessly into the international cadre of EU political managers. These are more likely to keep their residence in Paris than in the drab precincts of Brussels from which they issue their enlightened dictats. From the perspective of *la France périphérique*, evidently all this began to look like one big blob of bicycle moralists, electric scooter gliders-about, and carbon teetotalers.

Some hint of this cultural divide that underlies the noisier economic grievance of the Yellow Vests was evident in a photo that was published in the *New York Times* but not remarked upon: amidst the mayhem of street battles with police in early January 2019 was a bicycle that had been set on fire. It could be taken as a witty bit of trolling, directed against the self-image of the ruling class.

In his 2018 book The Revolt of the Public, Martin Gurri diagnoses the eruption of protest movements around the world in 2011-Occupy Wall Street, the indignados in Spain, and the violent street protests in London, to name a few-as a politics of pure negation, driven more by the romance of denunciation than by any positive program. These protests expressed distrust of institutional voices and a notable collapse of social authority. On left and right alike, people feel the system is rigged, to use one of President Trump's favorite words, and indeed political leaders themselves have stoked this conviction, insisting that elections lost by their side are illegitimate. This is dangerous stuff, a form of political nihilism that Gurri traces to an epistemic crisis brought on by the internet's destruction of those monopolies of information that once secured institutional authority. The Yellow Vest protesters would seem to fit Gurri's analysis, or came to do so as the movement was co-opted by semiprofessional agitators moved by the spirit of negation. But in its early phases, the Yellow Vests expressed something more substantive, and important for our purposes in this book.

The really significant material damage done by the protesters has been to France's vast network of photo radar speed traps. About 60 percent of them had been disabled as of January 2019. For the sheer scale of the vandalism. I can think of no modern parallel. How are we to understand this widespread guerrilla action? First, note that it was triggered by a reduction in the speed limit for many main roads from 90 kilometers per hour (about 55 mph) to 80 kilometers per hour (50 mph), a seemingly trivial adjustment. But also, an adjustment starting from a speed that seems a bit slow to begin with? It is hard to say, without knowing the roads firsthand. Claire Berlinski, writing about the Yellow Vests, said that with the destruction of the photo radar speed system, "The French state will lose tens of millions of euros in revenues from this. . . . In 2017, traffic yielded on average 84 million euros a month. This, of course, is exactly why the Gilets Jaunes smashed them. They believed the state was running a speedingticket racket."

Officialdom reacted as one would expect, but with an extra bit of moral muscle flexing. Christophe Castaner, France's interior minister, said, "I saw on social networks a few fools who appear next to burnt speed cameras. I do not wish for them to one day face the reality of a *death on the road*. It's not about figures, it's about life." Emmanuel Barbe, the head of France's road safety agency, said that lives had been endangered. "This damage to the speed camera network . . . will *lead to deaths*. And that makes me profoundly sad."¹²

The sadness of the functionary is profound. Death is no joking matter, and it goes without saying that *speed kills*. But let us look into this. It is certainly true that abrupt deceleration can kill. As a simple matter of physics, if two cars collide there is no doubt that

the higher the speed, the greater the damage and the likelihood of injury or death—keeping all other variables constant. But it is also true that billiard balls colliding on Newton's frictionless surface are not the most apt image for capturing the complex mix of road design, traffic, weather conditions, and "human factors" that make up the driving situation. That is why some states have a "Basic Speed Law" that overrides posted speed limits and holds motorists accountable for driving safely under prevailing conditions. The need for human judgment cannot be done away with by simple rules, yet automated speed enforcement is not sensitive to any of this.

As in every debate, statistics are one of the favorite instruments of advocates, but properly interpreting quantitative data is a more nuanced undertaking than most of us are prepared to undertake. Doing so requires access to the raw data, prior to its transformation into talking points through a process of cherrypicking and tendentious contextualization. Short of that, we can at least take note of the interests of those who use the data to persuade us of one thing or another. I can't speak to the various players in France, but in the United States, the source that gets cited the most by journalists when they write one of their click-bait genre pieces about an "epidemic" of speeding hooligans mowing people down on the roads is the Insurance Institute for Highway Safety. This entity is "wholly supported" by the insurance companies who make up its members, according to its own literature. It is not surprising that it favors lower speed limits and has taken a strong stand in favor of automated enforcement. As Labash points out, the industry "has a financial stake in seeing as many photo tickets issued as possible, since speeding and red-light infractions allow insurance companies to bleed their customers with higher premiums for the next three to five years."13

The U.S. government is presumably a more disinterested source for information about the role of speeding in crashes than the insurance industry, localities that depend on citations for revenue, or ministers in the government of a self-proclaimed "Jupiter" (Macron) with an approval rating in the low 20s trying to put down a drivers' revolt by invoking images of gratuitous carnage. The picture presented by the National Highway Traffic Safety Administration on the issue of speeding is mixed. It is complicated by some definitional issues, and the fact that statistics are compiled only for crashes involving fatalities, as it is only in these cases that police are required to gather the pertinent data, which are then entered into the Fatality Analysis Reporting System. With these methodological caveats in mind, here are the numbers for fatal crashes in 2016 (the last year for which data are available as I write) in which speeding was a "relevant factor": "Eighteen percent of the drivers involved were speeding at the time of the crash, and 27 percent of those killed were in a crash involving at least one speeding driver."14

According to its website, "NHTSA considers a crash to be speeding-related if any driver in the crash was charged with a speeding-related offense or if a police officer indicated that racing, driving too fast for conditions, or exceeding the posted speed limit was a contributing factor in the crash." It is largely up to the discretion of the responding police officer, then, to say that speed was a factor in the crash. Driving "too fast for conditions" is a discretionary judgment that I think we can trust state troopers to make appropriately, as they generally have wide experience. But "exceeding the posted speed limit" is a catchall that could, at least, gather in the great majority of drivers, given that only about one in ten speed zones has better than 50 percent compliance. Given the ambiguities of the scene that a responding officer encounters, the paucity of evidence, and conflicting testimonies, and given that he needs to check some box for "contributing factors," "exceeding the posted speed limit" has the advantage that it can be determined by relatively easy measurement of skid marks and

00

debris fields. It becomes a readily available way of cutting through the miasma, clearing the scene, and getting traffic moving again. The inclusion of the "exceeding the posted speed limit" criterion for specifying which crashes are "speeding-related" surely inflates this category. Even so, speeding has a much smaller role than both alcohol and "failure to keep in proper lane or running off the road" as a "relevant factor" in fatal crashes.¹⁵

What are we to make of the numbers? To make a sound judgment would require long immersion in the field of traffic safety research, and a disinterested assessment. Both criteria would seem to be met by a team of academic researchers at Virginia Tech, led by the former technical director for safety and research development at the Federal Highway Administration, who concluded that "most speed zones were posted 15 mph below the 'maximum safe speed,' and suggested that increasing speed limits would help increase compliance and target only the most dangerous drivers."¹⁶

IT IS CONVENTIONAL to frame the matter of speed limits as a tension between freedom and order that must be balanced. This seems roughly right. But the case of Germany is curious, and may lead one to question the necessity of such an opposition. A recent *New York Times* article pointed out that there are only a handful of places in the world without speed limits. Afghanistan and the Isle of Man are two, and the autobahn network of Germany is another. Yet Germany is a country that is famously rule bound and order obsessed in so many domains of life, with local officials dictating such things as the color of sun umbrellas. In some ways, the country resembles an American suburban development policed by the voluntary auxiliaries of a ruling Home Owners' Association, the sort that go around measuring the height of people's grass. Yet some significant minority of Germans routinely drive at more than a hundred miles an hour on their highways. Legally. Somehow these things cohere in the German personality. We will consider the origins of the autobahn, and the peculiar cultural conditions that make its unregulated speed workable, in the chapter titled "Road Rage, Other Minds, and the Traffic Community." Here I just want to briefly note that a recent controversy over the autobahn offers another data point for my thesis that popular responses to speed enforcement can illuminate broader political currents.

The *Times* reports that "when a government-appointed commission in January [2019] dared to float the idea of a speed limit on the autobahn, the country's storied highway network, it almost caused rioting. . . . Irate drivers took to the airwaves."¹⁷ Such proposals get floated about once per decade in Germany, with similar results.

Germany's drivers have long been politicized, as appears to be happening to the French at present. The issue of speed limits even prompted a rare show of solidarity between the Hun and the Gaul, those ancient enemies: with the proposed change to the autobahn, German labor leaders "menacingly put on their yellow vests, hinting at street protests." Not wanting to become a hated, Macron-like figure, the transport minister, Andreas Scheuer, quickly backpedaled and declared that a highway speed limit was "contrary to every common sense."

TRAFFIC COURT

Any speed above 80 mph counts as "reckless driving" in Virginia, even on highways where the speed limit is 70 mph. It is a Class 1 misdemeanor, punishable by up to a year in jail. In 2016 the state senate considered a bill to raise the threshold from 80 to 85 mph. According to one local report, "Democratic Caucus Chair Don McEachin (Richmond), who is a personal injury lawyer, argued that it is dangerous to drive over 80 mph, and that the law should continue to reflect that. . . . 'That is reckless driving. You are going faster than you could possibly go and be able to control your vehicle,' he said."¹⁸

Now, there surely exist motoring situations about which this could be said with a straight face, even by someone who is not a personal injury lawyer. If I picture Katharine Hepburn, tremulous yet dignified, driving a gravel truck at 80 mph on a twisty mountain road, I feel unsafe. But I was feeling just fine one sunny day in May as I cruised along a ruler-straight divided highway (Route 360), right up until I spotted the state trooper in the median strip and grabbed a handful of front brake. I was on my way back from Virginia International Raceway on a bike with triple disk brakes that weighs 8 percent of what a Chevy Suburban weighs, capable of generating perhaps twice the lateral cornering forces, with a width that is about one-third that of the highway lanes. He clocked me at 82 mph: reckless driving.

This was in Amelia County, one of those areas of rural Virginia where law enforcement appears to be the only viable industry. For these purposes, it is ideally situated on the route between Richmond and Virginia's premiere road race course. The transition from an environment ruled by Newton's laws to the realm of Virginia law takes time, and this presents an opportunity for law enforcement. Route 360 is indeed a "business corridor" for counties along the way, though not in the sense intended on the signs that announce it as such, to judge from the general desolation.

Such was my snide take on the matter until I showed up at the courthouse a couple of months later. There's nothing like talk of jail time to wipe the arrogant look off a man's face. I really did feel small, and damnably culpable, before the full majesty of the court. The gravity of the Commonwealth lay heavy in the room as the general cattle call of driving scofflaws loitering outside the building was admitted at 9:30 A.M. sharp by an extravagantly mustachioed sheriff wielding a wand. He waved his wand over the body of each person. (He said it was for detecting metal.) When we were seated he had a spiel to give, and he did so with the flourish of a carnival impresario. The room was packed to capacity, but as yet the judge was invisible. After a well-calibrated dramatic pause of some thirty minutes, during which there was nothing to do but silently contemplate the error of one's ways (no cell phones allowed), the sheriff bellowed, "All rise!" A man in a robe walked in.

The first defendant was an African immigrant with a name the judge struggled to pronounce. The judge asked whether he wanted to plead guilty, not guilty, or no contest. He did not answer; the seconds passed. I believe he did not understand the question. The inquiry was repeated several times. Finally he mumbled something, and the judge moved on. Did he want to hire an attorney, represent himself, or request a state-appointed attorney? Again, the man was stumped. A form was waved at him. I must have spoken aloud because the woman next to me on the bench turned to me as my brain screamed, "Don't sign it!"

I had been contacted by an attorney myself, one specializing in "reckless driving by speed" in certain counties. Was my citation public knowledge, even before a legal finding? I learned that the county shares its log of citations with lawyers who buy that list: another revenue stream. It would be interesting to know how often people actually go to jail for reckless driving by speed; perhaps the threat of jail is used to make the imposed fine seem like a bargain. My case was disposed with a fine of \$150, which I paid with great relief.

In France before the Revolution, the crown granted commissions for collecting taxes to individuals who came to be known as tax farmers. They enjoyed wide discretion, and showed great initiative. They were permitted to keep a cut of the proceeds; it was a lucrative position to have. They were universally hated. What inspires revolutionary hatred, I believe, is not taxes themselves (unless you are a Tea Party fundamentalist), but rather the false pretense of interested parties acting under color of the public good.

Ticket farming in America would seem to be a variant on this. The authority invoked is not that of an insolvent monarchy, but rather that of a certain kind of moralism that mouths "safety" to trump every other concern, and points to the least competent among us to justify its standards. Obviously, such an orientation is fitting in some settings. I think America is exceptional and truly admirable in the way it accommodates those with physical and mental disabilities, for example. But precisely because this morality is so difficult to criticize, it provides a nearly nonrebuttable pretext for the expansion of an administrative state that has no limiting principle of its own, absent the forceful articulation of countervailing concerns that will necessarily look "irresponsible" by its lights. Left to its own internal logic, the regime of public safety must find ways to justify its own growing payroll, and its colonization of ever more domains of life. This can always be accomplished through further infantilization of its clients, under the banner of good democratic values.

IN JULY 2018, I found myself back in traffic court, this time in Fluvanna County. The sheriff got me with rear-firing radar, his cruiser tucked into a shady hollow on the shoulder. I grabbed a handful of brake on the Yamaha but knew I was toast as I passed him. Looking in my mirror, I pulled over as soon as I saw him motivate the big Mopar out of the ditch and onto the road. He said I was going "eighty-six and accelerating." The speed limit was fifty-five. This was on Route 6, my usual corridor for eastwest travel.

The officer was all right. He didn't write it for reckless (they have discretion), and instead of eighty-six he wrote it for eightyfour, which I'm guessing brought it beneath some threshold of badness.

The courthouse in Palmyra sits next to the Old Stone Jail, built in 1828. You walk right past it on your way in, and it is hard not to notice the stockade that sits just outside. That's right, a stockade: a wooden contraption that clamps around your neck and wrists, putting you into a hunched-over position, presumably to be jeered at by upstanding citizens and small children. Of course (you think to yourself) it's *historic*, not part of the current repertoire of justice. Probably.

In the courtroom, I counted six officers of the Fluvanna County Sheriff's Department with plank-like vests bulging beneath their shirts, coiled radio wires snaking from their belts to their lapels, and a full complement of weapons strapped to their waists. I tried to pick out my man, but it had been a couple of months. With their muscled-up bodies, shaved heads, and shar-peilike neck folds that stood where a pony tail might have grown in another life, they looked like nothing so much as a superbutch leather gang. Somehow the sameness of them was the main effect of their presence, and it made the show of force more effective.

The judge, on the other hand, was an African-American woman. I was glad for this, for the simple reason that it was hard to imagine the cops and the judge meeting up at the Lions Club later to discuss law and order over a few drinks. Too often, the feeling you get in a courtroom is that there is this single thing, the State, that is arrayed against you. Of course, the way it is *supposed* to be is that there are two coequal parties, the cop and the defendant, who stand before a judge who privileges neither. It's a nice idea, but as a sociological matter, the fact is that you have a bunch of civil servants who see one another regularly and develop professional courtesies among themselves. So there is something to be said for introducing a sociological divide of some sort between the cops and the judge, lest things get too collegial.

I pleaded nolo contendere but indicated that I would like to make a statement. It's a little spiel I worked out for my Amelia County case, and would soon use again in Chesterfield County. You have to make last-minute adjustments to any such spiel after taking the temperature of the judge in the cases that are heard before your own, and the general vibe in the courtroom. It has to be super succinct. But I have also found that judges seem to appreciate it. Think about their day: an endless parade of sob stories, sullen indifference, and abject groveling. What they rarely get in traffic court is an *argument*, or an attempt at rhetoric—the stuff that presumably made them want to go to law school.

"Your Honor, the officer was perfectly professional [*it is he that is on trial here*], and I have no reason to question the calibration of his radar equipment [*but I am going to mention the issue of calibration, while simultaneously waving it away magnanimously, as beneath the dignity of this court*]. I am guilty as charged and won't waste your time with excuses. But if you will permit me, I would like to say something on behalf of motorcyclists in general [*like you, my concern is for the public interest*].

"As research shows, and any trooper will tell you [I turn ever so slightly and glance at him—ultimately, we are on the same side here], distracted driving can be every bit as dangerous as driving while intoxicated. When you are riding a bike you are not texting, not looking at a navigation screen, not fussing with the kids in the backseat. You're not doing anything but driving. And you have a lot of skin in the game-if you go down, it is literally your skin that comes off. So you are going to pay attention. Going eighty miles per hour on a motorcycle is different from doing so in a three-ton SUV that is loaded up with electronic gadgets, in terms of the hazard it poses to other motorists. I mention these facts not to suggest that motorcyclists should have their own speed limit [you say "not X" by way of insinuating the thought "X" into your auditor's head, while distancing yourself from X as too radical for consideration by people as responsible as yourself, or be in some way above the law [the majesty of which is resplendent, as are those robes that fit you so smartly, Your Honor], but only in the hope that this larger context might enter into your judgment of what penalty is fitting in my own case."

I would like to say I delivered this speech with the suavity of a Cicero. But in this case, as in Amelia, my voice was trembly and breathless, barely audible. You really do feel the gravity of the State in such a setting, and it affects your whole body. The judge listened with evident interest, and stated her appreciation for these considerations with warm sincerity. She then declined to reduce the charge in any way. But she pronounced her decision with a kindly beneficence that made me grateful merely to be in her presence. I don't mean that sarcastically. Justice was done.

Outside the courthouse I put myself in the stockade and took a selfie.

THERAPY FOR DELINQUENTS

A couple of months later, it happened again. On the Chippenham Parkway, a divided six-lane highway, a man had hidden himself just over a rise on a Saturday afternoon, holding a gun nestled into the crook of his left arm that emitted invisible rays, he said. He also had a book of printed yellow forms. There appeared to be enough for everybody. On mine he wrote 77/55. Since I had collected a number of these over the past eighteen months, I was more receptive to the lawyers' pitches that always show up in my mailbox after each infraction. After my last one, in Fluvanna County, I had briefly talked to a lawyer on the phone, but he wanted fifteen hundred dollars to take my case, so I had represented myself (an interesting locution) and now I had "eightyfour in a fifty-five" on my DMV rap sheet. But on this occasion, I received a flyer in the mail from a Mr. Joyner, Esq., who charged only \$149. I talked to one of his associates on the phone, he took my case, and sure enough he got the ticket dismissed-on the judge's condition that I complete a Basic Rider course.

The instructor had us sit on the little 250 cc bikes with our feet on the ground and rock back and forth, slowly, heel to toe and

back again. Earlier, in the classroom, I had regressed to a too-coolfor-school posture, writing rude commentary on my workbook and discreetly showing it to the guy next to me, and generally playing the class clown. The situation just seemed to demand it. But now we were out in the parking lot, learning to feel "the friction zone," where the clutch begins to engage. Worn out by the relentless negativity of my internal monologue, I had decided to change my attitude. I would approach this as an exercise in mindfulness. I tried to really *feel* the slippage of the clutch through the clutch lever, and be aware of my body and the bike as a unity. This worked; for about thirty minutes, I was able to think and act and feel more appropriately, as they say in school. We paddled slowly across the parking lot in unison with our feet on the ground, using them like training wheels. When we got to the far side, we each raised our left hand and kept it raised to show that we had completed the exercise. But as these exercises stretched out to fill the day, I soon found myself again engaged in an emotional struggle to keep my visible attitude one of compliance. I could not afford to get on the bad side of the two instructors, as I desperately needed the piece of paper they would give me after twenty hours of demonstrated appropriateness over two days. No wheelies, definitely.

Michel Foucault wrote a cultural history of punishment, the main point of which was that at some point in the eighteenth century, Western societies moved away from straightforward punishment (such as whippings or a stint in the stockade) toward what he called "discipline." It takes a variety of institutional forms: prisons, compulsory schools, the factory, the asylum. The point of these is not just to punish but to produce a certain kind of "subject"—the personalities and forms of self-understanding that allow power to operate smoothly. One way this is accomplished is through the "unequal gaze." There is a one-way-mirror quality to these disciplinary institutions; you can never be sure if, or when, you are being observed. In prisons this is accomplished through the architecture; in school, you can never be sure which infractions will end up on your "permanent record." The natural features of the road are sometimes put to similar use by the safety-industrial complex: there could be a man with a ray gun behind that bush, or there could not be. Quite randomly, you may get busted for what would otherwise feel normal and natural. The only way to resolve the resulting anxiousness and insecurity is to internalize the demands of the institution; to become a different kind of person. For example, the kind for whom it feels right and natural to travel fifty-five miles per hour on an empty, six-lane divided highway. Of course, the disciplinary entity must not be too successful in this reeducation, as the point of the system is to produce delinquents. Without them, the whole apparatus would lack a rationale (and a budget). The rate of enforcement, as well as the gap between the speed limit and the speed dictated by our natural reasonableness, needs to be carefully calibrated to produce the optimal number of delinquents.

WHAT IS RECKLESS DRIVING?

Getting speeding tickets puts me in a libertarian mood, as you may have noticed. But just last night I had one of those experiences, increasingly frequent, that make me wish for more traffic enforcement, not less. On the Huguenot Parkway, a four-lane suburban thoroughfare with stoplights every half mile or so, I looked in the mirror of my Scion xB to see a car about three feet off my rear bumper. Traffic was light. The lane to my left was empty. He would follow like that for a hundred yards, then drop back, then rush forward and do the same, repeatedly. It was a Friday night, so it occurred to me he might be intoxicated. At the next light I managed to pull alongside him. A slight bluish glow illuminated his downcast face, upon which played an expression of rapt reverie in response to some experience emanating from his lap. I rolled down my window as I crept up beside him, my face full of indignation, and in doing so I nearly rolled into the car in front of me: an exquisite embarrassment that nearly nullified all my felt moral superiority at a stroke. But not quite. I exchanged some unkind words with the tailgater. In the following half mile, I noticed a woman alone in a minivan in the lane next to me gazing at her phone on her steering wheel, laughing out loud. I felt surrounded, and desperate for the exercise of public authority against reckless driving.

Yet I believe there is no law one could pass, no public service announcement or educational campaign one could undertake, that would get people off the stuff. The impressively successful campaign against drunk driving in the 1980s is often invoked to demonstrate that cultural norms can be shifted. But drinking is done largely in a social setting, prior to getting behind the wheel. A gathering of friends or coworkers is a setting in which norms come into play, and social pressure is felt. The self-contained automobile cockpit, on the other hand, feels like a private space. Here, the power of shame is a weak lever of social reform.

The empowered moral isolation we feel in our cars is like that of an anonymous online comments section, which similarly generates antisocial behavior. But that isolation is illusory. We are hurtling toward one another, not in the cloud, but in sheet metal containers of gasoline and flesh, separated in our trajectories only by the gossamer conventions of painted lines on the pavement.

So powerful are the attractions of the screen, and so weak is the spirit of public concern at this late stage of the liberaldemocratic experiment, that I believe the remedy for distracted driving can only be technological. Driverless cars represent one approach. It is an approach that demands massive expenditures and promises to accomplish a massive transfer of wealth (much of it into the coffers of the same parties who created the problem). For this reason, it is the only approach that attracts speculative venture capital, and the endorsement of a political establishment (of both parties) that is largely captured.

There are other technological solutions that are simple and cheap; it would be a relatively trivial matter to disable specific functions on a smartphone while its owner is driving, and in fact the Apple iPhone now does this, to the credit of the firm. (Though this safety feature is overridden with a single touch at the prompt "I'm not driving.") Implementation of stronger technical controls on distracted driving would require only a bit of will to exercise stewardship over the common good by public servants who were hired to do just that. It would also require a tiny bit of deference to the common good by corporations whose charters-their very existence and legal privileges-are granted by the laws of the state, however much their executives regard them as sovereign entities. But, compared to driverless cars, such modest technical remedies for distracted driving offer nobody the prospect of extracting further wealth from the citizenry, and therefore enjoy little prospect.

MANAGING TRAFFIC Three Rival Versions of Rationality

They tell us that they have seen in a dream the glorious, collisionless manner of living proper to all mankind, and this dream they understand as their warrant for seeking to remove the diversities and occasions of conflict which distinguish our current manner of living. . . . And such people . . . understand the office of government to be to turn a private dream into a public and compulsory manner of living.

-MICHAEL OAKESHOTT, 1947

Imagine a typical suburban thoroughfare. You're at an intersection. Traffic is light. Most of the cars are stopped, waiting. What are they waiting for? Well of course they are waiting for the light to change. We do a lot of this.

If you are in a hurry, or as prone to impatience as I am, to sit there for minutes when you can see perfectly well the approach of cars from every direction, or the absence thereof, requires a certain amount of emotional labor. There is a conflict between what feels natural and reasonable in the particular circumstances—the emptiness of the intersection invites movement—and the law, which is indifferent to these circumstances. You feel this as an arbitrary restriction on the movement of your body, like an animal trapped in a Plexiglas enclosure: the barrier has no earthly features, and doesn't make sense to your body. Here is a radical thought experiment: what if we used our blessed *eyeballs* to determine if it is okay to turn left through an intersection? And our brains? Has anything so crazy ever been attempted?

Americans who travel to Italy come back with tales of traffic chaos, often related with a mix of horrified incredulity and admiration. Driving in Rome is "not for the faint of heart," they will say. Even being a pedestrian requires that you steel yourself for battle. But for a traffic geek, the Roman intersection presents something else as well: a spectacle of improvisation and flow that is beautiful to behold as cars, buses, motorcycles, and pedestrians weave among one another. If there are rules being followed, they are not the simple kind that can be stated in a driving manual, or readily condensed for a visitor. The drivers pay attention and find their way through the mess, seeming to rely on some uncanny Italian "hive mind" capacity more than traffic lights or rules. The *efficiency* of it is stunning, to judge from the visual impression it makes on a visitor.¹

But what about safety? According to the World Health Organization, in 2016 road fatalities in Italy were 6.3 per 100,000 vehicles, while in the United States they were 14.2 per 100,000 vehicles. Before we congratulate the Italians, we should note that this is a highly imperfect measure of road safety; one would prefer to know fatalities per vehicle mile driven, but this is reported only for a handful of countries, not including Italy. There are further complicating variables to take into account.² Therefore, for the sake of argumentative caution, let us merely stipulate that the Italian manner of driving is not grossly *more* dangerous than our highly rule-bound practices in the United States.

With the Roman intersection as a point of comparison, we may be emboldened to ask of our own society: does every possible path *within* a parking lot, and of ingress and egress from a parking lot, need to be determined by curbs and islands? every intersection of a cross street with a thoroughfare controlled by the batch turn taking enforced by an eight-way traffic light? In the last few years, red light cameras have sprouted up at many of the major intersections where I live, in western Henrico County in Virginia. They would seem to express a tacit recognition that our compliance with this kind of traffic control must be secured through surveillance and the threat of fines. Because it is not reasonable.

If we are educated into rule following with sufficient rigor, perhaps we will lose entirely that physiological response appropriate to a trapped animal. Maybe this is the socialization appropriate to a modern society. But how far do we want to go? Do we want to invoke the *fact* of human adaptability—clearly we can put up with quite a lot—as a legitimizing principle for the indefinite remaking of the human ecosystem? Philosopher Ivan Illich wrote of "the rising cost of fitting man to the service of his tools." "Increasing manipulation of man becomes necessary to overcome the resistance of his vital equilibrium." While sitting at a red light, such therapies must be self-applied. We all have our techniques for getting our Zen on.

As Freud taught us, to be a civilized person means accepting that there is a fundamental conflict between "what comes naturally" and the requirements of society. Civilization comes at a high cost to the individual; get over it.³ To rage against the red light is to reveal oneself as infantile. Yes? Or perhaps, as the most deranged sort of libertarian.

Fair enough. But each of us has such a creature inside us, a very frustrated little Mini-Me who sometimes gets the upper hand. (We will meet him in the next chapter, when we take up the phenomenon of road rage.) The point of comparing our arrangements to those of the Italians is to remind ourselves that different societies have different ways of reaching the necessary accommodation. The form of rationality preferred in America for managing traffic is rule following. It is individualistic in its premises. But this is a premise that artificially restricts the available solutions. By contrast, the form of rationality on display in Rome, or Addis Ababa, might be called "socially scaffolded mutual prediction." This is a concept elaborated in recent work by the philosopher and cognitive scientist Andy Clark. Clark offers a picture of what human beings are doing when they solve problems together that is very different from rule following. What we do is continually update our predictions of the world, including others' behavior, and modify our own behavior so as to make it more easily predictable by others. This is a cognitive strategy bequeathed us by evolution, and is embedded throughout our brain functions. It also happens to fit what one observes in the improvisational flow of an unregulated intersection. In such a scene, we are exercising endowments that are fundamental to the kind of creatures we happen to be. By contrast, a traffic regime that is based more rigorously on rules restricts the "problem space" that drivers face (recall the rat driving study), as well as the available solutions.

We'll get deeper into this in the next chapter.

Here, my point is that the various ways of managing traffic support and express different forms of political culture. How do we experience our compliance with the kind of rule-bound traffic order that must be secured through surveillance and the threat of fines? It feels quite different from the citizenly deference that emerges naturally (or doesn't) among people who need to cooperate. And this difference gets to the heart of what it means to be free.

In the unregulated intersection, you see the human genius for improvisation on display. But this doesn't make much impression on those who nurse a vision of order and feel empowered to impose this vision on a populace they regard as unruly and incompetent. Too often this comes at the expense of some customary practice or informal accommodation that has served us well enough, without expert tutelage. But such folk practices have no lobby, and the concepts we need to defend them enjoy little currency. Worse, the very fact that they are long established is an offense to the idea of progress. The progress promised often turns out to be illusory, but the enforced obsolescence of our native skills quite real.

Clearly, if forced into the categories of today's established political options, my argument here would count as libertarian. But it doesn't proceed from a naïve faith in the generative effects of disorder. *Disorder is bad* on the road. What I mean to argue is that the project for rational control rests on too narrow a view of where reason is located in society. The Roman intersection *is* a picture of rational order. It is closer to the kind that emerges in organic systems than the kind that seeks to project a system of control from afar, superimposing a grid of predetermined moves on the traffic landscape.

Perverse consequences follow from trying to disburden us of exercising judgment. This is what we are doing when we entrust the orchestration of daily life to systems that are blind to the extraordinary finesse of human beings in coping with situations of fluid uncertainty in concert with one another. Infrastructure predicated on too rigid an ideal of control fails to accommodate the exercise of our human capacities, or to exploit the social efficiencies they offer, leading instead to the atrophy of the human.

In the United States, we recognize that rule following can be highly inefficient, but we are leery of relying on forms of rationality that are socially realized. This predicament has led us to imagine a third form of rationality for managing traffic: artificial intelligence. At its most sophisticated, machine learning should be able to enact a more fluid sort of negotiated right-of-way. The "autonomous intersection" could relieve us of having to sit there at a red light; it could be a big improvement on our current arrangement based on simple rules. The key is that some means must be found for the drivers, that is, the computers, to communicate with one another and adjust on the fly—like Italians!

One can find a variety of treatments of this. One comes from researchers at the University of Texas at Austin who mean to develop a "multi-agent intersection control scheme." They say that "one technical challenge is to design a communication protocol between the agents [i.e., individual cars].... The Intersection Manager calculates the car's proposed trajectory based on the expected driver agent behavior and compares it to a reservation table storing past requests. As long as the space-time a car needs for its path is unclaimed, the Intersection Manager guarantees its safe passage through the intersection at the proposed time. It is the car's responsibility to arrive at the appointed time and velocity. If a reservation is denied, the car must slow down and request a later reservation."⁴

The overall impression one gets is that these people are trying to solve a problem that was solved long ago, using tools that are crude compared to those developed by biology and culture. The human brain and perceptual system evolved to be an exquisitely supple instrument of mutual prediction, and within any given culture local norms develop that further ease the predictive problem faced by individual minds.

According to the *Times*, "Experimental designs for autonomous cars incorporate as many as 16 video cameras, 12 radar sensors, half a dozen ultrasonic sensors, and four or five lidar detectors. And still more sensors and scanners might be necessary to make self-driving cars impervious to exigencies like blinding blizzards and soaking downpours." The chief executive of one of the leading lidar makers is quoted as saying, "You have to have ridiculous, superhuman sensors to make up for the fact that computers aren't nearly as smart as humans—and won't be for a very, very long time."⁵ It is estimated that an autonomous car will need a computer capable of 300 trillion operations per second.

RADICAL MONOPOLY

If, at some late date in the future, a highly coordinated system of autonomous cars were to achieve the level of efficiency that prevails today at an intersection in the old country, it would be counted a smashing success. But to achieve this miracle would require massive expenditures by you and me, and the wholesale reworking of the urban landscape according to the dictates of a handful of private enterprises and their fellow dreamers in the public sector.

Ivan Illich offers the idea of a "radical monopoly": not merely the predominance of one firm to the exclusion of others, but a reordering of what is possible. "The establishment of radical monopoly happens when people give up their native ability to do what they can for themselves and for each other, in exchange for something 'better' that can be done for them only by a major tool." A "major tool" is one that makes us dependent on claims of special expertise remote from our own experience. Thus, learning becomes the monopoly of a regime of compulsory schooling, for example, and tending to the ills of the body becomes nearly the exclusive preserve of what we call the health care system. We forget how to do things for ourselves, and for one another. "Institutions now optimize the output of large tools for lifeless people." By contrast, a "pluralism of limited tools" that are directly intelligible support what Illich calls conviviality. These are "individually accessible tools to support the meaningful and responsible deeds of fully awake people." In some respects, the automobile is a major tool in Illich's sense, compared to a bicycle. But the automobile is nonetheless a tool that admits of flexibility, judgment, and individual initiative in its use. Indeed, that is its defect, according to our utopians! Hence the need for an Intersection Manager.

PRACTITIONERS OF THE CITY

Michel de Certeau wrote that "walkers are 'practitioners of the city,' for the city is made to be walked."⁶ This could be said with equal justice of drivers, especially in a city such as Los Angeles that was made to be driven. On New Year's Eve, 2018, Pope Francis expressed the ethical significance of this in a homily at

St. Peter's Basilica in which he praised drivers "who move in traffic with good sense and prudence." Prudence is a capacity for judgment that we exercise when rules are inadequate to guide our behavior; it comes only from experience and is cultivated only when we are free to err. "These and a thousand other behaviors express concretely love for the city." In a beautiful phrase, Francis suggested that prudent drivers are "artisans of the common good, who love their city not with words but with deeds."

From my own travels, some of the best urban drivers I have seen are in London. The give-and-take of the cabbies and commuters as they jostle to advance is a supple play of deference and assertion, professional courtesy and opportunities seized, that prizes traffic *flow* over rule following. Traffic flow is a shared good of an interesting sort: it is a fragile, emergent property of a collective, a state that happens only if everyone is paying attention to the situation and brings a disposition of flexibility to it. At times, it resembles an improvisation among musicians. Urban driving at its best is an experience of civic friendship, an act of trust and solidarity that makes one proud to belong to the human race.

Rules become more necessary as trust and solidarity decline in a society. And reciprocally, the proliferation of rules, and the disposition of rule following that they encourage, further erode our readiness to extend to our fellow citizens a presumption of competence and good will. At the end of this trajectory, it becomes necessary to hand over our steering wheels to an Intersection Manager, who will solve our problems for us.

ROAD RAGE, OTHER MINDS, AND THE TRAFFIC COMMUNITY

The *Car and Driver* columnist John Phillips relates that his father was a Navy veteran and therefore presumably well versed in profanity. Yet "during his road rages the worst he ever shouted was 'Cowboy!'"

In Copenhagen, a motorist who has been cut off by another will typically shout something that translates as "Why don't you run around in my ass?" In Canada, according to Phillips, it is common to hear "You whore!" He reports once driving in Ontario behind someone stuck in traffic who yelled, "Why don't you pay my mortgage?" In the Netherlands, according to David Sedaris, popular road rage expressions include "cholera sufferer" and "cancer slut." In Austria, drivers sometimes address one another thus: "Why don't you find a spot on my ass that you would like to lick and lick it?" In Honolulu, Phillips once heard a local shout, "Sit on your gearshift till Easter!" In Wasilla, "Your mother sucks meatballs." He writes that "Brits trapped in desperate traffic sometimes shout 'Christ on a bendy bus' and 'You're as dense as Fat Pat's arteries.'" According to Sedaris, in Bulgaria the favored expression is "May you build a house from your kidney stones." In neighboring Romania, it gets even more elaborate: "I dragged my balls across your mother's memorial cake, from cherry to cherry, and to each of the candles."

The prison-sex theme once got taken to a whole new level during a *Car and Driver* test run when two members of the motoring press pulled over to compare notes. According to Phillips, the driver of a Chevy Avalanche, unhappy with their spirited use of the public road, pulled in behind them, got out, "pulled down his trousers, and rubbed his groinal bundle along Gluckman's door."

"That's my nuts on your car," the irate driver said. And so it was.

I must have prompted the use of some pungent terms by the driver of a small white pickup one day in 1989 when I turned left in front of him at an intersection in Wilmington, an unpleasant neighborhood adjacent to the Long Beach harbor. My turn was on the liberty-taking side of propriety, I'll grant, but I didn't think it was outright dangerous. What it was, I suspect, was disrespectful. The driver of the pickup can't have been feeling too urgent about his trip across town, because he promptly abandoned whatever plan he had for the day and proceeded to chase me through the barrio. I couldn't shake him, and from my nervous glances in the mirror I could tell he was irate. In retrospect, what should I have done? Maybe return to the main drag and pull into some establishment such as a gas station? I wasn't comforted by the ambient carelessness of the place, and a distinct sense that here I was the alien. What I did, finally, was pull into the job site where I was working as an electrician. This was a job I was doing for a fly-by-night contractor who would stop by once every couple of days (mostly to give me the Jesus talk; he had a fervor that I've come to associate with ex-cons). The job consisted of running new service to two adjacent shanties in a little dirt-lot compound,

totally illegal. I pulled into the lot, and the pickup pulled in behind me. I got out of my car, and he got out of his. I didn't have a plan. His face and neck were marked up with haphazard prison tattoos, including a few teardrops. I can't remember what he said, or what I said, but it was heated. At one point as he was stepping toward me, I saw his gaze shift over to my right, and turned to see my helper standing there, casually holding a length of two-byfour at his side. He was a cowboy. No, literally. He had previously made a living catching wild horses in northern Nevada, breaking them, and selling them. Anyhow, the traffic vigilante retreated to his pickup and drove off.

When he did so, an older gentleman who lived next door came out for a word. A Filipino who'd lost an arm in World War Two, he had lived in Wilmington since the forties. In retrospect, he resembled the character played by Clint Eastwood in *Gran Torino*, who watched his neighborhood descend into lawlessness. He had seen our confrontation with the local thug and advised us to get lost, because "he's going to come back, and they're going to bring machine guns." It seemed like a good stopping point for the day.

I spent the rest of that job with a .22-caliber pistol strapped to my side, which is not a comfortable way to crawl around in the dirt under a house (and no match for a machine gun). But the enforcer of traffic etiquette did not return.

As Jack Katz writes in his ethnographic study of drivers in Los Angeles, being pissed off is "an infinitely recurring experience" on the road. Further, "angry responses to other motorists are typically felt to be so deeply justified that they can be recounted readily to strangers without concern for loss of face."¹ What accounts for the Olympian righteousness of our anger when we are behind the wheel? Katz arrives at some fascinating insights into road rage. Even for those of us who haven't (yet) ended up on the six o'clock news, in reading his account it is impossible not to recognize oneself.

Have you found yourself chewing somebody out, in the most pungent terms, from behind windows that are completely rolled up? You have no illusion that you will be heard over the road noise, yet the tantrum seems to accomplish a needed emotional release. Do you express your exasperation with other drivers in tones of incredulity ("un-effing-believable"), day after day, year after year, as though you had some profound learning disability? Do you *relish* your anger, even after repeated episodes of becoming embarrassed at your own behavior once the hot moment has passed?

The first thing to notice is that cars traveling in the opposite direction, on the other side of the dividing line, are generally of no consequence or concern to us. One's interest is bound up with the cars traveling in the same direction as oneself. "The result is that drivers are most commonly gazing at the rear ends of others' vehicles, a perspective that is not incidentally related to the fact that the most common invective that emerges spontaneously in moments of anger, on L.A. roads at least, is 'asshole,'" Katz writes.² Whereas pedestrians have face-to-face encounters, motorists are locked in a pattern of face-to-tail interactions. And this has consequences for the kind of emotional equipment we bring to bear on the interaction. When two people approach one another on a sidewalk, each can see where the other's eyes are directed. "In pedestrian passings, the line between a glance and a gaze is morally significant; aware of the social accountability of their vision, pedestrians routinely encumber it." But in driving, the direction of one's attention is generally unknown to other drivers, and this has a number of consequences. It makes one free to address another motorist without inhibition, because it likely won't be noticed. But by the same measure, it is difficult to register one's existence to the other; to convey one's intentions; to make oneself understood. Being in a car severely impedes our expressive ability, making us dumb in that sense. And this becomes the basis for a bad spiral. "In effect, drivers project onto each other, in accusations of idiosyncratic personal incompetence, the

systematic incapacity that driving, as a method of going about in public, constructs for all. Each driver has reason to sense that his or her own vivid awareness of other cars is not reciprocated." This lack of reciprocity is especially enraging, and it is baked into the situation, a function of our face-to-tail orientation. "What drivers get mad about is their own dumbness experienced as a sensed inability to get other drivers to take them into account."³

Have you ever maneuvered your way alongside an offending driver and then tried to express your critique with sign language? I'll cop to this. Once I was driving from Yosemite to the Bay Area on a crowded freeway when I saw a tour bus severely tailgating the car in front of it, at about 65 mph. Eventually the car got out of the way and the bus did the same thing to the next hapless car in its path, and then another, and this went on for some time. I pulled up next to the bus on the passenger side (where a glass door gave me a full view) to find the driver staring down at the phone he held low, by his knees (out of sight of his passengers), blithely riding about six feet off the bumper of the car in front of him. Overcome with indignation, I gave a good long honk. On the assumption that now he was looking at me, I furiously pantomimed a mouth-breathing, bug-eyed cretin holding a phone in front of his face. Of course, in doing so I nearly rear-ended the car in front of me. When I glanced back at the bus driver, his posture was the same.

Katz points out that darkly tinted windows have an effect on the emotional dynamics of the road similar to that of interacting with someone wearing sunglasses. It exacerbates the difficulty of interpretation, and it is one-sided. You don't know where that person's attention is directed, but he knows where yours is, and this asymmetry is provocative. "Not uncommonly, a party in shades will be perceived as relatively indifferent to others, even disposed to at least small cruelties." A similar asymmetry of perception, and attendant readiness to posit callous indifference in others, is inherent in a train of cars facing the same direction, and exacerbated by tinted windows.

On the road, you will find no egalitarians. Katz writes:

The better you are as a driver, in the sense of being dutifully attentive to the movements of other cars, the more you are aware how circumscribed are the attentions of others. Your courtly efforts to accommodate the less competent run up against their failure to see, much less appreciate, what you are trying to do. Conscientiously monitoring others' awareness, superior drivers come to recognize how, on the road, ignorance is power. Their appreciation of the incompetence of other drivers is at once evidence of their own superior driving competence and an explanation of the frustrating futility of their superiority.⁴

Behind the wheel we are all Callicles, nursing a sense of superiority that doesn't receive its due. We also become amateur sociologists and psychologists while driving, analyzing the characters of other motorists based on, say, a turn signal left blinking for miles on end: how, no really, how is it possible to be so oblivious? We reach for explanations, and in doing so latch on to the only information available: the driver's readily visible demographic characteristics, the type of vehicle he or she drives, its condition, its bumper stickers, and from these we draw generalizations. Such analytical work is part of the process of becoming angry; it quickly becomes a kind of political anger. Women drivers. Macho drivers. Clueless old people. Heedless youth. Asian drivers. Prius drivers who want you to know they "buy local." Meth-head rednecks in jacked-up pickups. Blow-dried douchebags in BMWs. Vindictive fat people in Pontiac Aztecs. Sixty-year-old white guys in Corvettes, driving the speed limit. Vacant-eyed soccer moms in Suburbans. "Philosopher-mechanics" who think they're entitled to split lanes.

The common thread with all these populations is just how self-absorbed they are, compared to one's own exquisite sensitivity to the surrounding world. There is social psychology research that finds that Americans are more likely to attribute others' behavior to characteristics that they carry around with them as permanent features of their makeup, compared to other societies where there is a greater readiness to invoke the transient circumstances at hand to account for people's behavior.⁵ You could say we are more prone to stereotyping (bad) or you could put the point more neutrally, as Tocqueville did when he said that Americans seek generalizations. This native tendency seems to get enhanced by the poverty of particulars available to us on the road, which in turn mirrors our severely limited ability to express ourselves from within our vehicles. Perhaps there is no other area of life where we regularly have to engage in so much interpretive work. And this work has its rewards. Your anger feels like insight, doesn't it? It carries a deep intellectual pleasure, and I believe this is why we give ourselves over to it with such abandon.⁶

Anger is a uniquely articulate emotion. While lust is a mute longing, and grief a physical heaviness, anger makes speeches. It is perhaps the most prominent emotion of public life, always accompanied by reason-giving (however partial and tendentious). In driving as in politics, we feel an unavoidable citizenly engagement with all the idiots who surround us.

THE HUMAN MIND IS A PREDICTION ENGINE

The poverty of signals by which to judge others' intentions on the road, the unknown disposition of their attention, and hence the ambiguous meaning of their observed behavior, is highly novel from an evolutionary standpoint. In our usual, face-to-face interactions we have evolved exquisite sensitivity to a rich variety of signals. Further, we are normally engaged in a reciprocal loop wherein our initial interpretation of another's actions, utterances, and facial expressions shows up on our own face and influences the other person's posture and purpose, as these often evolve reciprocally in the course of the interaction. Road rage would seem to be a natural emotional response to the fact that these usual social-cognitive circuits are thwarted on the road, where we have to coordinate with others without being able to communicate with them, hardly.

In such a situation, social *norms* become all the more important. If we can take certain patterns of behavior for granted, this eases the predictive problem faced by individual minds. We will return to this point shortly.

According to an emerging paradigm of cognitive science, the human mind is fundamentally organized as a prediction machine. As Andy Clark puts it, "We see the world by (if you will) guessing the world, using the sensory signal to refine and nuance the guessing as we go along."⁷ For our purposes, I believe this explanatory framework of "predictive processing" can enhance our understanding of traffic. In part, it can do so by helping us build a bridge from the narrowly "cognitive" and physiological aspects of the traffic equation (for example, the reaction times of drivers) to the social dimension. If I am on the right track here, such an integration should yield a more holistic and therefore more realistic picture of what we are doing when we drive. Such a picture may be of interest to those who seek formal descriptions of traffic, for the sake of automating it or otherwise improving it.

Minds reside in bodies and constantly move around. As we do so, we have expectations of what the world will present to us, and continually refine these in light of incoming sense data. But we also move in such a way as to *generate* data for ourselves that will bear on the aptness of our current predictions; it is an iterated cycle in which action and perception are inseparably joined in a probabilistic reality-grasping operation. Other people are doing the same. As Clark writes, this fact "yields an opportunity. Perhaps our predictions of other agents can be informed by the very same generative model that structures our own patterns of action and response? We may sometimes grasp the intentions of other agents, this suggests, by deploying appropriately transformed versions of the multilayered sets of expectations that underlie our own behavior. Other agents are thus treated as context-nuanced versions of ourselves."⁸

Given that other agents are engaged in the same strategies of probabilistic reality grasping, we can help each other out. That is, our individual "processing loads" can be reduced when we exploit this commonality, letting others provide some external scaffolding for our grasp of the situation. Because others are themselves predictors, one sometimes gets into a loop of "continuous reciprocal prediction" that can be mutually beneficial, as in the case of a flowing, unregulated intersection in Rome or Addis Ababa. It can also spiral down into a case of mutual assured misunderstanding, as sometimes seems to be the case in an episode of road rage. Let us consider these in turn.

When all goes well, the unregulated intersection resembles a lively conversation in its improvisational, collaborative quality. Other nonverbal parallels to a conversation may be found in team sports and in mundane activities such as changing the bedsheets with a partner (examples mentioned by Clark). In a conversation, each person uses her own facility with language to "help predict the other's utterances, while also using the output of the other as a kind of external scaffolding for their own ongoing productions."⁹ All of this is probabilistic; there may be any number of paths the conversation could take, and in weighing what to say next you read the likelihood of the other person's possible responses in "computing" how to proceed. Clark doesn't touch on the playful or humorous quality that the best conversations often have, which may depend on *disrupting* an interlocutor's expectations. But for our purposes, as an analog to coordination among drivers, his treatment of conversation serves well enough. He says that in a typical conversation, each party tries to match his or her behavior and expectations to those of the other. In part, we do this through imitation, which helps to support mutual prediction and mutual understanding. The result is that conversation may feel easy, despite its complexity.

On the other hand, sometimes a conversation goes very badly. Your hypothesis that the other party is angry, for example, comes to control the *actions* by which you then probe the world for confirming evidence, scanning her face for signs of anger, tension in the body, and so on. These probings are not invisible to the other party, and make her tense. This becomes a feedback loop that can spiral into "self-fulfilling psycho-social knots and tangles," as Clark puts it. He cites work showing that "our active top-down models of other people's current mental states and intentions do indeed influence how we physically perceive them to be, affecting our base perception of their gaze direction ... form of motion, etc."¹⁰

As Clark notes, sometimes we constrain or artificially stabilize our own behavior in order to make ourselves more predictable to others. This is what good drivers do. When changing lanes across two or more lanes at once, a driver who is aware of himself as an object for others will briefly signal, crisply move over one lane, cancel the signal, and then crisply execute the same sequence again. Doing so is an extra courtesy that helps others feel at ease. A good driving culture is one in which practices like this have become norms, guiding our social intercourse in unobtrusive ways. Such norms reduce uncertainty and make us more mutually predictable to one another.

Note that the utility of the norm for guiding expectations derives from its dual nature, as both a description (of what is normally done) and a prescription (for what one does). Only if the norm carries some prescriptive force, capable of mustering praise and blame on its behalf, will it persist in practice, and thus serve as a description that captures actual behavior well enough that it can serve to anchor sound expectations.¹¹

Social norms vary across cultures, of course, and the variations can get quite localized indeed. Uber, for instance, encountered difficulty in its deployment of self-driving cars in Pittsburgh, due to a certain "baffling idiosyncrasy" of that city's drivers known as the "Pittsburgh left." Apparently it is a matter of some civic pride for Pittsburghers that when the light turns green, they allow a car headed in the opposite direction to turn left before proceeding through an intersection. "I'm a big believer in the Pittsburgh left," the mayor said, to the consternation of tech workers brought in from elsewhere to work on Uber's project. The programmers of driverless cars wonder whether they should instruct them to wait a couple of seconds after a light turns green before proceeding. But of course, that in itself could cause testy reactions from other drivers, if turned into a rule. Autonomous cars face the same predictive problem as human drivers, except that they are subject to neither the benefits nor the hazards of being engaged in a socially bootstrapped, interpretive process of mutual prediction.

There are both upside efficiencies and downside risks to human drivers sharing the road, guided only by their natural socialcognitive capacities. How will this balance sheet (and therefore the relative attractiveness of automation) be affected by other features of the society? In particular, given the importance of social norms in facilitating mutual prediction by drivers, we need to consider the question of social cohesion: how much purchase do norms have on our behavior, and is this changing?

Another way of putting the problem of mutual prediction would be to speak of social trust. The Harvard sociologist Robert Putnam found that as diversity increases in a society, there is "less expectation that others will cooperate to solve dilemmas of collective action."¹² And this expectation is self-fulfilling; as society becomes more diverse, people "hunker down" and become socially isolated. A lack of shared enculturation leads to a relative poverty of shared norms to guide behavior and, just as crucially, expectations of behavior.

One wonders how considerations like these will play out in Germany in particular. The absence of speed limits on the autobahn depends on a strong social compact; it is a marvel of mutual trust that is possible only with robust norms. Beneath the noisy debates over immigration, the fate of autobahn culture may be taken as an index of Germany's success in assimilating its new peoples.¹³

In the 1930s, when the autobahn was being built, the Nazis promoted the idea of a "traffic community" (*Verkehrsgemeinschaft*) that was to be a road-going manifestation of the "people's community."¹⁴ The hope was that "chivalry" and "discipline" on the road would render speed limits beside the point, and in fact they were abolished. After adoption of the Reich Highway Code in May 1934, traffic fatalities in Germany shot up, and became the worst in Europe. It was an embarrassment for the regime, and by 1939 speed limits were back in place. Perhaps the lesson for any would-be traffic idealist is that a traffic community of chivalrous and disciplined drivers cannot be created by fiat. It is something that has to grow organically over time, as it depends on social norms that have worked their way into people's dispositions.

Today, Germany has one of the lowest rates of traffic fatalities in the world, despite (or because of?) the discretion granted its drivers. Germans had to learn how to drive fast, over the course of decades. This involved not just acquisition of a technical skill, but a kind of moral education that took place during the postwar peace. The latter includes individual traits such as responsibility and self-control, but includes a social dimension as well. One thing it involves is being aware of what is going on behind you; the autobahn is a place of intensive mirror use. Such (literal) circumspection indicates that Germans have somehow succumbed less than most of us to that natural solipsism that the automobile seems to encourage, maintaining awareness of themselves as objects for other people. Together they enact a certain collective identity, that of the German Driver, and this makes them sufficiently predictable to one another that they are able to accommodate a wider range of speeds on the highway. If they are to preserve this cultural achievement, they will have to insist on it.

Meet the New Boss

STREET VIEW Seeing Like Google

Google launched Street View in 2007. It added 360-degree, street-level camera angles to its Maps function. One could now zoom down from a Google Earth satellite view to what a pedestrian would take in if she were to continuously swivel her head and pivot about. Places one has never been, and may never visit, have become available for full inspection from afar.

By January 2009, the effort was meeting resistance around the world from communities who felt somehow violated by the incursion. In responding to it, the firm chose to focus on objections coming from the developing world, characterizing such resistance as just what one would expect from authoritarian "closed information societies." Openness is good.

A bit of a wrinkle in the PR strategy occurred in the UK in April 2009 when the residents of the village of Broughton in Buckinghamshire blocked a Street View camera car from entering, on the grounds that it was intrusive. This was in a Western nation, not a banana republic or repressive regime. As protests against Street View spread through Britain, as well as Germany, Japan, the Netherlands, Australia, Belgium, Canada, France, Hong Kong, Ireland, Israel, Italy, New Zealand, Poland, Spain, South Korea, and the United States, John Hanke, Google's vice president for maps, reminded the London *Times*, "I tend to think that societies like ours come down on the side of information being good for the economy and good for us as individuals." It is the *revanchistes* among us, then, who perversely want to hurt "the economy," and themselves. "It is about giving people powerful information so that they can make better choices."¹

Of course, geographical information really does "empower" people. I rely on my phone's map function whenever I travel to a strange city or an unfamiliar part of my own city. This lends a basic plausibility to Google's rhetoric. But spreading the light of knowl-edge, by itself, doesn't yet amount to a business strategy, does it?

There was a spot of awkwardness when it emerged that Google's camera cars were using Wi-Fi to suck up data from people's home networks as they slowly cruised around. Investigators in several countries discovered that this included "names, telephone numbers, credit information, passwords, messages, emails, and chat transcripts, as well as records of online dating, pornography, browsing behavior, medical information, location data, photos, and video and audio files. They concluded that such data packets could be stitched together for a detailed profile of an identifiable person."²

"We are mortified by what happened," said the firm's newly appointed director of privacy.³ Google said it was due to the work of a rogue engineer, a bad apple who undertook an experiment on his own initiative, which somehow found its way into the Street View system—a clerical error. Subsequent investigations by the FCC and thirty-eight state attorneys general found that,

≥

STREET VIEW | 267

on the contrary, it was all part of the plan. But this finding took four years, as the firm simply ignored subpoenas, administrative rulings, civil investigative demands, and other efforts by democratic institutions to hold it accountable to the law, during which time people became habituated to the idea that Google can unilaterally claim the right to photograph and map physical space, to create a master index of the world.⁴ This has been the pattern in every country the firm operates in. Sovereign political entities can only get in the way of this supranational enterprise.

It makes sense, then, to view these developments in the context of political history. Street View may be understood as part of a long history of mapmaking as an instrument of empire. Political consolidation—gathering power from far-flung territories to an administrative capital—requires that a territory be knowable from afar, and this has always presented challenges to a would-be imperial power.

In his book Seeing Like a State, the Yale anthropologist and political historian James C. Scott writes that towns built in medieval times generally look disordered from an aerial view, in the sense that they have no discernible form. "Streets, lanes, and passages intersect at varying angles with a density that resembles the intricate complexity of some organic processes." The defensive structures of walls and moats would be outgrown in a town that prospered; "there may be traces of inner walls superseded by outer walls, much like the growth rings of a tree."⁵

Such towns developed without a master plan or design, but this does not mean that they were confusing to those who lived in them. Scott gives the example of Bruges, a city in Belgium. "One imagines that many of its cobbled streets were nothing more than surfaced footpaths traced by repeated use. For those who grew up in its various quarters, Bruges would have been perfectly familiar, perfectly legible. Its very alleys and lanes would have closely approximated the most common daily movements." But for someone arriving from outside, such as a trader or a representative of the king looking to collect taxes or conscript soldiers for military adventures, the city would be hard to orient in; hard to read. The cityscape "could be said to privilege local knowledge over outside knowledge." Combining an organic metaphor with a linguistic one, Scott writes that the arrangement of the city "functioned spatially in much the same way a difficult or unintelligible dialect would function linguistically. As a semipermeable membrane, it facilitated communication within the city while remaining stubbornly unfamiliar to those who had not grown up speaking this special geographic dialect."

This membrane, and the illegibility to outsiders that it maintained, had real political significance: it provided a margin of safety from "control by outside elites. A simple way of determining if this margin exists is to ask if an outsider would have needed a local guide (a native tracker) in order to find her way successfully. If the answer is yes, then the community or terrain in question enjoys at least a small measure of insulation from outside intrusion."⁶

From the perspective of the imperial center, knowledge that is scattered and localized in the periphery is an obstacle to central control—unless it can be gathered and collated. All those lanes and alleys need to be mapped.⁷

THE UBERIZATION OF LONDON

Though Seeing Like a State was written before Google and Uber existed, I think Scott's framework allows us to see that Big Tech's project of enhanced geographic legibility may be understood, yes, as making things more convenient for visitors and new arrivals to any locale, but also—in some sense we need to explore—as a program of political and economic dispossession affecting established residents. Some intuition of this must lay behind the allergic reaction that people around the world have had to the sight of Google's camera cars prowling through their neighborhoods.

STREET VIEW | 269

London is very much a medieval city of the sort Scott describes, with about twenty-five thousand streets within a six-mile radius of Charing Cross. When I visit London, I have found myself flagging down a cab even if I need to go only a few blocks, because trying to find my way on foot is mentally exhausting. I almost always get turned around and disoriented, even with the help of the blue dot on my phone and frequent recourse to the compass function.

In 2012, Matt McCabe was studying to become a London taxi driver. The process takes four years, on average, for those who devote themselves to it full-time. In an arresting piece of journalism, Jody Rosen told McCabe's story at length.8 To prepare for the licensing exam takes "unnumbered thousands of hours of immersive study, as would-be cabbies undertake the task of committing to memory the entirety of London, and demonstrating that mastery through a progressively more difficult sequence of oral examinations." conducted in formal attire by examiners who are themselves taxi drivers. Would-be initiates generally work in pairs, calling out routes to one another, with their eyes closed, in a head-bobbing exercise of recall that would look familiar to any serious student of Talmud. They do this while facing each other across a table, in a room filled with giant maps. But the real preparation consists of walking the city, or driving a motorbike with a map attached to the windscreen, to find the most efficient routes. McCabe logged more than fifty thousand miles on a scooter during his period of study, a distance equal to traversing the North American continent sixteen times, but almost entirely within the city center. And such a curriculum is typical for those who seek the Knowledge, as it is called. For the sheer cognitive accomplishment it marks, it has been called the most demanding professional test of any kind, comparable to those that control admission to the legal and medical professions.

Rosen writes:

London cabbies need to know all of those streets, and how to drive them—the direction they run, which are one-way, which are dead ends, where to enter and exit traffic circles, and so on. But cabbies also need to know everything on the streets. Examiners may ask a would-be cabbie to identify the location of any restaurant in London. Any pub, any shop, any landmark, no matter how small or obscure—all are fair game. Test-takers have been asked to name the whereabouts of flower stands, of laundromats, of commemorative plaques. One taxi driver told me that he was asked the location of a statue, just a foot tall, depicting two mice sharing a piece of cheese. It's on the facade of a building in Philpot Lane, on the corner of Eastcheap, not far from London Bridge.

Knowledge of the streets shades into something more comprehensive, knowledge of the city and its history, as the city is constantly changing. Traveling to a fish market on the outskirts of town that supplies high-end restaurants, McCabe gathers intelligence on which chefs are currently where. "You have to look into these things. You know, the examiner could turn around and say, 'Name me two Angela Hartnett restaurants,' or 'Name me four Gordon Ramsay restaurants.""

Thirty-seven months into his studies, McCabe reckons that, once he figures in lost income since devoting himself to the Knowledge full-time (he previously had a business in the building trades), he has invested about \$200,000 in becoming a taxi driver. He was once rear-ended on his scooter while surveying a route, and went flying over the roof of the car.

It is largely a skill of visual memory that the "Knowledge boys" develop; in plotting a route in their minds' eye they will alternate between a street-level view and the aerial views that they absorb by poring over maps for many hours every day. According to Rosen they "speak of a Eureka moment when, after months or years of doggedly assembling the London puzzle, the fuzziness recedes and the city snaps into focus, the great morass of streets suddenly appearing as an intelligible whole. McCabe was startled not just by that macroview, but by the minute details he was able to retain. 'I can pull a tiny little art studio just from the color of the door, and where it's got a lamppost outside. Your brain just remembers silly things, you know?'"

How are we to understand this knowledge, and its value? How should we view its likely demise as the GPS-enabled ride sharing firm Uber muscles its way into London, with its standing reserve army of subsistence drivers who have little investment in the job? One response would be to say, good riddance. The taxi drivers are like a medieval guild who have been able to charge high fees because of their knowledge, which is personally held. But that knowledge has been rendered as "information," available to all without effort, through a machine process. And this is all to the good for consumers. That is, for the people (who only show up as consumers in this train of thought). Where's the problem? Wouldn't it be a little too precious to worry about the London taxi drivers, a romantic indulgence? One probably rooted in some rigid mental habit, a fear of change and hankering after the past? Or some merely aesthetic objection to technology, typical of privileged intellectuals? These are the stock phrases of forward thinkers on left and right alike who invoke inevitability to quarantine doubts that may arise about the progressive good will of Big Tech. To be free of nostalgia is the first point of pride for such intellectuals. This makes them useful to the tech firms in overcoming popular resistance when those firms launch fresh incursions into previously autonomous realms.

To understand the resentments provoked by Street View in the UK, one has to select a Brexit hat and try it on for size. The slogan of the Leave campaign was "Take Back Control." That, in a nutshell, expresses the political issue: sovereignty. It is visible in microcosm in the fight between a guild of taxi drivers who spend their lives on the streets of London gaining hard-won knowledge, on the one hand, and a small cadre of data entrepreneurs armed with satellites who live in Mountain View, California, on the other. And by the way, those satellites actually belong to the United States military, which developed GPS for its own purposes. Those initial purposes of military surveillance turned out to be admirably adaptable to this brand of economic colonialism, perhaps a karmic reversal of the state-enabled piracy practiced by Britain's Hudson's Bay Company in North America three centuries earlier.

Let us give the angry nationalist intuition a bit further rein, and see where it leads us. The incursion of Street View and GPS has opened London up for easier inspection, making it more legible to outsiders. These include the Esperanto meritocrats who come from all corners of the globe to throng the city's financial center in smartly tailored suits, and representatives of various trans-European administrative bodies who must visit the island, like a Roman proconsul, to keep it abreast of pronouncements by the European Parliament. The flood of GPS-guided cars trolling for fares, piloted by ill-paid drivers as lost in London as you or I, has increased congestion but also made London more cheaply available to tourists who come for a few days. What's not to like, for the cockney East Ender who took four years out of his life to master his own city from the cobbles up, on two wheels, in all manner of weather? To complain about your own economic and political dispossession is to be a Luddite.9

Clearly the discontent of a Leave voter cannot be met simply with economic arguments, as the Remain campaign tried to do, as this kind of despair shades into something more existential than economics. In fact, throughout the Western democracies we have seen the advent of what we might call existential politics, and one factor in this is surely that sense one has that there is something new and voracious in the world that feeds on local sovereignty and hard-won, personal knowledge of the material world.

In 2008 Google launched a project called Ground Truth but kept it tightly under wraps, likely due to the controversies surrounding StreetView. It was more or less forced to reveal the program after the FCC issued its final report on Google's surveillance lawlessness in 2012. Ground Truth takes the logic of StreetView one step further. It is essentially an effort to capture *all* locally embedded intelligence of the sort the London taxi drivers call the Knowledge. In natural settings, it aspires to what a wilderness guide in some particular mountain range or swamp might call local ecological awareness.

The senior product manager for Google Maps introduced the Ground Truth project by saying, "If you look at the offline world, the real world in which we live, that information is not entirely online." This is a defect in reality. It represents darkness and inaccessibility, and these are bad. More cheerfully, it is a gap to be bridged. Because we can. As Shoshana Zuboff reports, "Ground Truth is the 'deep map' that contains the detailed 'logic of places': walking paths, goldfish ponds, highway on-ramps, traffic conditions, ferry lines, parks, campuses, neighborhoods, [the interiors of] buildings, and more. Getting these details right is a source of competitive advantage in the contest for behavioral surplus accrued from mobile devices."

We will parse Zuboff's revelatory concept of behavioral surplus in the chapter "If Google Built Cars." Right now, let us consider what it would mean for a single corporation to develop a comprehensive index of the physical world. For what Google seeks is nothing less than this. It has put its cameras on backpacks and snowmobiles to access places not canvassed by its Street View cars, and offered use of the backpack cameras to nonprofits and tourist boards to "collect views of remote and unique places."¹⁰ There is always a democratic-sounding rationale that can be produced if anyone balks at this, a one-liner before which the kind of people who staff nonprofits are likely to crumble: you wouldn't want to hoard remote and unique places for "the privileged," would you?

A world that is fully known by Google, and indexed by Google, will be accessed via Google as well. It will be the reality platform. As Zuboff puts it, "My house, my street, my favorite café: each is redefined as a living tourist brochure, surveillance target, and strip mine, an object for universal inspection and commercial expropriation." And this: "Google's ideal society is a population of distant users, not a citizenry. It idealizes people who are informed, but only in the ways the corporation chooses."

To make every place available to all is not to erase privilege, if by that term we mean something illegitimate. Rather it is to erase an earned ability to know and to use diverse and localized pockets of the world according to different levels of personal investment and responsibility. Another way to name this would be the end of ownership, conceived not simply as private property, but as title to inhabit some place on the earth as one's own. We do so with others who are also in *this* place, rather than another place; let us call that collective ownership citizenship. Such existential or experiential ownership is to be sacrificed, not for the sake of a socialist ideal, but for the sake of perfect legibility from afar, mediated by a single corporation.

Such an end point, if it were to be reached, would dispossess us not only of a home, but of that elusive thing that we seek in a road trip or a backpacking trip: moments of discovery that cannot be anticipated, purchased, or gotten cheaply through a screen. With such discoveries, we gain the kind of acquaintance with a new place that is earned through personal risk. Such possibilities are the common wealth of the human race.

Sustained habitation of a place in this bodily manner becomes the foundation of local solidarity. Jody Rosen relates the moment when Matt McCabe was accepted into the fraternity of London

STREET VIEW | 275

taxi drivers as one of overwhelming emotion. After years of merciless grilling by his examiners, conducted with all the formality of a legal deposition, his final recitation of a route, or "call," consisted of twenty-seven turns from Camberwell to Holloway before an examiner named O'Connor:

When McCabe finished the call, he and O'Connor sat in silence for what seemed to McCabe an eternity. Finally, O'Connor stood up and extended his hand. He said: "Well done, Matt. Welcome to the club. I'm pleased to say that you're now one of London's finest." It was the first time in the more than three years McCabe had been coming to LTPH that an examiner had called him by his first name. . . . "It was hard to hold back the tears. Three years of complete financial stress, family stress-studying for 13 hours a day, seven days a week. Suddenly, the whole thing was very casual. It was quite, you know, 'Sit back, relax, loosen your tie.' And then Mr. O'Connor was telling me what to expect doing the job. He was giving me his inside knowledge after being a London cabbie for, like, 20-odd years." McCabe went home to his family. He and his wife, Katie, ordered take-out from a Thai restaurant, put on loud music, and danced around the house with their children. When the kids went to bed, the McCabes drank a few beers and dismantled the Knowledge library: stored the flashcards and pages of notes, took the maps off the wall. Katie, McCabe said, "cried for about two days solid."

What this scene depicts is a livelihood. Or to use a more comprehensive term, it depicts a lifeworld: an economic, social, and existential home, based on a deep cognitive accomplishment earned through sheer dint of intellectual labor and bodily exposure, a world of hours invested and relationships formed, of financial risk undertaken in uncertainty and hope, redeemed through faith and perseverance. To make the streets of London navigable by machine processes brings real benefits to the many, while destroying the lifeworld of a small minority. There is a real trade-off here; there is no political algebra that solves for justice. As always, it will be a contest of competing interests, with winners and losers. In thinking about the contest of learned cabbies versus Google and Uber, we do well to recognize that it is just one of many that stretch out before us in the coming years, and that each of us belongs to a small minority of some sort. Most of these contests have not yet been recognized by you and me, but you can be sure that as you read this, they are being identified by the Blob that seeks to claim every nook and cranny of human experience as raw material to be datafied and turned to its own profit. What this amounts to is a concentration of wealth, a centralization of knowledge, and an atrophy of our native skills to do things for ourselves.

However one comes down on a contest such as that between the highly professional taxi savants and the indifferent drivers of the gig economy; between consumer convenience and a living wage; between waiting an extra five minutes to hail a cab versus spending an extra ten minutes in traffic because the streets are flooded with empty Ubers, shouldn't these questions be decided by *us*, through democratic contest and market forces? That is not at all what is happening. It is more like colonial conquest, this new and very unilateral form of political economy.

A GLORIOUS, COLLISIONLESS MANNER OF LIVING

The vision of smooth-flowing mobility that is offered on behalf of driverless cars can be fully laid out only as part of a larger vision, that of the "smart city." The idea is that our movements through the city, the infrastructure we depend on, the police protections, trash collection, parking, deliveries and all the other services that make a city work, will be orchestrated by an "urban operating system."

As part of the smart city vision, driverless cars are thus one element in a striking intellectual movement. It is striking not least for its revival of a long-standing modernist ambition, that of transformative urban planning. The goals of such planning are usually public health, efficiency, beauty, and, something more elusive, order. Some cities that have gotten the full treatment over the last two centuries are wonderful places to visit despite their controversial remakings; see Paris (much of it demolished and rebuilt by Haussmann under Louis Napoleon). Others, like Brasilia and Chandigarh (both designed from the ground up by Le Corbusier), quickly became ghost towns, full of high-modernist buildings and plazas of impressive conceptual ambition through which the wind whistled, eventually to be repurposed by squatters or stripped of building materials for use in the surrounding shanty towns where urban life carries on in defiance of the master plan. Such projects are sometimes sited in countries in the developing world that are attractive to Western visionaries precisely because they have no robust tradition of self-rule, and therefore offer no organized resistance to the plan. Le Corbusier offered his services as a planner to Western authoritarians—both the Vichy regime and Stalin's USSR—before hitting upon this third world strategy.

The history of trying to render the city as an object of rational planning is a checkered one, with successes and failures both. The longing for order that underlies it is sometimes impervious to chastisement by the stubborn realities of human behavior. Something in the technocratic personality is easily tempted into a moralintellectual space that floats free of the empirical, and has more in common with the nonfalsifiable commitments of religious faith.

Grand visions are easy to criticize on these grounds, and I will mount such a criticism of the smart city shortly. But let's begin by noting that usually it is more small-bore, uncoordinated attempts to assert control that, cumulatively, can lead to a clampdown on the human spirit in urban spaces. Yet, precisely because of the petty-tyrant character of such clampdowns—the obvious fact that they *are* clampdowns—they may summon a response in certain bold souls that is beautiful to behold.

CALL SECURITY

One of my favorite YouTube videos features a guy who is clearly a skilled stunt motorcycle rider practicing controlled, nearly walkingspeed wheelies in the empty parking lot of a shopping mall. He has a video camera attached to his helmet. He is approached by a man with a clipboard, that universal talisman of functionaries who take themselves to be deputized on behalf of order. What the functionary says is hard to make out in the recording (probably something about safety). But then it hardly matters, does it? It is really the clipboard that conveys the message, a mute form of authority that often has no real argument to give, and can be effective only if everyone automatically defers to it.

But our stunt rider doesn't do this. From his helmet cam, we see him riding in a slow circle around Clipboard Man on one wheel, and you can sense that he is at ease. "Does this look dangerous?" he asks, a bit incredulously.

He has a point, which is easy to grasp if you have ever been nearly killed in a parking lot by some upstanding member of the PTA backing out in her Suburban.

But then wheelie guy takes it to the next level. He says to Clipboard Man, "You're just confused, and it makes you feel things." The poor guy really does seem to be stumped by this interaction.

Wheelie guy rides off. He clearly won the battle, in some important sense, but isn't fool enough to think the police are hip to his higher logic.

According to that logic, it is not just that Clipboard Man's mission is gratuitous, objectively speaking (the parking lot is empty). He is "confused" and it makes him "feel things." The fetish of rule following becomes its own justification, and it fills him with a lust for enforcement even when there probably isn't, in fact, any rule to cover parking lot wheelies. At the risk of seeming unpatriotic, I have the sad duty of pointing out that this seems to be a distinctly American phenomenon. As my French friend Jean-Pierre Dupuy said to me, "You are rule worshippers," to the point we will make up rules on the fly to cover unanticipated eruptions of the human spirit. To compensate, we keep singing a song to ourselves about being "the land of the free and the home of the brave."

The rapper Lupe Fiasco has a beautiful track titled "Kick, Push" that tells the story of an urban kid who comes to maturity through skateboarding, and in doing so comes up against clipboard authority.

Since the first kick flip he landed Labeled a misfit a bandit His neighbors couldn't stand it So he was banished to the park Started in the morning Wouldn't stop till after dark Yea when they said its getting late in here So I'm sorry young man there's no skating here

He goes on to meet a girl skater; she takes him to a spot in a parking lot he didn't know about, with an odd feature to it, and they grind it until "security came and said there's no skating here." They become part of a crew. They get chased out of office building plazas. "Just the freedom was better than breathing they said."

Coming of age, fugitive love, fugitive solidarity: getting chased off by "security" plays a role in creating the dissident bond. What a shame it would be if there were no Clipboard Men to heighten the experience of freedom! Like Wheelie Guy, and like Hunter S. Thompson in his encounter with the CHP cop, the protagonists of "Kick, Push" confront the forces of order *personified*: functionaries who are nonetheless flesh and blood, giving chase to kids on skateboards and probably relishing the chase for human reasons of their own. What becomes of this human drama—the drama of freedom—when order is rendered algorithmically? Where is the fight? Before turning to the smart city proper, let us consider the *spirit* in which digital innovations in urban management are likely to be deployed.

THE SPIRIT OF ADMINISTRATION

Sometimes urban spaces are designed to forestall moments like those depicted by Lupe Fiasco, making the explicit intervention of "security" unnecessary because the possibilities of use have been more rigorously constrained by the design itself. Thomas de Monchaux writes of "the taste for order" that prevails when public parks, for example, come to be funded by private interests. It is natural to suppose this is driven by liability concerns, but the taste for order tends to slip the bonds of any such calculation and become a kind of murky moralism: not something openly avowed but rather taken for granted, hard to grab hold of, and therefore hard to contest.

Monchaux writes about the High Line in New York City, a wonderful park created with private financing out of an elevated railway that had long been out of service. He gives the park its proper due, but then notes that "its defining detail is the prim arrangement of metal pins and ropes that enforce the border between paving and planting. They seem to say: Do not wander, do not play, do not fool around."

Perhaps such features have a legitimate safety rationale to them (stepping off the deck and into the flower beds, a distance of some six inches, could cause you to twist an ankle). "Yet there is also something in this regulation that goes beyond defense against the worst possibilities, toward a discouragement of all the benign irregularities—the unruly felicities, creative improvisations, leisurely inefficiencies and insouciant eccentricities—that are the heart of urban life."

Monchaux brings the point home nicely, and connects the

design of public spaces to political culture: "In our liberal democracy, any occupation of public space—even, sometimes especially, at play—is a celebration of the rights of assembly and expression. The greatest success of parks and plazas is not in some efficient, one-to-one mapping of activities to facilities, or in the controlled consumption of culture, but in the ways that, as a matter of policy and design, they encourage the taking of liberties."

This is what skateboarders represent, and more. They take a plaza, not as a mere empty space for assembly, but as a constitutive element of their activity. Its hardscape features define specific challenges; they develop a repertoire of skills that may be specific to the place. They appropriate it for purposes that were never intended but are latent in it, lying dormant as affordances to be discovered by people who roll. Their "misuse" has a revelatory quality.

Understood this way, skateboarding easily lends itself to being viewed as contemporary art. But this would be to risk misidentifying skateboarding with the feckless "subversive" aspiration of art people. I think it is more instructive to view urban skating as an expression of civic republicanism, if one may apply a stodgysounding term here. To bring out this aspect of its appeal, we need to consider more carefully Monchaux's parenthetical remark that the best parks and plazas encourage the taking of liberties "as a matter of policy and design." Yes and no. If the liberties in question are to be actively *taken* (for that is what is impressive about the skaters), rather than prescribed, the "encouraging" must have a minimal quality to it. Such is the tactful quality required of the design, and it is a quality characteristic of liberalism as originally understood: securing the minimal conditions for living together, and a bit more, but not trying to control everything.

Liberalism too easily slides into something more ambitious, and by that measure less liberal. Public spaces that feel unadministered seem to be vanishing. If the "policy and design" of parks and plazas is to be modest, deliberately underdetermining of the uses that might be found for them, the designer must refrain from precisely that which is most exciting to intellectuals: a comprehensive vision. Such visions invariably clamp down on play, because play insists on making its own rules, internal to some game that is "for us," as Huizinga taught us. Urban skaters are a play community.

Jane Jacobs criticized the kind of planning that seeks to bring order "by repression of all plans but the planners." Speaking of the Garden City plans of Ebenezer Howard, Jacobs called these "really very nice towns if you were docile and had no plans of your own and did not mind spending your time among others with no plans of their own. As in all Utopias, the right to have plans of any significance belonged only to the planners in charge." Recall that this is, precisely, the complaint that Bernard Williams made against utilitarianism: that its totalizing logic demands we all subordinate our own plans to the plans of whoever is in charge of the Universal Utility Calculation.

In assessing the smart city vision, we need to keep one eye on how well the proposed order will leave room for those sources of unplanned urban delight so well named by Monchaux: "unruly felicities, creative improvisations, leisurely inefficiencies and insouciant eccentricities." What if Clipboard Man is to be installed in an opaque, proprietary "urban operating system" that is highly determinate, an "efficient, one-to-one mapping of activities to facilities" in which parking lot wheelies do not compute?

Much of our driving takes place in a city setting, so urban design goes a long way toward determining the driving experience. We have considered the automation of automobiles, and some of the unpublicized costs that are likely to attend the more obvious benefits. The same logic of automation is being extended from cars to cities, as indeed it must to achieve the driverless vision. How is this package likely to reverberate through society? Will it modify the liberal inheritance that we take for granted? Can the proposed transformation be taken as the token of a larger ambition? Whose?

THE SMART CITY

Writing in *Tablet*, Jacob Siegel points out that "democratic governments think they can hire out for the basic service they're supposed to provide, effectively subcontracting the day to day functions of running a city and providing municipal services. Well, they're right, they can, but of course they'll be advertising why they're not really necessary and in the long run putting themselves out of a job." There is real attraction to having the tech firms of Silicon Valley take things over, given the frequent dysfunction of democratic government. Quite reasonably, Siegel writes, many of us would be willing to give up "some democracy for a bit of benign authoritarianism, if it only made the damn trains run on time. The tradeoff comes in the loss of power over the institutions we have to live inside."

The issue, then, is sovereignty.

Google is building a model city within Toronto, a sort of Bonsai version of what is possible, conceived in the spirit of other demonstration cities that were intended to sway elite opinion, such as Potemkin's village that so impressed Catherine the Great. Sensors will be embedded throughout the physical plant to capture the resident's activities, then to be massaged by cutting-edge data science. The hope, clearly, is to build a deep, proprietary social science. Such a science could lead to real improvements in urban management, for example by being able to predict demand for heat and electricity, manage the allocation of street capacity based on demand, and automate waste disposal. But note that hoarding the data collected, and guarding it with military-grade secrecy, is key to the whole concept, as without that there is no business rationale. Smart cities have been called the next trillion-dollar frontier for big tech.

Given the governmental aspirations of Google, it may be instructive to glance once more at James C. Scott's Seeing Like a

UT1

State, published in 1998. He traces the development of the modern state as a process of rendering the lives of its inhabitants more "legible." The premodern state was in many respects blind; it "knew precious little about its subjects, their wealth, their landholdings and yields, their location, their very identity. It lacked anything like a detailed 'map' of its terrain and its people." This lack of a comprehensive view put real limits on the aspiration for centralized control; the state's "interventions were often crude and self-defeating." The rise of a more synoptic administrative apparatus in the eighteenth century made it possible to improve the delivery of services and the keeping of records, mainly for purposes of taxation and military conscription. Enhanced legibility also led to a new way of viewing society, as a system that is intellectually graspable. As such it becomes an attractive object to the gaze of visionaries, and invites intervention. The more rigorous the vision, and the more confidence it inspires in those who share it, the more the intervention seems to demand that a blank slate be prepared for the master strokes, from Baron Haussmann's demolition of Paris to create a more legible order of boulevards radiating out from the center, to Le Corbusier's selection of an uninhabited jungle as the site for the rationalist utopia of Brasilia.

"Human beings currently live in cities that are the equivalent of flip-phones," a certain smart city urbanist née venture capitalist recently told the *New York Times*. We need to understand the impatience that underlies the analogy, the sense of waste, the sheer lack of *optimization* that offends. Another investor-urbanist, a Mr. Huh, says "We have not affected the fundamental building blocks of infrastructure and society." The *Times* reporter writes that Mr. Huh gestured to his laptop and said, "We've made this better. We've made the new things better. We haven't made the old things better." In a helpful gloss, the reporter points out that in thinking about how to make the old things better, "people in tech prize 'first principles,' a concept that suggests that historical awareness and traditional expertise can get in the way of breakthrough ideas."

Here we see the old drama of modernism playing out one more time. The urban blank-slater reminds us of Thomas Hobbes's disgust with the customary or common law, that body of precedents and practices that ordered English life, but which appeared to him as a sediment of inherited mindlessness. For Hobbes, life needed to be governed by laws that would be excogitated (by him) from scratch, according to clear principles, not by the haphazard accumulation of informal usages and understandings.¹ Rather than seeking the reasons *latent* in our unthought practices, and from them trying to reverse engineer the logic of a city (as Jane Jacobs did), the smart city epigones of Hobbes place their trust in their own powers of apriori reason.

What would it mean to make a city more like a smartphone? Presumably such a city would be one in which a glassy façade of high design opens into a cornucopia of apps tailored to my needs, to be satisfied with maximum efficiency and minimum effort on my part, through mechanisms that are utterly unknown to me. This is a trajectory we have investigated in the context of automobile design. But it has also become prominent in institutional life, through the increasing role of algorithmic decision-making. The smart city, and our movements through it, would likely share in some of the difficulties that have emerged on this front.

ALGORITHMIC GOVERNANCE AND POLITICAL LEGITIMACY

In The Black Box Society: The Hidden Algorithms That Control Money and Information, University of Maryland law professor Frank Pasquale elaborates in great detail what others have called "platform capitalism," emphasizing its one-way-mirror quality. Increasingly, every aspect of our lives—our movements through space, our patterns of consumption, our affiliations, our intellectual habits and political leanings, our linguistic patterns, our susceptibility to various kinds of pitches, our readiness to cave in minor disputes, our sexual predilections and ready inferences about the state of our marriage, our moment-to-moment emotional state as revealed by our facial expression-are laid bare as data to be collected by companies who, for their own part, guard with military-grade secrecy the algorithms by which they use this information to herd and nudge our behavior. The version of yourself that is known (or constituted) in this manner increasingly determines the world that is presented to you through various electronic means. The classic stories that have been with us for decades, of someone trying to correct an error made by one of the credit-rating agencies and finding that the process is utterly opaque and the agencies unaccountable, give us some indication of how this can go badly. Your credit rating may create a picture of your character that is misleading, but it exerts decisive sway over your life. In a far more comprehensive way, you are coming to inhabit a world that is tailored to your data-self through a process that is beyond your reach, and designed to serve the interests of whoever owns the algorithm.

This lack of accountability to citizens cannot be overcome by good-faith efforts to achieve "transparency," for reasons intrinsic to the technology. The logic by which an AI reaches its conclusions is usually opaque even to those who built the AI, due to its sheer complexity.²

When a court issues a decision, the judge writes an opinion, typically running to many pages, in which he explains his reasoning. He grounds the decision in law, precedent, common sense, and principles that he feels obliged to articulate and defend. This is what transforms the decision from mere fiat into something that is politically *legitimate*, capable of securing the assent of a free people. It constitutes the difference between simple power and authority. One distinguishing feature of a modern, liberal society is that authority is supposed to have this rational quality to it—rather than appealing to, say, a special talent for priestly divination. This is our Enlightenment inheritance.

You see the problem, then. Institutional power that fails to secure its own legitimacy becomes untenable. If that legitimacy cannot be grounded in our *shared* rationality, based on reasons that can be articulated, interrogated, and defended, it will surely be claimed on some other basis. What this will be is already coming into view, and it bears a striking resemblance to priestly divination: the inscrutable arcana of data science, by which a new clerisy peers into a hidden layer of reality that is revealed only by a self-taught AI program—the logic of which is beyond human knowing.

For the past several years it has been common to hear establishmentarian intellectuals lament "populism" as a rejection of Enlightenment ideals. But we could just as well say that populism is a reassertion of democracy, and of the Enlightenment principles that underlie it, against priestly authority. Our politics have become at bottom an epistemic quarrel, and it is not at all clear to me that the well-capitalized, institutional voices in this quarrel have the firmer ground to stand on in claiming the mantle of legitimacy—*if* we want to continue to insist that legitimacy rests on reasonableness and argument.

Alternatively, we may accept technocratic competence as a legitimate claim to rule, even if it is inscrutable. But then we are in a position of *trust*. This would be to move away from the originating insight of liberalism: power corrupts.

Such a move toward trust seems unlikely, given that people are waking up to the business logic that often stands behind the promise of technocratic competence and good will. Let us consider a couple of recent cases of "smart" road infrastructure development. When Kansas City was ripping up its Main Street to install a trolley line, Cisco convinced city officials that this was a perfect opportunity to install various sensors and a fiber-optic cable, to monitor traffic. The pitch was that this wouldn't add much additional cost, and it would help the municipal authorities understand how their city works. The city did this and also built twenty-five kiosks along the trolley line to provide public Wi-Fi, and put surveillance cameras on the streetlights. The city had to borrow money for some of this, but the bulk of the expense was covered by Cisco and Sprint. The latter firm manages the Wi-Fi network. The *New York Times* reports that "the city's downtown corridor now monitors nearly everything that happens along this stretch of road [2.2 miles]—cars, pedestrians and parking spaces. The wireless system has been used by 2.7 million people."

Are projects like this to be understood as an eruption of civic spirit and philanthropy by these corporations? The motivation becomes a little less murky when we learn that "Sprint collects data from the users who log onto the wireless network, including their home zip codes, internet searches and location. Some of the information—including phone numbers and other potentially identifying information—is available even if one does not log onto the wireless network." Sprint declined to discuss the data or what use they make of it, though the firm's director of emerging solutions did aver that "people are ready for smart things."

Meanwhile, in another bit of civic-mindedness, this one in Pittsburgh, Uber has deployed driverless cars that suck up traffic data as they roam. The pitch to the city, once again, was that such information would help the city manage its affairs. But in fact the firm has refused to share the data, and this has been the case wherever it has deployed its autonomous cars. "This was an opportunity missed," said Pittsburgh's city controller. He might have misunderstood what the opportunity was in the first place.

We might be tempted to say, the dumber the city, the more

eager it is to become a smart city. This is fair, so long as by "dumb" we mean not an actual cognitive impairment, but having a low standing in the smarty-pants political economy.

Economically bludgeoned by developments of the last few decades, flyover country is determined to be forward thinking. Kansas City has declared itself the nation's "smartest city" and hosts international conferences to tell others about this. Bob Bennett, the city's tech guru, vibrates the region's anxieties with a pitch-perfect phrase when he says, "Cities that fail to embrace technology today, that fail to embrace a data-driven approach, those cities will be in the *digital Rust Belt* 20 years from now."³

As used in neoliberal economic chatter, "Rust Belt" means a place that failed to adapt to the inevitable, and therefore fell to decay and ultimate extinction. Wrong-side-of-history-ism is a progressive version of social Darwinism; both invoke inexorable natural processes to cast political losers in a certain light. A sense of inevitability is constantly cultivated in the pronouncements of the tech firms, and this seems to be a deliberate strategy to demoralize political opposition wherever it appears in response to some new incursion.

But if we regard the smart city as just another scam, I think we're likely to miss what is distinctive about it. The ambitions of Sprint and Cisco may be those of garden-variety corporate hacks, but the subtle operators of Google represent something more Jesuitical. To get a sense of the ends toward which we are likely to be steered in a Google-run city, we need to take a look behind the curtain and consider the firm's commitments, and its manner of pursuing them, as revealed by its core business of search. Presumably it would bring a similar ethos to the management of cities.

TRUSTEESHIP THROUGH INFRASTRUCTURE

Of all the platform firms, Google is singular. It's near monopoly on search (about 90 percent) puts it in a position to steer thought. And increasingly, it avows the steering of thought as its unique responsibility. Famously founded on the principle "Don't be evil," it has since taken up the mission of actively doing good, according to its own lights.

In an important article titled "Google.gov," the law professor Adam J. White writes that Google views "society's challenges today as social-engineering problems" and aspires to "reshape Americans' informational context, ensuring that we make choices based only upon what they consider the right kind of facts while denying that there could be any values or politics embedded in the effort." Good governance means giving people *informed* choices. This is not the same as giving people what they *think* they want, according to their untutored preferences. Informed choices are the ones that make sense within a well-curated informational setting or context. What will it be like when this spirit of supervision is licensed to orchestrate our movements through the physical world? We will consider this in detail in the next chapter, "If Google Built Cars." But let us linger a bit longer on the character of this firm as revealed thus far.

A bit of recent intellectual history is important for understanding the mental universe in which Google arose. The last two decades saw the rise of new currents in the social sciences that emphasize the cognitive incompetence of human beings. The "rational actor" model of human behavior—a simplistic premise that had underwritten the party of the market for the previous half century—was deposed by the more psychologically informed school of behavioral economics, which teaches that we need all the help we can get in the form of external "nudges" and cognitive scaffolding if we are to do the rational thing. There are two things to be noted. First, this was a needed correction in our understanding of how the mind works. Second, it is a philosophy that nicely dovetails with the project of enlightened social engineering, and has reemboldened the authoritarian tendencies of technocratic rule.

In the Founders Letter that accompanied their 2004 initial

public offering, Larry Page and Sergey Brin said their goal is "getting you exactly what you want, even when you aren't sure what you need." The perfect search engine would do this "with almost no effort" on the part of the user. As Eric Schmidt told the *Wall Street Journal*, "One idea is that more and more searches are done on your behalf without you having to type. . . . I actually think most people don't want Google to answer their questions. They want Google to tell them what they should be doing next."

The ideal being articulated in Mountain View is that we will integrate Google's services into our lives so effortlessly, and the guiding presence of this beneficent entity in our lives will be so pervasive and unobtrusive, that the boundary between self and Google will blur. The firm will provide a kind of mental scaffold for us, guiding our intentions by shaping our informational context. This is to take the idea of trusteeship and install it in the infrastructure of thought.

The smart city would presumably export the same set of guiding principles beyond the screen and install them in the physical world, where they would guide the activities of our bodies. Unplugging would not be an option. Presumably this city-like place would be a more tractable thing, resembling a city but without the offending frictions and collisions of free citizens. Such a terrarium of optimization may yield at last a true science of behavior management.

Given its competence at everything it does, we can be pretty confident that Google would make the trains run on time. This, and other benefits like it, would be concrete improvements to urban life. The price we are to pay is something more amorphous. We become providers of behavioral data, to be used for the purpose of nudging our behavior according to various purposes, whether for profit or for the sake of some enlightened bit of social engineering.

Let us now ask how this is likely to play out in driving.

IF GOOGLE BUILT CARS

At a COMDEX computer expo back in the Middle Ages (November 1997), Bill Gates compared the computer industry with the auto industry. He said of the computer industry, "The openness, the innovation, it's really unequaled. . . . The price of a midsized auto, it's about double what it used to be. . . . And if you take that and say, what would those prices be if it were like the PC industry, the car would cost about \$27." As embellished in urban legend, he went on to say, "If GM had kept up with technology like the computer industry has, we would all be driving \$25 cars that got 1,000 miles to the gallon." According to legend, General Motors issued a press release in response, stating that if GM had developed technology like Microsoft, we would all be driving cars with the following characteristics:

1. For no reason at all, your car would crash twice a day.

- 2. Every time they repainted the lines on the road, you would have to buy a new car.
- 3. Occasionally your car would die on the freeway. You would have to pull to the side of the road, close all of the windows, shut off the car, restart it, and reopen the windows before you could continue. You might have to re-install the engine as well. For some reason, you would simply accept this.
- 4. Apple would make a car that was powered by the sun, was reliable, five times as fast, and twice as easy to drive, but would run on only 5 percent of the roads.
- 5. Oil, water temperature, and alternator warning lights would be replaced by a single "general car default" warning light.
- 6. New seats would force everyone to have the same size butt.
- 7. The airbag would say "Are you sure?" before going off.
- Occasionally, for no apparent reason, your car would lock you out and refuse to let you in until you simultaneously lifted the door handle, turned the key, and grabbed hold of the radio antenna.
- The Macintosh car owners would get expensive Microsoft upgrades to their cars, which would make their cars run much slower.
- 10. GM would require all car buyers to also purchase a deluxe set of road maps from Rand-McNally (a subsidiary of GM), even though they neither need them nor want them. Trying to delete this option would immediately cause the car's performance to diminish by 50 percent or more.

11. You would press the "start" button to shut off the engine.

In the mind of Bill Gates, automobiles stand for stagnation, the dead weight of industrial legacy. The fact that they work somehow fades from consideration. It's amazing how ready we are to abandon this standard of assessment and still regard a product as acceptable, if it has a forward-thinking sheen to it. Or it is forced upon us.

I RIPPED THE two-by-four off the abandoned chicken coop and brought it down as hard as I could on the roof of the little structure. The two-by-four, well rotted, broke in half. I used the remaining stump to beat on the roof some more, watching the corrugated plastic material shatter. Shirtless, scratched up and bleeding from the chicken wire, I grabbed the entire roof and forced it back against its hinges, ripped it off the coop, and hurled it into the woods. But I needed to destroy something more. So I cut down a small tree in my backyard, using a Sawzall (OK, it was a sapling). Then I got the gasoline and matches, and lit some shit on fire. The fire had a calming effect. Feeling almost meditative now, I pulled my phone out of my pocket and starting shopping for an AK-47, the weapon of choice for jihadists everywhere. For about \$850 you can get a really nice one.

You see, I had spent the last seven hours trying to get a newly purchased copy of Microsoft Office 2016 installed on a newly purchased MacBook Air. Rather than buy the software from one of the dodgy vendors online for \$66, I went to the official Microsoft site and paid \$149. So I wouldn't have any issues.

Do I really need to relate the details of this ordeal? Probably not; it is a universal experience that punctuates contemporary life. The frustrations of "tech" are different from those presented by other material things, and we need to consider this as we contemplate turning the car into a "device." The device has regular feeding times, dictated by the schedule of planned obsolescence. And what it demands is not just money and time; there is something more that is wanted. What this is, is hard to say, but let's note the pattern: with the exception of those "early adopter" dolts who stand in line overnight for the latest release, at each of these moments of upgrade or update most of us rage against the machine, and then we submit. Cumulatively, this pattern accomplishes a kind of education. The upshot of the education is that pride is maladaptive.

We don't use the word "technology" to name things like a toothbrush or a screwdriver; we reserve it for devices made of silicon chips and whatnot. But really, we're not referring to anything material. Rather, what makes a device "tech" is that it serves as a portal to bureaucracy. You cannot use them without involving yourself with large organizations, each with a quasi monopoly in its domain. The Microsoft Corporation has a product, adopted around the world, that allows me to do word processing on my computer. But for whatever reason, after paying for the product I must then serve as an unpaid bureaucrat as I try to reconcile the firm's sprawling, contradictory, out-of-date technical advice with whatever it is I downloaded from their site.

I dutifully persisted, and traveled far enough into the bowels of the organization that I found an offer to "talk to a person." This turned out to be a tease. The bot promised someone would call me in seventy-two minutes, but by the time the call came in from Bellevue, Washington, it was about five hours later and I was asleep. I did finally manage to interact with a human-like entity at the firm going by the name of "Christian E." He took control of my laptop remotely and spent the next thirty-six minutes getting it figured out. As my cursor flew around on its own, we interacted in a text box. When you interact with an actual person who is charged with presenting the face of facelessness, you can only feel sympathy for him and soften your antagonism.

In such situations, sometimes a gesture of human solidarity is reciprocated, so I thought it worth a try. I typed, "I hope your employer's surveillance software is giving you good marks for getting this sorted quickly." In this case, Christian E. never broke script. He pitched me on some Microsoft service I might want ("You get more while paying less. Would you like to know more about this offer?"). I assumed this was a query he generated with a single key-stroke, part of the routine. I wrote "It's OK, I understand that was the robot speaking," hoping a wink and a charitable assumption that his soul remained untouched by the job might elicit something real. He responded, "I understand it may take a while to reconsider the offer," etc.

Poor Christian. I tried another tack and wrote, "I will be sending a bill to Microsoft for seven hours of my time at \$158 per hour." He responded, "Thank you for being part of Microsoft," etc.

I did indeed feel part of Microsoft, a worker like him. "Team Beta," I wrote. What I meant was that he and I were engaged in beta testing, the debugging process. But immediately after typing it, I worried he might interpret it as me calling him a beta, meaning a nondominant male. That could be touchy, since his job, as well as my "user experience," required that we both adopt an ironic posture toward any claim either of us might have been inclined to make about not deserving to be fucked with in this way.

I described this episode to my friend Matt Feeney, and he pointed out that the more clearly you view the customer experience, *the worse the experience is.* So it is more adaptive not to engage in critical thought. The whole exchange presupposes your willingness to suspend those capacities and dispositions that form the basis for self-respect. Such resignation only feels like defeat for a little while, until the numbness sets in.

Confronted with the dysfunction and human waste of such an operation, you may have a hard time trusting your own experience, simply because it doesn't fit the collective story we tell about ourselves: we are a "free market" society. One thing this means is that you are free to vote with your feet and go elsewhere. Are you not happy with your bank? Is your statement riddled with mysterious, recurring charges that nobody can explain? Well, all you need to do is open an account somewhere else. It's simple. Then contact the twelve entities (each with its own bureaucracy—you'll need those PINs) that you have automatic monthly payments going to from your bank, and then speak to someone in the payroll department at your employer about getting your deposits transferred over as well. So yes, you can be persnickety about your thieving bank, and cable company, and cell phone provider, and health and auto and home insurers, if you are willing to become a full-time, unpaid bureaucrat yourself. Apparently that's what it takes to be free, in the free market sense. Who has the time? Instead we are angry; that is the bargain we have struck. It is the *ressentiment* of a slave, based on objective weakness and fantasies of revenge, as well as the inevitable selfloathing of the weak.

My point is that if the "exit costs" are high enough, you don't need an actual monopoly to get monopoly behavior. And the more interconnected everything is, the more "seamlessly" it all works together, the higher the cost of wrenching yourself free of the whole apparatus, if doing so is even an option.

Let us think about that, as we contemplate turning mobility over to a cartel of tech firms who seek to make everything interconnected. Do we want to make getting from point A to point B something you do, not in a car, but in a *device*, that is, a portal to overlapping bureaucracies? Will we obligingly accept the same conceit of a "seamless user experience" that the poor souls at those call centers in Bangladesh are required to repeat as they work through a script that has nothing to do with your problem? Do we want to make the basic *animal* freedom of moving your body through space contingent on the competence of large organizations?

Now, General Motors is a large organization as well. And they too make a product that is immensely complex. Further, it is one that spends its life outdoors in all manner of weather, subject to the heat of combustion, relentless vibration, and the implacable forces of corrosion. And yet it works, more often than not. "Seamlessly," if you like. The automobile is a *thing*, not a device in the sense we are exploring here. It simply is what it is, what it appears to be: an inanimate machine that obeys the laws of physics. You can use it without involving yourself with an office building full of people at some undisclosed location.

If that is no longer to be the case—if the automobile is to be reconceived as a device—we would want to know something about this office building full of people. What do they want? What is their business model?

If General Motors is a paradigmatic firm of the industrial era, and Microsoft of the software era, Google represents something different still. Though it traffics in hardware and software (mostly by buying up firms that produce them), it is only because these are instruments that serve its core business of advertising.

The novelist T. Coraghessan Boyle published a short story in the *New Yorker* that spins out a likely scenario of the driverless future.

The car says this to her: "Cindy, listen, I know you've got to get over to 1133 Hollister Avenue by 2 P.M. for your meeting with Rose Taylor, of Taylor, Levine & Rodriguez, L.L.P., but did you hear that Les Bourses is having a thirty-per-cent-off sale? And, remember, they carry the complete Picard line you like—in particular, that cute cross-body bag in fuchsia you had your eye on last week. They have two left in stock."

They're moving along at just over the speed limit, which is what she's programmed the car to do, trying to squeeze every minute out of the day but at the same time wary of breaking the law. She glances at her phone. It's a quarter past one and she really wasn't planning on making any other stops, aside from maybe picking up a sandwich to eat in the car, but as soon as Carly (that's what she calls her operating system) mentions the sale, she's envisioning the transaction—in and out, that's all it'll take, because she looked at the purse last week before ultimately deciding they wanted too much for it. In and out, that's all. And Carly will wait for her at the curb.

"I see you're looking at your phone."

"I'm just wondering if we'll have enough time . . ."

"As long as you don't dawdle—you know what you want, don't you? It's not as if you haven't already picked it out. You told me so yourself." (And here Carly loops in a recording of their conversation from the previous week, and Cindy listens to her own voice saying, "I love it, just love it—and it'd match my new heels perfectly.")

"O.K.," she says, thinking she'll forgo the sandwich. "But we have to make it quick."

"I'm showing no traffic and no obstructions of any kind."

"Good," she says, "good," and leans back in the seat and closes her eyes.

Boyle imagines a fleet of cars trolling the streets, which can be hailed and ridden for free. But "it isn't really free, and you have to plan for the extra time to listen to the spiel and say no about sixty times, but then, eventually, you get where you want to go."

How is the experience depicted here different from the frustrations of dealing with Microsoft Office? Office is a *product*, something that you pay for. That makes you a *customer*. However distorted by lack of competition, this is still a straightforward exchange that can be understood within the framework of a market. Google would like you to retain these familiar concepts and, out of sheer inertia of expectations, accept the idea of driverless cars as an improvement on regular cars—the kind of improvement you might be willing to pay for (like an automatic transmission, or a hybrid power train). But what they have in mind is something altogether different from a market exchange. An autonomous car *may* hold some genuine utility for you, but their purpose is not to make the car better *for you*, and ask for money in return. Autonomous cars *may* increase the efficiency of traffic and its safety. But their development is not driven by such public-spirited concerns. To understand the forces behind the promised driverless revolution, we have to come to grips with something genuinely new in the world, and that is the rise of surveillance capitalism.

DRIVERLESS CARS AND SURVEILLANCE CAPITALISM

The short version is this: when automakers started turning their cars into data vacuums, sucking up gobs of data about your movements through the world and your behavior as you go about your day, the car became a rival to the mobile phone as a supply of raw material that Google claims as its own.¹ The auto industry needed to be taken over—to protect the supply route.

The longer version requires a substantial detour. The first thing is to understand how powerful location data is, for purposes of inferring things about a person. This is called "pattern of life analysis," a technique first developed by military intelligence. As a pair of Princeton computer scientists put it, "There is no known effective method to anonymize location data, and no evidence that it's meaningfully achievable."² The *New York Times* did an independent study of location tracking by smartphone apps, analyzing data that supposedly had been anonymized. It is worth quoting the article at length, as it gives a good indication of what one can learn about a person, and the identity of the person, from following their movements.

One path tracks someone from a home outside Newark to a nearby Planned Parenthood, remaining there for more than an hour. . . . Another leaves a house in upstate New York at 7 a.m. and travels to a middle school 14 miles away, staying until late afternoon each school day. Only one person makes that trip: Lisa Magrin, a 46-year-old math teacher. . . . The app tracked her as she went to a Weight Watchers meeting and to her dermatologist's office for a minor procedure. It followed her hiking with her dog and staying at her ex-boyfriend's home. . . .

The database reviewed by The Times . . . reveals people's travels in startling detail, accurate to within a few yards and in some cases updated more than 14,000 times a day. . . . "Location information can reveal some of the most intimate details of a person's life—whether you've visited a psychiatrist, whether you went to an A.A. meeting, who you might date," said Senator Ron Wyden, Democrat of Oregon. . . .³

Like many interested citizens, I have been reading analyses and critiques of Silicon Valley for the last twenty-five years, and even contributed a few of my own. But it was only upon reading Shoshana Zuboff's masterwork *The Age of Surveillance Capitalism*, published in 2019, that the big picture came into view. What follows is heavily indebted to her work, both the details and the larger frame.

Let's start with the big picture of surveillance capitalism and some definitions, and work our way to the implications for internet-mediated mobility. Zuboff is emerita professor at Harvard Business School. She writes:

Surveillance capitalism unilaterally claims human experience as free raw material for translation into behavioral data. Although some of these data are applied to product or service improvement, the rest are declared as a proprietary *behavioral surplus*, fed into advanced manufacturing processes known as "machine intelligence," and fabricated into *prediction products* that anticipate what you will do now, soon, and later. Finally, these prediction products are traded in a new kind of marketplace for behavioral predictions that I call *behavioral futures markets*...⁴

The raw material to be converted into prediction products include our voices, our emotions, our personalities, and the patterns of our movements through the world. But more than that, the competition among players in the behavioral futures market leads them to seek something even better than predictions: the real advantage comes if one can *intervene* to coax and herd people, shaping our behavior at scale. As Zuboff writes, "it is no longer enough to automate information flows *about* us; the goal now is to *automate us.*"

Does this sound overheated? Why would anyone want to automate human beings? The market is a system in which return on investment is linked to risks borne. Risk is a function of uncertainty. Anything that reduces uncertainty can be used to tilt this balance in one's favor. The rise of "big data" has altered the landscape such that marketers are no longer content with a scattershot approach to potential customers; it is grossly inefficient compared to a micro-targeted approach. The value of targeting can be construed as a quest for certainty, because ultimately what a marketer is weighing is the "expected value" of making a pitch, and this is a function of probabilities. A conventional advertisement has an expected value of some fraction of a penny for every consumer reached. But suppose you could make a pitch to an individual customer at this moment when they are in this location engaged in this activity with this physiological state and this emotional state and this constellation of social pressures and this history of past purchases and these insecurities and these aspirations and this holiday bonus coming, and this facial expression, which our machine learning tells us is highly correlated with a mood of receptivity? And what if you could run statistical regressions on all these messy

factors of human experience even as this moment is unfolding, to yield a highly reliable prediction that a certain intervention will succeed, with some quantified likelihood? At some point, when the likelihood of a purchase approaches one, the expected value of making a pitch approaches the profit margin on the product or service. In that limit case, a firm that sits atop the flow of behavioral data and analyzes it into prediction products should be able to claim a share of the profits that approaches 100 percent. A firm that aspired to such a position would adopt a business strategy of acquiring companies that tap into new veins of behavioral data. Such as our patterns of driving.

With characteristic German blandness, the CEO of Daimler (maker of Mercedes-Benz cars) has said that "Google tries to accompany people throughout their day, to generate data and then use that data for economic gain. It's at that point where a conflict with Google seems preprogrammed."⁵ Rather than sustained conflict, it is more likely that the auto companies will accept their role as subcontracted suppliers of raw material (primarily location data) for Google's prediction products, as they cannot hope to match the firm's prowess in machine learning and data analysis. Google's market capitalization (\$849 billion as I write this) already exceeds that of GM, Ford, Fiat-Chrysler, Toyota, Honda, Volkswagen, Nissan, Daimler, BMW, and Tesla *combined*, by a factor of 1.4.

Driverless cars, whatever else they may accomplish for good or ill, will be harnessed to the economic logic of "smart" devices. Let us consider how this works. If you are still sleeping on a dumb mattress, rather than a Sleep Number Bed, you are missing out on knowing your SleepIQ, which is compiled from your heart rate, respiration, movements during the night, and other data conveyed to your smartphone. It's best to give the accompanying app access to your fitness tracker and internet-enabled thermostat as well, to get the full benefits. Benefits for whom? Well, to know that you would need to spend some time with the twelve-page privacy policy that comes with your Sleep Number Bed, in which you will read about "third party sharing, Google analytics, targeted advertising," and much else. In the contract, as quoted by Zuboff, the company can share or exploit your personal information even "after you deactivate or cancel the Services or your Sleep Number account or User Profile(s)." You are unilaterally informed that the firm does not honor "Do Not Track" notifications.

The bed also records all the audio signals in your bedroom. (I am not making this up.) This could be a big plus for an exhibitionist. But it could also give you new reasons to worry about your partner faking it—if not for the crowd-pleasing fun of it (third parties!), then perhaps for the sake of an insurance discount for having a "healthy relationship."

When you first heard of the existence of an "internet-enabled rectal thermometer," you might have thought to yourself, why does a rectal thermometer need enabling by the internet? The answer, of course, is that it doesn't. But the internet needs to know the temperature inside your rectum. If you find this intrusive, or extraneous to the purpose for which you bought a thermometer, you may not be ready for an autonomous car. Give yourself an adjustment period. With time, your expectations will dilate to accommodate the probing style of your new friend.

Nest is a company that makes a "smart" thermostat for your home. It was incubated at Google and is owned by Google's parent company, Alphabet. Legal scholars who analyzed all the stuff you agree to when you use the Nest thermostat and its ecosystem of apps and devices concluded that, to do so knowingly, you would need to review nearly a thousand separate contracts. Of course, hardly anyone reads even one such contract, and they are counting on that. Zuboff writes that if the customer refuses to agree to all the stipulations, "the terms of service indicate that the functionality and security of the thermostat itself will be deeply compromised. . . . The consequences can range from frozen pipes to failed smoke alarms to an easily hacked internal home system. In short, the effectiveness and safety of the product are brazenly held hostage to its owners' submission to rendition [of data] as conquest . . . for others' interests."⁶

If you have a Roomba robot vacuum cleaner, you should know that it is busy creating a floor plan of your house, to be sold to the highest bidder. The "internet of things," made up of all those smart devices, represents "the extension of [data] extraction operations from the virtual world into the 'real' world' where we actually live," Zuboff writes.⁷

These aren't simply cases of what I like to call "Sky Mall capitalism" (expensive solutions for nonproblems). The point is that capitalism is coming to rest on fundamentally different terms than the ones we are familiar with, and this is going to transform the driving experience. Zuboff expresses it well: "In this new product regime the simple product functions that we seek are now hopelessly enmeshed in a tangled mixture of software, services, and networks. The very idea of a functional, effective, affordable product or service as a sufficient basis for economic exchange is dying."

Why should this be? It is due to competitive pressures unleashed by the discovery of behavioral surplus; a competition to lay claim to a resource that is free, meaning that it is *not defended by law*. Compared to free, the trouble and expense of making a good, functional product that stands on its own merits is simply not a viable business strategy. "The whole team of seething insistent 'smart' things joins the migration to surveillance revenues. As we are shorn of alternatives, we are forced to purchase products that we can never own while our payments fund our own surveillance and coercion."⁸

As people wake up to the new realities, "dumb" things will likely become luxury items that you will have to pay a premium for, compared to "smart" things. Standing outside the logic of surveillance revenues, they will have to justify their cost purely on their own merits, and meeting this market niche will be a boutique operation. Presumably the captains of surveillance capitalism will populate their own lives with such dumb stuff, just as they currently send their children to special schools from which devices with screens are rigorously excluded, so as not to compromise their own progeny's development.

But wait a minute. Zuboff speaks of "surveillance and coercion." Surveillance, yes, but where does the coercion come in? And further, why worry about being known? There are no thumb screws applied. What one has to grasp is that the totalitarian regimes of the twentieth century were rank amateurs, having to rely on such crude measures as violence. In the current version, the whole landscape of human behavior becomes subject to nudging and herding into profitable channels, and ideally this occurs beneath the threshold of awareness. The more thorough the herding, the more the predictions approximate observations, and the behavioral futures market approaches certainty. "The surest way to predict behavior is to intervene at its source and shape it," as Zuboff writes.

Now the logical necessity of driverless cars becomes clear. It seems likely there will be real-time auctions to determine the route your Google car takes, so you can be offered empowering choices along the way. This is sometimes called "life pattern marketing." One marketer put it quite frankly: the goal is to "intercept people in their daily routines with brand and promotional messages."⁹

In the driverless future, I imagine Sergey and Larry cruising the peninsula in "dumb" vintage Ferraris with six smelly Italian carburetors and a set of ignition points living inside a grimy centrifugal-advance distributor. Their middle managers, making only seven figures, will buy up the remaining muscle cars and vintage Volkswagens, doing for the old car market what they have already done for the Bay Area real estate market: make it inaccessible to the Helot class. These dumb cars will help to secure for our captains the undisturbed head space they need to do their deep thinking while commuting.

In the summer of 2016, large crowds of people in cities around the world could be seen moving in unison while holding their smartphones. They were playing Pokémon Go!, an "augmented reality" game that had people running around on a scavenger hunt (in the real world) to find cartoon characters who had been inserted into the landscape, as viewed through a player's smartphone camera. This was a social experiment conceived by John Hanke, product vice president for Google Maps and the force behind Street View. (Earlier he had founded Keyhole, a satellite mapping company, with funding from the CIA. It was acquired by Google and became Google Earth.) From within Google, he started Niantic Labs, the purveyor of the game. At a mobile gaming conference in Barcelona in early 2017, he explained the significance of Pokémon Go!

It had the most wholesome of motivations: "getting more exercise, getting outside, being more active, and really at the core of it having an opportunity to socially go out and do something fun with other people and meet other people through the game." His team was learning "how to inspire people to go outside and walk, how to host events, how to create a social gaming community in the real world, which places are cool."

This last bit—helping people learn which places are cool would seem to be at the heart of it, as this is how the monetization occurs. Niantic partners with businesses, allowing them to sponsor a location and generate foot traffic, "which draws players into places like Starbucks or Sprint stores."¹⁰ Those are some supercool places, it cannot be denied.

At this point, the imperative mood of the game's name-

"Go!"—begins to seem quite apt. Gamification has been recognized as a highly effective means of engineering behavior by the practitioners of "persuasive design." We like to compete against others, and get the little rewards of winning. We may also get pulled into a quasi-autistic loop, giving ourselves over to the machine's own logic of stimulus and response (as in slot machines and video poker terminals).¹¹ Such rewards (in this case, collecting all 151 Pokémon characters) become the leverage points for operant conditioning, that classic means of behavior modification pioneered by B. F. Skinner.

Zuboff parses Pokémon Go! as a sort of proof-of-concept experiment for working out the next stage of surveillance capitalism, in which ubiquitous computing—the saturation of the material world with digital devices—serves not merely to gather behavioral data for the sake of predicting behavior, but to make such prediction unnecessary. The game was a smashing success, "providing fresh data to elaborate the mapping of interior, exterior, private and public spaces. Most important, it provided a living laboratory for telestimulation at scale as the game's owners learned how to automatically condition and herd collective behavior, directing it toward real-time constellations of behavioral futures markets, with all this accomplished just beneath the rim of individual awareness."¹²

These are the same people who would like to sell you a Google car that steers itself, and relieve you of the burden of finding your own way through the world.

MOVING AROUND FREELY is one of the most basic liberties we have as embodied creatures. That liberty is enhanced by machines that amplify our mobility, from skateboards and bicycles to motorcycles and automobiles—but only because they are not subject to remote control. Further, to be out roaming, giving nobody an account of your movements or whereabouts, is one of those subtle respites from the grid of accountability that tightens in the course of adult life.

Perhaps a more regularized, remotely administered regime of mobility is a bargain worth striking in exchange for the promise of enhanced safety and efficiency; people can reasonably come to different conclusions about that. The question is: who gets to decide?

It comes down to the question of sovereignty.

Concluding Remarks SOVEREIGNTY ON THE ROAD

We seem to be entering a new dispensation. Qualities once prized, such as spiritedness and a capacity for independent judgment, are starting to appear dysfunctional. If they are to operate optimally, our machines require deference. Perhaps what is required is an adaptation of the human spirit, to make it more smoothly compatible with a world that is to be run by a bureaucracy of machines. Or maybe we need to burn that house down.

The biggest tech firms of the Valley shuttle their employees down the peninsula from the fashionable residential districts of San Francisco in discreet white tour buses, marked "MV" for Mountain View (Google) or "LG" for Los Gatos (Netflix). (Their routes and schedules are secret, for fear the buses will be attacked.) Behind the elevated, tinted windows of the Google Liner, our captains peer deep into the data that dances on the screens of their laptops, looking for mathematical beauty beneath the noise outside. Our informal norms for accommodating one another on the road, relying on our capacity for mutual prediction—that endowment we share as social beings—are to be replaced by something machine executable. Automation is to replace trust and cooperation—for the sake of safety and efficiency, we are told, but also for the sake of certainty. As we have learned, that certainty will be turned to the purposes of whoever is in charge of the algorithms. Given the current constellation of forces, that means the very people who brought us Pokémon Go! to help us discover cool places. Like the Sprint store.

Of course, one can imagine some other entity, such as the state, being in charge of the algorithms and putting them to purposes that are public-spirited. Our experience thus far with red light cameras and photo radar speed enforcement should inform any hopes we choose to place in this variant of the project to replace individual judgment with remote control.¹ We do well to periodically reacquaint ourselves with the founding insight of the liberal tradition: power corrupts, especially when it is placed in a black box and thereby insulated from popular pressure.

But the ethic of suspicion, rooting around to unmask the operation of power (whether of corporations or of the state), will take us only so far. There is something more basic at work in the way things are tending, a certain habit of mind that is much deferred to. According to this mind-set, the world presents as a series of problems to be solved.

This basic stance toward the world has accomplished much good. It has, in fact, solved problems. In medicine, for example, and bridge building, and water treatment. And yes, in automobile safety. It also brings with it a train of entailments, and if we trace these through the foregoing essay on driving, I think we arrive at a better understanding of the central issue of politics: sovereignty. That is because the spirit of problem solving claims every domain as its own. There is nothing that exists that cannot be viewed as a problem that needs fixing. And so sovereignty gets transferred to a cadre of problem solvers. Who are these people?

They are many of the characters who populate this book: the blank-slaters of the smart city who regard existing cities like pathetic flip-phones; the benevolent pushers of idiot-proofing as a design mandate in cars; those who would melt down *your* old car to "solve" (that is, evade) their own, unrelated problems; those who would install a supercomputer in every car in the hope of reproducing the efficiency of an Old World intersection; those who would turn the performance car into an amusement park ride to spare us an encounter with our own limitations; those who would clamp down on the spirit of play in the name of order; and all the other wielders of clipboards we have encountered.

To see a problem that needs fixing often stems from a failure to see that a solution has already been achieved—through the skill and intelligence of ordinary people. For example, the practice of two-wheeled lane splitting is a free source of massive traffic efficiencies, a well-tried expedient used in cities all over the world.² Let's make it legal in the United States. If you like, view it as an unadministered form of "congestion pricing" that takes into account the fact that each of us has a "risk budget." That is, we accept risk not because we are daredevils, but because we have things to do and places to go, and getting them done is worth something to us. Some of us have more willingness to *pay* attention to the cars around us, and are willing to *pay out* some bodily exposure into the traffic community, saving time for all concerned.

When the traffic lights go out during a storm, it sometimes feels like waking up from a long slumber. We realize that we can work things out for ourselves, with a little faith in one another. Recall that Pope Francis called the prudent drivers of Rome, who "express concretely their love for the city" by moving through it with tact and care, "artisans of the common good." The common good may be understood in this way, as something enacted by particular people who are fully awake. Alternatively, it may be understood as something to be achieved by engineering herd behavior without our awareness, in such a way that prudence and other traits of character are rendered moot. Our role will be to step out of the way gracefully, and in this way help "optimize the output of large tools for lifeless people," as Ivan Illich wrote.

Consider the importance of the characters actively *driving* in *Thelma and Louise*, that parable of escape that featured a windblown convertible, an unplanned encounter with the impossibly beautiful Brad Pitt, and an inspired, terrible moment of selfdestruction: let's exit the whole shit-show by driving off a cliff. Try that in your Waymo.

Perhaps suicide is a bad example to invoke, so here is another. When Captain Sully landed that airplane on the Hudson River, relying only on his hard-won skill and firsthand knowledge of airplanes, I believe the reason the whole country was electrified is that this presented a counterimage to the ideal that has been marked out for us. It was an *ecce homo* moment: here is a human being.

To drive is to exercise one's skill at being free, and one can't help but feel this when one gets behind the wheel. It seems a skill worth preserving.

Postscript THE ROAD TO LA HONDA

Upon sending a complete draft of this book to my publisher, I packed up and moved to California. There are amazing roads through the Santa Cruz mountains, minutes from where I am staying. I daydream about taking the Bug on these roads when it is finished. In the meantime, I have been making a study of them on the powerful Yamaha, carving the canyons with growing confidence. Rounding a sweeping left-hand turn marked 25 mph at about 45 mph, I lean further to tighten my line. The "feeler" on my inside foot peg grinds on the pavement, sending a shiver of vibration into my boot and up my leg. My eyes are fluid, running out ahead into the next corner, and now I am out of the seat, up on the pegs, sliding my body to the right. "Soft hands," I say aloud. My head directed into the turn, I toss the bike to the right, hanging off on the inside and getting low again. As the right peg scrapes, I get another reward—the tingle of edge work—and

exit the turn on the throttle. As the motor surges up through the rpm range, the sound is intoxicating. In the momentary release of concentration that comes with a straight section of road, a line from Snoop Dogg comes, the sound of my voice resonant in my helmet: "I lay back in the cut and contain myself." For me it is an attitude to emulate, an admonishment against getting tight and hurried. I take Snoop to mean what jazz drummers mean when they talk about playing slightly behind the beat, letting the song come to them. It is a posture of musical cool perfectly suited to the pavement-jazz of riding a bike at eleven, on the far side where time slows down.

There was one day in particular, on the road to La Honda from Alice's Restaurant, when everything came together exquisitely. It was a slalom through the redwoods, dappled sunlight playing on *perfect* black tarmac as I came hard out of a corner, front wheel lifting off the ground. On this stretch of road, there are several serpentine sections where you can see, in a single take, a series of three corners ahead in their entirety, with nowhere for surprises to hide. These chicanes have a bodily rhythm to them that is sublime, when taken at speed. I have never been a good athlete, and can only admire those who move with natural grace. But on a sport bike on a canyon road, for a brief spell I feel raised up from my God-given mediocrity. By a machine! What a miracle.

Acknowledgments

I would like to thank Forrest Wang for the best passenger experience I have ever had, tandem drifting around Virginia International Raceway in his Formula D race car. Dave Hendrickson kindly offered me a co-driver seat in his desert racer for the Caliente 250, and this opened doors to interesting conversations with racers Journee Richardson and Victoria Hazelwood, whom I also thank. Barron Wright introduced me to the hare scramble scene in central Virginia, and once showed up at my house late at night after a heavy snowfall, on a dirt bike, towing his young son behind him on a sled. I thank Matt Linkous and Darryl Allen for stopping and waiting for me to catch up on many trail rides through the Blue Ridge Mountains.

Thanks to Charles "Chas" Martin for initiating me, as a teenager, into the rich world of the mechanic. In doing so, he showed me an order of value that was more appealing to me than the prevailing one. The members of Shop Talk Forums on the internet have taught me most of what I know about air-cooled Volkswagens; thanks to everyone for sharing their hard-won knowledge.

The Specialty Equipment Manufacturer's Association (SEMA) was the first institution to give me a platform for exploring "the psychology of vehicle customization." Thanks to Zane Clark for the invitation to speak at SEMA 2017. At the opposite end of the spectrum, as far from Las Vegas as one can get, Mathieu Flonneau invited me to give a talk at the Sorbonne, "Managing Traffic: Three Rival Versions of Rationality." I would like to thank Flonneau, Jean-Pierre Dupuy and the other attendees for their comments in the resulting seminar, held under the auspices of LabEx EHNE at the International Social Science Council in Paris in April, 2018. I presented the same material in Montreal, at a conference of the International Association for the History of Traffic, Transport and Mobility, and thank the participants for their criticisms. The Center for the Humanities and Social Change at the University of California, Santa Barbara, hosted a lecture and two seminars in which the ideas in this book were subject to scrutiny from a variety of disciplines. Thanks to Tom Carlson for arranging that, and for his own thoughtful engagement with the book.

The Institute for Advanced Studies in Culture at the University of Virginia has been an unflagging source of support and intellectual fellowship, a rare space for truly open inquiry. They hosted a workshop to discuss this project at an early stage of its development. I would like to thank Ann Brach, Director of Technical Activities for the Transportation Research Board of The National Academies of Sciences for driving down from Washington to participate, and for her invaluable comments. At this workshop, Jackson Lears alerted me to the "vitalist tradition" as a useful point of orientation for thinking about the value of risk. I also got very helpful comments from Joe Davis, Peter Norton, Jay Tolson, Ari Schulman, and Garnette Cadogan.

Matt Feeney and Matt Frost, my companions in text message samizdat, have helped keep the pleasure of thinking alive for me. Thanks to Beth Crawford for teaching rats to drive, for countless fascinating conversations about the role of the body in cognition, and for accompanying me on the long road of writing this and previous books. Thanks to Mario and Luigi for persevering when the Fruit Loop was so close, and yet so far.

I want to thank the man who filled my jugs with water when I was broken down in rural California in the dead of night, and the man who gave me fifty dollars (in exchange for a cursed Jeepster) the next day, to cover the train ride home. Thanks to Troy, the gangster who terrorized my childhood neighborhood, for trying to jump over ten garbage cans on his BMX bike. In doing so, he recalibrated my sense of what human beings are capable of, and what they might be willing to risk in the attempt. Thanks to my father, Frank S. Crawford, for chasing down the lowland bicycle thieves in an excellent episode of vigilante justice, conducted in style from behind the wheel of a Ford Fairlane convertible with his freak flag flying in the wind. Thanks to the taxi drivers of London, for their erudition and gentlemanliness. To whoever laid out Route 9 through the Santa Cruz mountains. To my daughters, G and J, for insisting that I take the twisty road on the way home from their preschool, squealing "go faster!"

Notes

INTRODUCTION: DRIVING AS A HUMANISM

- 1. Uber's then chief executive Travis Kalanick was named to the president's Strategic and Policy Forum, and Trump selected Elaine Chao for transportation secretary. The driverless car industry is "salivating over Elaine Chao's light touch when it comes to regulations and her vocal support for the ride-sharing economy," according to the *Hill*. Paul Brubaker, a spokesperson for the industry, said, "She has a keen understanding that technology presents a great opportunity to . . . create new mobility paradigms." Melanie Zanona, "Driverless Car Industry Embraces Trump's Transportation Pick," *Hill*, December 4, 2016, http:// thehill.com/policy/transportation/308590-driverless-car-industry -embraces-trumps-transportation-pick.
- 2. See Neal E. Boudette, "Biggest Spike in Traffic Deaths in 50 Years? Blame Apps," *New York Times*, November 15, 2016, http://www.ny times.com/2016/11/16/business/tech-distractions-blamed-for-rise -in-traffic-fatalities.html.
- 3. "The improved stability of modern cars and the smoothness of paved roads already allow drivers to take their eyes off the road and their hands off the steering wheel . . . [reducing] driving to a remarkably mundane

task, sometimes requiring little attention from the driver and luring the driver into distraction." Stephen M. Casner, Edwin L. Hutchins, and Don Norman suggest these problems with contemporary (but not yet automated) cars offer a preview of difficulties presented by partially automated cars. "The Challenges of Partially Automated Driving," *Communications of the ACM* 59, no. 5 (May 2016), pp. 70–77.

4. The history of the Honda Accord is typical. It went from under 2,200 pounds in the early 1980s to more than 3,600 pounds for the 2017 model.

- 5. "[R]elieving drivers of even one aspect of the driving task results in reports of increased driver drowsiness and reduced vigilance when driving on open stretches of road" according to the findings of A. Dufour, "Driving Assistance Technologies and Vigilance: Impact of Speed Limiters and Cruise Control on Drivers' Vigilance," presentation at the International Transport Forum (Paris, France, April 15, 2014), as characterized in Casner et al., "The Challenges of Partially Automated Driving."
- 6. "Lyft Co-founder Says Human Drivers Could Soon Be Illegal in America," according to a headline in *Business Insider*, December 15, 2016. In November 2017 in *Automotive News*, Bob Lutz, the head of GM, suggested that driving will be outlawed in twenty years. Bob Lutz, "Kiss the Good Times Goodbye," *Automotive News*, November 5, 2017, http://www .autonews.com/apps/pbcs.dll/article?AID=/20171105/INDUSTRY REDESIGNED/171109944/industry-redesigned-bob-lutz.
- Ian Bogost, "Will Robocars Kick Humans off City Streets?" Atlantic, June 23, 2016, https://www.theatlantic.com/technology/archive/2016 /06/robocars-only/488129/.
- A. M. Glenberg and J. Hayes, "Contribution of Embodiment to Solv-8. ing the Riddle of Infantile Amnesia," Frontiers in Psychology 7 (2016), as characterized in M. R. O'Connor, "For Kids, Learning Is Moving," Nautilus, September 22, 2016, http://nautil.us/issue/40/learning /for-kids-learning-is-moving. There have been experiments giving infants with severe motor impairments motorized carts to enable them to explore their environment, resulting in accelerated cognitive and language development compared to those without the benefit of self-locomotion, M. A. Jones, I. R. McEwen, and B. R. Neas, "Effects of Power Wheelchairs on the Development and Function of Young Children with Severe Motor Impairments," Pediatric Physical Therapy 24 (2012), pp. 131-140, as cited in O'Connor, "For Kids." See also M. R. O'Connor, Wayfinding: The Science and Mystery of How Humans Navigate the World (New York: St. Martin's Press, 2019), especially the chapter "This Is Your Brain on GPS," pp. 261-276.

 For a wonderful, deep dive into traffic engineering and the various social sciences that bear on traffic, see Tom Vanderbilt, *Traffic: Why We Drive* the Way We Do (And What It Says About Us) (New York: Penguin, 2008).

NOTES

- 10. According to a 2011 study by the Belgian research firm Transport and Mobility Leuven, if 10 percent of all private cars are replaced by motorcycles, the total time loss for all vehicles decreases by 40 percent. This is after taking into account the elasticity of demand (that is, the improved flow of traffic would attract more vehicles onto the road). Further, "New motorcycles emit fewer pollutants compared to average private cars (less NOX, NO2, PM2.5 and EC, but more VOC). They also emit less CO₂. Total external emission costs of new motorcycles are more than 20% lower than average private cars. On the section of motorway between Leuven and Brussels, total emission costs can be reduced by 6% if 10% of private cars are replaced by motorcycles." From Griet De Ceuster, "Commuting by Motorcycle," Transport and Mobility Leuven, https://www.tmleuven.be/en/project/motorcycles andcommuting.
- 11. See my book *The World Beyond Your Head: On Becoming an Individual in an Age of Distraction* (New York: Farrar, Straus and Giroux, 2015) for an elaboration of the concept of ecologies of attention.
- 12. "To many people, the idea of a speed limit feels like an affront to masculinity, like we're getting softer, we're degenerating," said Erhard Schütz, a retired professor and expert on the autobahn's history. According to a Mr. Kornblum quoted in the *New York Times*, "Germany is terribly regulated, for reasons which have to do with the past, with a fear of uncertainty, a fear of being overwhelmed. But then people look for their little spaces of freedom and the autobahn is one of them." Katrin Bennhold, "Impose a Speed Limit on the Autobahn? Not So Fast, Many Germans Say," *New York Times*, February 3, 2019, https:// www.nytimes.com/2019/02/03/world/europe/germany-autobahn -speed-limit.html.
- 13. For their part, the authorities sometimes recognize this, tacitly. In Los Gatos, California, I saw a meter maid cart bristling with six large surveillance cameras, the size of your forearm, just like the ones that cover every angle from poles in Tiananmen Square. Maybe they are there to make your infraction incontrovertible, in recognition of the fact you may contest it. Or maybe they serve to document attacks on meter maids from irate citizens. Protesters in France have been throwing paving stones at the police, in a precise echo of the street battles in Paris early in the French Revolution. One truck driver wrote on his yellow vest, "France wake up! Stop being sheep."

CARS AND THE COMMON GOOD

1. This account is from H. B. Creswell, writing in the British journal Architectural Review, December 1958, as quoted by Jane Jacobs, *The Death* and Life of Great American Cities (New York: Vintage, 1992), pp. 341–342.

- 2. James J. Flink, *The Automobile Age* (Cambridge: MIT Press, 1988), p. 364.
- 3. See Dan Albert, Are We There Yet? The American Automobile Past, Present, and Driverless (New York: Norton, 2019), p. 100.
- 4. Flink, The Automobile Age, p. 364.
- 5. Albert, Are We There Yet?, pp. 102-103.
- 6. https://www.pewsocialtrends.org/2006/08/01/americans-and-theircars-is-the-romance-on-the-skids/.
- 7. "Half of U.S. adults think automated vehicles are more dangerous than traditional vehicles operated by people, while nearly two-thirds said they would not buy a fully autonomous vehicle, according to [a 2019 Reuters/Ipsos opinion poll]. In the same poll, about 63 percent of those who responded said they would not pay more to have a self-driving feature on their vehicle, and 41 percent of the rest said they would not pay more than \$2,000.... The findings are similar to those in a 2018 Reuters/Ipsos poll. They are consistent with results in surveys by Pew Research Center, the American Automobile Association and others."

Paul Lienert and Maria Caspani, "Americans Still Don't Trust Self-Driving Cars, Reuters/Ipsos Poll Finds," Reuters, April 1, 2019, https:// www.reuters.com/article/us-autos-selfdriving-poll/americans-still-dont -trust-self-driving-cars-reuters-ipsos-poll-finds-idUSKCN1RD2QS.

Other findings consistent with these are collected from opinion polls conducted by various industry groups, insurance institutes, and consumer advocacy groups and available at Saferoads.org.

- Christopher Mele, "In a Retreat, Uber Ends Its Self-Driving Car Experiment in San Francisco," New York Times, December 22, 2016, http://www.nytimes.com/2016/12/21/technology/san-francisco-california -uber-driverless-car-.html?hp&action=click&pgtype=Homepage&click Source=story-heading&module=first-column-region®ion=top-news &WT.nav=top-news&_r=0. Mike Isaac, "Uber Defies California Regulators with Self-Driving Car Service," New York Times, December 16, 2016, https://www.nytimes.com/2016/12/16/technology/uber-defies -california-regulators-with-self-driving-car-service.html.
- 9. John Harris, "With Trump and Uber, the Driverless Future Could Turn into a Nightmare," *Guardian*, December 16, 2016, https://www .theguardian.com/commentisfree/2016/dec/16/trump-uber-driverless -future-jobs-go.
- 10. These are the findings of the city's transport department as characterized by Nicole Gelinas in "Why Uber's Investors May Lose Their Lunch," *New York Post*, December 26, 2017, available at https://www .manhattan-institute.org/html/why-ubers-investors-may-lose-their -lunch-10847.html.

NOTES

- 11. "Uber and Lyft Want to Replace Public Buses," New York Public Transit Association, August 16, 2016, https://nytransit.org/resources /transit-tncs/207-uber-and-lyft-want-to-replace-public-buses.
- 12. Huber Horan, "Uber's Path of Destruction," American Affairs 3, no. 2 (Summer 2019).
- 13. Horan, "Uber's Path of Destruction." Horan cites structural problems that are intrinsic to the taxi market, requiring extra-market remedies. For example, as with all urban transport modes, taxi demand has "extreme temporal and geographic peaks," leading to a combination of overcapacity at slow hours and scarcity at peak demand. That demand is also "bipolar," corresponding to different uses. There is conflict as "wealthier people headed to restaurants and clubs fight over the limited supply of cabs with late-shift workers at hospitals and warehouses." He also notes, "Any attempt to balance supply and demand [on strictly market terms] will either drive lower-income passengers out of the market or result in wealthy customers being charged less than they might be willing to pay" (pp. 114–115).
- 14. In New York City, 90 percent of app-based rideshare drivers are recent immigrants, largely from Haiti, the Dominican Republic, and South Asia. Horan reports that in recruiting among these populations, Uber has been highly deceptive, misrepresenting gross pay (before vehicle costs) as net pay. "Traditional cab drivers could easily move to other jobs if they were unhappy, but Uber's drivers were locked into vehicle financial obligations that made it much more difficult to leave once they discovered how poor actual pay and conditions were." In 2015, Uber reported an improvement to its operating losses. As it turns out, almost all of this was due not to increased efficiency, but because the firm had unilaterally claimed a greater share of each fare, rising from 20 percent to 25–30 percent (Horan, "Uber's Path of Destruction," p. 113).

PROJECT RAT ROD

- 1. See the chapter "Embodied Perception" in my book *The World Beyond Your Head*, pp. 45–68.
- 2. Crawford has posted instructions for building a rat-operated vehicle, reflecting the latest iteration of the design she developed with Kelly Lambert and Thad Martin, available at https://www.instructables.com/id/Rat-Operated-Vehicle/.
- 3. The first paper from the rat driving study was published as this book was in final copy edits: L.E. Crawford et al, "Enriched Environment Exposure Accelerates Rodent Driving Skills," *Behavioral Brain Research* 378, January 27, 2020. When the paper went online ahead of publication, it caused a media sensation, even making an appearance on

the satirical site the Onion. Videos of the rats driving are available at https://www.washingtonpost.com/science/2019/10/24/rats-are-capable -driving-tiny-cars-researchers-found-it-eases-their-anxiety/.

4. Kelly G. Lambert, "Rising Rates of Depression in Today's Society: Consideration of the Roles of Effort-Based Rewards and Enhanced Resilience in Day-to-Day Functioning," Neuroscience and Biobehavioral Reviews 30 (2006), pp. 497–510. See also Kelly G. Lambert, "Depressingly Easy," Scientific American Mind (August-September 2008) and Kelly G. Lambert, Well-Grounded: The Neurobiology of Rational Decisions (New Haven: Yale University Press, 2018).

OLD CARS: A THORN IN THE SIDE OF THE FUTURE

- 1. Peter Egan, "Side Glances," Road and Track, November 1988, p. 24, as cited by David N. Lucsko, Junkyards, Gearheads, and Rust: Salvaging the Automotive Past (Baltimore: Johns Hopkins University Press, 2016), p. 128.
- 2. David Freiburger, "Patina," Hot Rod Magazine, April 2007, p. 61, as quoted by Lucsko, Junkyards, Gearheads, and Rust, p. 128.
- 3. The 2017 Lexus NX hybrid gets a combined 31 city/highway mpg and has an MSRP of \$39,720.
- 4. Lucsko, Junkyards, Gearheads, and Rust, p. 133.
- 5. Zelda Bronstein shows how light industry gets chased out of cities under the banner of progressive urbanism. Whole ecosystems of industrial know-how that took long to develop are vacated, to be replaced with urban landscapes devoted to "lifestyle" consumption, art galleries, and all the rest. Zelda Bronstein, "Industry and the Smart City," *Dissent*, Summer 2009, https://www.dissentmagazine.org/article/industry-and-the -smart-city. Bronstein, whom I count a friend, is in her seventies and exemplifies an older left: her sympathies lie with production over consumption, and labor over *rentiers*. In this she has found herself out of joint with some of today's progressives who seem to worry about gentrification, not out of a concern to preserve space for productive activities, but to block incursions of what they take to be a malignant force directed against innocents, a moral drama understood in racial terms.
- 6. Lucsko, Junkyards, Gearheads, and Rust, p. 134.
- 7. Michael Oakeshott, "On Being Conservative," Rationalism in Politics (Indianapolis: Liberty Fund Press, 1991), p. 414.
- 8. Lucsko, p. Junkyards, Gearheads, and Rust, 136.

9. Lucsko, Junkyards, Gearheads, and Rust, p. 164.

10. Nancy Fraser, The Old Is Dying and the New Cannot Be Born: From Progressive Neoliberalism to Trump and Beyond (New York: Verso, 2019), p. 13.

NOTES 32

- 11. See Lucsko, Junkyards, Gearheads, and Rust, p. 163.
- 12. Lucsko, Junkyards, Gearheads, and Rust, pp. 162-163.
- 13. The sad tale of ballooning commutes is one of land use and development planning, as well as public investment that prioritized the automobile over public transportation, as we learned in the chapter "Cars and the Common Good." The rise of the parent as chauffeur to kids scheduled up with far-flung activities is surely also a factor. Another is growing income inequality and cheap credit, which helped to create a housing market in which you trade a longer commute for lower mortgage payments on a bigger house, located farther out. "Drive till you qualify" is the usual shorthand for this among real estate agents. Driverless cars, because they make commute time available for other activities, would surely make even longer commutes viable, exacerbating the land-use problems of recent decades and the corollary issues of congestion and pollution.
- 14. Lucsko, Junkyards, Gearheads, and Rust, p. 164.
- 15. Lucsko, Junkyards, Gearheads, and Rust, pp. 166, 170.
- 16. Hence, in the air-cooled VW world, the ridiculous prices paid for SPG roller-bearing crankshafts, Judd superchargers, anything touched by Gene Berg, and anything made by the German firm Okrasa, whose complete engine kits claimed to *lower* your 0–60 time by twelve seconds. That's right, the badass Bug of 1956 was putting down a ground-shaking 48 horsepower (up from 36). If the claims made for the Okrasa kit remain true, I will put one on my car and reduce my 0–60 time to approximately negative seven seconds, theoretically allowing me to travel back in time. When I arrive at 1956, I plan to buy a big stash of these parts and come back a rich man.
- 17. As this book neared completion, the Cathedral of Notre Dame in Paris burned. The Harvard architecture historian Patricio del Real captured a certain haute-vandal mentality when he said, "The building was so overburdened with history that its burning felt like an act of liberation" (as quoted in E. J. Dickson, "How Should France Rebuild Notre Dame?" *Rolling Stone*, April 16, 2019, https://www.rollingstone.com /culture/culture-features/notre-dame-cathedral-paris-fire-whats-next -822743/).
- 18. Joe Mayal, "Curbside," Street Scene (May 1981), p. 6, as quoted in Lucsko, p. 67.

THE DIMINISHING RETURNS OF IDIOT-PROOFING AS A DESIGN PRINCIPLE

 Mindful Mode "employs theories of meditation and mindfulness therapeutic techniques used to maintain mental wellness by focusing on just one element or moment in time—by eliminating data the driver may not need to see." "No Place Like 'Oommm," Ford, March 27, 2019, https://media.ford.com/content/fordmedia/fna/us/en/news /2019/03/27/2020-explorer-mindful-mode-digital-cluster.html.

- "NHTSA's Implausible Safety Claim for Tesla's Autosteer Driver Assistance System," Safety Research & Strategies, February 8, 2019, http:// www.safetyresearch.net/Library/NHTSA_Autosteer_Safety_Claim .pdf. The original NHTSA report has been taken down from the government website.
- 3. Neal E. Boudette, "Tesla's Self-Driving System Cleared in Deadly Crash," New York Times, January 19, 2017; Tom Randall, "Tesla's Autopilot Vindicated with 40% Drop in Crashes," Bloomberg, January 19, 2017; Andrew J. Hawkins, "Tesla's Crash Rate Dropped 40 Percent After Autopilot Was Installed, Feds Say," Verge, January 19, 2017; Elon Musk (@elonmusk-Twitter), "Report highlight: "The data show that the Tesla vehicles crash rate dropped by almost 40 percent after Autosteer installation," Twitter, January 29, 2017, https://twitter.com /elonmusk/status/822129092036206592; Chris Mills, "Report Finds Tesla's Autopilot Makes Driving Much Safer," BGR, January 19, 2017.
- 4. In its report on this matter, the firm states that it has no financial stake in Tesla, its competitors, or any other interests connected to the technology of autonomous cars and driver assistance systems.
- 5. "NHTSA's finding that the airbag deployment crash rate for Teslas dropped following the installation of Autosteer would have been even more dramatic if more of the Autosteer installation mileage data had been missing. The Agency's treatment of missing or unreported mileage data in its calculations of exposure mileage as though the mileage were non-existent is not justifiable. This problem affects more than half the dataset." See "NHTSA's Implausible Safety Claim."
- 6. "We discovered that the actual mileage at the time the Autosteer software was installed appears to have been reported for fewer than half the vehicles NHTSA studied. For those vehicles that do have apparently exact measurements of exposure mileage both before and after the software's installation, the change in crash rates associated with Autosteer is the opposite of that claimed by NHTSA—if these data are to be believed.

"For the remainder of the dataset, NHTSA ignored exposure mileage that could not be classified as either before or after the installation of Autosteer. We show that this uncounted exposure is overwhelmingly concentrated among vehicles with the least 'before Autosteer' exposure. As a consequence, the overall 40 percent reduction in the crash rates reported by NHTSA following the installation of Autosteer is an artifact of the Agency's treatment of mileage information that is actually missing in the underlying dataset" ("NHTSA's Implausible Safety Claim").

- Timothy B. Lee, "In 2017, the Feds Said Tesla Autopilot Cut Crashes 40%—That Was Bogus," Ars Technica, February 13, 2019. See also Timothy B. Lee, "Sorry Elon Musk, There's No Clear Evidence Autopilot Saves Lives," Ars Technica, May 4, 2018.
- 8. Sam Peltzman, *Regulation of Automobile Safety* (Washington, DC: American Enterprise Institute for Public Policy Research, 1975), p. 4.
- 9. According to the Fatal Analysis Reporting System of the National Highway Traffic Safety Administration, in the year 2000 seat belts alone were estimated to have a 48 percent effectiveness in preventing fatalities (to people over twelve years old) in crashes that otherwise would have been fatal. The effectiveness of seat belts combined with air bags was estimated at about 54 percent. This according to a paper published in 2011 by Donna Glassbrenner of the National Center for Statistics and Analysis at the NHTSA, http://www-nrd.nhtsa.dot.gov /pdf/nrd-01/esv/esv18/CD/Files/18ESV-000500.pdf.
- 10. https://patents.justia.com/patent/9296424.
- NHTSA, Estimating Lives Saved by Electronic Stability Control, 2008– 2012, DOT HS 812 042 (Washington, DC: National Highway Traffic Safety Administration, 2014).
- 12. For a fuller and more academic account of how this literature bears on driving, see the section titled "The Role of Language in Acquiring Skill Under Conditions of Risk" in the chapter "Embodied Perception" in my book *The World Beyond Your Head*.
- 13. https://www.roadandtrack.com/new-cars/car-technology/a26960542 /the-eu-wants-cars-to-have-speed-limiters-and-more-by-2022/. The mandatory system will also use GPS and road sign cameras to determine if you are exceeding the speed limit. If you are, the system will reduce power to the engine. The rule-making entity that submitted this plan to the European Commission, the European Safety and Transport Council, says that to allow the public time to get used to this system, when it is first introduced it will nag the driver rather than intervene immediately. "If the driver continues to drive above the speed limit for several seconds, the system should sound a warning for a few seconds and display a visual warning until the vehicle is operating at or below the speed limit again."
- 14. Edward N. Luttwak, "Why the Trump Dynasty Will Last Sixteen Years," *Times Literary Supplement*, July 25, 2017, https://www.the-tls .co.uk/articles/public/trump-dynasty-luttwak/.
- 15. Further, we have seen the development of new financial instruments to aggregate and securitize auto loans, and the corresponding rise of an auto loan credit bubble, in exact parallel with the housing bubble that caused the financial crisis. See Albert Fowerbaugh and Julie

Rodriguez Aldort, "What If the Auto Loan Securitization Market Crashes?" *Law* 360, August 13, 2018, https://www.porterwright.com /content/uploads/2019/02/What-If-The-Auto-Loan-Securitization -Market-Crashes.pdf.

Bloomberg reported in 2019 that "prices of risky auto bonds have risen even as car loans that haven't been paid in at least three months exceeded 7 million at the end of last year, the highest since the New York Federal Reserve began tracking the data two decades ago." See Adam Tempkin, "Subprime Auto Bond Market Is Unmoved by Record Late Loan Payments," Bloomberg, February 14, 2019, https://www .bloomberg.com/news/articles/2019-02-14/subprime-auto-bond -market-unmoved-by-record-late-loan-payments.

16. This is something I learned only recently in a motorcycling context. After some eighteen years of riding almost every day, for the first time I bought a bike with antilock brakes. Applying the front brake progressively, rising to maximum effort smoothly over the course of about one second, allows time for the weight to transfer to the front tire. The result is that the antilock braking system does not intervene, but neither does the front lock up. Instead it digs in, to the point that my rear tire may come six inches off the ground as I come to a maximum-effort stop. If instead I grab my brakes suddenly and rely on the bike's ABS, I am not able to generate nearly as much stopping power. The system intervenes before the weight transfer occurs and doesn't let go, limiting braking to the traction available at that point of initial grab.

- In 2004 the National Highway and Traffic Safety Administration released results of a field study in the U.S. of the effectiveness of electronic stability control and concluded that it reduces crashes by 35 percent.
- 18. To see this spelled out in more scientific language, see my discussion of perception-action-affect circuits in the chapter "Embodied Perception" in *The World Beyond Your Head*, especially pp. 53–68.
- 19. Casner, Hutchins, and Norman, "The Challenges of Partially Automated Driving," pp. 70-77.
- David L. Strayer, Joel M. Cooper, Jonna Turrill, James R. Coleman, and Rachel J. Hopman, "Measuring Cognitive Distraction in the Automobile III: A Comparison of Ten 2015 In-Vehicle Information Systems," AAA Foundation for Traffic Safety, October 2015.
- 21. As Casner et al. put it, "In such situations, [drivers] tend to reduce their active involvement and simply obey the automation. There is already ample evidence drivers disengage from the navigation task when the automation is programmed to lead the way." Here they cite G. Leshed et al., "In-Car GPS Navigation: Engagement with and Disengagement from the Environment," in *Proceedings of the ACM Conference on Human*

Factors in Computing Systems (Florence, Italy, Apr. 5–10, 2008) (New York: ACM Press, 2008), pp. 1675–1684.

- 22. Casner et al. cite K. A. Hoff and M. Bashir, "Trust in Automation: Integrating Empirical Evidence on Factors That Influence Trust," *Human Factors* 57, no. 3 (2014), pp. 407–434.
- 23. This is consistent with earlier work that established that having a passenger also tends to increase our (jointly enacted) attention to the road, the idea being that two pairs of eyes are better than one. J. Forlizzi, W. C. Barley, and T. Seder, "Where Should I Turn?: Moving from Individual to Collaborative Navigation Strategies to Inform the Interaction Design of Future Navigation Systems," in *Proceedings of the ACM Conference on Human Factors in Computing Systems* (Atlanta, GA, Apr. 10–15, 2010) (New York: ACM Press, 2010), pp. 1261–1270, as cited in Casner et al., "The Challenges of Partially Automated Driving."
- 24. C. Gold et al., "Take Over! How Long Does It Take to Get the Driver Back into the Loop?" in *Proceedings of the Human Factors and Ergonomics Society Annual Meeting* (San Diego, CA, Sept. 30–Oct. 4) (Santa Monica, CA: Human Factors and Ergonomics Society, 2013), pp. 1938–1942, as cited in Casner et al., "The Challenges of Partially Automated Driving."
- 25. Thus MacArthur Job, Air Disaster, vol. 3 (Australia: Aerospace Publications, 1998), p. 155.
- 26. Nicholas Carr, The Glass Cage: Automation and Us (New York: Norton, 2014), pp. 90-91, citing Mark S. Young and Neville A. Stanton, "Attention and Automation: New Perspectives on Mental Overload and Performance," Theoretical Issues in Ergonomics Science 3, no. 2 (2002) and a classic work in psychology by Robert M. Yerkes and John D. Dodson, "The Relation of Strength of Stimulus to Rapidity of Habit-Formation," Journal of Comparative Neurology and Psychology 18 (1908).
- 27. From Henry Petroski, *The Road Taken* (New York: Bloomsbury, 2017): "In the summer of 2014 the U.S. Department of Transportation announced its plan to require in the not-too-distant future the installation of vehicle-to-vehicle communication technology in all cars and trucks, new and old. Fitting a vehicle with a transmitter is projected to add about \$350 to the cost of a new car in 2020; an existing car could be retrofitted with an equivalent device" (p. 275).
- 28. Vision Zero (meaning zero deaths and injuries from traffic) is a movement for traffic safety that started in Sweden and has spread. Its motto is that "life and health can never be exchanged for other benefits within the society." This is meant as a high-minded rebuke to the callous principle of cost-benefit analysis. But the costs they consider are only monetary. Our concern in these chapters is with costs that are more difficult to see and judge, arising from transformations of the human ecology: contraction of the space for intelligent human action.

29. Casner et al. write that "due to the many remaining obstacles, and the rate at which cars are replaced on the roadways worldwide, the transition to fully automated driving for a majority of the public will take decades. The safety challenges of partially automated driving will be significant and, at least as of today, underestimated. . . . Our experience in aviation tells us this transition will not go smoothly for a cadre of cursorily trained drivers in an environment in which milliseconds might mean the difference between life and death. Drivers will expect their cars' automation systems to function as advertised, and the systems will do so most of the time. And with automation in charge, drivers will learn they can attend more and more to non-driving activities. They will grow to trust the automation to take care of them while they do other things. They will count on automated warnings to alert them when their attention is needed. When the unexpected happens and driver attention is needed with little or no warning, a new kind of accident may emerge, in significant numbers." On the other hand, "we could see dramatic safety enhancements from automated systems that share the control loop with the driver (such as brake-assist systems and lane-keeping assistance) and especially from systems that take control from the hands of aggressive, distracted, or intoxicated drivers. It is entirely possible that reductions in these categories of accidents could match or even outnumber any increase in accidents caused by other unexpected problems with automation."

FEELING THE ROAD

- See Nadine Sarter, "Multiple-Resource Theory as a Basis for Multimodal Interface Design: Success Stories, Qualifications, and Research Needs," in *Attention: From Theory to Practice*, ed. Arthur F. Kramer, Douglas A. Wiegmann, and Alex Kirlik (Oxford: Oxford University Press, 2007).
- 2. Rodney A. Brooks, "Intelligence Without Representation," Artificial Intelligence 47 (1991), pp. 139–159.
- 3. As mentioned in an earlier note, the history of the Honda Accord is typical. It went from under 2,200 pounds in the early 1980s to more than 3,600 pounds for the 2017 model.
- 4. See David Sax, *The Revenge of Analog: Real Things and Why They Matter* (New York: PublicAffairs, 2016).
- 5. Shortly after my exchange with Porsche (via the PR firm), my publisher announced its acquisition of *Why We Drive* in the usual publishing trade journals. About a year later, Porsche launched an ad campaign based on the slogan "Why We Drive." Perhaps I flatter myself, but I like to imagine that was a tip of the hat from the losing side of Porsche's internal quarrel.

AUTOMATION AS MORAL REEDUCATION

- 1. Nietzsche called English utilitarianism "altogether an *impossible* literature, unless one knows how to flavor it with some malice.... One simply has to read them with ulterior thoughts, if one *has* to read them," these "ponderous herd animals with their unquiet consciences." Friedrich Nietzsche, *Beyond Good and Evil*, section 225.
- 2. Earlier generations of computer scientists tended to have broader educations, and therefore some independent ground to stand on in assessing the aptness of the computer as an analog of human being. The artificial intelligence pioneer Joseph Weizenbaum wrote that "the computer . . . has brought the view of man as a machine to a new level of plausibility." He worried about this plausibility, as he himself had deep reservations about the human-as-machine metaphor. Man is the animal who creates images of himself, and then comes to resemble the images (thus Iris Murdoch).
- 3. Edmond Awad et al., "The Moral Machine Experiment," *Nature*, October 24, 2018.
- M. D. Matthews, "Stress Among UAV Operators: Posttraumatic Stress Disorder, Existential Crisis, or Moral Injury?" *Ethics and Armed Forces: Controversies in Military Ethics and Security Policy* 1 (2014), pp. 53–57. See also R. E. Meagher and D. A. Pryer, eds., *War and Moral Injury: A Reader* (Eugene, OR: Cascade Books, 2018).
- 5. Sophie-Grace Chappell, "Bernard Williams," Stanford Encyclopedia of *Philosophy*, available online.
- 6. William Hasselberger, "Ethics Beyond Computation: Why We Can't (and Shouldn't) Replace Human Moral Judgment with Algorithms," *Social Research*, 86, no. 4 (Winter 2019).
- 7. These were the findings of the NTSB in the case of the Asiana Airlines crash in San Francisco in 2013. "Asiana's automation policy emphasized the full use of all automation and did not encourage manual flight during line operations."
- 8. The New York Times reports, "The issue has become more acute in recent years as aircraft have become more automated and a global pilot shortage has forced carriers to fill their cockpits with less experienced pilots, particularly in emerging markets." But this same problem is growing more acute in the United States as well, because "the stream of military aviators that the big carriers have long relied on is dwindling. The most seasoned pilots are aging out of the profession—they are required to retire at age 65 in the United States—and many said their successors might not know how to handle the unexpected." https://www.nytimes.com/2019/03/14/business/automated-planes.html.
- 9. "In the Ethiopian Airlines crash this week, one of the pilots had just 200 hours of flight time, less than a seventh of the time the F.A.A. generally

requires to fly a passenger plane," according to the same *Times* article. "Dennis Tajer, an American Airlines captain and a spokesman for the airline's pilots' union, said Boeing and Airbus had encouraged that sort of reliance on automation by pitching their planes to carriers as capable of being flown by lesser-trained pilots. 'We've seen insidious marketing of aircraft to accommodate less experienced and perhaps a lower grade of pilot,' he said." He says this with the indignation of a trained professional, but of course from the perspective of an airline looking to save money, the deskilling he refers to is a feature, not a bug.

- According to Representative Peter A. DeFazio (D-Ore.), chairman of the House Transportation Committee, as reported in the Washington Post, Boeing's internal communications "paint a deeply disturbing picture of the lengths Boeing was apparently willing to go to in order to evade scrutiny from regulators, flight crews, and the flying public, even as its own employees were sounding alarms internally." https://www.washingtonpost .com/local/trafficandcommuting/internal-boeing-documents-show -employees-discussing-efforts-to-mani/2020/01/09/83a0c6ec-334f-11ea -91fd-82d4e04a3fac_story.html.
- 11. When a self-driving Uber struck and killed a pedestrian in Tempe, Arizona, in March, 2018, the National Transportation Safety Board launched a twenty-month investigation, at the conclusion of which it was revealed that Uber's self-driving system was not programmed to recognize a pedestrian crossing outside of a crosswalk. Doing so makes the engineering challenge more difficult, and solving such challenges takes time. But given the "platform" or "network effect" economics of Uber, in which the goal is to achieve monopoly and discourage competitors as early as possible, being first to market is an overwhelming business consideration. The NTSB documents are available at https://dms.ntsb.gov/pubdms /search/hitlist.cfm?docketID=62978&CFID=2951047&CFTOKEN =433700b0892cd668-640F9CEA-D954-5E42-4EBD48460CC5D731.
- Günther Anders, "On Promethean Shame," in Christopher John Müller, Prometheanism: Technology, Digital Culture and Human Obsolescence (Lon-don: Rowman and Littlefield, 2016), p. 30.
- 13. Anders, "On Promethean Shame," p. 31.
- 14. An account of this seminar, convened in Los Angeles in August 1942 by Max Horkheimer and Theodor Adorno, and the quote I present here, are from Christopher John Müller's interpretive essay on Anders, "Better than Human: Promethean Shame and the (Trans)humanist Project," in *Prometheanism*, p. 100.

FOLK ENGINEERING

 For a fascinating account of corrosion (really!), read Jonathan Waldman, Rust: The Longest War (New York: Simon and Schuster, 2016).

- 2. I assume an average engine speed of 2,500 rpm and an average vehicle speed of 30 mph, over the course of 200,000 miles.
- 3. A case could be made that the building arts deserve this title, as they have been practiced and refined for millennia. But the building arts have also been subject to forgetting. The millimeter-scale precision with which the ancient Egyptians laid the massive stone blocks of the Great Pyramids baffle today's engineers. The structural advantage of the Roman arch was lost to Europe and had to be recovered. Closer to home, the thermal efficiency of antebellum homes in the South, with their deep verandahs and high ceilings, fell into disuse in the twentieth century. By contrast, the development of the internal combustion engine has occurred entirely in an era of mass literacy and communication, and perhaps that is why it has a more consistently progressive character, while oral and person-to-person traditions of apprenticeship are easily lost with social upheavals.
- 4. Sir Harry R. Ricardo, *The High-Speed Internal-Combustion Engine*, 4th ed. (London: Blackie and Son, 1953), p. 1.
- See William Shirer, The Rise and Fall of the Third Reich, Chapter 7: 5. "The Nazification of Germany 1933-1934." (I have relied on the audio book.) To prevent a labor strike, the Nazis proclaimed May Day, 1933, a national holiday and prepared to celebrate it as never before. Labor union leaders were duly charmed, and enthusiastically cooperated. They were flown to Berlin, and thousands of banners were unfurled proclaiming the Party's solidarity with the German worker. Before a crowd of one hundred thousand people at Templehof air field, Hitler proclaimed the motto "Honor work and respect the worker!" Goebbels, who had orchestrated the rallies, wrote in his diary that night, "Tomorrow we shall occupy the trade union buildings. There will be little resistance." A document that came to light during the Nuremberg trial detailed a plan to "coordinate" the trade unions on May 2. SS troops were to seize all trade union property and take unions leaders into "protective custody." All this indeed happened. Unions funds were seized, labor leaders were arrested, some of them beaten and sent to concentration camps. Robert Ley, the Cologne party boss who had been assigned by Hitler to take over the unions and establish the German Labor Front, proclaimed, "Workers! Your institutions are sacred to us National Socialists! I myself am a poor peasant's son and understand poverty. I know the exploitation of anonymous capitalism. Workers, I swear to you we will not only keep everything that exists, we will build up the protection and the rights of the worker still further." Three weeks later, the right to collective bargaining was abolished, and all labor contracts would now be set by "labor trustees" appointed by Hitler. The effect was to make strikes illegal. Speaking not to workers but to industrialists, Ley promised to "restore absolute leadership to the natural leader of a factory, that is, the employer." Clearly, this level of false

dealing goes beyond the usual historical pattern in which "socialists" (of various degrees of sincerity) come to power and proceed to concentrate power in party cadres.

6. O. G. W. Fersen, "The People's Car," *Autocar*, May 1, 1969 (VW Supplement), reprinted in Bill Fisher, *How to Hot Rod Volkswagen Engines* (New York: HP Books, 1970), pp. 4–6.

7. Edward Eves, "Beetle Power," *Autocar*, May 1, 1969 (VW Supplement), reprinted in Fisher, *How to Hot Rod Volkswagen Engines*, pp. 1–4.

Throughout the Mediterranean world and into northern Europe, the 8. Damascus steel developed in the Near East (Syria today) was known for its extraordinary plasticity (resistance to shattering) as well as its ability to hold a finely honed edge. Legend held that it could cut through a gun barrel, and slice a hair dropped upon the edge. Though there are modern alloys that outperform it, attempts to reproduce Damascus steel have not been fully successful. In 2006, German researchers discovered the presence of carbon nanotubes and nanowires in an ancient Damascus sword. The qualities of steel depend on the particular impurities present (small quantities of these are crucial; they are a function of the particular ore from which the steel is made and the type of fuel used to provide the heat of smelting); the heat cycles during production processes of quenching, tempering, and annealing; various methods of cold-working such as being drawn over a mandrel; and the semimolten foldings and poundings that a smith does during the forging process, among many other factors. Together these determine the crystal structure and "grain growth" present in the metal. This craft knowledge can't be fully articulated in language because some of it depends on judgment that comes only with individual experience-for example, being able to read the state of the metal based on its heat-color, and the sound it makes when struck. Such knowledge gets transmitted from master to apprentice, and takes only one generation to be lost if the process of transmission gets disrupted, as happened in the case of Damascus steel around 1750. India appears to have supplied the precursors to Damascus steel technology, via Persia and Arabia. But only in the twenty-first century has Indian steel become once again competitive (some speculate that the knowledge was deliberately suppressed by the British Raj), approaching the quality of German, Japanese, and American steel of the industrial era. (The desirable qualities of modern steel are due to innovations that occurred mainly in England in the nineteenth century.) This last judgment of today's Indian steel is my own unscientific hunch, based on my experience as a user of it in fabrication work over the last decade, compared to Indian steel hand tools I purchased in the 1980s that were total crap. Applying even a moderate amount of torque to an open-end wrench, the flats would simply spread apart. By contrast, I am prepared to trust my life to a roll cage I am currently building of drawn-on-mandrel steel tubing sourced from India.

- 9. Ricardo, The High-Speed Internal-Combustion Engine, p. 5.
- 10. Ricardo, The High-Speed Internal-Combustion Engine, p. 27.
- 11. Ricardo, The High-Speed Internal-Combustion Engine, p. 88.
- 12. More precisely, they resemble our polemical caricature of the medieval. The polemic helps to maintain our modern self-image but is rather poor at capturing what life was actually like in the Middle Ages, to judge from Johan Huizinga's *The Waning of the Middle Ages*, for example.

THE MOTOR EQUIVALENT OF WAR

- 1. For this season Forrest was running 600 rather than 1,000 horsepower, as an experiment in trying to preserve tires and transmissions.
- 2. Johan Huizinga, *Homo Ludens: A Study of the Play-Element in Culture* (New York: Roy Publishers, 1950), p. 63.
- 3. Huizinga, Homo Ludens, p. 50.
- There arises a circle of players who contend against one another, but 4. who also recognize each other-as players. The game is not for everyone; the circle is closed. The play community therefore comes under suspicion from the surrounding society. Do they think they're better than us? And what exactly goes on in their clubhouse, anyway? Such associations look potentially seditious. And in fact, in the course of political history, they often have been. Thus the emperor Trajan, for example, outlawed the formation of firefighting crews in the eastern Roman empire, despite their obvious utility, for fear they would become political. The fact that they fight fires makes them proud. Recognizing this problem. Thomas Hobbes called Leviathan "King of the Proud," meaning that the state had to undertake a project of moral reeducation-taming the spirit of rivalry and masculine play-if it was to establish and maintain a monopoly of power. My Ph.D. dissertation investigated this phenomenon in the ancient world. See especially the chapter "Life in the Greek Cities Under Roman Rule" in Matthew B. Crawford, Eros Under a New Sky: Greek Reassessments of Politics, Philosophy and Sexuality in Light of Roman Hegemony (Ph.D. diss., University of Chicago Department of Political Science, 2000).
- 5. Huizinga relays the anthropological findings of Marcel Granet, who reconstructed ancient Chinese ritual songs. "In ancient China almost every activity took the form of a ceremonial contest; the crossing of a river, the climbing of a mountain, cutting wood or picking flowers." Granet wrote, "The spirit of competition which animated the men's societies or brotherhoods and set them against one another during the winter festivities in tournaments of dance and song, comes at the beginning of the line of development that led to State forms and institutions." Marcel Granet, *Civilization*, as quoted by Huizinga, *Homo Ludens*, p. 55.

- 6. The father represents external reality, and is felt as a threat—a threat to the bubble of love between mother and child. He is the conduit for the superego, that locus of universal demands and shared norms. On Freud's account (as relayed by Howard S. Schwartz), "the father's job is to convey to the children the image that indifferent others would have of them." See *The Revolt of the Primitive: On the Origins of Political Correctness* (New York: Routledge, 2017).
- 7. Huizinga, Homo Ludens, p. 48.
- 8. Winston Churchill, My Early Life: 1874–1904 (New York, Touchstone, 1996), p. 64.
- 9. This passage comes from "Ace for the Ages: World War I Fighter Pilot Manfred von Richthofen," HistoryNet, https://www.historynet.com /red-baron-world-war-i-ace-fighter-pilot-manfred-von-richthofen .htm. See also Richtofen's own account, "The Red Air Fighter," in Jon E. Lewis, ed., Fighter Pilots: Eyewitness Accounts of Air Combat from the Red Baron to Today's Top Guns (New York: MJF Books, 2002), pp. 37–59.
- 10. "Ace for the Ages."
- War as exclusive contest presumes the humanity of one's opponent. 11. And conversely, paradoxically, the idea of an inclusive "humanity," and corresponding doctrine of generic human rights (the Geneva Convention, for example), has a poor record of securing humane limits to war. On the contrary, wars prompted by humanitarian principles seem to tend toward ferocity. One's opponent must be understood not merely as a political foe but as an enemy of humanity, and treated accordingly. It was the United States that used nuclear weapons to incinerate the populations of two cities, and currently uses unmanned drones, piloted from behind a screen, to attack wedding parties. The high-minded concept of human rights has an unacknowledged dark side: it seems to fit the concept of "total war" admirably well precisely because it is undiscriminating. It doesn't allow for the game-like political distinctions between "us" and "them" (such distinctions offend our universal principles) and instead substitutes a moral distinction between good and evil, enlightened and backward, which turns every conflict into a holy war on behalf of "humanity." This is one of the critiques leveled against liberalism by Carl Schmitt in his book The Concept of the Political (Chicago: University of Chicago Press, 1996).

12. This sentence, modified, would provide the rhetorical grace note in his speech to the House of Commons four days later. The story of its modification is interesting. In 1954, the same general who accompanied Churchill to the RAF bunker, Hastings "Pug" Ismay, related that shortly after the event, when he and Churchill were riding in a car together and Churchill was rehearsing the speech, he came to the

now-famous sentence and Ismay interrupted, saying "What about Jesus and his disciples?" "Good old Pug," said Churchill, who immediately changed the wording to "Never in the field of human conflict have so many owed so much to so few." "Never Was So Much Owed by So Many to So Few," Wikipedia, https://en.wikipedia.org/wiki/Never_was _so_much_owed_by_so_many_to_so_few.

13. With the creation of the RAF Volunteer Reserve in 1936, the RAF's processes for selecting potential candidates were opened to men of all social classes. It "was designed to appeal, to ... young men ... without any class distinctions." Thus John Terraine, *The Right of the Line: The Royal Air Force in the European War, 1939–45* (London: Hodder & Stroughton, 1985), pp. 44–45.

TWO DERBIES AND A SCRAMBLE

- Marilyn Simon, "#NotMe: On Harassment, Empowerment, and Feminine Virtue," Quillette, April 4, 2019.
- 2. As the left-wing daughter of a working-class family (she was a longtime editor at the *Nation*), Sexton was concerned about the feminization of males in an educational environment that was increasingly devoted to funneling everyone into white-collar work, and into the gentile norms of the office.

DEMOCRACY IN THE DESERT: THE CALIENTE 250

- Many of these "mirrored the federal government in form: Local chapters elected representatives to state-level gatherings, which sent delegates to national assemblies. . . . Executive officers were accountable to legislative assemblies; independent judiciaries ensured that both complied with rules." Yoni Appelbaum, "Americans Aren't Practicing Democracy Anymore," *Atlantic*, October 2018, https://www.theatlantic.com /magazine/archive/2018/10/losing-the-democratic-habit/568336/.
- 2. In the same book, Thompson writes that his central memory of living in the Bay Area in the mid-sixties is of nights when he left the Fillmore half-crazy and, instead of going home, aimed the big 650 Lightning across the Bay Bridge at a hundred miles an hour wearing L.L. Bean shorts and a Butte sheepherder's jacket . . . (always stalling at the toll-gate, too twisted to find neutral while I fumbled for change) . . . but being absolutely certain that no matter which way I went I would come to a place where people were just as high and wild as I was: No doubt at all about that. . . . There was madness in any direction, at any hour. . . . There was a fantastic universal sense that whatever we were doing was right, that we were winning. . . . And that, I think, was the handle—that sense of inevitable victory over the forces of Old and Evil. . . .

Then as now, that heady sense of *winning* at a generational culture war—the inevitability of it—is taken to license a certain kind of journalism by those who share it, the point of which is to advance the forward-moving narrative more than it is to capture social reality.

Thompson is often lumped together with Tom Wolfe, both pioneers of a New Journalism. Wolfe too had a central concern—not cultural revolt, but the play of status in its many forms, particularly among men. But in this there was no sense of something new in the world, something needing to be ushered in, or to gather partisans around itself. And that probably helps to explain why in reading Wolfe you feel you are learning something about the world as it is.

Thompson's saving grace is his spirit of play (his wonderfully illadvised tutorial on how to deal with a traffic cop is priceless), which he allows to override his generation-gap agenda. He also has a sense for decline or historical tragedy (nostalgia, if you prefer). Just after the passage quoted above, he refers to his idealized Bay Area of the mid-sixties as "a high-water mark" left by a wave that "finally broke and rolled back." This redeems as ironic the earlier bit about inevitability and winning, which reads now as a commentary on the mind-set of youth—from a man who clung to youth desperately.

"RECKLESS DRIVING:" RULES, REASONABLENESS, AND THE FLAVOR OF AUTHORITY

- Andy Medici, "The District Raked in a Record \$199M in Fines Last Year. It's Almost All from Traffic," *Washington Business Journal*, January 6, 2017, https://www.bizjournals.com/washington/news/2017/01/06/the -district-raked-in-a-record-199m-in-fines-last.html.
- 2. "A decade-old study by the Texas A&M Transportation Institute, since bolstered by other research, found that increasing yellow times by just half a second resulted in a decrease in accidents of up to 25 percent and a decrease in red light violations of up to 40 percent." David Kidwell, "Experts: Chicago's Short Yellow Light Times, Red Light Cameras a Risky Mix," *Chicago Tribune*, December 23, 2014, https://www.chicagotribune .com/investigations/ct-yellow-light-timing-met-20141223-story.html.
- 3. "The study also included a control group of similar intersections that never had cameras for comparison. After the data were compiled, the academic researchers applied a complex mathematical formula to strip away any other factors that might have caused changes in crash rates. Then they compared crash rates from periods before and after the camera installations.

"What the research concluded largely mirrored the findings of studies done on other, smaller programs throughout the country. Overall, there was a 15 percent reduction in more dangerous T-bone crashes involving injury, but a 22 percent increase in injury-causing rear-end crashes.

"Perhaps more significant, the study concluded that the cameras

did not reduce T-bone crashes at those intersections that had fewer than four such crashes per year before the cameras were installed. And the lack of safety benefits likely means that the increase in rear-enders made those intersections more dangerous for Chicago drivers.

"The Tribune found 73 camera-equipped intersections throughout the city that fit that criteria. Those cameras have earned the city more than \$170 million in traffic fines since the program began." David Kidwell and Abraham Epton, "Red Light Verdict Casts Harsh Light on Rationale for Cameras," *Chicago Tribune*, January 30, 2016, http:// www.chicagotribune.com/news/watchdog/redlight/ct-chicago-red -light-cameras-met-0131-20160129-story.html.

- 4. David Kidwell, "Red Light Camera Trial Offers Rare Insight into City Hall Intrigue," *Chicago Tribune*, January 22, 2016, https://www .chicagotribune.com/investigations/ct-red-light-camera-trial-0124 -20160122-story.html.
- 5. Yeshim Taylor, director of the DC Policy Center, said, "Were the automated traffic enforcement revenue to go down, we could make up for it through our larger portfolio of taxes. But high collections do hook us to the revenue and makes it incredibly hard to make changes driven by safety considerations." Andy Medici, "These D.C. Speed, Red Light Cameras Generate the Most Revenue," *Washington Business Journal*, April 10, 2017, https://www.bizjournals.com/washington/news/2017 /04/10/these-d-c-speed-red-light-cameras-generate-the.html.
- This according to the D.C. Office of the Chief Financial Officer, as reported in Andy Medici, "Here's How Much the District Plans to Collect in Traffic Fines over the Next Five Years," Washington Business Journal, March 9, 2017, https://www.bizjournals.com/washington/news /2017/03/09/here-s-how-much-the-district-plans-to-collect-in.html.
- "Lane Width," Federal Highway Administration, U.S. Department of Transportation, https://safety.fhwa.dot.gov/geometric/pubs/mitigation strategies/chapter3/3_lanewidth.cfm.
- 8. Matt Labash, "The Safety Myth," *Weekly Standard*, April 2, 2002, http://www.weeklystandard.com/the-safety-myth/article/2375.
- 9. A parallel suggests itself between law enforcement and other institutional actors that thrive on conflict. Political correctness has arguably become a device by which bureaucracy extends its purview into previously autonomous domains, where people once worked things out for themselves. Unreasonable rules for behavior and taboos on speech are demanded by activists, people's predictable failure to meet them generates conflict, and this in turn becomes the occasion for new initiatives by administrators in universities and corporations—those whom Michel Foucault called "the minor civil servants of moral orthopedics." Harvard University, for example, has more than fifty Title

Nine administrators on staff. The rationale offered is usually safety from trauma. Just as with mechanized traffic enforcement, this social apparatus has to characterize people as childlike in their vulnerability, and the world as bristling with hazards that need to be regulated. A further parallel is that the system guarantees more collisions, as it were, and hence calls for more intervention. Our social amber time is approaching zero.

- 10. Jason Chaffetz, former chairman of the House Committee on Oversight and Government Reform, details the absurdities of airport security theater in his book *The Deep State*. In contemporary America, the role of Congress appears to be mainly that of brokering business deals, using its budgetary oversight of the administrative state (the customer) to take a brokerage fee in the form of campaign contributions from vendors—while distracting voters with culture war. Meanwhile, the substantive political disputes underlying the culture war are settled elsewhere, by the courts and by executive branch fiat.
- 11. Claire Berlinski wrote in January 2019 that "according to the police, there have so far been 1,700 serious injuries among the protesters, and 1,000 among law-enforcement officers."
- 12. As reported by CNN, via *Newsweek*: Brendan Cole, "Yellow Vest Protesters Vandalized or Destroyed 60 Percent of France's Speed-Camera Network," *Newsweek*, January 11, 2019, https://www.newsweek.com /yellow-vest-protesters-have-vandalized-or-destroyed-60-frances -entire-speed-1287832 (italics added).
- Matt Labash, "Getting Rear-Ended by the Law," Weekly Standard, April 3, 2002, https://www.washingtonexaminer.com/weekly-standard /getting-rear-ended-by-the-law.
- 14. NHTSA, "Traffic Safety Facts, 2016 Data: Speeding," p. 1, https:// crashstats.nhtsa.dot.gov/Api/Public/ViewPublication/812480.
- 15. One would have to query the data with custom-designed regressions to get at the interactions among these relevant factors. Surely speeding and running off the road will be correlated, for example. To its great credit, the NHTSA makes its data available for such purposes. For whatever it is worth (again, consider the source), *Car and Driver* reported that according to the NHTSA data in 2007, only 3.1 percent of fatal crashes list speed as the "only related factor."
- 16. Labash, "The Safety Myth."
- 17. Bennhold, "Impose a Speed Limit on the Autobahn?"
- Max Smith, "Going 11 Miles over the Speed Limit in Va. May No Longer Land You in Jail," WTOP, February 13, 2016, http://wtop.com/dc-transit /2016/02/going-11-mph-speed-limit-va-may-no-longer-land-jail/.

NOTES | 34

MANAGING TRAFFIC: THREE RIVAL VERSIONS OF RATIONALITY

- 1. With the caveat that comparisons between cities are methodologically tricky, according to the Urban Mobility Index, Rome ranks 4.6 on the congestion index (which compares traffic flow at rush hour peaks to the free-flow rate), with an additional thirty minutes required to travel 100 kilometers at peak demand, and 10.95 percent of roads congested. For comparison, Washington, DC, with its extensive use of red light cameras and photo speed cameras, ranks 5.9, with thirty-seven-minute delays and 15.47 percent of roads congested. https://urbanmobilityindex.here.com.
- 2. For example, merely counting up the number of traffic fatalities and dividing by the number of vehicles in a country doesn't account for the fact that cars are used more intensively in a poor country than they are in a country in which a single household may have multiple cars. Also, some of the difference in the World Health Organization fatality rates can surely be attributed to differences in the availability and quality of trauma care, car maintenance practices, and the condition of roads. https://www.who.int/violence_injury_prevention/road_safety_status/2018/en/.
- 3. Freud wrote, "It is impossible to overlook the extent to which civilization is built up on a renunciation of instinct, how much it presupposes precisely the non-satisfaction (by suppression, repression or some other means?) of powerful instincts. This 'cultural frustration' dominates the large field of social relationships between human beings. As we know, it is the cause of the hostility against which all civilizations have to struggle," *Civilization and Its Discontents*, trans and ed. James Strachey (New York: Norton, 1962), p. 44.
- The University of Texas researchers present their ideas in a video demonstration: https://www.youtube.com/watch?v=4pbAI40dK0A&t=58s.
- 5. John R. Quain, "Cars Will Have to Get Faster, on the Inside," *New York Times,* August 17, 2018, p. B5. "Self-driving cars will generate 4 terabytes of data per hour." A senior director at one of the suppliers of computer chips for autonomous car research says, "They think we need 300 teraflops of computing power." Quain writes, "A teraflop is a trillion operations per second, which means that every vehicle would be a rolling supercomputer."
- Michel de Certeau, *The Practice of Everyday Life* (Berkeley: University of California Press, 2011), p. 93. See also Rebecca Solnit's discussion of de Certeau's phrase in her book *Wanderlust* (New York: Penguin, 2001), p. 213. I am grateful to Garnette Cadogan for these references, and for many interesting conversations about walking.

ROAD RAGE, OTHER MINDS, AND THE TRAFFIC COMMUNITY

1. Jack Katz, "Pissed Off in L.A.," in *How Emotions Work* (1999); reprinted in *The Urban Ethnography Reader*, ed. Mitchel Duneier, Philip Kasinitz and Alexandra K. Murphy (New York: Oxford University Press, 2014), pp. 215–216.

- 2. Katz, "Pissed Off in L.A.," p. 220.
- 3. Katz, "Pissed Off in L.A.," pp. 220-222.
- 4. Katz, "Pissed Off in L.A.," p. 223.
- A good review article that gathers this research and presents an overview is Hazel Rose Markus and Shinobu Kitayama, "Culture and the Self: Implications for Cognition, Emotion, and Motivation," *Psychological Review* 98 no. 2 (1991), pp. 224–253.
- 6. Katz rightly rejects the idea that reason and emotion are totally separate. Emotions bring into awareness, "in the ... medium of the body, commitments that previously were tacitly engaged" ("Pissed Off in L.A.," p. 227). But he goes on to insist that "this self-reflection does not take the form of thought." He says it is sensual and aesthetic, accomplished "through a kind of living poetry, and not in the form of discursive reason." That last bit doesn't sound right to me. Anger is, precisely, discursive. We address ourselves to somebody. Often this person is absent or merely imagined. But anger wants to have its say and be heard. For Plato's Socrates, *thumos* (the spirited part of the soul; the part prone to anger) is the natural ally of the reasoning part of the soul. In other words, anger can be distorting of one's thinking, yes, but it also arises from, and spurs, thinking.
- 7. Andy Clark, Surfing Uncertainty: Prediction, Action and the Embodied Mind (New York: Oxford University Press, 2014).
- 8. These suggestions by Clark provide an evolutionary rationale for "the development and deployment of 'mirror neurons' and (more generally) 'mirror systems': neural resources implicated both in the performance of actions and in the observation of the 'same' actions when performed by others." Clark, *Surfing Uncertainty*, pp. 139–140.
- 9. Clark, Surfing Uncertainty, p. 285.
- 10. Clark, Surfing Uncertainty, p. 73.
- These last remarks are my extrapolation from a remark by Clark (Surfing Uncertainty, p. 286), citing the work of M. Columbo, "Explaining Social Norm Compliance: A Plea for Neural Representations," Phenomenology and the Cognitive Sciences 13, no. 2 (June 2014).
- Robert D. Putnam, "E Pluribus Unum: Diversity and Community in the Twenty-first Century, The 2006 Johan Skytte Prize Lecture," Nordic Political Science Association (Oxford, UK: Blackwell Publishing, 2007), accessed at https://drive.google.com/file/d/1FvFN8ACY 6taivkcbzDGgYy1-EPb1kbbQ/view.
- 13. In 2016, the last years for which I was able to find data from the World Health Organization, the rate of road fatalities per 100,000 motor

vehicles was 6.8 in Germany. The combined figure for eastern Mediterranean nations was 139, larger than Germany's by a factor of twenty. The combined figure for African nations was 574, larger by a factor of eighty-four. https://www.who.int/violence_injury_prevention/road safety_status/2018/en/.

A better measure would be fatalities per mile traveled by car, but this figure is not available for most countries. Presumably each car is used more intensively in a poor country than in a country in which a single household may have multiple cars. Also, some of the difference in the WHO fatality rates can surely be attributed to differences in the availability and quality of trauma care, car maintenance and road maintenance. But not all of it.

 Bernhard Rieger, The People's Car: A Global History of the Volkswagen Beetle (Cambridge, MA: Harvard University Press, 2013), p. 53.

STREET VIEW: SEEING LIKE GOOGLE

- 1. Alistair Jamieson, "Google Will Carry On with Camera Cars Despite Privacy Complaints over Street Views," *Telegraph*, April 9, 2009 (reporting an interview in the *Times*), https://www.telegraph.co.uk /technology/google/5130068/Google-will-carry-on-with-camera -cars-despite-privacy-complaints-over-street-views.html.
- 2. Shoshanna Zuboff, The Age of Surveillance Capitalism: The Fight for a Human Future at the New Frontier of Power (New York: Public Affairs, 2018), p. 44.
- 3. Zuboff, Age of Surveillance Capitalism, p. 48.
- 4. Zuboff, Age of Surveillance Capitalism, pp. 146-50.
- 5. James C. Scott, Seeing Like a State (New Haven: Yale University Press, 1998), p. 53.
- 6. Scott gives some historical examples of geographic inscrutability (to outsiders) playing this defensive role. The Casbah was the stronghold of resistance to the French in Algiers, and in Iran it was from the political space maintained in the bazaar that a challenge to the rule of the Shah was launched. The townships of South Africa under apartheid provide another example of precincts whose illegibility made them ungovernable. In Paris, it was in the oldest and most confusing *quartiers* that uprisings were launched in the eighteenth and nineteenth centuries, with barricades going up nine times in the second quarter of the nineteenth century and full-blown revolutions in 1830 and 1848. When Louis Napoleon seized power in 1851 in a coup d'état, he authorized Baron Haussmann, prefect of the Seine, to undertake a radical reconstruction of Paris, requiring widespread demolition, that would permit "a synoptic grasp of the ensemble," as Scott writes. And this for a number of

reasons: to make the city more governable, more healthy, and more imposing in the manner proper to an imperial power. In 1860 the insurrectionary outskirts were annexed to Paris. Haussmann described these districts as a "dense belt of suburbs, given over to twenty different administrations, built at random, covered by an inextricable network of narrow and tortuous public ways, alleys, and dead-ends, where a nomadic population . . . without any effective surveillance, grows at a prodigious speed."

"How do you create a map showing every road in the United States, with the precise location of every stop sign, all the lane markings, every exit ramp and every traffic light—and update it in real time as traffic is rerouted around construction and accidents? . . . 'If we want to have autonomous cars everywhere, we have to have digital maps everywhere,' said Amnon Shashua, chief technology officer at Mobileye, an Israeli company that makes advanced vision systems for automobiles." Neal E. Boudette, "Building a Road Map for the Self-Driving Car," *New York Times*, March 2, 2017.

 Jody Rosen, "The Knowledge, London's Legendary Taxi-Driver Test, Puts Up a Fight in the Age of GPS," New York Times Style Magazine, November 10, 2014, https://www.nytimes.com/2014/11/10/t-magazine /london-taxi-test-knowledge.html.

9. In much commentary and reportage, several unrelated developments get mixed up together: driverless cars, electric vehicles, and ride hailing. I believe this fuzziness is deliberately cultivated, as it imparts a sheen of technological progress to the ride-hailing firms when in fact their core business is one of labor arbitrage. Their innovation is merely to exploit the deskilling effect of GPS for this purpose. The main divide across which they practice labor arbitrage is time of residence in a city, which corresponds to the acquisition of knowledge held independently, without reliance on GPS. Continued high levels of immigration guarantee a persistent gradient—of personal knowledge—along which to conduct this labor arbitrage. See Horan, "Uber's Path of Destruction," pp. 109–110.

10. Zuboff, Age of Surveillance Capitalism, p. 152.

A GLORIOUS, COLLISIONLESS MANNER OF LIVING

 Here I rely on an unpublished manuscript by Thomas S. Schrock, who parses the perversity of Hobbes's insistence on "governing by syllogism." One consequence is that the sovereign thereby squanders the easy, habitual law-abidingness that custom secures. "We follow customary laws, not out of fear, but because they are here with us, our own, part of us." Governing by syllogism, on the other hand, requires heavy police work.

7.

- 2. In "machine learning," an array of variables is fed into deeply layered "neural nets" that simulate the fire/don't fire synaptic connections of an animal brain. Vast amounts of data are used in a massively iterated (and, in some versions, unsupervised) training regimen. Because the strength of connections between logical nodes within layers and between layers is highly plastic, just like neural pathways, the machine gets trained by trial and error and is able to arrive at something resembling knowledge of the world. That is, it forms associations that correspond to regularities in the world. As with humans, these correspondences are imperfect. The difference is that human beings are able to give an account of their reasoning. Of course, human beings sometimes deceive themselves, give false rationalizations, and so on. But these are available to challenge; they are the stuff of democratic politics.
- 3. Timothy Williams, "In High-Tech Cities, No More Potholes, but What About Privacy?" *New York Times*, January 1, 2019, https://www.nytimes.com/2019/01/01/us/kansas-city-smart-technology.html (italics added).

IF GOOGLE BUILT CARS

- 1. "Though drivers may not realize it, tens of millions of American cars are being monitored . . . experts say, and the number increases with nearly every new vehicle that is leased or sold. The result is that carmakers have turned on a powerful spigot of precious personal data, often without owners' knowledge, transforming the automobile from a machine that helps us travel to a sophisticated computer on wheels that offers even more access to our personal habits and behaviors than smartphones do." Peter Holley, "Big Brother on Wheels: Why Your Car Company May Know More About You Than Your Spouse," Washington Post, January 15, 2018, https://www.washingtonpost.com/news /innovations/wp/2018/01/15/big-brother-on-wheels-why-your-car -company-may-know-more-about-you-than-your-spouse/.
- Arvind Narayanan and Edward W. Felten, "No Silver Bullet: Deidentification Still Doesn't Work," July 9, 2014, Arvind Narayanan— Princeton (personal website), http://randomwalker.info/publications /no-silver-bullet-de-identification.pdf, as cited in Zuboff, Age of Surveillance Capitalism, p. 245.
- 3. Jennifer Valentino-deVries et al., "Your Apps Know Where You Were Last Night, and They're Not Keeping It Secret," *New York Times*, December 10, 2018, https://www.nytimes.com/interactive/2018/12/10 /business/location-data-privacy-apps.html.
- 4. Zuboff, Age of Surveillance Capitalism, p. 8 (emphases in original).
- 5. Zuboff, Age of Surveillance Capitalism, pp. 217-218.
- 6. Zuboff, Age of Surveillance Capitalism, p. 238.

- 7. Zuboff, Age of Surveillance Capitalism, p. 201.
- 8. Zuboff, Age of Surveillance Capitalism, p. 240.
- 9. Monte Zweben, "Life-Pattern Marketing: Intercept People in Their Daily Routines," SeeSaw Networks, March 2009, as cited in Zuboff, *Age of Surveillance Capitalism*, p. 243.
- Dyani Sabin, "The Secret History of 'Pokémon GO,' as Told by Creator John Hanke," *Inverse*, February 28, 2017, https://www.inverse .com/article/28485-pokemon-go-secret-history-google-maps-ingress -john-hanke-updates.
- 11. See Natasha Dow Schull, Addiction by Design: Machine Gambling in Las Vegas (Princeton, NJ: Princeton University Press, 2012), and the chapter "Autism as a Design Principle" in my The World Beyond Your Head.
- 12. Various journalists took it upon themselves to actually read the pageslong privacy policy and data-collection practices of the Pokémon Go! app and discovered that it requires you to grant it access not only to the phone's camera, but also permission to harvest your contacts and find other accounts on the device, yielding a "detailed location-based social graph." See Joseph Bernstein, "You Should Probably Check Your Pokémon Go Privacy Settings," *Buzzfeed*, July 11, 2016, as cited in Zuboff, *Age of Surveillance Capitalism*, p. 317.

CONCLUDING REMARKS: SOVEREIGNTY ON THE ROAD

 Further, license plate readers are being installed on those digital road signs you may have noticed going up, creating a database that is shared by government agencies, from which a portrait of one's movements can be drawn. https://www.fbo.gov/index?s=opportunity&mode=form &id=85f3d16be46d2e424ba5c07339dde153&tab=core&_cview=0.

This was begun by the Drug Enforcement Administration, and is now metastasizing. For example, the San Diego Police Department shares its data from license plate readers with about nine hundred different federal, state, and local agencies. "Data Sharing Report San Diego Police Department," DocumentCloud, https://www.document cloud.org/documents/4952878-Data-Sharing-Report-San-Diego -Police-Department.html.

2. Recall the Belgian study, cited in note 10 of the Introduction, which found that if 10 percent of car drivers switched to motorcycles, time wasted sitting in traffic would be reduced for the remaining car drives by 40 percent. For a comparison of traffic flow rates in different cities around the world, including the street capacity use of motorcycles compared to other vehicles, see Alain Bertaud, Order Without Design: How Markets Shape Cities (Cambridge, MA: MIT Press, 2018), chapter 5.

Index

Note: Page numbers in *italics* indicate illustrations.

absenteeism, 119 abstraction, 94, 118-119, 133 AC Cobra, 66-67 accidents. See also reckless driving motorcycle, 5 reduction in, 4 risk budget and, 90 road fatalities, 242 role of speeding in, 226-229 safety devices reducing, 91-92 Tesla vehicles and, 88-89 traffic fatalities, 260-261 action and perception, 112-113 adaptive cruise control, 101 Adult Soapbox Derby. See Portland's Adult Soapbox Derby aerial combats, 173-176 affection for the present, 82 affective capitalism, 114 Afghanistan, 229 Agape Baptist Church, 201 The Age of Surveillance Capitalism (Zuboff), 302-303 air quality, 75-79 airbag deployment, 86, 88 airbags, 90-91, 95, 96-97 air-cooled Volkswagens. See also Volkswagen Beetle folk engineering and, 16 Porsche, Ferdinand and, 16 restorations, 16-17 speed scene, 144 timing gears, 150-151 type 4 motor, 145 aircraft. See also pilots automation in, 102-104, 112, 123 driving compared to flying, 6-7 engines, 134 Albert, Dan, 38

algorithmic governance, 286-290 Alphabet, 305 Alvarez, Jose, 143, 144 amber times, 219-220, 222 amnesia, infantile, 13 analytical moral philosophy, 116-117 Anders, Günther, 126-127 angular momentum, 11-12 animosity, 184 antijunk ordinances, 18 aporia, 3 Appelbaum, Yoni, 204 Apple iPhone, 240 Arendt, Hannah, 15, 217 Aristotle, 12, 142 arrested development, 172 Ars Technica, 87, 89 artificial intelligence, 245, 287 Asian car modifications, 80-81 Audi RS3, 109-111 Australian Field Artillery, 176 Austria, 249 auto industry, computer industry compared to, 293-295 autobahn culture, 229-230, 260 automated speed enforcement, 227. See also photo radar speed traps; red light cameras automated traffic enforcement systems. See red light cameras Automated Traffic Solutions, 221 automation. See also driverless cars; smart cities in airplanes, 102-103, 112, 123 braking, 97 first principles, 285-286 human factors in, 8 human intelligence sharing control with, 104-105

automation (cont.) lane keeping, 97, 100 levels of, 98 moral intuitions and, 117-118 partial, 102-103 for pilots, 123 pilots trust in, 124-125 replacing trust and cooperation with, 120-121, 312 skills atrophy from, 123 spiritlessness in, 123 traffic enforcement, 217 automobile safety. See also risk reduction airbag deployment, 86, 88 airbags, 90-91, 95, 96-97 automated. See automation in autonomous cars, 86-87, 301 Autosteer, 86-89 in-car information system, 99 changing driving behavior, 90-91 cost of, 95-96 design elements, 91-92 deskilling effect of, 97-98 dual-circuit master cylinders, 91-92 electronic stability control, 92 enclosing crash structure, 94 energy-absorbing steering columns, 90 European Commission on, 95 loss of situational awareness and, 94-95 rearview cameras, 95 safety devices, 90 seat belts, 90, 97 steering and brake inputs, 97 technology progress in, 86 in Tesla cars, 86-89 traction control, 92 unobtrusive features, 93-94, 96-97 vitalist critique of, 33-34 automobiles. See also automobile safety; old cars; project cars autonomous. See autonomous cars; driverless cars, semiautonomous cars; Uber deadening of cities and, 35-36 driver's attitudes toward, 41-42 empowered moral isolation of, 239 horses vs., 36-37 as intruders, 20 overabundance of, 38-39 personalities of, 41-42

as sheltering space, 40-42 transformation of cities and, 35-36 automotive improv artist, 81-83 automotive subcultures, 10, 28 autonomous cars. See also driverless cars; semiautonomous cars; Uber efficiency of, 246-247 experimental designs for, 246 predictive problems of, 259 programming local social norms, 259 safety of, 86-87, 301 virtues of, 122 autonomous intersections, 21, 245-246 Autosteer, 86-89 Barbe, Emmanuel, 226 Basic Rider course, 236-237 behavior constraint, 258 behavior modification, 309 behavioral data, 304 behavioral surplus, 273, 302 behind the Martin's, 1 being scared, tonic effect in, 15 Belgium, 267 Bennett, Bob, 290 Bergson, Henri, 169 Berkeley High School, 108 Berlin Auto Show, 139 Berlinski, Claire, 226 better self, 170 bicycle moralists, 179-183 bicycles, 12, 182-183 big data, 303 Bills, John, 221-222 The Black Box Society (Pasquale), 286-287 blueprinting an engine, 148-149 Boeing 737 MAX 8, 124 Bogost, Ian, 9-10 Boyle, T. Coraghessan, 299-300 braking, automated, 97 Brexit, 271-272 Brin, Sergey, 292 British Ford Escort, 80 brittleness of navigation systems, 99-100 Brooks, Rodney A., 113 Brown, Arthur Roy, 176 Bruges, Belgium, 267 Bulgaria, 250 Burke, Edward, 221

Cadogan, Garnette, 2 Caliente, Nevada, 200–202

Caliente 250, 22–23. See also SNORE Knotty Pine 250 Caliente Youth Center, 202 California Air Resources Board, 77, 79 California Highway Patrol (CHP), 24, 50, 215-216, 224, 280 calvary, 174-175 cam gears, 150-151 Cambridge University Automobile Club, 133-134 Camp Roberts, 55 Canada, 249 capitalism affective, 114 crony, 90 enforcing old car obsolescence and, 79 platform, 286-287 predatory forms of, 76 techno-, 10 Carr, Nicholas, 103 Carrell, Tom, 77 cars. See automobiles cash-for-clunkers programs, 18, 74, 76, 78 Casner, Stephen M., 98, 100, 101, 102, 106 Castaner, Christophe, 226 Certeau, Michel de, 247 Chappell, Sophie-Grace, 120 Chevrolet Corvair, 108 Chevy rods, 144 Chicago, Illinois, traffic enforcement automation, 218-222 Chippenham Parkway, 236 Chrysler Corporation, 135 Churchill, Winston, 174, 177 Cisco, 289 cityscape, medieval times, 267-268 civic republicanism, 282 Claremont Resort, 108 Clark, Andy, 244, 256-258 Clean Air Act of 1970, 77-78 Clean Air Act of 1990, 74 Cleese, John, 25 clunker programs. See cash-for-clunkers programs coercion, surveillance and, 306-307 cognitive extension, 111. See also embodied cognition cold starts, 17 collective ownership citizenship, 274 COMDEX computer expo, 293 common good, 30, 43, 209, 240, 248, 313-314

common law, 286 commutes, air pollution and, 78 competitive instinct, 171 complacency, 100-101 computer geeks, 16 computer industry, auto industry compared to, 293-295. See also automation congestion pricing, 313 conjoined drivers, 23 connecting rods, 146 Connolly, John, 146 conversation, nonverbal parallels to, 257 - 258conviviality, 247 convoy, 19 cops. See California Highway Patrol (CHP) corporate libertarianism, 43 corrosion, 130-131 countersteering, 167 courtesy pullovers, 23 crankshaft, 144-145, 149 crankshafts, 143 crashes, speeding-related, 226-228 Crawford, L. Elizabeth, 59-65. See also Crawford-Lambert rat driving project Crawford-Lambert rat driving project building rat car, 61 Crawford, L. Elizabeth and, 59-65 driver's education, 62-63 effort-driven rewards, 64-65 inducing a conditioned response, 62-63 rat ergonomics and, 61-62 self-motion and, 59-60 skills vs. tasks, 60 tool use, 62-63 Croly, Herbert, 38, 138 crony capitalism, 90 cultural development, 65 Daimler, 304

Datsun 510, 80 David, Joe, 203 Davis, Joe, 19 death algorithm, 117 *The Death and Life of Great American Cities* (Jacobs), 35–36 deference to machines, 126 delegation, societal effect of, 119 demolition derby, 184–187. *See also* motor sports; soap box derby Department of Motor Vehicles experience, 213-214 digital Rust Belt, 290 dilemma zone, 219-220 dirt bike riding. See also motorcycles behind the Martin's, 1-3 female riders, 192-194 hare scramble race, 191-193 distracted driving, 235 District of Columbia, 218, 222 DMV experience, 213-214 dogbox sequential transmission, 166 dogfights, aerial, 173-174 Dolgov, Dmitri, 105 dowel pins, 157-158 DPR Machine, 144 dragsters, 135-136. See also hot-rodding drifting blind turns, 168 compared to figure skating, 167 countersteering, 167 as motor sport, 164-168 practice run, 165-168 tandem drift, 167-168 driverless cars. See also automation; autonomous cars; semiautonomous cars; Uber affect on people, 122 boredom and, 5 communicating with one another, 104 dystopian films on, 22 ethical dilemmas of, 117 future scenario of, 299-300 getting public on board with, 42 Google's interest in, 40, 105 Obama on, 4-5 realizing full potential of, 7-8 road infrastructure for, 43 sharing control with, 104-105 as smart device, 304 smooth-flowing mobility of, 277 surveillance capitalism and, 301-308 Volvo Concept 26, 39-40 driver-road mediation, 111 drivers. See also driving attentional capacity, 103-104 attitudes toward automobiles, 41-42 changing behavior, 90-91 conjoined, 23 courtesy pull-overs by, 23 demographic characteristics, 254 deskilling effect from safety features, 90-91, 97-98

disconnection of, 113 early education for, 184 feeling released from social observation, 40-41 London taxi, 30 long haul truckers, 19 mental workload, 103 as moral types, 23-25 prudence of, 248 semiautonomous cars and, 98 superior, 254 urban, 248 driver-vehicle combination, licensure of, 26-27 driving. See also drivers air travel compared to, 6-7 body language of, 105 distracted, 235 emotional labor when, 241 German laws of, 25-26 reckless, 230-232, 238-240 road rage. See road rage as routine, 9 types of, 8-9 utopian experiment, 25-27 dual-circuit master cylinders, 91-92 Dupuy, Jean-Pierre, 279

Easy Rider (film), 24-25 ecology of attention, 26-27 economic sovereignty, 30-31 economy. See political economy effort-driven rewards, 64-65 Egan, Peter, 67 Eisenhower administration, 38 electroless nickel plating, 152 electronic stability control, 92 Emanuel, Rahm, 220-221 embodied cognition, 59, 61, 93, 112, 244 emissions reduction, 77-78 emotional labor, 241 emulation, 170 energy-absorbing steering columns, 90 episodic memory, development of, 13 Esperanto meritocrats, 272 ethical dilemmas, 117 European Commission, 95 Eves, Edward, 140 existential politics, 272-273 external scaffolding, 257

face-to-face orientation, 252–253, 255 false environmentalism, 83

ŝ

w

Fatality Analysis Reporting System, 228 fathers, 182-183 Fear and Loathing in Las Vegas (Thompson), 207-208, 215-216 Federal Highway Administration (FHWA), 223 Feeney, Matt, 297 female riders, hare scramble race, 192 - 194Ferdinand, Franz, 137 Fersen, O. G. W., 140 Fiasco, Lupe, 280 Fifty-Third Battery, Australian Field Artillery, 176 Fight Club (film), 170 fight to the death, 172-173. See also human need to fight filtering, 24-25 first principles, 285-286 Fisher, Bill, 146 Flink, James J., 37-38 Fluvanna County traffic court, 233-234 flywheels, 156-157 folk engineering. See also internal combustion engines air-cooled Volkswagens and, 16 blueprinting an engine, 148-149 cam gears, 150-151 crankshaft, 144-145, 149 dowel pins, 157-158 electroless nickel plating, 152 flywheels, 156-157 in off-road world, 205 of the Outback, 158-159 panel beating, 137 pistons, 146-147 rod caps, 147 rust and corrosion, 130-131 sunk costs, 131 timing gears, 149-151, 149 transmissions, 156 Ford Mustangs, 158 Formula D points series, 165 Foucault, Michel, 237 France, 29-30, 232 Francis, Pope, 247-248, 313 Fraser, Nancy, 76 free flow speed, 222-223 free market society, 297-298 freedom of faith, 57 freedom of movement, 10 Freeman, Kenny, 203 Freud, Sigmund, 171-172, 243

friction zone, 237 futurism, 42 Galileo, 153 gamification, 308-309 gas cans, 84-85 Gates, Bill, 293, 294 gearheads, 16, 18, 80-81, 151-152, 159 gender equity in motorcycle racing, 192-193 General Motors, 293-294, 298-299 George Washington Parkway, 222-223 German flywheels, 157 Germany autobahn network, 229-230 Berlin Auto Show, 139 driving laws, 25-26, 30, 260 Hitler, Adolf, 139-140 labor movement, 139 Reich Highway Code, 260 traffic fatalities, 260-261 girl-power affirmation, 194 The Glass Cage (Carr), 103 Glenberg, A. M., 13 **Global Automotive Elections** Foundation, 138 global positioning systems (GPS), 272 good governance, 291 Google, 40, 105 building a model city, 284-285 driverless cars interest, 40, 105 effortless integration into human lives, 292 Founders Letter, 291-292 generating data for economic gain, 304 geographical information, 266 governmental aspirations of, 284-285 Ground Truth project, 273-274 ideal society of, 274 parent company of, 305 steering public thought, 290-291, 300 - 301Street View. See Street View Gorgias (Plato), 25 GPS-guided cars, 272 Groff, Daniel, 71 Ground Truth project, 273-274 Guilluy, Christophe, 224 Gurri, Martin, 225

Hanke, John, 266, 308 hare scramble race, 191–193 Harris, John, 43 Hasselberger, William, 121 Hawking, Stephen, 163 Hayes, J., 13 Hazlewood, Victoria, 208 helical-cut timing gears, 150, 151 Hendrickson, Dave, 200, 203 high-performance bricolage, 153-154, 155 The High-Speed Internal-Combustion Engine (Ricardo), 134-135 Highway Beautification Act of 1965, 72-73 highway deaths, rates of, 5 highways, as expression of national pride, 72-73 Hitler, Adolf, 139-140 Hitting the Apex (film), 173 Hobbes, Thomas, 171, 286 homo faber, 15 Homo Ludens (Huizinga), 168-169 homo moto, 11-14 Honda, 80 Honolulu, 249 Horan, Hubert, 44-45 horses, 36-37 hot-rodding, 15-16, 136. See also dragsters How to Hot Rod Volkswagen Engines (Fisher), 146 hubris, 126 Huguenot Parkway, 238 Huizinga, Johan, 15, 69, 168-169, 171-173, 185, 283 human action, colonized by machines, 122 human adaptability, 243 human behavior, 5, 258, 278, 291, 307 human control, 4, 113 human judgment, 104, 224, 227 human mind, as prediction machine, 256-261 human need to fight, 179, 185. See also fight to the death human play competitive instinct and, 171 expressing animal spirits, 168 fight to the death and, 172-173 as inherently exclusive, 177 play-community, 176-177 social order and, 170-172 utilitarianism and, 170 war and, 177 Hutchins, Edwin L., 98

ice hockey, 110-111 idiot-proofing, gas cans, 84-85. See also automobile safety Illich, Ivan, 243, 247, 314 impartial agency, 120 in-car information system, 99 individual agency, 29 individual judgment, 7, 31, 312 Indochina, 80 industrial psychology, 214 infantile amnesia, 13 infantile narcissism, 171-172 inference, 112 information overload, 103 institutional power, 288 Insurance Institute for Highway Safety, 227 intelligence, bodily skills vs., 59-60, 65 internal combustion engines, 131-134 International Harvester Scout, 50 internet of things, 306 Intersection Manager, 246, 247, 248 Interstate Highway System, 38 Isle of Man, 229 Isle of Man TT motorcycle race, 172 - 173Ismay, Hastings, 177 Italy, 242-243, 245

Jacobs, Jane, 31, 35, 37, 283 Jakob Lohner & Company, 138 James, William, 169-170 Jeepster Commando breakdown at the diner, 49-50 driving home, 56-57 engine swap, 51 fetching water, 52-54 jerry-rigging used radiator, 56 junkyard radiator search, 55-56 punctured oil filter, 51 purchase of, 50-51 radiator damage, 50-52 radiator mount repairs, 51-52 selling off the Commando, 57 Johnson, Lady Bird, 72 joy, connection to movement, 11-12 judgment discretionary, 228-229 human, 227 human/individual, 7, 31, 104, 224, 227, 312 machines and, 224 mechanized, 217-218 moral, 23

NDEX 355

prudence of, 248 replacing with remote control, 312 of responsibility, 71 traffic enforcement as substitute, 217 unregulated intersections and, 245 junkyards, 51, 71–72, 74, 81–82 Junkyards, Gearheads and Rust (Lucsko), 71–72

Kansas City, 289, 290 Karmann Ghia, 68–69, 94–95 Katz, Jack, 251–254 KdF (Kraft durch Freude), 139 Kdf-Wagen. *See* Volkswagen Beetle Keyhole, 308 "Kick, Push" (Fiasco), 280 kitchen restaurant culture, 194–195 Koch, Tom, 203 Kübelwagen, 141

Labash, Matt, 218, 227 Lambert, Kelly, 60, 64-65. See also Crawford-Lambert rat driving project lane departure warnings, 101 lane keeping, 97, 100 lane splitting by motorcycles, 24-25 Lasch-Quinn, Elizabeth, 19 lash, 152-153, 152 Le Corbusier, 278 Lee, Timothy B., 88-89 The Leviathan (Hobbes), 171 liberalism, 217-218, 282 Life of Brian (film), 25 life pattern marketing, 307 lifeworld, 275 livelihood, 275 London, England, 30, 269-271 The Long Haul (Murphy), 19 long haul truckers, 19 Lorenzo, Jorge, 173 lovers, typology of, 196-197 Lucsko, David N., 71-72, 74-75, 79,81 Lucsko, John, 154 Luttwak, Edward, 95-96

machine ethics, 118 machine intelligence, 302–303 machines, deference to, 126 Macron, Emmanuel, 29–30, 224 Madigan Electric, 221 Magrin, Lisa, 302 major tool, defined, 247

managing traffic. See traffic management mass absenteeism, 119 Mayall, Joe, 82 McCabe, Katie, 275 McCabe, Matt, 269-271, 274-275 McEachin, Don, 230 mechanized judgment, 217-218 MegaSquirt, 129 Mercedes-Benz, 117 metallurgy, 145 Meyer, Greg, 201 Microsoft Corporation, 293, 295-297 mobile phones, reckless driving and, 238 - 240modern state, 285 Monchaux, Thomas de, 281-282 monopoly capital, 43 monopoly pricing, 44 monopoly(s) behavior, 298 Google as near, 290-291 inventive genius, 135 Microsoft and, 296 radical, 246-247 moral choice, 122 moral injury, 118-119 moral judgments, 23 morality affect of abstraction and, 118 automation and, 117-118 trolley problem, 116-118 utilitarianism and, 119-120 virtues and, 121-122 Most Excellent Order of the British Empire, 134 motivated reasoning, 56 MotoGP motorcycle racing, 173 motor sports, 14-15 Caliente 250, 22-23 demolition derby, 184-187 drifting as, 164-168 fight to the death and, 172-173 Formula D points series, 165 SNORE Knotty Pine 250, 200 soap box derby, 187-191 social element of, 168-169 Virginia International Raceway, 66 motorcycle races. See dirt bike riding; hare scramble race motorcycles California Highway Patrol, 24 compared to coke, 163 death rates from, 5

motorcycles (cont.) friction zone, 237 helmets, 166 lane splitting by, 24-25 off-road riding, 2-3 parking lot wheelies, 278-279 saddle rugs on, 28 motorcyclists, as footdraggers, 180 motorization of America, 37-39 Mt. Tabor, 187 Muir, John, 94 multi-agent intersection control scheme, 245-246 Musk, Elon, 87 mutual predictions, 121, 258-259 Nader, Ralph, 108 narcissism, 171-172 National Economic Council, 4 National Highway Traffic Safety Administration (NHTSA), 86-87, 98, 228 National Socialist German Workers' Party (Nazis), 138-139 National Transportation Safety Board, 122 - 123navigation systems, 98-100 neighborhoods disturbed by automobiles, 35-36 social life of, 69-70 zoning laws, 71 Nest thermostat, 305 Netherlands, 249 New Deal, 38 New Nationalism, 38, 138 new urbanism, 35-36 Niantic Labs, 308 Nicholson, Jack, 25 Nietzsche, Friedrich, 12, 169, 196-197 Noë, Alva, 61 Norman, Don, 98 Norton, Peter D., 20 NSU Motorenwerke, 139-140 nuisance alerts, 101 Nürburgring, 115

Oakeshott, Michael, 73, 82 Obama, Barack, 4 Obama administration, 95 O'Connor, M. R., 13 Oedipal dynamic, 197 off-road riding, 2–3, 205. See also SNORE Knotty Pine 250 Oh My God Hill, 207 old cars artistry of, 81-83 authenticity of, 67 cash-for-clunkers programs, 18, 74, 76.78 deep attachments to, 73-74 dispossession and, 71-79 feelings from, 67 focal point to orient the world, 67 - 68folk-classic status of, 80 forced obsolescence of, 83 gearheads and, 80 as gross polluters, 74-75 new cars emissions vs., 76-78 organic quality of, 128-129 prejudice against, 73 as ruin porn, 81 scrappage fever, 78-79 yard wealth and, 68-71 open problem spaces, 65 overcomer complex, 197 oxidative process, 130 Page, Larry, 292 panel beating, 137 partial automation, unnatural cognitive demands of, 102-103 parts cars, 18 parts managers, 154-155, 158 parts numbers, 154-155 Paso Robles, California, 57 Pasquale, Frank, 286-287 patriarchy, 195, 196 pattern of life analysis, 301 Pee Wee classes, hare scramble race, 192 Peltzman, Sam, 90, 92-94, 97 people's car. See Volkswagen Beetle perception, action and, 112-113 Phillips, John, 249 photo radar speed traps, 29-30, 218, 222-223, 226, 312. See also red light cameras pilots. See also aircraft aerial dogfights, 173-174 character dispositions of, 123-124 RAF fighter, 177-178 skills atrophy of, 123 spirited readiness of, 125 trust in automation, 124-125 pistons, 146-147 Pitt, Brad, 173, 314

Pittsburgh, 289 Pittsburgh left, 259 platform capitalism, 286-287 Plato, 25 play. See human play play community, 176-177, 283 pluralism, 10 Plutarch, 197 pogo sticks, 12 Pokémon Go! 308-309 political culture, 22, 244, 281-282 political economy, 83, 276, 290 political legitimacy, 287-288 populism, 29-31, 288 Porsche, Anton, 137 Porsche, essays commissioned by, 114 - 115Porsche, Ferdinand, 16, 137-140 Portland's Adult Soapbox Derby art cars, 189-190 fast cars, 189 participant costumes, 191 spectator descriptions of, 188-189 Power Wheels derby, 185 prediction products, 302-303 predictive processing, 256-261 premodern state, 285 primary-secondary task inversion, 100 - 101probabilistic reality grasping, 257 progressive neoliberalism, 75-76 Progressives, 38 project cars, 69-70 Promethean defiance, 126 Promethean pride, 126 Promethean shame, 129, 153 Prometheus myth, 126 propositional knowledge, 93 protest movements, 225 prudent drivers, 248, 313-314 public infrastructure, 9-10 public parks, 281-282 public spaces, 281-283 public transportation municipal funding of, 37-38, 44 prioritizing automobiles over, 96 road construction and, 38 punishment, cultural history of, 237-238 push-button transmissions, 74 Putnam, Robert, 204, 259

Quality Control Systems Corporation, 87-88

radiators, 51-52 radical monopoly, 246-247 RAF fighter pilots, 177-178 Rainbow Canyon Motel, 200 rapid onboarding, 101-104 rat project. See Crawford-Lambert rat driving project rational actor, 291 Reagan, Ronald, 77 rearview cameras, 95 reckless driving, 230-232, 238-240. See also accidents Red Baron. See Richthofen, Manfred von red light cameras, 30. See also photo radar speed traps amber time and, 219-220 Automated Traffic Solutions, 221 in Chicago, 218-222 in District of Columbia, 218 Redflex Traffic Systems, 221 reducing amber times, 222 replacing individual judgment, 312 revenue generating, 220 Redflex Traffic Systems, 221 Regulation of Automobile Safety (Peltzman), 90 Reich Highway Code, 260 restorations. See also folk engineering air-cooled Volkswagens, 16-17 antijunk ordinances and, 18 bliss from, 17 class war and, 18 parts cars, 18 rolling your own and, 17 rust and, 130-131 Volkswagen Beetle, 128-130, 136 - 137The Revolt of the Public (Gurri), 225 Ricardo, Harry, 133-135, 145, 146-147, 159 Richardson, Journee, 203 Richmond, Virginia, 1 Richthofen, Manfred von, 174-176 ride-share vehicles, 45. See also Uber risk budget, 91, 93, 313 risk ecology, 90 risk reduction, 34. See also automobile safety rivalry, psychology of, 170 road construction, 37-38, 43 road fatalities, 242 road rage behavior constraint, 258

road rage (cont.) as emotional release, 251-252 examples of, 250-251 experiences of, 249-250 Katz's views of, 251-254 as natural emotional response, 256 prison-sex theme, 250 stereotyping offenders, 255 road trips, 8, 274 roaming, 8 rod caps, 147 rolling your own. See restorations Roman intersection, 242-243, 245 Romania, 250 Roomba robot vacuum cleaner, 306 Roosevelt, Franklin D., 38 Roosevelt, Teddy, 169 Rosen, Jody, 269-270 Rousseau, Jean-Jacques, 197 rule following, 243-245, 279-280 rule of Nobody, 216-217 rust, 130-131 Rust Belt, 290

safety. See automobile safety safetyism, 33 salvage vards. See junkyards Sandia National Laboratories, 76 Santa Barbara Air Quality Management District, 76 scaffolding, 257 Scaller, Bruce, 43 scared, tonic effect in being, 15 Scheuer, Andreas, 230 Schmidt, Eric, 292 Schumacher, Michael, 115 Schwimmwagen, 141 Scion xB, 112 scooters, 12 Scott, James C., 267-268, 284-285 scrappage fever, 78-79 seat belts, 90, 97 Sedaris, David, 249-250 Seeing Like a State (Scott), 267-268, 284 - 285self, better, 170 self-driving cars. See autonomous cars; driverless cars; semiautonomous cars self-government, 31-32, 193, 204 self-locomotion, 12-13 self-mobility, memory and, 12-14, 60-61 semiautonomous cars. See also

autonomous cars; driverless cars

in-car information system, 99 cognitive demands in, 102-103 driver's role in, 98 lane departure warnings, 101 lane-keeping alerts, 100 navigation systems, 98-99 nuisance alerts, 101 primary-secondary task inversion, 100-101 resuming manual control in, 102 speed alerts, 101 senseless violence, 184-185 serendipity, streets beckoning with, 2-3 Sexton, Patricia, 196 Siegel, Iacob, 284 Simon, Marilyn, 194-195 situational awareness, loss of, 94-95 skateboarding, 281, 282, 283 Skinner, B. F., 309 Sleep Number Bed, 304-305 sleepers, 142 SleepIQ, 304 Sloan, Alfred, 74 smart cities as big tech frontier, 284-285 Google and, 284 informed choices, 291 infrastructure development, 288-290 legible order of, 285 as object of rational planning, 278 public parks and, 281-282 unplanned urban delight and, 282-283 vision, 277 smartphones, 5 smoothness, defined, 18 SNORE Knotty Pine 250 awards ceremony, 208-209 description of, 200 midcourse, 206 Oh My God Hill, 207 post-race, 208 prerace drivers' meeting, 203 start of race, 205-206 soap box derby, 187-191. See also demolition derby; motor sports social Darwinism, 290 social norms, 121, 256, 259-260 social order, 32, 170-172 socialism, 138-139 socially scaffolded mutual prediction, 244 Socrates, 142 Sons of Anarchy (television show), 196

South Coastal Recycled Auto Program (SCRAP), 74-75 sovereignty, 29-31, 271-272, 284, 312-314 speed, need for, 11, 12 speed alerts, 101 speed cameras, 30, 217. See also red light cameras speed traps. See photo radar speed traps speed zones, 222-223, 228 Sprint, 289 stability control, 92, 112 steering columns. See energy-absorbing steering columns steering of thought, 290-291, 300-301 stereotyping, 255 storytelling, 13 straight-cut timing gears, 150-151, 152 street use, 20-21 Street View GPS and, 272 Hanke and, 308 launch of, 265 protests, 265-266 resentments provoked by, 271-272 Subaru transmissions, 156 Super Squish pistons, 146-147 superior drivers, 254 Surry, Virginia, 191 surveillance and coercion, 306-307 surveillance capitalism behavioral data and, 302 driverless cars and, 301-308 location data and, 301 prediction products and, 302-303 sustained habitation, 274

tandem drift, 167-168 tank engines, 134 tax farmers, 232-233 taxis, regulating, 45 tech companies, 39 techno-capitalism, 10 technology big data, 303 defined, 296 exit costs, 298 increasing car safety, 86 Tesla customer demographics, 89 Musk, Elon, 87 safety systems, 86-89 stock price, 86

Thelma and Louise (film), 314 Thompson, Hunter S., 207, 215-217 thrust, 150, 151 Tibet, 27-28 ticket farming, 233 Tignor, Samuel, 223 timing gears, 149-151, 149 tinted windows, 253 Tocqueville, Alexis de, 22, 73, 193, 209, 255 Tocquevillian awareness, 10 Toyota Camry, 67 traction control, 92 traffic community, 260 traffic control, 243 traffic court, 230-236 traffic enforcement, as judgment substitute, 217 traffic jams, 4, 18-19, 23-25 traffic management amber times manipulations, 222 autonomous intersections, 21, 245-246 improvisational flow of unregulated intersections, 244 lane width reduction, 222-223 photo radar speed traps. See photo radar speed traps political culture and, 244 public revolt to, 30-31 rationality and, 243-244 rationality of, 245 red light cameras. See red light cameras role of speeding in crashes, 226-229 Roman intersection, 242-243, 245 rule following and, 243-244 rules for, 21 speed cameras, 30 speed traps, 222-223 surveillance and, 243 traffic rationality, 20-22 transmissions, 156, 166 Trieber, Todd, 156 Trobriand Islanders, 69 trolley problem, 116-118 Trump, Donald, 4 Tygum, Carl, 201

Uber

economic plan, 44 fare subsidies, 44–45 flouting local driving laws, 43 Z

Uber (cont.) in London, 271 narrative construction of, 45 Pittsburgh left and, 259 ridership costs, 43-44 sucking up traffic data, 289 United Kingdom, 271-272 Universal Utility Calculation, 283 unobtrusive safety devices, 93-94, 96-97 Unocal, SCRAP program, 74-75 upper-class society, working class vs., 196 urban bicyclists, 180-183 urban drivers, 248 urban skaters, 283 U.S. Department of Transportation, 4 utilitarianism, 117, 119-120, 169-170, 283 utopian experiment, 25-27

Vietnamese immigrants, 80 Virginia, reckless driving, 230-232 Virginia International Raceway, 66, 164, 231 virtues, 121-122 Volkswagen Beetle. See also air-cooled Volkswagens crankshaft, 143 development of, 139-141 folk engineering. See folk engineering ownership experience, 107-109 as the "people's car," 141 restorations, 128-130, 136-137 Volkswagen bus, author's purchase of, 57-58 Volkswagens. See air-cooled Volkswagens; Volkswagen Beetle voluntary associations, 193, 204 Volvo Concept 26, 39-40

walking. See also neighborhoods as act of faith, 2-3

cities made for, 247-248 exposure in, 20 WALL-E (film), 6, 189 Wang, Forrest, 165 Warren County Fair, 185 Wasilla, 249 Werlin, Jacko, 139 White, Adam J., 291 Whitfield, Randy, 87-89 Wiener, Earl, 101 Williams, Bernard, 119-120, 283 windows, tinted, 253 women female riders, 192-194 girl-power affirmation, 194 in kitchen restaurant culture, 194-195 overcomer complex, 197-198 working-class, 195-196 working class, 196 Works Progress Administration, 38 World Health Organization, 242 World War One aerial combats, 173-176 calvary, 174-175 Churchill, Winston, 174, 177 RAF fighter pilots, 177-178 Richthofen, Manfred von, 174-176 wrecking yard. See junkyards Wyden, Ron, 302

Yamaha, 164 yam-houses, 69 yard wealth, 68–71 Yellow Vest movement, 29–30, 224–226

Zients, Jeffrey, 4 Zuboff, Shoshana, 273–274, 302–303, 305–306, 309 Zündapp, 139–140